The Great Exhibition, 1851

MANCHESTER
1824
Manchester University Press

Series editors: Anna Barton, Andrew Smith

Editorial board: David Amigoni, Isobel Armstrong, Philip Holden, Jerome McGann, Joanne Wilkes, Julia M. Wright

Interventions: Rethinking the Nineteenth Century seeks to make a significant intervention into the critical narratives that dominate conventional and established understandings of nineteenth-century literature. Informed by the latest developments in criticism and theory the series provides a focus for how texts from the long nineteenth century, and more recent adaptations of them, revitalise our knowledge of and engagement with the period. It explores the radical possibilities offered by new methods, unexplored contexts and neglected authors and texts to re-map the literary-cultural landscape of the period and rigorously re-imagine its geographical and historical parameters. The series includes monographs, edited collections, and scholarly sourcebooks.

Already published

The Great Exhibition, 1851

A sourcebook

Edited by
Jonathon Shears

Manchester University Press

The right of Jonathon Shears to be identified as the editor of this work has been asserted by him in accordance with the Copyright, Designs and Patents Act 1988.

Published by Manchester University Press
Altrincham Street, Manchester M1 7JA
www.manchesteruniversitypress.co.uk

British Library Cataloguing-in-Publication Data
A catalogue record for this book is available from the British Library

ISBN 978 0 7190 9912 0 hardback
ISBN 978 0 7190 9913 7 paperback

First published 2017

Typeset
by Servis Filmsetting Ltd, Stockport, Cheshire
Printed in Great Britain
by CPI Group (UK) Ltd, Croydon CR0 4YY

Contents

Figures

Acknowledgements

There are a number of people that I would like to thank for their help in the production of this book. At the head of the list is Amber K. Regis, with whom I worked on the early stages of this project, particularly in compiling the material that eventually ended up in Chapter 4. Angela Kenny was a godsend at the archive of the Royal Commission, giving assistance on my research trips and patiently and promptly responding to my many email requests (including those asking for images that I'd already been sent). Thanks go to the Royal Commission and the Victoria and Albert museum for generously allowing me to reproduce some of the images included here free of charge and to *Punch* magazine for some fee reductions. The Research Institute at Keele University helped me cover other costs for image permissions and research trips for which I am very grateful. The suggestions of the two anonymous readers for MUP were important in prompting me to expand the range of sources that the book presents. David Fallon and Anna Barton very kindly agreed to read and provide suggestions on the content of some of the chapters: their thoughts helped to keep me on track. The series editors were always available to answer questions, as were the staff at Manchester University Press, and I was extremely fortunate to have such a capable and conscientious copy editor in Susan Womersley. I owe a special debt of gratitude to Geoffrey Cantor who generously gave of his time and expertise in reading the near-completed book. Geoffrey saved me from making several slips, particularly regarding my reading of the various versions of the Exhibition Catalogues. Kimberley Braxton and Hannah Scragg were so helpful in proofing the final manuscript, while I am indebted to Ros Davies and Ellie Patient for getting me out of a tight spot. As always I also thank my family, particularly Gill and Jessica, who gave me the love and support to keep my spirits up when working long hours transcribing and editing material.

Abbreviations

Minutes – *Minutes of the Proceedings of Her Majesty's Commissioners for the Exhibition of 1851, 11 January 1850 to 24 April 1852* (London: William Clowes & Sons for HMSO, 1852)

NLS – National Library of Scotland

Official Catalogue – *Official Descriptive and Illustrated Catalogue*, 3 vols (London: William Clowes & Sons, 1851)

RC – The Archive of the Royal Commission for the Exhibition of 1851, Imperial College London

Victorian Prose – R. J. Mundhenk and L. McCracken Fletcher (eds), *Victorian Prose: An Anthology* (New York: Columbia University Press, 1999)

Tallis's History – John Tallis, *Tallis's History and Description of the Crystal Palace, and the Exhibition of the World's Industry in 1851*, 3 vols (London: John Tallis, 1851–52)

Introduction

A miniature working colliery. A priceless – though poorly cut – Indian diamond. Fossils that glowed in the dark. Waterproof paper. A statue of a Greek slave. A statue of an Amazon on horseback being attacked by a lion (cast in zinc and bronze). Amazone, or 'essence of meat'. Steam engines. Everlasting chlorine. A pair of anaxyridian (self-suspending) trousers. Cashmere from the goats of Prince Albert. An ivory howdah on the back of a stuffed elephant. Innumerable colossal blocks of coal. A canister of boiled mutton from an Arctic expedition. A sea-water regenerator, a set of whippletrees and any number of machines to remove smut from wheat.[1] All found their way into the Crystal Palace at Hyde Park for the Great Exhibition of 1851. Even though the event went on for just shy of six months, this astonishing and eclectic array of material challenged an individual's capacity to comprehend it in its entirety. '[T]he eye is dazzled, the brain is feverous' wrote Thackeray's fictional French reporter, Monsieur Gobemouche (*Punch*, 20 May 1851, p. 198; see 3.4). As *The Times* of 2 May marvelled, 'thirty visits will hardly be sufficient for those who wish to "get up" the whole Exhibition'; many evidently agreed and decided to pay £3 3s (men) or £2 2s (women) for a season ticket. The sense of something epic was palpable. 'We are', announced John Charles Whish in his *Great Exhibition Prize Essay* (1851), 'upon the eve of an event which may certainly be looked upon as the greatest wonder of the world' (p. 1). This wonder, in all its glorious miscellany, in its noise, colour and light, perplexed just as frequently as it inspired. Part trade fair, part festival, part shopping mall, part art gallery and museum: what was the Great Exhibition and what did it mean?

Anyone new to the subject of the Great Exhibition could be forgiven for sharing in this confusion. While there has never been much doubt that Prince Albert, Henry Cole and the other Commissioners who organised the Exhibition wanted it to demonstrate to British manufacturers the advantages of embracing free trade, as Louise Purbrick argues, later historians have 'saturated the Great Exhibition with meanings'.[2] This is partly due to the diversity of exhibits but also because 'the Crystal Palace Exhibition was a new

kind of spectacle, a modern-day mass-cultural event too large and unknown for its meaning to be easily pinned down' (Teukolsky, 2007: p. 84). Rachel Teukolsky's view is endorsed by the influential historical work of Jeffrey Auerbach and John R. Davis, and the editors of *Victorian Prism*, who have argued that its uniqueness meant the Exhibition became an occasion for debating numerous issues about the position of Britain on a global stage and 'an unofficial forum on the meanings of modernity' (Buzard *et al.*, 2007: p. 1).

Part of the Exhibition was always about making sense of novelty and the unknown, about generating meaning from – and, in some senses, finding ways to express and control – the modern, expanding world that was felt to contain a surplus of significance. For Paul Young (developing the argument of Anne McClintock, 1995), it was precisely the fact that many of the objects in the Exhibition were odd or unfamiliar and therefore slightly threatening – often those from abroad, but we might also include the gamut of new mechanical inventions on display – that seemed to necessitate their incorporation within 'the historical moment of modernity' (2008: p. 25). Allardyce Nicoll was partly right in arguing that 'The Great Exhibition was a symbol of an age that was passing away and the premonition of an age that was to come' (1946: 1, p. 7). Even so, shaping and curating a 'modern' world at the Exhibition – a world of incongruity and idiosyncrasy, of gravity and absurdity, of steam power and innovations in trouser design – was manifestly not so much a way of splitting with the past, but of providing reassurance about the future.

If the Exhibition is significant primarily because it represented something new – and it undoubtedly inaugurated a new era of international expositions – Geoffrey Cantor reminds us that there are 'many ways to map modernity' (2011: p. 8). Modernity's meanings are characteristically protean. For Judith Flanders and Thomas Richards the Exhibition was a watershed moment in the development of modern-day consumer habits, 'the first outburst of the phantasmagoria of commodity culture' (Richards, 1990: p. 18). The Crystal Palace was, despite the absence of prices, a vast arena for advertising consumer goods. Tony Bennett and, more recently, Dan Smith have aimed to understand the role that the Exhibition played in forging a modern consciousness of behavioural patterns grounded in formations of 'display', 'spectacle' and 'surveillance' (Bennett, 1988: p. 78) that derive from the work of Foucault. Both view the phenomenon of the Exhibition as playing a crucial role in the development of public spaces of display, such as museums and galleries, which perpetuate or critique Western cultural values. Then there is the normalisation of the machine. Purbrick, influenced by Marx, notes that one of the functions of the Exhibition was to illustrate the 'achievement of industrial technology without reference to the conditions of industrial labour' (2001: p. 2). Part of the fetishisation of the manufactured object was evidently an attempt to win a larger argument about the relevance of the labourer in

an age of mechanical reproduction which Walter Benjamin had identified as far back as the 1930s. (The average visitor would, however, have been struck much more forcefully by the noise generated by the Machines in Motion than by the alienation of the workforce.)

For all these reasons the Exhibition continues to be significant in the studies of material culture, particularly regarding issues of commodification, which have grown increasingly important to Victorian scholars since the 1980s.[3] As Lyn Pykett puts it, there has been a 'material turn' in Victorian studies and Victorian historiography. The Victorians, as with later critics of the period, were 'preoccupied with the signifying power of things' (Pykett, 2004: p. 1): the ability of objects to disclose information and meaning, whether this was about individuals or a wider culture. The consumption of objects and the growth of a commodity culture in the nineteenth century has been a focus of critics interested in the development of capitalism – particularly those influenced by Marx and Adorno – such as the social anthropologist Arjun Appadurai (1988) who extensively theorised the exchange value of commodities. Jeff Nunokawa (1994) traced anxiety about commodities to increased ownership of property, while Asa Briggs (1988) examined the historical reasons for the explosion of consumer goods in the nineteenth century. The attribution of value to material substance has also been the source of friction in material studies where objects are often considered to pass through, rather than abide in, different states that variously decree their use value, functionality, exchange value or aesthetic worth. Consequently the texts selected for this book, and the editorial material which introduces them, are situated within and will periodically refer to some of these debates. At the Great Exhibition they can be seen at work in the contestations of meaning and value that inhere in the most considerable of all its objects: Paxton's Crystal Palace, which occupied a predominant position as the object housing other objects; remarkable for its prefabricated construction, initially disputed for fears concerning its serviceability, but routinely lauded for its aesthetic appeal. They can also be seen at work in the frequent contrasts made between the functionality of British products and the higher aesthetic merits of French design.[4]

Our critical fascination with the way the value systems of modernity are disclosed by its material products ought, however, to be accommodated to the popular Victorian rhetoric of 'progress'; indeed, the two words are practically synonymous. '[T]he history of England', wrote Thomas Babington Macauley in 1835, 'is emphatically the history of progress' (Dodson, 2002: p. 135), but in the 1850s many remained ambivalent about the narrative that presented industry and commerce as the instigators of universal peace. It was a narrative on which the Commissioners, particularly Albert, sold the Exhibition to the general public. In an attempt to alter insular British views, according to Siegfried Giedeon, 'Industry, after all the blight and disorder it had

brought about, now displayed another and gentler side' (2008: p. 249). Albert undoubtedly won over many sceptics. In *A Poem on the Great Exhibition of the Industry of All Nations* (1852) for example, Henry Tilney Bassett voiced a new confidence that the triumphs of man were now first and foremost industrial, rather than military, in nature:

> What has not Genius done with toil combined?
> Th' electric wire has baffled time and space, –
> The thundering train outstrips the winged wind,
> That drives the clouds along in eddying race, –
> They've changed the river's course, the lofty mountains rent,
> And turned to human use each wondrous element.

<div align="right">(XVI)[5]</div>

No doubt the four-point taxonomy that Albert proposed to conceptualise the arrangement of exhibits in the Crystal Palace – Raw Materials, Machinery, Manufactures and Plastic Arts – was also designed to demonstrate the view that man was gradually harnessing each 'wondrous element' of the natural world, modifying and improving them according to desire, and that industry provided an irresistible centripetal force. The Exhibition, at least in theory, demonstrated Albert's conviction that his was an age of intellectual enlightenment but also, as Auerbach notes, an attempt 'to forge a society that was receptive to a certain form of industrialization' (1999: p. 98). If the military conflicts in the 1850s and 1860s, including the war in the Crimea, subsequently made the rhetoric of peace and progress seem naïve, the Exhibition should nevertheless be viewed as symbolic of the movement from what Nietzsche called monumental history – history measured through the great deeds of great individuals such as Napoleon – to the history of economics, consumerism, nation states and social engineering.

By anyone's calculation, the Exhibition's novelty, scale, heterogeneity and 'mountains of matter' (Buzard *et al.*, 2007: p. 3) meant that its meanings were not easily digestible. The official line of the Commissioners was also put under enormous strain by competing narratives and subtexts. Modern critics, some of whose work I have summarised above, have added to the proliferating readings, but one thing that has come to be accepted is that the Exhibition was as much an issue of reading as it was of viewing, of textuality as of materiality. The Exhibition had 'a seemingly boundless capacity to *inspire* description' (Buzard *et al.*, 2007: p. 1), which is the occasion for this book. The sources collected and edited here demonstrate that the Great Exhibition was exhaustively documented in all sorts of ways, from private diaries and letters, to the official communications of the Royal Commission and Executive Committee, from the vast numbers of stories and commemorative poems, to the many column inches in the organs of the press. The viewpoints captured here are

<div align="center">4</div>

domestic – both metropolitan and regional – but also foreign; indicative of the opinion of upper, middle and lower classes; and taken from those who championed the Exhibition and from those who protested vehemently against it. Right wing and left wing politics are here, as are modernists and protectionists, the labouring man and the aristocrat.

Compiling such a book and sifting through the large number of potential texts that could be included does, however, involve an ongoing process of selection which is implicated in some of those same problems about reading, writing and representing the Exhibition – belonging to the Victorian period and our own – that I have begun to identify and outline. Central to these is the relationship between language – particularly language's tendency to categorise – and materiality. That relationship is, as many recent theorists of 'things' – including Bill Brown (2003) and Elaine Freedgood (2006) – have told us, a vexed one. Rather than transparently disclose objects, language often has a tendency to become opaque. This phenomenon might be seen in two introductory examples: the floor plan of the Palace and the compilation of the *Official Descriptive and Illustrated Catalogue* (1851).

The first of these is well known and so can be dealt with briefly. There was an incongruity between the physical space of the Exhibition (indicated by the floor plan of the Palace that readers can find in Figure 5 in this book) and the attempt to superimpose an organising taxonomy upon it (see 2.1), which eventually ran to an arrangement of thirty classes; as Joseph Childers explains, these were 'conflicting cartographies' (2007: pp. 203–15). Whilst it was originally intended that a visitor could follow the story of industrial production (and therefore of Victorian progress) in the aisles and bays of the Palace, beginning with Class 1 – 'Metallurgy and Mineral Products', passing through classes such as 'Agricultural and Horticultural Machines', 'Cotton' and 'Ceramic Manufacture' and eventually arriving at Class 30 – 'Models and Plastic Art' (the crowning achievements of culture), there were, in practice, a mountain of logistical problems which meant that the science of classification yielded to expediency. The original idea that the space designated for each country could be distributed throughout the Palace by class – and so the products visibly compared and contrasted – was replaced by divisions based on nation. '[T]he only course now open', according to a Memorandum of the Commission, 'is to assign one particular location of the Building to each Nation'.[6] Only the British exhibits, which occupied the western nave, were in fact arranged by the class system, designed by Lyon Playfair, but whether this was adequate to capture and master the objects on display is open to debate.

The *Official Descriptive and Illustrated Catalogue*, compiled by Robert Ellis, functioned in a similar way to the Commissioners' taxonomy by imposing another official narrative upon the Exhibition, wherein Britain was presented as the paradigm of modern occidental society. Originally intended as

a two-volume work, the *Catalogue* eventually grew to three volumes (with further supplementary volumes added later).[7] A one-volume, 'Small' edition for the price of a shilling was also published at the opening of the Exhibition in May (largely due to the fact that only the first volume of the comprehensive catalogue was ready by 1 May, but also to capitalise on the market of immediate visitors). British exhibits occupied the first two volumes of the *Official Catalogue*, along with a general introduction and accounts of such things as the construction of the Crystal Palace and the catalogue's compilation, with 'Foreign States' relegated to the third volume (colonial exhibits were described separately in the second half of volume two). No doubt hugely informative, the descriptive categorisation was clearly designed to codify a set of British values indicating commercial supremacy. We learn, for example, that Germany's 'territorial divisions … have always proved a material hindrance to the advancement of industry and commerce' (*Official Catalogue*, 3, p. 1,046), and India, one of the cradles of civilisation, has, despite its vast mineral wealth, failed to advance commercially in contrast to Britain (2, p. 857). It also becomes clear, as Eileen Gillooly explains, that whilst Britain 'begrudgingly admitted aesthetic superiority to France' in design, they 'claimed ethical superiority' (2007: p. 31) for placing emphasis on use value and affordability.

Do generalisations such as these represent the actual experience of visitors who witnessed the masses of material in person? This is a difficult question to answer and involves engaging with the unknown (and, to a degree, unknowable) man and woman discussed by Darling and Whitworth (2007: p. 2).[8] We might note contrasts in the reception and representation of some of the exhibits as a way of providing an answer. One of the most striking and celebrated pieces of statuary on display in the whole Palace was Professor Kiss's Amazon attacked by a tiger, part of the German contribution, which dominated the main avenue. The impressive Bavarian lion (Figure 1) by Ferdinand Müller of Munich, displayed in the Eastern Avenue, likewise provided evidence that the trade union of the Zollverein – a collection of German states and potential economic rival to Britain (Davis, 2008: p. 151) – offered supreme artistic achievement. As Davis has pointed out, however, the significance of the industrial products of the Zollverein, which were legion and had the potential to knock British industrial confidence, was underplayed in the likes of the *Official Catalogue* and Robert Hunt's *Hand-Book to the Official Catalogues* (1851). The praise for German art could be viewed as distorting the industrial significance of the Zollverein which was encountered just as extensively by visitors.

Or we might go further and examine the compilation of the *Official Catalogue* for evidence of the inconsistencies which classification could promote. Ellis's introductory material to the one-volume edition explains that all exhibitors were asked to provide a written account of the items submitted for

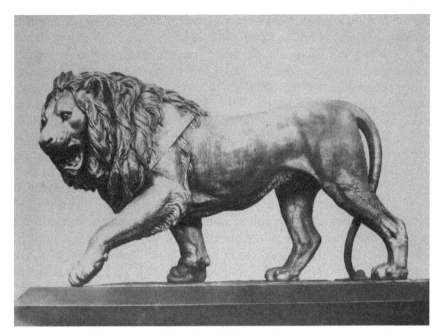

1 The colossal Bavarian lion

display, which would be edited by a group of 'scientific gentlemen' to form the bulk of the material in the *Catalogue*. The undertaking was, he admits, too much for one man:

> The desirableness of obtaining a symmetry of proportion in the works, and as far as possible a harmony of style and consistency of expression, in addition to the great importance of attempting to communicate to them a character of scientific accuracy, demanded the adoption of general principles of correction and reconstruction. But the varied nature of the contents of the Exhibition, and of the descriptions supplied, rendered this a duty difficult to be undertaken by any single individual ('Shilling Catalogue', p. 7).

Ellis's specific remit is worth noting. He was tasked to render each object with 'scientific accuracy', to attain an 'Archimedean point' (Buzard *et al.*, 2007: p. 4) from which to make the exhibited material legible and expressively coherent. The description of the Bavarian lion presents a reader with the kind of technical accent we might therefore expect, the exhibit remarkable for 'showing the possibility of executing casts in one piece' and for 'preserv[ing] the pure natural metallic colour of the cast without [the founder] being obliged to use the chisel' (3, p. 1,102). Recording the processes of production, rather than aesthetic merit, is the *Catalogue*'s function and there is no place

for the kind of aesthetic judgement that we find, for example, in the *Art-Journal*'s appraisal of Hiram Powers's *Greek Slave* (see 2.3).[9] Statuary, like all other exhibits, had its place in the thirty-class taxonomy. In the one-volume edition of the *Catalogue* that William Clowes & Sons produced to coincide with the opening in May, which was unpretentious and little more than a list of exhibits, the entry for the lion of Munich has been trimmed down to one measly sentence – 'Colossal Lion, fifteen feet long and nine feet high, by Müller of Munich' ('Shilling Catalogue', p. 15), undifferentiated from the adjacent 'bell of brass, 383 kilogr. weight, with iron clapper and tackle, by F. Gruhl, Kleinwelka, near Bautzen'. There is no way, within the remits of the one-volume catalogue, to make any appraisal or value judgement. It should be remembered, however, that this is the same lion that prompted extensive, contrary and powerful reactions from public and art critics alike; it was lauded as a testament to 'the pre-eminence of Saxon genius in treating subjects on a grand and colossal scale' (Timbs' *Year-Book*, 1851: p. 102), but described in *Tallis's History* (1851–52) as 'a so-so affair' (1, p. 169) and by the *Morning Chronicle* as having 'far too gentle and amiably simple an expression' (15 September 1851) to provoke fear. The indelible impression left upon the public imagination is, however, felt by the sheer weight and frequency of its reference, captured most successfully when *The Times* imagined it prowling the courts 'amid a perfect wilderness of boxes' (12 November 1851) following the closing ceremony. Like many, Thackeray's Gobemouche felt his descriptive powers baffled by the Exhibition's statuary – 'How select a beauty where all are beautiful? how specify a wonder where all is miracle?', but it is precisely language's capacity to make distinctions and serve different functions, dependent on context and purpose, that readers of this book might like to look out for.

In a sense the *Official Catalogue* (and certainly the shilling version) could be viewed as a textual version of what McClintock has called an 'anachronistic space' (1995: p. 40): the display of objects shorn of their ability to signify diversely through their incorporation in an encyclopaedic system. The indexing function of a catalogue presents distinctions that are arbitrary or syntactic rather than evaluative, perhaps an example of one of the many 'taxonomic troubles' that Gillooly has identified at the heart of nearly all writing about the Exhibition. In the absence of an adequate 'scientific classificatory system', she argues, textually the Great Exhibition 'constitutes a paratactic narrative', or a series of narratives placed side by side, resulting in 'a spectacle of national exhibits seen contiguously' without proper connections (2007: p. 25). This is precisely the experience that the *Catalogue* – and Albert's taxonomy – attempted to remedy but, in some ways, ended up amplifying.

In the absence of that adequate scientific classificatory system it could be argued, however, that reading the Exhibition becomes a more interactive

process, generating the kinds of other distinctions through which the texts presented in this book are organised. Bearing in mind taxonomic imperatives and the challenges of classification, readers will, I hope, approach the contents of this sourcebook alert equally to pattern and singularity. Each chapter title has been chosen because it is prominent in the growing body of critical work on the Exhibition in disciplines such as History, Design, and Literary and Cultural Studies. The chapter headings – 'Origins and organisation', 'Display', 'Nation, empire and ethnicity', 'Gender', 'Class' and 'Afterlives' – all break down into further subsections so, for instance, the chapter on Class contains themes such as welfare, the 'Shilling Days', the radical press and local committees, and ballads. Each section is prefaced with an introductory guide, which will draw your attention to related issues and documents and provide some historical context, but these are not intended to set a limit on evaluation and analysis. At times I have found that a single document crystallises all pertinent issues but at others, the complexity of the subject matter meant that it was appropriate to include numerous texts. Subdivisions are not consequently uniform in length.

Some of the documents that I have chosen to include in one section may also address the concerns that predominate in another. In section 4.3 for example, the extract from *John Bull* of 19 April on the presence of Queen Victoria at the Palace carries the kind of sceptical tone, and objections to free trade, that speak to the texts collected under 'Doubts and objections' in 1.3. The decision I made to include an extract from John Tallis's *History and Description of the Great Exhibition* (1851) in subsection 3.1 on Patriotism was due to the fact that he addresses specifically British achievements in industry when his overtly masculine rhetoric means it could easily feature in the discussion of this topic in Chapter 4. Some subjects such as work, technology and mechanisation are so widespread and multifarious that I felt they were best accommodated in different chapters such as Organisation and Class, whereas peace and warfare feature in the chapter on Gender, when they could have filled a chapter on their own.

By its very nature, and due to the amount written on it, many of the sources in this volume have been used elsewhere in books about the Great Exhibition. In some ways this has promoted piecemeal reading, where famous statements, such as those made by Albert in his speech at the Mansion House on 21 March 1850 (see 1.2), have come to represent a whole series of views. One of the main functions of this book therefore, is to allow students and researchers to read some of these texts in their entirety for the first time – some which have never previously been reprinted in full and are only otherwise available in the archives of the Royal Commission and the Victoria and Albert Museum – and, granting my editorial interventions, make their own, essentially, unmediated evaluations. Where there has not been space enough

to reproduce a long text in full I have tried to give as accurate a picture of its substance as possible. Alive to the fact that books on the Exhibition often raid the same texts again and again, I have also tried to provide readers with as wide a range of sources as can reasonably be included. It was often the case in the Victorian period that regional publications, and those in the colonies, sourced their material from articles in the London press, and so any searches of the online catalogue of Nineteenth-Century British Library Newspapers will usually reveal the same report featuring multiple times in various outlets. Despite this fact, there remains a good deal of press coverage – in working-class newspapers such as the *Northern Star* for example – that is independent of the major outlets of the metropolis and that I have been able to reproduce.

Those who will take most from *The Great Exhibition, 1851: A sourcebook* are students and researchers new to the topic and particularly those who want to teach the subject without resorting to hours of trawling through primary texts to produce course material. So the book is primarily conceived as a teaching aid, but it also offers numerous departure points for researchers in the history of the Exhibition, and material culture more generally, and those working on specific issues such as British imperialism, social class and the representation of gender politics in the Victorian period. To a great degree the documents speak for themselves: I have provided endnotes for each chapter where some of the contemporary references are obscure but have endeavoured to keep these to a minimum. If certain issues are raised on a number of occasions, I have tried to explain them in detail just once and included notes to that section of the book for the purposes of cross-referencing. Full references for each text can be found in the comprehensive bibliography. In the case of text taken from newspapers, I have indicated date and page reference wherever possible.[10] All emphasis is in the original. It may not be feasible to 'get up' the whole Exhibition in one book, but I hope that readers coming to the subject for the first time, and those returning to it, will alike find that here, they will come pretty close.

Notes

1 All of these items appear in the *Official Descriptive and Illustrated Catalogue* (1851) of the Exhibition. A howdah is a seat for riding on the back of an elephant or camel while a whippletree is used to distribute force evenly in the mechanisms used by draught animals.
2 This is part of the blurb to Purbrick (2001).
3 The list of books is extensive but the most notable include: Appadurai (1988); Briggs (1988); Richards (1990); Nunokawa (1994); Miller (1995); Brown (2003); Freedgood (2006); Waters (2008); Shears and Harrison (2013).
4 See, for example, the article from *The Times* for 20 October 1849 in section 3.1.

5 Bassett's 1852 essay received the Vice-Chancellor's first prize awarded by the University of Dublin. It was published in stanzas, without line numbers.

6 See 3.2 for the full document.

7 For any student of the Exhibition, it is worth remembering that the numbering of these volumes is somewhat problematic. The *Official Catalogue* is usually taken to be three volumes plus one supplementary volume, but in some cases parts are counted rather than volumes.

8 Unknowable in the sense of being unnamed: that is 'the factory worker, the shop clerk, the house wife' (2007: p. 2).

9 As Auerbach notes, the editors who assisted Ellis – including Robert Owen, Philip Pusey and Brunel – 'could add scientific annotations, but could not offer criticism' (1999: p. 243).

10 Although in the case of some newspapers and obscurer sources – and these are usually only extant at the Archive of the Royal Commission and have minimal reference data – that information is missing.

1

Origins and organisation

It is difficult to trace the germ of the idea for the Great Exhibition to one particular source. The 'Exhibition of the Industry of all Nations', as it was initially referred to, was the product of a number of issues of which three stand out most prominently: the liberal shift in politics of the 1830s that popularised *laissez-faire* attitudes to manufacture and enterprise; the need to address Britain's position as an economic power and moral arbiter in post-Napoleonic Europe; and the fortunate incidents that occurred in the 1840s to bring together the men who would shape the venture.

The importance of the two first of these issues might be seen reflected in a report of 1835–36 from a Select Committee on Arts and Manufactures which concluded, according to David Raizman, that 'the arts in Britain had received very little encouragement and that the result was both a decline in demand abroad for British goods and an increase in foreign imports at home' (2003: p. 50). While British commodities such as pottery, textiles and furniture were more affordable than foreign equivalents, frequently they were negatively compared to the better designs of continental, especially French, manufacturers. The Select Committee recommended that the education of British workers be improved along continental lines by reformation of the Mechanics' Institutes and the Schools of Design. The economic driver was the repeal of the Corn Laws in 1846, which had effectively removed restriction on imports and exports, placing British goods in a new competitive marketplace.

The third of these issues must be viewed against the backdrop of free trade, but there can be no doubt that the most noteworthy incidents were those that brought together Albert, Prince Consort of Queen Victoria, and Henry Cole, a civil servant, otherwise remembered as the first commercial producer of Christmas cards. Lacking any constitutional role, Albert sought a position as patron of the Arts, which led in 1843 to his joining the Society for the Encouragement of Arts, Manufactures, and Commerce (henceforth Society of Arts). The Society was founded in 1754, with its objective to stimulate domestic manufacture and design through the award of prizes for innovation. The death of the Society's president, the Duke of Sussex, saw Albert elected to

that position in 1844. His appointment coincided with the reintroduction, by secretary Francis Whishaw, of the Society's small exhibitions for useful inventions in December of that year, with prizes totalling £300. Along with the reform of the Schools, they were intended to give British design a shot in the arm. It was here that Albert's path would cross that of Cole;[1] Cole, working as a clerk in the Public Records Office, joined the Society of Arts before being elected to its council. A series of annual exhibitions followed which garnered some press and public interest – Cole winning a prize at the 1846 exhibition for a tea service submitted under the pseudonym Felix Summerley – leading to the Society being granted a royal charter in 1847.

If the small domestic exhibitions were one thing, the impetus to turn them into an event that would match or outdo the kind of expositions that had taken place in Paris throughout the first half of the nineteenth century was quite another and is testimony to the vision – and opportunism – of Cole. While Whishaw had found little public interest in a national exhibition in 1844 (when only 150 people attended the event), the Society of Arts' exhibition for 1847 was a much bigger success (with over 20,000 people in attendance). The change in fortune was ascribed to increased economic confidence, something on which Cole was keen to capitalise, organising a meeting with Albert in January 1848 to propose reviving Whishaw's plan for a national – or even international – exhibition. The Prince was initially reluctant, an attitude explained by his view that government assistance would be unforthcoming.[2] But Cole was a man in the right place at the right time. He found parliamentary support in another Select Committee, which had been established to investigate the management of the Schools of Design and the revival of British arts manufactures. With royal endorsement for the subsequent 1849 Society of Arts exhibition (and 100,000 visitors), Cole, along with John Scott Russell, Thomas Cubitt, and the surveyor Francis Fuller (armed with a financial plan for a national exhibition), had the confidence to arrange a meeting with Albert on 30 June 1849 (see 1.1) to discuss the possibility of holding an exhibition in 1851 that would stimulate innovation in British design and manufacture. It was this meeting, as Auerbach puts it, 'that launched the Great Exhibition of 1851' (1999: p. 23) and that settled its character as something more than a trade fair. It was envisaged as an event wherein, as Cole records in *Fifty Years of Public Work* (1884), 'particular advantage to British industry might be derived from placing it in fair competition with that of other nations' (1, p. 136). This was to be an international event.

The Exhibition had a rationale and a vision. But, as we will see in this chapter, the logistical problems faced by Cole and the other members of the Society of Arts were not over. For one thing, having decided that the 1851 exhibition should not be subsidised by government but by public subscription, Cole encountered an impasse: potential subscribers wanted a royal commission

as indication that the event would proceed before making a financial commitment, but to gain a royal commission Albert wanted the reassurance of subscriptions. The deadlock was broken when the contractors, George and James Munday, agreed to provide £20,000 up front, including additional money for prizes, which was considered sufficient to guarantee the exhibition. That contract would prove to be short-lived, however, and the Mundays less than equitably treated. When a royal commission was eventually granted on 3 January 1850 – encouraged by the support from northern manufacturers that Cole, Fuller and Matthew Digby Wyatt had encountered when soliciting opinion in the autumn of 1849 – the decision was reached instead to request public support through local committees. The Commission bowed in part to pressure from the press, *The Times* lamenting on 21 December that it was 'a pity that the element of private speculation should be mixed up with a high national object'.

Even with the increased support from manufacturers and the press through the summer of 1850 it would be wrong, as Auerbach (1999) is at pains to point out, to ascribe a narrative of industrial, scientific and technological progress to the activities of the Royal Commission. The reality is that they were, until the Exhibition opened, a group beset by contingencies and, despite their public expressions of confidence, self-doubt. It is for that reason you will find that the documents included in this chapter demonstrate, amongst other things, that the formation of the Commission had to be fought for, that the nature of the exhibition and its national character was continually being defined, press opinion needed to be carefully navigated (particularly over issues such as the choice of site) and a sceptical public given reassurance (primarily over cost and security). It is also the case that manufacturers had to be convinced that the terms and conditions of the prizes would not disadvantage British industry in favour of Europe, specifically France. During the period of 1849–51, key subscriptions were gained (and lost), plans for a building were drawn up and torn up, contractors employed, and international relations strained. Documents, both public and private, included here testify to the fact that reputations were also at stake, and the stakes were high in the run up to the eventual triumphant opening of the Crystal Palace on May Day 1851.

1.1 Early years

By 1849, for a number of reasons listed above, an appetite existed for a national exhibition to be held in London in 1851. The immediate catalyst was arguably, however, not domestic but foreign. In the summer of 1849, the Society of Arts sent Cole and Wyatt to assess an exhibition of French Industry in Paris. The event was also attended independently by Francis Fuller, who reported back enthusiastically to Thomas Cubitt, then finishing the construction of

Osborne House on the Isle of Wight, that something 'much grander' could be achieved in London 'with contributions from every nation' (Fuller Diary, June 1849). It appears that it was Cubitt's report to Albert that instigated the meeting of a group of interested parties at Buckingham Palace on 29 and 30 June 1849 to discuss the proposition of an exhibition to be held in London, the minutes of which crucial meeting are included here in full.

Several of the key components that would inform the planning for the Exhibition were in place from the word go. An improvement in public taste was deemed necessary in order to stimulate a market for high-end goods at home, and an exhibition of the best that British manufacture had to offer in a favourable international context was considered the way to achieve this. Both the original taxonomy with four primary divisions – which was later refined into thirty classes (see 2.1) – and the choice of Hyde Park are noticeably attributed in the minutes to Albert (the government had previously offered Somerset House as an alternative venue) although Cole may well have been the originator of these suggestions. The emphasis of the meeting was on stimulating innovation for nobler ends than financial remuneration and the rhetoric has a moral flavour. Sizeable, though at this stage unspecified, financial incentives for manufacturers were proposed – a decision which was later overturned in favour of a system of medals (RC/H/1/A/30), the issue of public subscriptions, rather than taxation, as a major source of funding was raised, and the need for a royal commission emphasised. The minutes pre-date the contract with the Mundays, which was agreed with the Society of Arts on 23 August.

The second document included from the period prior to the founding of the Royal Commission is a record of the speech given by Henry Cole at the Mansion House banquet on 17 October 1849, at which members of the Society of Arts met with potential investors from the commercial sector. During the autumn of 1849 Cole, Fuller and Scott Russell had travelled to the industrial north – including Lancashire, Yorkshire and the Potteries – to solicit endorsements and financial subscriptions and in September they were able to present a list of supporting names that grew to 6,000 by January 1850 (Auerbach, 1999: p. 26). Encouraged by this endeavour, and the security of the Mundays' loan, Albert arranged a banquet at the Mansion House in order to publicly declare the intention to stage an international exhibition. Cole's speech was, as Auerbach puts it, '*a tour de force*' (1999: p. 27) after which there could be no turning back.

Referring to the minutes of the first meeting, Cole explains in detail the decisions that had been taken up to this point. Speaking as a representative of the Society of Arts, the rationale he gives for an international exhibition is that British manufacture could confidently be compared to that of other nations. It was an exercise in reassurance. According to Cole's evidence the

weight of popular support was firmly behind an international event and he proceeds to provide testimonies from several worthies, the East India Company and northern industrialists in support of the council of the Society of Art's proposals. A Rev. Mr. Yate of Dover, demonstrating his assurance that the exhibition would lead to the peace and prosperity of nations, weighs in with reference to Isaiah 2:4: 'They will beat their swords into ploughshares and their spears into pruning hooks. Nation will not take up sword against nation, nor will they train for war anymore'.

Cole continues by explaining the benefits of Albert's preferred taxonomy, indulging the thought of raw materials – gold from California, silver from Mexico and iron ore from Wales – displayed under the same roof as the latest technological advances – steam engines, power looms, flax wheels and printing presses. Only at the exhibition of 1851 would one be able to con-template such heterogeneity as 'enormous elephants' tusks from Africa and Asia; leather from Morocco and Russia; beaver from Baffin's Bay; the wools of Australia, of Yorkshire, and of Thibet; silk from Asia and from Europe; and furs from the Esquimaux'.

The next two issues Cole addresses were to cause more problems than any other for the organisers: the proposed site and funding. The Society's preferred location was Hyde Park, for reasons of its accessibility for all classes, with voluntary public subscription, rather than compulsory taxation, favoured. Noticeably he mentioned neither the possibility of private financing nor, specifically, the contract that had been drawn up with the Mundays to underwrite the cost of building and prizes. When, two months later, the exist-ence of the contract was made known to the press, it became apparent that certain sections objected strongly to the thought of a public and national exhi-bition being mixed up with the profit motives of the private sector (see 1.3). On the occasion of the Mansion House speech, however, such thoughts were far from the minds of the assembled audience who provided a raucous back-drop to Cole's impassioned rhetoric.

Minutes of meeting held at Buckingham Palace (30 June 1849; RC/A/1849/1)

On the 30th June, 1849

AT BUCKINGHAM PALACE.

There attended HIS ROYAL HIGHNESS PRINCE ALBERT.

By Special Command,

T. CUBITT.
H. COLE.
F. FULLER.
J. SCOTT RUSSELL.

His Royal Highness communicated his views regarded [*sic*] the formation of a Great Collection of Works of Industry and Art in London in 1851, for the purposes of the Exhibition, and of competition and encouragement.

His Royal Highness considered that such Collection and Exhibition should consist of the following Divisions:—

Raw Materials of Manufactures,—British, Colonial, and Foreign.
Machinery and Mechanical Inventions.
Manufactures.
Sculpture and Plastic Art generally.

It was a matter of consideration whether such Divisions should be made subjects of simultaneous Exhibition, or be taken separately. It was ultimately settled that, on the first occasions at least, they should be simultaneous.

Various sites were suggested as most suitable for the building; which it was settled must be, on the first occasion at least, a temporary one. The Government had offered the area of Somerset House; or if that were unfit, a more suitable site on the property of the Crown. His Royal Highness pointed out the vacant ground in Hyde Park on the South side, parallel with and between the Kensington drive and the ride commonly called Rotten Row, as affording advantages which few other places might be found to possess. Application for this site could be made to the crown.

It was a question whether this Exhibition should be exclusively limited to British Industry. It was considered that, whilst it appears an error to fix any limitation to the productions of Machinery, Science, and Taste, which are of no country, but belong as a whole to the civilized world, particular advantage to British Industry might be derived from placing it in fair competition with that of other Nations.

It was further settled that, by offering very large premiums in money, sufficient inducement would be held out to the various Manufacturers who produce Works which, although they might not form a Manufacture profitable in the general Market, would, by the effort necessary for their accomplishment, permanently raise the powers of production, and improve the character of the Manufacture itself.

It was settled that the best mode of carrying out the execution of these plans would be by means of a Royal Commission, of which His Royal Highness would be at the head. His Royal Highness proposes that inasmuch as the Home Trade

of the country will be encouraged, as many questions regarding the introduction of Foreign productions may arise,—in so far also as the Crown property may be affected, and Colonial products imported,—the Secretaries of State, the Chief Commissioner of Woods, and the President of the Board of Trade should be ex-officio Members of this Commission; and for the execution of its details some of the parties present, and who are also Members or Officers of the Society of Arts, and who have been most active in originating and preparing for the execution of this plan, should be suggested as Members, and that the various interests of the community also should be fully represented therein.

It was settled that a draft of the proposed Commission grounded on prec-edents of other Royal Commissions be prepared, and that information regarding the most expeditious and direct mode of doing this be procured, and privately sub-mitted to Her Majesty's Government, in order that no time be lost in preparation for the Collection when the authority of the Government shall have been obtained. Mr. Cole consented to undertake the performance of these duties.

It was settled that subscriptions on a large scale, for donations to carry this object into effect, would be required to be organized immediately. It was sug-gested that the Society for Encouragement of Arts under its Charter possessed machinery and [is] an organization which might be useful, both in receiving and holding money, and in assisting the working out of the exposition.

It was settled by His Royal Highness that minutes be taken of the proceedings of this Conference, and Mr. Scott Russell undertook to produce them. His Royal Highness desired an early meeting of some of those present at Osborne to carry forward this business without delay.

Henry Cole, Mansion House speech (17 October 1849), *Fifty Years,* vol. 1, pp. 134–44

My Lord Mayor and Gentlemen, before I submit to you the outlines of the pro-posal which his Royal Highness Prince Albert has charged us, the members of the Society of Arts, to communicate to the citizens of London, I would ask you to bear in mind that these proceedings are strictly preliminary. His Royal Highness wishes that you should not take anything as absolutely settled with regard to his proposal, beyond the fact that it is intended to have a great exhibition of works of industry; and it is his Royal Highness's desire that we should lay before you the details of the plan—which I shall endeavour to do with all possible brevity—in order that, when the proper time comes, you may be prepared to aid his Royal Highness with your counsel and advice, if you should think fit to carry his proposals into effect. (Hear, hear.)

This subject, I may observe, has been under the consideration of the Society of Arts, of which his Royal Highness Prince Albert is the President, for the last five years; but, during the last two years, his Royal Highness has been watching

the symptoms of public feeling on this question with great intentness, and the members of the council well know that he has on all occasions taken a most active interest, as President of the Society, in furthering the education of the public for appreciating an exhibition of the kind suggested.

We had this year, at the Society of Arts, the finest exhibition of precious metal work that has, probably, ever been seen in the world; and the chief specimen of that work was sent by Her Majesty herself.[3] (Hear, hear, and cheers.) Indeed, so great a point was made by that exhibition, that Prince Albert considered himself warranted in endeavouring to mature his plans for the much more extensive and important exhibition which he contemplated. Accordingly, soon after the termination of the exhibition of the Society of Arts, his Royal Highness commanded the attendance of several members of the council, and of the secretary, at Buckingham Palace, where he explained the details of what he considered should be the chief features of the proposed exhibition. On that occasion his Royal Highness directed that minutes should be kept; and the minutes of that, as well as of subsequent meetings—of which there have been several—have been revised and approved by the Prince himself. (Hear, hear.) I think it is only right that I should mention this circumstance, because it shews that his Royal Highness takes a direct personal interest in the subject (cheers), and that he is not acting in his dry official capacity as President of the Society of Arts. (Hear, hear.) In the course of the observations which I shall address to you, you will see that, so far as the plan has proceeded, the Prince has himself considered some of the probable details. It will, I think, conduce to brevity to give you some extracts from the minutes taken on the occasions to which I have alluded.

The first minute is this:—'Buckingham Palace, June 30, 1849. His Royal Highness communicated to the members of the Society of Arts, his views regarding the formation of a great collection of works of industry and art in London in 1851, for the purposes of exhibition and of competition and encouragement.' The first point that then arose for consideration was, whether the subjects of this exhibition should be limited exclusively to the productions of our own country; and I may perhaps be allowed to say that the passage I am now about to read is one which the Prince himself inscribed upon the minutes. (Hear, hear.) 'It was a question whether this exhibition should be exclusively limited to British industry. It was considered that, whilst it appears an error to fix any limitation to the productions of machinery, science, and taste, which are of no country, but belong, as a whole, to the civilized world, particular advantage to British industry might be derived from placing it in fair competition with that of other nations.' (Cheers.)

That seemed to his Royal Highness to be a fundamental principle to be regarded in any great exposition which this country might undertake, and I may observe that the feeling on that subject, in every part of the country, has been absolutely unanimous. I believe one gentleman only, out of some 600 or 700 whom we have consulted, expressed his opinion that, in the first instance, the exposition should be confined to British industry alone; but when he came to see his opinion put

19

in print for the Prince's perusal, it appeared so very singular that he requested it might be cancelled (a laugh), and in the course of six weeks, therefore, he completely changed his views. (Laughter.)

If it will not be tedious to the meeting I will read a few passages, which will shew the feeling that has been manifested on this subject. The Lord Provost of Edinburgh said at a meeting that 'he considered the preparation of such an exhibition would direct the minds of the whole world to the peaceful pursuits of industry, and by friendly competition and generous rewards would more closely than ever cement the amicable relations of all the nations of the earth.' I am reading the words which we took down at the time, and which will shew you the individual and personal feeling exhibited. Messrs. Kershaw and Co., of Manchester, extremely large cotton manufacturers, who weave 1,000,000 miles of cotton yarn weekly, said, 'Open the exhibition to receive the productions of all nations certainly.' Messrs. James Black and Co., of Glasgow, very extensive calico printers, who will be exposed to considerable competition with French goods in the proposed exhibition, said they 'considered it highly desirable to compare our productions not only with those of our countrymen, but with those of foreigners;' and they added, 'The exhibition will be well worth all the money it may cost.' They stated, at the same time, that they did not fear any competition; that they thought great advantage would arise from letting the ladies of Great Britain see that English manufacturers could produce as good articles as the French; and that the contemplated exhibition might serve the cause of morality by preventing English goods from being sold, as was frequently the case, as French manufactures. Mr. Jobson Smith, of Sheffield, a member of the firm of Stuart and Smith, one of the largest steel-grate manufacturers in the world, said he 'thought it most desirable to see the best metal work of all nations, though England would be behind in ornamental metal work.' Messrs. Hoyle and Sons, of Manchester, whose name has a sort of world's reputation for a particular class of fabric, were unanimously agreed that the exhibition ought certainly to be international. 'The Lancashire feeling,' said Alderman Neild, 'eminently is to have a clear stage and no favour, and to shew what Lancashire people can do.' (Laughter and cheers.) The Master of the Merchants' Company at Edinburgh said, rather graphically, that 'he thought the exhibition should be universal, and that its tendency would be to rub the sharp corners of many nations off.' (Hear, hear, and a laugh.) The Rev. Mr. Yate, of Dover, expressed his hope and belief that the proposed exhibition would hasten the period when men shall beat 'their swords into ploughshares and their spears into pruninghooks.' (Hear, hear.)

I think, then, gentlemen, that you will agree with his Royal Highness in the opinion that it is expedient that such an exhibition as is now proposed, should be open to all nations. (Cheers.)

The next point for consideration was the subjects that should be comprehended in the projected exhibition. 'His Royal Highness considered that such collection and exhibition should consist of the following divisions: raw materials, machinery

and mechanical inventions, manufactures, sculpture, and plastic art generally.' It must be borne in mind, that the exhibition will not be an assemblage of ordinary productions, but of the very best works, in all their classes, which the world probably can shew. With respect to raw materials, we shall most likely have, from all quarters of the globe, specimens of animal and vegetable life, as well as of minerals,—samples of what is in the earth and of what is produced on the earth. In the class of animal substances, we shall probably have enormous elephants' tusks from Africa and Asia; leather from Morocco and Russia; beaver from Baffin's Bay; the wools of Australia, of Yorkshire, and of Thibet; silk from Asia and from Europe; and furs from the Esquimaux.

As an evidence of what we may expect from the suggested exposition, I may state that the Court of Directors of the East India Company intend to exhibit the best of everything that India can produce; and we shall therefore probably obtain, by this means, the best practical notion of the value of our East Indian possessions. (Hear, hear.) I will read to the meeting a short extract from a letter addressed to me by the Chairman of the Court of Directors:—

'I beg to inform you that I communicated to the Court of Directors, the conversation which I had with you on the subject of the proposed exhibition of the works of industry which his Royal Highness Prince Albert is desirous to institute in the year 1851. I have the satisfaction of acquainting you, for the information of his Royal Highness, that the Court expressed their entire concurrence in the views which I then suggested, and that they will be prepared to give their cordial co-operation in carrying out the wishes of his Royal Highness, by obtaining from India such specimens of the products and manufactures of that country as may tend to illustrate its resources, and to add to the interest of the great national exhibition of which his Royal Highness is the patron.'

We have also reason to believe that the Australian Company, and other public companies interested in our colonies, will not be backward in affording us their co-operation on this occasion. Then, with regard to vegetable productions, which will come under the class of raw materials, we shall have cotton from Asia compared with that from America. We may, perhaps, have corn from the virgin soil of Connemara; for when we were in Ireland Lord Clarendon pointed out to us some corn, observing that if the English people could see it they would be convinced that there were far better 'diggings' in Cork than in California. (Cheers and laughter.) We shall have, also, corn from the shores of the Baltic in competition with that from Ireland and from the counties of England. We shall have spices from the East; the hops of Kent and Sussex, the raisins of Malaga, and the olives of the Pyrenees. An immense impulse will, therefore, be given by this exhibition to the exertions of all the cultivators of raw produce. It is unnecessary that I should go into detail on this subject, and I only allude to it to shew how comprehensive the exposition is intended to be, and how completely all persons, whether as producers or customers, will be interested in it.

Of mineral productions, we shall have gold from California and from the East Indies; silver from Mexico, Russia, and Cornwall; iron ore from Wales, Wolverhampton, and Tunbridge Wells,—for perhaps many persons do not know that the iron railings round St. Paul's were manufactured near Tunbridge Wells years ago, though the manufacture has now been almost entirely abandoned. Then we shall have clays from Bideford, Truro, and perhaps from Putney,—for near Vauxhall Bridge there is an enormous nest of factories for a certain description of pottery.

In machinery we shall have the steam-engine in all its endless applications, both to land and water purposes. We shall have marine engines in all their varieties; and we may probably have such machines as Messrs. Whitworth of Manchester have recently constructed, measuring to the fifty-thousandth part of an inch. We may have the looms of the Dacca muslin weaver, and the last new power-looms made by Messrs. Roberts. We shall compare the old spindle, which the Egyptians still use, with the modern flax-wheel from Belfast. An extensive papermaker has said, that, if practicable, he will bring up a machine into which rags will be put at one end, while 20 feet beyond they will come out a large sheet of elephant drawing-board. We shall also have printing presses of all varieties; and I should not wonder if Messrs. Applegarth were to exhibit a printing-machine like that now used by 'The Times,' which pours forth 10,000 copies of that newspaper per hour. (Hear, hear.)

I need scarcely dwell on the subject of manufactures, but we may expect to have at our exhibition some of those Indian manufactures which are now almost unknown to us. We now seldom see the manufacture called 'nankeen' in this country. The Indian merchant finds it more profitable to send his raw material here to have it spun and made up and sent back to him, than he did formerly to make it himself and send it to this country for consumption. There are, however, in India and in other parts of the world, a great many indigenous manufactures, which may probably be brought under our notice by the proposed exhibition.

The next and last department of exposition is that of plastic art and sculpture, which will comprise all that relates to building and architectural art. We may learn from it how much the French are in advance of us in the manufacture of bronzes; but it may be a comfort to us and to others to know that the great bronze manufactories of France have grown up within the last thirty years. (Hear.)

I now come to the question of site. 'Various sites were suggested,' say the minutes, 'as most suitable for the building, which it was settled must be, on the first occasion at least, a temporary one. The Government had offered the area of Somerset House, or, if that were unfit, a more suitable site on the property of the Crown. His Royal Highness pointed out the vacant ground in Hyde Park, on the south side, parallel with and between the Kensington drive and the ride commonly called Rotten Row, as affording advantages which few other places might be found to possess. Application for this site could be made to the Crown.' The particular

advantage of this site, according to the views of the Prince—and I believe you will all concur with them—was that high and low, rich and poor, would have an equally good access (hear, hear); and that those who rode down in omnibuses, and those who went in their private carriages, would have equal facilities of approach. (Cheers.)

It was next settled that it might be expedient to give large prizes to the competitors. You are aware that foreign governments are accustomed, for important inventions, to give the inventors large prizes; and it was considered that, in order to induce the whole world to enter into this sort of amicable competition, large prizes would be necessary. We thought, therefore, that we might with certainty say that £20,000 worth of prizes will be offered to the world at the proposed exhibition.[4] How that sum may be apportioned will be a matter for subsequent consideration. It is proposed to organize an executive to carry out the plan in cooperation with the Government, and all the details with regard to the prizes will have to be settled by that executive.

The next question, and it is an important one, is HOW THE FUNDS ARE TO BE RAISED. I need not trouble you with the details of the discussions which have taken place in the council on this subject; but the result was that Prince Albert, as well as the council of the Society, came to the conclusion that the best course would be to leave the contributions optional, rather than to obtain the required amount by compulsory taxation. We all know that in other countries, projects of this kind have been carried out by the governments; but we also know that in other countries, governments are accustomed to do many things which I, for one, believe that the English people do much better for themselves than any government can do for them. (Hear.)

[...]

Then, the funds being forthcoming—of which we have no doubt—it is proposed that the Government should be asked to *appoint a royal commission* to arrange the disposal of a certain portion of the funds, that portion which is to be allotted for prizes, with the utmost impartiality. The Society of Arts felt that it would not do for them, as a private corporation, to undertake the very delicate task of distributing £20,000 in prizes; and, therefore, it is proposed to ask the Government to nominate such a commission as it shall think suitable, for the purpose of securing the best advice in the distribution of the prizes, in order that tribunals for awarding them may be appointed which shall be above all suspicion, as far as human ingenuity can make them so. (Hear.) The duties and powers of this commission would be to determine the nature of the prizes, and the selection of the subjects for which they are to be offered. Of course those gentlemen who have been about the country to make the matter known, have been more or less obliged, in order to embody the idea, to hint at the class of prizes in view; but I

would wish you to remember that the time will come when all who are interested will be asked to give their best advice in this matter, and that no part of the question of prizes can be considered as settled, beyond the fact that £20,000 are to be given. (Hear, hear.) The Society of Arts has organised the means of getting these funds. (Hear, hear.) I shall read to you only one extract with relation to this part of the subject:—'The prizes proposed to be submitted for the consideration of the commission to be medals, with money prizes. It was proposed that the first prize should be £5,000, and that one, at least, of £1,000 should be given in each of the four sections. Medals conferred by the Queen would very much enhance the value of the prizes.' (Hear, hear.) We are not privileged to say more than that, but that, perhaps, will be sufficient to show the interest which we may hope that our Sovereign will take in the subject. (Hear, hear.)

I end with this statement, gentlemen, without attempting to advocate the merits of the proposition before you; standing here, as we do, to represent the views of the Prince, we have thought it would be most becoming to appear as little as possible as partisans; we have laid before you what is the proposal of the Prince, and we leave you to deal with it as you think fit. (Hear, hear.) I will only say, that if there is a place in the world interested in the matter, it is London. I think we may expect some hundred thousand people to come flowing into London from all parts of the world, by railways and steamboats, to see this great exhibition.[5] I think we may calculate on the advent of foreign merchants who may want to buy, pleasure-seekers in abundance, and men of science anxious to see what has been done. In short, London will act the part of host to all the world at an intellectual festival of peaceful industry, suggested by the Consort of our beloved Queen and seconded by yourselves—a festival, such as the world never before has seen.

1.2 The Royal Commission

With Albert satisfied that public opinion towards an exhibition was favourable, a royal commission for the exposition was formally announced on 3 January 1850 and its details published in the *London Gazette* the following day signed by the Home Secretary, Sir George Grey. The remit of the Commission was initially fourfold: to administer plans for an international exhibition; to choose and secure an appropriate site; to solicit subscriptions from manufacturers throughout the country; and, most pressingly, to cancel, with the minimum of fuss, the contract with the Mundays. This last objective features in the minutes of the very first meeting of the Commission that took place at the Palace of Westminster on 11 January 1850, but it came to dominate the discussions of the Commissioners during the early months of 1850 until the contract was eventually terminated through a clause which had been inserted by Cole allowing the Commission to withdraw if the Treasury agreed to refund the money.

The composition of the Royal Commission is indicative of Albert's view that the exhibition should belong to the people. He was particularly anxious to avoid the impression that it would serve the narrow interests of business or, worse still, the aristocracy, and so it comprised peers, bankers, industrialists, patrons of arts and science and politicians. The peerage was less well represented than the commercial sector and even then those peers who sat on the Commission were carefully chosen for their commitment elsewhere to the advancement of science and the arts (the Earl of Rosse was, for example, President of the Royal Society). The dominant political viewpoint was liberal and progressive; only Lord Stanley, the Leader of the Opposition, the banker Thomas Baring, William Thompson, Alderman of the City of London and Philip Pusey, founder of the Royal Agricultural Society, were Protectionists. The list of names also included the Prime Minister, Lord John Russell, an ex-Prime Minister, Robert Peel (who unfortunately died in July 1850 when his support for the Exhibition in the Commons was most needed), the Chairman of the East India Company, Archibald Galloway, and presidents of the Institute of Civil Engineers (William Cubitt), the Royal Academy (Charles Eastlake) and the Geological Society (Charles Lyell). Thomas Bazley and John Gott represented the interests of the industrial north. The problem of incorporating more extensive representation of regional interests was solved by the creation of more than three hundred local committees, which administered the exhibits from their regions. Key administrative decisions, including the handling of exhibits and their display, were to be taken by an executive committee – comprising the engineer Robert Stephenson, Cole, Fuller, Charles Wentworth Dilke and George Drew – which would report to the Commission (Drew, who represented the interest of the Mundays, left once the contract with the Society of Arts had been terminated). There were also a Finance Committee, two special commissioners – Lyon Playfair and Digby Wyatt – who functioned as intermediaries between the Commission and the local committees, and two Secretaries, Stafford Northcote and John Scott Russell. The Building Committee included engineers such as Isambard Kingdom Brunel and William Cubitt and the architect Charles Barry.

While the Commission was a distinct body from the Society of Arts, the relationship between the two needed to be cordial, especially as the representatives of the Society, who had so far planned the Exhibition, now formed the body of the Executive Committee and feared being marginalised by the creation of the new Commission. Many points of tension emerged, even within the respective groups, particularly between Cole and Scott Russell, and the structure of the Executive Committee required reorganisation several times with Fuller unable to devote sufficient time to organisation, Stephenson replaced as Chairman by the less divisive Colonel William Reid and Stafford Northcote replaced by the more efficient civil servant Edgar Bowring.

The documents in this section derive from the watershed moment at which the formation of the Royal Commission was announced and the ensuing months. The minutes of the first meeting of the Royal Commission, attended by only fifteen members, demonstrate that many of the notables were never to be active in organisation. There is an extract from the speech that Albert delivered at the Mansion House on 21 March 1850, in which he addressed an invited audience of representatives from around Britain.

The cartoon from *Punch* – titled 'The Industrious Boy' – shows Albert begging for contributions with cap in hand, although he did none of the soliciting for funds personally. The satirical piece is accompanied by a humorous lyric wherein Albert is depicted in 'a fix' due to his blank subscription lists. His diminutive stature, ill-fitting clothing, particularly the short breeches, and demure expression emphasise the Prince's perceived naivety and vulnerability, while the grim countenance of the silhouetted John Bull appears to foreshadow – literally – the perceived ramifications of pursuing such a foolhardy and 'costly scheme'. The cartoon illustrates the scepticism present within much of the press at this period.

The Royal Commission, *London Gazette* (4 January 1850), pp. 23–4

Whitehall, January 3, 1850.

THE Queen has been pleased to issue the following Commission for the Promotion of the Exhibition of the Works of Industry of all Nations, to be holden in the year 1851, videlicet:

VICTORIA, R.

Victoria, by the Grace of God, of the United Kingdom of Great Britain and Ireland, Queen, Defender of the Faith; to Our most dearly beloved Consort, His Royal Highness Francis Albert Augustus Charles Emanuel Duke of Saxony, Prince of Saxe-Coburg and Gotha, Knight of Our Most Noble Order of the Garter, and Field Marshal in Our Army—Our right trusty and right entirely-beloved Cousin and Councillor, Walter Francis Duke of Buccleuch and Queensberry, Knight of Our Most Noble Order of the Garter—Our right trusty and right well-beloved Cousin William Earl of Rosse, Knight of Our Most Illustrious Order of Saint Patrick—Our right trusty and right well-beloved Cousins and Councillors Granville George Earl Granville, and Francis Earl of Ellesmere—Our right trusty and right well-beloved Councillor Edward Geoffrey Lord Stanley—Our right trusty and well-beloved Councillors John Russell (commonly called Lord John Russell), Sir Robert Peel, Baronet, Henry Labouchere, and William Ewart Gladstone—Our trusty and well beloved Sir Archibald Galloway, Knight Commander of Our Most Honourable Order of the Bath, and Major-General in

Our Army in the East Indies, Chairman of the Court of Directors of the East India Company, or the Chairman of the Court of Directors of the East India Company for the time being—Thomas Baring, Esquire, Charles Barry, Esquire, Thomas Bazley, Esquire, Richard Cobden, Esquire, William Cubitt, Esquire, President of the Institution of Civil Engineers, or the President of the Institution of Civil Engineers for the time being—Charles Lock Eastlake, Esquire, Thomas Field Gibson, Esquire, John Gott, Esquire, Samuel Jones Loyd, Esquire, Philip Pusey, Esquire, and William Thompson, Esquire, greeting.

Whereas the Society for the Promotion of Arts, Manufactures, and Commerce, incorporated by Our royal charter, of which Our most dearly beloved Consort, The Prince Albert, is President, have of late years instituted Annual Exhibitions of the works of British Art and Industry, and have proposed to establish an Enlarged Exhibition of the works of Industry of all Nations, to be holden in London in the year one thousand eight hundred and fifty-one, at which prizes and medals, to the value of at least twenty thousand pounds sterling, shall be awarded to the exhibitors of the most meritorious works then brought forward; and have invested in the names of Our right trusty and entirely beloved Cousin Spencer Joshua Alwyne Marquess of Northampton, Our right trusty and right well-beloved Cousin and Councillor George William Frederick Earl of Clarendon, Knight of Our Most Noble Order of the Garter, Our trusty and well-beloved Sir John Peter Boileau, Baronet, and James Courthorpe Peache, Esquire, the sum of twenty thousand pounds, to be awarded in prizes and medals as aforesaid; and have appointed Our trusty and well-beloved Arthur Kett-Barclay, Esquire, William Cotton, Esquire, Sir John William Lubbock, Baronet, Samuel Morton Peto, Esquire, and Baron Lionel De Rothschild, to be the Treasurers for all receipts arising from donations, subscriptions, or any other source, on behalf of, or towards the said Exhibition; Our trusty and well-beloved Peter le Neve Foster, Joseph Payne, and Thomas Winkworth, Esquires, to be the Treasurers for payment of all executive expenses; and Our trusty and well-beloved Henry Cole, Charles Wentworth Dilke the younger, George Drew, Francis Fuller, and Robert Stephenson, Esquires, with Our trusty and well-beloved Matthew Digby Wyatt, Esquire, as their Secretary, to be an Executive Committee for carrying the said Exhibition into effect, under the directions of Our most dearly beloved Consort.

And whereas the said Society for the Promotion of Arts, Manufactures, and Commerce, have represented unto Us, that, in carrying out the objects proposed by the said Exhibition, many questions may arise regarding the introduction of productions into Our kingdom from Our colonies and from foreign Countries; also regarding the site for the said exhibition; and the best mode of conducting the said exhibition; likewise regarding the determination of the nature of the prizes, and the means of securing the most impartial distribution of them; and have besought Us that We would be graciously pleased to give Our sanction to this

undertaking, in order that it may have the confidence, not only of all classes of Our subjects, but of the subjects of Foreign Countries:

Now know ye, that We, considering the premises, and earnestly desiring to promote the proposed exhibition, which is calculated to be of great benefit to Arts, Agriculture, Manufactures, and Commerce, and reposing great trust and confidence in your fidelity, discretion, and integrity, have authorized and appointed, and by these presents do authorize and appoint you Our most dearly beloved Consort Francis Albert Augustus Charles Emanuel Duke of Saxony, Prince of Saxe-Coburg and Gotha, you Walter Francis Duke of Buccleuch and Queensberry, William Earl of Rosse, Granville George Earl Granville, Francis Earl of Ellesmere, Edward Geoffrey Lord Stanley, John Russell (commonly called Lord John Russell), Sir Robert Peel, Henry Labouchere, William Ewart Gladstone, Sir Archibald Galloway, or the Chairman of the Court of Directors of the East India Company for the time being, Sir Richard Westmacott, Sir Charles Lyell, or the President of the Geological Society for the time being, Charles Lock Eastlake, Thomas Field Gibson, John Gott, Samuel Jones Loyd, Philip Pusey, and William Thompson, to make full and diligent inquiry into the best mode by which the productions of Our Colonies, and of Foreign Countries may be introduced into Our Kingdom; as respects the most suitable site for the said Exhibition; the general conduct of the said Exhibition; and also into the best mode of determining the nature of the prizes, and of securing the most impartial distribution of them.

And to the end that Our Royal Will and Pleasure in the said inquiry may be duly prosecuted, and with expedition, We further, by these presents, will and command and do hereby give full power and authority to you, or any three or more of you, to nominate and appoint such several persons of ability as you may think fit to be Local Commissioners, in such parts of our Kingdom, and in Foreign parts, as you may think fit, to aid you in the premises; which said Local Commissioners, or any of them, shall and may be removed by you, or any three or more of you, from time to time, at your will and pleasure, full power and authority being hereby given to you, or any three or more of you, to appoint others in their places respectively:

And furthermore, we do, by these presents, give and grant to you, or any three or more of you, full power and authority to call before you, or any three or more of you, all such persons as you shall judge necessary by whom you may be better informed of the truth of the premises, and to inquire of the premises, and every part thereof, by all lawful ways and means whatsoever.

And Our further will and pleasure is that, for the purpose of aiding you in the execution of these premises, We hereby appoint our trusty and well-beloved John Scott Russell and Stafford Henry Northcote, Esquires, to be joint Secretaries to this Our Commission.

And for carrying into effect what you shall direct to be done in respect of the said Exhibition, We hereby appoint the said Henry Cole, Charles Wentworth Dilke the younger, George Drew, Francis Fuller, and Robert Stephenson, to be

the Executive Committee in the premises, and the said Matthew Digby Wyatt to be Secretary of the said Executive Committee.

And Our further will and pleasure is that you or any three or more of you, when and so often as need or occasion shall require, so long as this Our Commission shall continue in force, do report to us, in writing, under your hands and seals respectively, all and every of the several proceedings of yourselves had by virtue of these presents, together with such other matters, if any, as may be deserving of Our Royal consideration touching or concerning the premises.

And, lastly, we do by these presents ordain that this Our Commission shall continue in full force and virtue, and that you, Our said Commissioners, or any three or more of you, shall and may from time to time, and at any place or places, proceed in the execution thereof, and of every matter and thing therein contained although the same may not be not continued from time to time by adjournment.

Given at Our Court at Saint James's, the
third day of January 1850, in the thirteenth
year of Our reign.

By Her Majesty's command,

G. GREY.

Minutes of the first meeting of the Commissioners (11 January 1850) *Minutes*

AT THE NEW PALACE, WESTMINSTER,
Friday, January 11th, 1850.

Present—

HIS ROYAL HIGHNESS PRINCE ALBERT

SIR ROBERT PEEL.	MR. COBDEN.
MR. LABOUCHERE.	MR. CUBITT.
SIR ARCHIBALD GALLOWAY.	MR. EASTLAKE.
SIR CHARLES LYELL.	MR. GIBSON.
MR. BARING.	MR. GOTT.
MR. BARRY.	MR. JONES LOYD.
MR. BAZLEY.	MR. ALDERMAN THOMPSON.

The Secretary read the Queen's Warrant appointing the Royal Commission.
A Report from the Executive Committee, containing a short summary of their proceedings to the time of the meeting of the Commission, was read, and order to be received.

The following Resolutions were put and carried for regulating the mode of conducting the business of the Commission.

1. That all orders shall originate with the Royal Commission; and that the functions of the Executive Committee shall be limited to executing such orders, and to instituting inquiries and reporting the results when directed so to do.

2. That the Commission will correspond through its Secretaries with the Government, the Executive Committee, the Local Commissioners, and such persons or bodies of persons as it may be put in communication with in Foreign Countries, and in the Colonies; but will direct, as a general rule, all other correspondence to be carried on by the Executive Committee.

3. That the Executive Committee be directed forthwith to issue a circular to the Mayors of all Towns within the United Kingdom having a Municipal Constitution, announcing to them the issue of the Royal Commission, and inquiring whether a Local Committee has been appointed within the Town; and requesting that if no Local Committee has been formed, the Mayor will communicate with the principal Inhabitants for the purpose of ascertaining whether, in their opinion, the circumstances of the Town render it advisable to appoint a Local Committee.

In the cases wherein such Local Committees do exist, or in which they may hereafter be appointed, the Mayor to be requested to place himself in communication with the Local Committee, and to report whether it is wished that Local Commissioners should be appointed for the Town—on what grounds their appointment is desired—what number of Commissioners is proposed, and what persons are recommended.

In the case of Municipal Towns having Chambers of Commerce, a similar circular to be addressed also to the President of the Chamber, and a request made that he will communicate with the Mayor upon the subject.

In Towns or Districts not having Municipal Constitutions, but in which Local Committees have been or may be formed, the circular to be sent to such Local Committees.

As there may be Districts not included within the above designations, for which it may be desirable that Local Committees should be appointed, and in respect to which further information is required by the Commission, the Executive Committee are requested to direct their immediate attention to this subject.

The Commission will enter into communication with the Royal Agricultural Societies in the three parts of the United Kingdom, for the purpose of inviting their co-operation, and their assistance in determining whether it be advisable that so far as Agriculture is concerned Local Committees be appointed, and on what principle they should be formed.

But there are districts and occupations connected, for instance, with the Mining Interests, and with great Branches of Manufacture not carried on in Municipal Towns, which might be advantageously included within the objects of the Commission; and the Executive Committee is to be requested to consider in what

mode their co-operation can be secured, and through what channel the requisite preliminary communication can best be made.

4. That a letter be written to the Secretary of State for Foreign Affairs, requesting his Lordship to notify the appointment of the Commission to Foreign Powers, and to request that such Powers will put the Commissioners in communication with such persons or bodies in their respective dominions as may best represent those who are likely to be interested in the forthcoming Exhibition.

The Executive Committee to send copies of all documents which have been or may be published by them, or by the Commissioners, to the Foreign Ministers and Foreign Councils in this Country, and to supply the Foreign Office with such documents, to be transmitted to Her Majesty's Ministers and Consuls in Foreign Countries.

5. That a letter be written to the Secretary of State for the Colonies, requesting his Lordship to take such steps as he may think expedient for putting the Commissioners in communication with such persons or bodies in each British Colony as may best represent those who are likely to be interested in the forthcoming Exhibition.

6. That a similar letter be written to the Court of Directors of the Honorable East India Company.

The Commissioners then proceeded to consider the expediency of directing the publication of a statement explanatory of the objects of the Commission, and the draft of such a statement was presented by His Royal Highness Prince Albert, and read over.

The statement containing a reference to the Contract between the Society of the Arts and Messrs. Munday, and questions having been raised upon this point, and the Secretary having also laid before the Commissioners a communication which he had received from the Mayor of Manchester, praying, on behalf of the Local Committee of that Town, that the Contract might not receive the sanction of the Commission till the opinions of the Country had been collected respecting it, and inclosing Resolutions of the Manchester Committee to the same effect, the Commissioners proceeded to the consideration of the subject.

The Executive Committee were called in, and their opinion taken on the subject of the Contract.

After the Executive Committee had retired, the following Resolution was put and carried:—

That it is expedient to cancel the Contract with the Messrs. Munday; and that the Executive Committee be directed forthwith to take proper steps for that purpose.

It was ordered that a statement relative to the termination of the Contract be prepared, and sent to the Executive Committee for publication.

The Commissioners adjourned to Friday, the 18th January, at 12 o'clock.

(Signed) ALBERT.

Prince Albert, Mansion House speech (21 March 1850), *Victorian Prose*, pp. 279–81

I conceive it to be the duty of every educated person closely to watch and study the time in which he lives, and as far as in him lies, to add his mite of individual exertion to further the accomplishment of what he believes Providence to have ordained.

Nobody, however, who has paid any attention to the peculiar features of our present era, will doubt for a moment that we are living at a period of most wonderful transition, which tends rapidly to accomplish that great end, to which, indeed, all history points—the *realisation of the unity of mankind*. Not a unity which breaks down the limits and levels the peculiar characteristics of the different nations of the earth, but rather a unity, the *result and product* of those very national varieties and antagonistic qualities.

The distances which separated the different nations and parts of the globe are rapidly vanishing before the achievements of modern invention, and we can traverse them with incredible ease; the languages of all nations are known, and their acquirement placed within the reach of everybody; thought is communicated with the rapidity, and even by the power, of lightning. On the other hand, the *great principle of division of labour*, which may be called the moving power of civilisation, is being extended to all branches of science, industry, and art.

Whilst formerly the greatest mental energies strove at universal knowledge, and that knowledge was confined to the few, now they are directed on specialities, and in these, again, even to the minutest points; but the knowledge acquired becomes at once the property of the community at large; for, whilst formerly discovery was wrapt in secrecy, the publicity of the present day causes that no sooner is a discovery or invention made than it is already improved upon and surpassed by competing efforts. The products of all quarters of the globe are placed at our disposal, and we have only to choose which is the best and the cheapest for our purposes, and the powers of production are intrusted to the stimulus of *competition and capital*.

So man is approaching a more complete fulfilment of that great and sacred mission which he has to perform in this world. His reason being created after the image of God, he has to use it to discover the laws by which the Almighty governs His creation, and, by making these laws his standard of action, to conquer nature to his use; himself a divine instrument.

Science discovers these laws of power, motion, and transformation; industry applies them to raw matter, which the earth yields us in abundance, but which becomes valuable only by knowledge. Art teaches us the immutable laws of beauty and symmetry, and gives to our productions forms in accordance with them.

Gentlemen,—the Exhibition of 1851 is to give us a true test and a living picture of the point of development at which the whole of mankind has arrived in this great

task, and a new starting point from which all nations will be able to direct their further exertions.

I confidently hope that the first impression which the view of this vast collection will produce upon the spectator will be that of deep thankfulness to the Almighty for the blessings which He has bestowed upon us already here below; and the

THE INDUSTRIOUS BOY.

"Please to Remember the Exposition."

Pity the troubles of a poor young Prince,	This empty hat my awkward case bespeaks,	Station brings duties : why should we repine?
Whose costly scheme has borne him to your door,	These blank subscription-lists explain my fear;	Station has brought me to the state you see;
Who's in a fix—the matter not to mince—	Days follow days, and weeks succeed to weeks,	And your condition might have been like mine,
Oh, help him out, and Commerce swell your store !	But very few contributors appear.	The child of Banter and of Raillery.

2 'The Industrious Boy', *Punch*, 5 June 1850, p. 225

second, the conviction that they can only be realised in proportion to the help which we are prepared to render each other; therefore, only by peace, love, and ready assistance, not only between individuals, but between the nations of the earth.

1.3 Doubts and objections

Those in favour of the Exhibition and those objecting to it can generally be separated into two factions. Firmly supporting the vision of Albert and Cole were the proponents of free trade, the newly emergent liberal party, the broad church and, most significantly amongst the press, the *Daily News* and the *Illustrated London News*.[6] Objecting to the plans were the Protectionist wing of the Tory party, high church Anglicans and conservative organs of the press such as *The Times*, *Blackwood's* and *John Bull*.

Many of the reservations need to be set in the context of those typical English anxieties about the working classes and foreigners (explored in greater depth in Chapters 3 and 5 in this book). The revolution of 1848 in France, and the Chartist riots at home, still loomed large in the public consciousness and the conservative press predicted further insurgence. Hazards ranged from the plagiarism of English inventions to the spread of disease from the flood of foreigners and workmen to the capital. Addressing the first of these scenarios, Peter Le Neve Foster noted, in an Appendix included in the Commission's first report on the Exhibition, 'At various public meetings which were held all over the country it was a constant question by artisans and others how, under the existing patent laws, they could exhibit their inventions without forfeiting protection to the fruit of their talent and skill' (*First Report*, p. 109). Concerns were alleviated by the passing of the Designs Act (1850) and the Protection of Inventions Act (1851).[7] The second issue is perhaps best exemplified by the anonymous author of the pamphlet titled *The Philosopher's Mite*, who predicted a return to the days of Edward II: 'and there you will trace the tragic consequences of such influx at the founding of the Order of the Garter. What followed at Windsor? The Black Death'.

According to C. H. Gibbs-Smith, July 1850 was the blackest month for the Executive Committee as 'Attacks on the Exhibition from all sides rose to a crescendo' (1964: p. 8). Most prominent and potentially damaging were the objections to the choice of site on the south side of Hyde Park, which would necessitate uprooting the elm trees. On 4 July, the plans were attacked in both Houses of Parliament, led in the Lords by the Chancellor, Lord Brougham, and in the Commons by Colonel Charles Sibthorp, MP for Lincoln. The latter was perhaps the most vocal of all those who protested against the Exhibition. On this occasion he brought a motion before the Commons that a report should be sought on the proposed site, which, had it been passed, would have undoubtedly delayed the work of the Commission and possibly

derailed the entire enterprise. The fate of the Exhibition seemed to hang in the balance, but Sibthorp's motion was eventually defeated by 166 to 46. Sibthorp based his complaints on a report by the developer John Elger, who had building interests close to Hyde Park. The extracts taken from *Hansard* – from the speeches delivered by Brougham and Sibthorp – demonstrate the fervour of the attack. Brougham presented a petition signed by eighty residents of Kensington Gore and focused on the disruption by the construction of such an enormous edifice and the incessant traffic of vehicles and workmen in and out of the Park that was anticipated. Notably Brougham's reference to the transportation of raw materials, including no less than twelve million bricks, is made prior to the commission of Paxton's glass and iron superstructure. His calculations derive from a building designed by Brunel and T. L. Donaldson, both members of the Building Committee, incorporating a vast brick dome of 200 feet. The expense involved in construction, fears for security and the mingling of classes are high on Brougham's list of concerns, as they are on Sibthorp's. But Sibthorp added to these the perceived economic disaster of inviting cheap foreign produce into the country, which he perceived as an endorsement of the *laissez-faire* 'trash and trumpery system' designed to bring down prices and damage the livelihood of manufacturers; these were the very manufacturers who were being asked to fund the Exhibition by subscription. In addition, the Exhibition was depicted as an open invitation to the criminal classes to descend on West London. It was not the first, nor would it be the last, time that Sibthorp publicly decried the Exhibition and although he has often been painted as a comical figure, Geoffrey Cantor argues that he 'spoke for a significant minority' (2011: p. 24). Perhaps most memorably, according to Joseph Irving, on 4 February 1851 he addressed the House vehemently 'pray[ing] that some hail-storm or some visitation of lightning might descend to defeat the ill-advised project in Hyde Park. When the foreigners came he warned the people of this metropolis to beware of thieves, pickpockets, and whoremongers: "Take care," he said, "of your wives and daughters – take care of your lives and property."'(*Annals of Our* Time, 1872: p. 197).

Suspicions about the purposes of such a large undertaking as the Exhibition were not confined to Parliament. One of the most common objections in the press and broadsides of the period was that the Exhibition was to be what was commonly called a 'job', or a swindle, designed not for public interest but for profit. In one such broadside, entitled 'The Great Job of 1851', the author makes clear his view that the Exhibition will be a giant shopping arcade erected for the benefit of foreign manufacturers rather than domestic, the latter of whom will have paid for the pleasure of seeing prices driven down through increased competition. A similar attack came from the *Patent Journal* in December 1849, which focused directly on the contract with the Mundays seeming to have been deliberately concealed at the time of Cole's October

Mansion House speech while public subscription was also being sought (see 1.1). They label the Executive Committee a 'clique', indicating that, prior to the formation of the Royal Commission, the operations of Cole and others were sometimes viewed as furtive and undemocratic. The Executive Committee is depicted here as an unelected group of dilettantes, ready to take any power they could from the Society of Arts.

While in hindsight such objections seem exaggerated, placed in the context of the uncertainty that is even at times evident within the Commission and the Executive Committee about the conflict of interests in a public exhibition serving commercial imperatives, they are understandable. The status of the Executive Committee without a royal commission was certainly ambiguous. Their case wasn't helped by the way that information trickled out into the press throughout 1849.

Exhibition of the Works of Industry of All Nations—the Building in Hyde Park, *Hansard*, vol. 112 (6 July 1850), 866–871

[Lord Brougham] had to present a petition, couched in the language of great drama, from eighty most respectable individuals, the owners and occupiers of that magnificent row of houses which stretches through Kensington Gore below Rutland Gate ... What right had any body of persons to erect in the park a huge building, which would resemble nothing so much as, he was going to say, the Tower of Babel; but he would select another resemblance, and say a building the like of which had not been erected since the days of the Egyptian pyramids—a building that was to cover 24 acres of the finest part of Hyde Park; and which was to have in the middle of it a monstrous cupola, larger, people said, than the dome of St. Paul's. What right had any body of men to cut up the roads in the neighbourhood, making it impossible for the inhabitants to reach their houses or leave them without the greatest inconvenience and difficulty, if not danger? There were to be 12,000,000 of bricks, and at least 40,000 tons of material in all, used in the erection of this building. The conveyance of the material would require 400 carts a day, and during working hours there would be cartage equal to one cart every 1½ minute entering the park ... They were to have, therefore, all these carts, for a long period of time, going into the park loaded with lime and bricks—wagons groaning under large beams and loads of wood, extending fore and aft—over the vehicles—the heavy vehicles rumbling along, that there might be no want of noise to grate upon the ear, as well as huge forms to appal the eye ... Why, if anything ever deserved the name of public nuisance, this surely did ... He said the expenses of the building would be enormous; but there was one item of expense that had not been considered. Had they examined the superintendents of police as to the means of preserving order at the Exhibition and its neighbourhood? Only let their Lordships think of the numbers of people who would be gathered together for

this occasion. All those who had great curiosity—all those who liked to run after sights—all those who had not only great curiosity, but little occupation—all the idle, and all those out of employment, whether from their fault or misfortune—all the vagrant classes of the community of whom the police evidence stated there were from 70,000 to 80,000 in London having no visible means of subsistence— all the persons out of employment from the sister kingdom, and elsewhere—the workmen of St. Giles's, the east parts of London, Westminster, Southwark, Deptford, and Greenwich—all this class of the population, most respectable no doubt in their station—all of them would go to Hyde Park, where, besides the works exhibited, they might see lords and ladies, and princes and princesses, royalties and nobilities, statesmen and philosophers collected within the enormous building erected there … They would have, too, some good specimens of Socialists and men of the Red colour, whose object it would be to ferment the mass.

Hyde Park—Exhibition of 1851, *Hansard*, vol. 112 (6 July 1850), 902–905

As to the objection for which Hyde Park was to be desecrated, it was the greatest trash, the greatest fraud, and the greatest imposition ever attempted to be pushed upon the people of this country. The object of its promoters was to introduce amongst us foreign stuff of every description—live and dead stock—without regard to quantity or quality. It was meant to bring down prices in this country, and to pave the way for the establishment of the cheap and nasty trash and trumpery system. It would better become the promoters of this affair to encourage native industry, and support the industrious people of England, from whom they drew all they possessed. 'Live and let live' was [Colonel Sibthorp's] maxim. It was painful to hear the accounts that daily reached him of the measures resorted to to compel industrious tradesmen and mechanics to contribute from their hard earnings to the furtherance of a scheme directly inimical to their dearest interests … All the bad characters at present scattered over the country would be attracted to Hyde Park as a favourite field for their operations, and to keep them in check an immense body of police must be constantly on duty night and day. That being the case he would advise persons residing near the park to keep a sharp look-out after their silver forks and spoons and servant maids. The public press had condemned the selection of the Hyde Park for the site of the Exhibition, and pointed out other places more suitable for the purpose. Now, what he wanted was the appointment of a Select Committee to inquire whether this absurd Exhibition should take place at all; and if that should be decided in the affirmative, then to determine what would be the most fitting site for it. It had been calculated by some persons that the building for the Exhibition would cost 100,000*l.*; but he had been informed by one of the most eminent practical men of the day that it could not be completed

for less than 200,000*l*. Where the money was to come from he knew not, unless the Chancellor of the Exchequer was to be called on. He must say that a more wildgoose chase, a more undefined scheme, a more delusive or dangerous understanding never had been attempted by any man. And who was to pay for it all? John Bull. And who was to give the prizes for the things exhibited? John Bull.

'Thalaba', 'The Great Job of 1851', *NLS*

FELLOW COUNTRYMEN!—workers, either with head or hands, who take an interest in securing for honest English industry its just reward—grant me, I pray, a few moments' attention while I inflate this great bubble of 1851, 'till it burst, and be resolved into its primitive *lixivium* of soap and water.[8]

The scheme of an Exhibition of the Industry of all Nations, resisted by successive administrations, has, at length, been foisted upon the public by a court intrigue, carried on with some five or six members of the Society of Arts in the Adelphi,—of which society Prince Albert is president—who in Prince Albert's name, and under his especial patronage, have succeeded in launching this unwieldy project on the vast ocean of Great British gullibility, and, at the same time, have thrust themselves into lucrative appointments on a Royal Commission—ever a fertile source of jobbing and corruption. As yet, no trustworthy evidence has been brought forward to prove that such Exhibitions were ever beneficial to the arts, manufactures, or trade of any country.

In a state of transition, from an artificial, high-duty system, called protective, to a more sound and healthy one, we have not yet obtained free-trade. The duty on foreign corn has been repealed; the duty on slave sugar reduced, by canting and recanting Lord John Russell; but many important necessaries of life are still as heavily taxed; tea, some three hundred per cent; beer, paper, tobacco—almost the only luxury of the working man—twelve hundred per cent; the Press, now consequently become, with few exceptions, the organ of the Money Power—the window tax, it appears, is above the working man's level of luxury—all these taxes are still raised; yet despite this onerous amount of taxation—which the chief promoters of this scheme are deeply interested in maintaining at the cost of the productive classes—it is proposed suddenly to drive the English artisan and mechanic—still an unenfranchised political *cipher*—into direct competition with all the nations of the world. Cheapness, mark me,—('tremendous sacrifice!' 'nominal prices!')—is one of the qualifications of articles for exhibition, though cheap things will be found *dear enough at last*,—after the mischief has been done. If this forced introduction of continental prices for manufacturers be found necessary to the Money Power, at all events, let the working classes *insist* upon being *first relieved* from the system of indirect taxation upon articles of consumption, which falls *directly* upon *them*, and put a stop to the Whig million loans to the landlords out of the surplus taxation from the people.

The productive classes will be the *first to suffer* by this forced reduction in the price of all manufactured commodities; the *difference* must be paid by the working man, by a *reduction* of his *wages*, unless relieved by a proportionate reduction of taxation. He requires untaxed raw material, untaxed necessaries of life, and the Whigs repeal the duty on BRICKS! He asks—small blame to him—UNIVERSAL SUFFRAGE, and a Royal Commission is issued to devise means for increasing the already fearful amount of competition, the devil-take-the-hindmost principle, against which he already finds it so difficult to contend. Who is to profit, I ask, by this reduction? The Money Power, now becoming omnipotent, unless the people secure to themselves their fair share of political influence. People of England, remember the railway mania! and tremble, when you reflect that political power in this country, is still monopolized by men who parcelled you out and sold you, like bullocks in Smithfield, to the highest bidder.

Not content with inviting foreigners to exhibit their wares duty free, the Royal Commission has offered them money premiums to tempt them to compete with us, and has obtained considerable sums of money for that purpose—the foreigners not subscribing one farthing, and I confess myself unable to comprehend how the British artist, manufacturer, legitimate trader or mechanic is to benefit by a National Subscription, for the purpose of erecting sixteen acres of *shop fronts* in Hyde Park, three-fourths of which must be devoted to the wares of our foreign competitors. In these days of steam-boats and railways, the trader runs no risk of having his goods damaged on their journey, and the cost is insignificant. The foreigner pays no English rates, rents, nor taxes, and will exhibit at our expense, with a sure sale afterwards, and probable future *demand* for *his* goods. He may and probably will deprive the 'legitimate trader,' who has to *pay* English *rent*, *rates*, and *taxes*, of his regular customers, who have already and to a perceptible amount *stopped their orders*, 'until the great Exhibition of 1851.' When the Exhibition is over, to whom will the orders be given? Why to the foreigner, to be sure, and his foreign novelties—novelties to John Bull at least, however ancient they may be. BULL! you are a great bubble swallower: but if you allow yourself to be bamboozled by this barefaced imposition, this *imprudent job*, this *conspiracy of art-manufacturers*—who cant sell their trumpery wares, then I say, and I say it with the highest respect for your many virtues, that *you* are a greater fool than I took you for. Therefore, I say, brave BULL, take timely warning! First very widely extend the suffrage, and then cut down your 'Budget, as it is,' to what 'it might be.' When you have accomplished these important preliminaries; when you have emancipated yourself from the thraldom of the feudal Whigs of the soil; when you have returned a House of Commons *which shall represent the People*; and when you have established *public* repositories of fine art in all your large towns—then, but *not till then*, invite your foreign competitors to exhibit specimens of their handy work. But if you do not mind what you are about, my worthy friend, the foreigner will come over, win your prizes, carry off your regular customers, and laugh at

you for your pains, as a silly gullible old fool. And you, my dear BULL, will *not* laugh, unless it be at your own folly.

None but exceeding flat fish will be caught by the cock and bull story of the enterprising Yankee speculators who are to purchase the whole Exhibition! From whom are they to purchase the Exhibition? What are they to purchase?—an Adelphian *idea* of an Exhibition—a *pendant* to the great sea serpent! Have *they* also got a sham capitalist contractor and paid patriotic *Executive Committeemen* at £800 a year? Are the Yankees so rich in Californian dust that they have better use for it than to fling it in our eyes? or perhaps they might like to purchase the Exhibition with Pennsylvanian securities? Therefore, do not subscribe to 'great plan' of 1851! You will find that you have rather more serious work on hand than getting up shilling exhibitions for the *gobemouches* of Europe, and cannot afford to subscribe a large capital for the purpose of stimulating the manufacturers of Germany and France at your own cost.[9]

Having lately consulted that invaluable instrument called a *foolometer*, discovered according to Sydney Smith by a celebrated stump orator of his day, I am assured on this infallible authority, that the great British *genus* meant to subscribe no more money to be squabbled and scrambled for by a gang of rapacious speculators.

Your sincere friend and well-wisher,

THALABA[10]

Percival, Typ., 62, Piccadilly, corner of Albemarle Street.

The Exhibition of 1851; Is it to Be Made a 'Job'?, *Patent Journal* (29 December 1849; RC/H/1/29)

A MUNDAY Exhibition it will be—MUNDAY prizes, and MUNDAY profits. On the terms of the contract we have little to say. In their eagerness to grasp the proffered bonus of £20,000, the Committee would appear to have been willing to make any sort of agreement. Here is one clause, which will sufficiently show how competent they were to manage such a matter:—

'the residue (if any) will be supplied to the reimbursement to the Messrs. Munday of the sums advanced by them, with interest at 5 per cent. If the residue shall more than cover these repayments, two-thirds of the clear surplus will be paid to the contractors for their own absolute use and benefit, and the remaining one-third to the Society of Arts.'

We object to the *spirit* of the agreement, as being derogatory to the character of the nation. Far better would it be that Government had found the money, than

that such an arrangement should have been made; better still, that the money should have been voluntarily subscribed.

The gentlemen who effected the Mundayan arrangement have placed themselves so prominently before the public in connexion with the proposed Exhibition (*and among other things in soliciting public contributions for it,*) that it is but justice that they should bear the odium of this transaction.

We avail ourselves of the following notice from a contemporary:—

It is stated, that the Council of the Society of Arts sought out these gentlemen, and thrust the honour upon them; after achieving which they seem to have resigned their powers into the hands of a small Executive Committee or clique of their members, associated with the Messrs. Munday, and their nominee or appointee, Mr. George Drew of Guildford; the said committee to consist of Mr. Henry Cole, Mr. R. Stephenson, Mr. F. Fuller, and Mr. C. W. Dilke, jun. Against the respectability or the ability of these four gentlemen, entrusted with so important a duty, we have not a syllable to say. Their high qualifications may be equal to the trust. Mr. Stephenson's great talents in engineering and mechanical science are well known; Mr. Fuller, we know less, but he made a fluent and appropriate speech as one of the deputation to Worcester; Mr. Cole is famous for his Felix Summerley articles of small ware, and (we believe) editor of the *Journal of Design*; and Mr. Dilke is a proprietor and superintendent, and if not co-nominee, editor of the *Athenaeum*. In their respective publications the latter two have been playing into each other like electric clouds, now flashing into this and then reciprocating into that; so as to illumine both, and the public from week to week. One good turn deserves another.

The 'clique,' to use the words of our contemporary, is the same which is known among the members of the Society of Arts as 'Cundall & Co.,' from the circumstance, we presume, of their being the authors and designers of certain articles of 'High Art' Manufacture, which were (intended) to supersede the 'common place' of ordinary life, and which for the nonce, graced the windows of ironmongers, and stationers. Mustering in strong numbers in the 'Council' of the Society, they have adopted the policy of 'clanship,' and hang together like Scotchmen in India, or the English at Boulogne. They ride rampant at the Society of Arts. The council in its constitution is formed on the model of a select vestry, and the councillors, who elect one another, never take the advice of the members of the society, but when, like Governor Stuyvesant, they have made up their minds to abide by their own.[11] In fact, there is a partnership deed between the above gentlemen and the Society of Arts, whereby the name of the society is used whenever, and for whatever they please.

An 'exhibition' of pictures has for some time past been their principal hobby, and as they cannot find other pictures to exhibit at this time of the year, they have

41

issued tickets to view the old pictures of Barry, which have adorned the walls of their room for the last forty years. Now there can be no possible objection to these gentlemen curvetting about on their gingerly steed, so long as they keep within decent bounds; but it remains to be seen whether the members of the Society of Arts will always permit them to have the exclusive management of their affairs, more especially after the present 'exhibition' of their competency to manage matters of business. The members of the Society of Arts will not, we think, feel themselves to be much honoured when they come to consider that they have not had, and are not likely to have, any voice, control, or share in the management of the forthcoming exhibition. They will, probably, think that they might have been *consulted* on business transacted in their names; and many among them, we venture to say, would have been found not unqualified to render service in their work. But the self-elected executive have resolved to keep the business in their own hands—to fill every office with their own myrmidons, and we presume, to farm out what little else remains to be done. Under their management, the Society of Arts, with an increasing income, has been brought into some *three thousand pounds* of debt; and under their arrangements, the industrial exhibition of 1851 will prove to be a —mull.[12]

1.4. Joseph Paxton and the Crystal Palace

It is the iconic building of the Victorian age, a vast edifice of iron and glass that adorns the cover of most books about the Great Exhibition. Yet, were it not for a fortunate series of events, Joseph Paxton's 'Crystal Palace' might never have been built at all. Its fate is at the centre of the problems that the organisers experienced in winning over public support for the venture.

In the spring of 1850, the Building Committee sought suggestions from designers for a building to house the Exhibition. By the deadline of 8 April, 233 designs had been submitted (although more arrived after this date) but, while many had merits, none were deemed fit for purpose. As Hermione Hobhouse notes, there were a number of factors to be considered involving cost and the fact that the Commission was committed to removal of the building after the Exhibition closed at the end of October 1851: 'The Committee was faced with the problem of a temporary building, which economy demanded should be as reusable as possible, which had to be constructed in a very short time, by then under twelve months. It had not only to be cheap, but also to provide for the display of goods, and the convenient circulation of visitors' (2002: p. 20). With no feasible design to work with, the Committee decided to take matters into its own hands, and in May they announced a building designed by Brunel made entirely from brick and surmounted by a vast dome of some 200 feet to be constructed in Hyde Park. Criticism of the building was widespread and even led to a motion against

the Exhibition in the Commons on 4 July (see 1.3). It was at this point that Paxton submitted his design, famously first scrawled on a piece of pink blotting paper (Figure 3).

At the time of the preparations for the Exhibition, Joseph Paxton was working as head gardener for the Duke of Devonshire. He had designed, and was overseeing the completion of, a giant glass Lily House at Chatsworth that used an innovative ridge and furrow system and hollow iron columns for drainage. Paxton developed this model on a grander scale and travelled to London with Stephenson to show it to Albert. While a decision was pending, Paxton opportunistically sought a contractor in Fox and Henderson of Birmingham, and on 6 July published his design to great acclaim in the *Illustrated London News*. At the same time Cole was despatched to seek tenders for Brunel's brick building but was unable to gain interest due to the huge cost and time constraints. Meeting with Fox and Henderson, who also declined the opportunity to construct the Committee's favoured building, the subject turned to Paxton's glass design which met with approval. At a meeting of 15 July, the Building Committee therefore advised the Commissioners to accept Paxton's design, awarding the contract for £79,800 to Fox and Henderson on the understanding that they could keep the components of the building when it was disassembled (see 6.2). Even then, with the Mundays no longer providing security, the precarious financial state of the venture meant that it was only through an intervention by Samuel Morton Peto, a member of the Finance Committee, to the tune of £50,000 that swung the deal in Paxton's favour. His letter to Albert, included here, testifies that the loan was made on the strong hint that Paxton's design was adopted.

Initially the beauty of Paxton's plan lay not primarily in its aesthetic appeal but in its prefabricated nature: the component parts of the building could be manufactured off-site and transported to Hyde Park where they could be assembled *in situ*. Paxton's initial idea could also be modified to incorporate a dome above the transept of the building so that the mature elm trees in the park need not be cut down (which had been one of the main objections to the use of Hyde Park). The report accompanying the publication of the design in the *Illustrated London News* reads like an advertisement, emphasising the suitability of the building for display, its temporary nature, its huge dimensions but, crucially, the speed of construction.

The completed building was an unprecedented architectural achievement, being at the time the largest enclosed space in the world. It covered a massive 990,000 square feet and was 1,848 feet in length and 408 feet wide. While Fox and Henderson produced the iron, the 900,000 square feet of glass was provided by Chance Brothers of Birmingham.[13] More than one thousand iron columns supported girders by connection brackets. Sixteen semi-circular wooden ribs were used to make the iconic vaulted transept. Working at

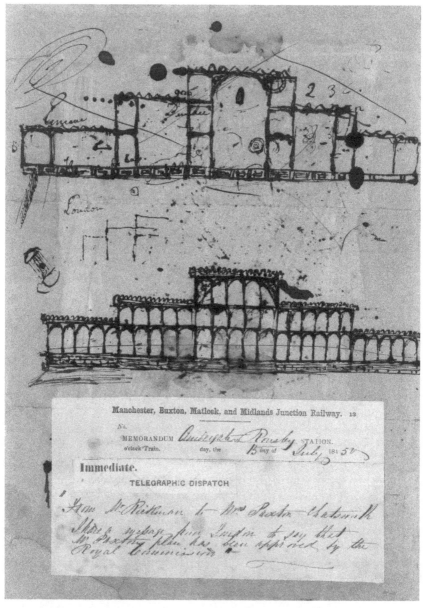

3 First sketch of the Great Exhibition building by Sir Joseph Paxton

breakneck speed, teams of navvies and glazers completed the construction over a period of only five months.

The building was first dubbed 'The Crystal Palace' by *Punch*'s editor, Douglas Jerrold, on 18 July in a regular column written under the pseudo-

nym Mrs Amelia Mouser. Mrs Mouser wrote of the transparent, illuminated space, as if it were a vision (which set the tone for many of the reactions to the building which were to follow): 'I dreamt that the Exhibition, which wasn't in Hyde Park after all, though, being awake, I can't be sworn where – was, as it ought to be, a palace of very crystal, the sky looking through every bit of the roof upon all nations under it'. As Stanley Weintraub records '"Crystal Palace" caught on quickening the excitement of the curious who came to gape at the preparation of the site, the delivery of enormous quantities of parts, and the assembly of the structure, each rising section a small drama' (1997: p. 239).

Design by Joseph Paxton F.L.S., for a Building for the Great Exhibition of 1851, *Illustrated London News* (6 July 1850), p. 18

The accompanying design, by Mr. Paxton F.L.S., of a building for the Exhibition of the Industry of all Nations in 1851, has been considered and planned with a view to its fitness for the objects intended, as well as to its permanent occupation or removal to another site for a winter garden or a vast horticultural structure; and which might, if required, be used for a similar exhibition to that intended in 1851.[14]

A structure where the Industry of all Nations is intended to be exhibited should, it is presumed, present to parties from all nations a building for the exhibition of their arts and manufactures, that, while it afforded ample accommodation and convenience for the purposes intended, would, of itself, be the most singular and peculiar feature of the Exhibition. It is hoped, with all deference to others, that the design in question will prove so. The plan is made to fit the ground proposed for the Exhibition in Hyde-Park; and very little alteration would have to be made to the ground-plan already proposed by the Building Committee.

The building is a vast structure, covering a space of upwards of twenty-one acres; and, by the addition of longitudinal and cross-galleries, twenty-five per cent. more space may be obtained. The whole is supported by cast-iron columns, resting on patent screw piles: externally, it shows a base of six feet in height. At each end there is a large portico, or entrance veranda; and at each side there are three similar entrances, covered in for the purpose of setting down and taking up company. The longitudinal galleries running the whole length of the building, together with the transverse galleries, will afford ample means for the display of lighter articles of manufacture, and will also give a complete view of the whole of the articles exhibited. The whole being covered in with glass, renders the building light, airy, and suitable. Every facility will be afforded for the transmission on rails from the entrances to the different departments; and proper means will be employed for hoisting the lighter sorts of goods to the galleries; in which, and on the columns, there will be suspension-rods, chains, &c., on which to hang

woollen, cotton, and linen manufactures, and all other articles requiring to be suspended. Magnifying-glasses, worked on swivels, and placed at short distances apart on the galleries, would give additional facilities for commanding a more perfect general view of the entire Exhibition.

The extreme simplicity of this structure in all its details will, Mr. Paxton considers, make this a far more economical building than that proposed in THE ILLUSTRATED LONDON NEWS of the 22nd of June.[15] One great feature in its erection is, that not a vestige of stone, brick, or mortar is necessary. All the roofing and upright sashes would be made by machinery, and fitted together and glazed with great rapidity, most of them being finished previous to being brought to the place, so that little else would be required on the spot than to fit the finished materials together. The whole of the structure is supported on cast-iron columns, and the extensive roof is sustained without the necessity of interior walls: hence the saving internally of interior division-walls for this purpose. If removed after the Exhibition, the materials might be sold far more advantageously than a structure filled with bricks and mortar, and some of the materials would bring in full half the original outlay.

Complete ventilation has been provided, by filling every third upright compartment with luffer-boarding, which would be made to open and shut by machinery: the whole of the basement will be filled in after the same manner. The current of air may be modified by the use of coarse open canvas, which, by being kept wet in hot weather, would render the interior of the building much cooler than the external atmosphere.

In order to subdue the intense light in a building covered with glass, it is proposed to cover all the south side of the upright parts, together with the whole of the roofs outside, with calico or canvass, tacked on the ridge rafters of the latter. This would allow a current of air to pass in the valleys under the calico, which would, if required, with the ventilators, keep the air of the house cooler than the external atmosphere.

To give the roof a light and graceful appearance, it should be on the ridge and furrow principle, and glazed with sheet glass. The ridge and valley rafters will be continued in uninterrupted lines the whole length of the structure, and be supported by cast-iron beams. These beams will have a hollow gutter formed in them to receive rain-water from the wooden valley rafters, which will be thence conveyed through the hollow columns to the drains. These drains will be formed of ample dimensions under the whole of the pathways throughout.

The floors of the path-ways to be laid with trellis boards, three-eighths of an inch apart, on sleeper-joists. This kind of flooring is both economical and can always be kept clean, dry, and pleasant to walk upon. The gallery floors to be close boarded.

After the Exhibition is over, and on the supposition of the structure being removed to another site, should be made carriage-drives and equestrian promenades for winter use while pedestrians would have above two miles of galleries

for promenades, and more than two miles of walks on the ground-floor. At the same time plenty of space will be left for plants, &c.

It is important to state that by the adoption of the proposed design, no timber trees be cut down, as the glass would fit up to the boles of the trees, leaving the lower branches under the glass during the Exhibition; but Mr. Paxton does not recommend this course, as, for the sum of £250, he would engage to remove and replace every living tree on the ground, except the large old elms opposite to Prince's Gate.

Only a few years ago, the erection of such a building as the one contemplated would have involved a fearful amount of expense; but the rapid advance made in this country during the last forty years, both in the scientific construction of buildings and the cheap manufacture of glass, iron, &c., together with the amazing facilities in the preparation of sash-bars and other wood-work, render an erection of this description, in point of expense, quite on a level with those constructed of more substantial materials.

No single feature, but the structure as a whole, would form a peculiar novelty in mechanical science; and, when we consider the manner of supporting a vast glass roof covering twenty-one acres on the most secure and scientific principles, and filling in a structure of such magnitude wholly with glass, Mr. Paxton ventures to think that such a plan would meet with the almost universal approval of the British public, whilst it would be unrivalled in the world.

Samuel Morton Peto, Letter to Prince Albert (12 July 1850; RC/H/1/4/61)

Reform Club, 12th July, 1850.

Sir,—Having, as a member of the Finance Committee, had occasion to confer with Lord Granville on the subject of providing a Guarantee Fund towards carrying out the Great Exhibition of Industry of all Nations in 1851, and understanding that the subject is likely to be discussed by the Royal Commission to-morrow, I request you to have the kindness to communicate to His Royal Highness Prince Albert, the President of the Commission, my desire to promote the Exhibition, and that I am willing, on behalf of myself and *friends* to guarantee the sum of £50,000, or, if necessary, to advance the same for the purposes of the Exhibition. I take this course, as I am compelled to leave town tomorrow from indisposition.

I have the honour to be, &c.,

S. Morton Peto.

P.S. Perhaps I might take the liberty of saying that I consider the success of the Exhibition would be considerably increased by the adoption of Mr. Paxton's plan, if it is not too costly.

1.5 Opening day

Originally it was intended that the royal opening of the Exhibition should be for officials and invited diplomats only, but complaints rained in at the exclusion of the populace. *The Times* was foremost in seeing the apparent snub to working men and women as a matter of national significance: 'Where most Englishmen are gathered together there the Queen of England is most secure' (17 April 1850), it countered. In the event 30,000 season ticket holders were allowed entry along with dignitaries from 9 a.m. on the opening day. What they had come to see was recorded in the press but also in the Journal of Queen Victoria, a document which deserves to take centre stage in this section for its vibrancy.

For Victoria, it is apparent that this was a celebration for the family; as she notes, the rewards of Albert's hard work coincided with the first birthday of Prince Arthur. Victoria records the many thousands of spectators who thronged the route of the royal carriage from Buckingham Palace, up Constitution Hill and along Rotten Row, to the north entrance of the building. Arriving just before noon, the royal party were hailed with a salute of cannon on the Serpentine and the royal standard was raised on the transept roof. The dais stood in front of two of the elm trees that had been preserved, while Victoria remarks upon the palm trees and azaleas which decorated the aisles. The scene was immortalised in Henry Selous's famous oil, but it is Louis Haghe's painting (Figure 4) that really captures the majesty of the event, including the vast dais, blue silk *baldacchino* and elms. The ceremony was opened with the national anthem, followed by formal addresses from Prince Albert, the Archbishop of Canterbury and the Queen herself. Most impressive was the rendition of Handel's *Hallelujah Chorus* by the choirs of St Paul's, Westminster Abbey, the Chapel Royal and St George's, Windsor. The royal party then processed, accompanied by the Commissioners, Paxton and the contractor Charles Fox, inspecting the objects on the north side of the east–west nave before returning via the south side. Visibility was evidently restricted by the large crowd of spectators lining the nave – 'One could of course see nothing, but what was high up in the Nave, & nothing in the Courts' – but, as Michael Leapman puts it, 'Queen Victoria was quite consumed by the Exhibition' (2011: p. 128), and the regular visits she made subsequently meant that she missed little. Following the procession, Victoria gives Albert authority to announce the Exhibition open for the public.

The opening was not without its oddities, two of which are captured by Victoria. The Chinese mandarin who made his 'obeisance' was actually the captain of a junk, moored on the Thames, who gained admission uninvited and took it upon himself to address the Queen. The 82-year-old Duke of Wellington added his own brand of colour: also celebrating his birthday, his

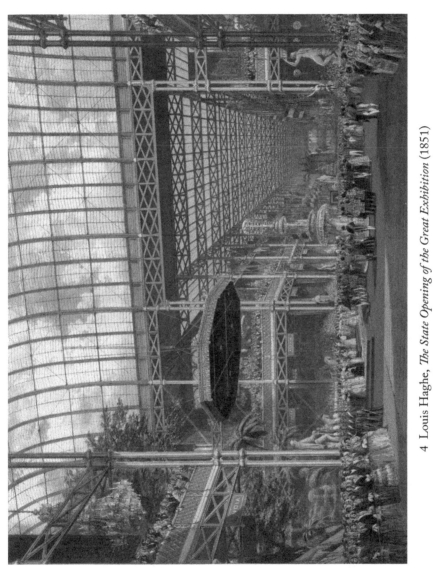

4 Louis Haghe, *The State Opening of the Great Exhibition* (1851)

public reconciliation with the 83-year-old Marquis of Anglesey, whom he had fought alongside at Waterloo, was viewed as symbolic of the climate of peace.[16]

The Times leader of the following day is also included here as it is particularly noteworthy in the way it ascribes the kind of significance to the Exhibition which was later to become commonplace. The first impressions of the Palace suggest a dream or vision, a surfeit of sensations from which the extrapolation of meaning is problematic. The Exhibition is more than the sum of its parts and the discourse is sublime: 'the vista seemed almost boundless'. It is also unambiguously portrayed as a religious, rather than material, experience, the account even going so far as to indicate that the Crystal Palace appeared as proof of intelligent design. As Geoffrey Cantor argues, rhetoric in which 'unprecedented scopic experience' seems to have 'reorganized the senses' (2011: p. 6) was often of a religious nature, and its intensity endowed the Exhibition with a feeling of divine providence. Self-conscious about his florid prose, *The Times* author nevertheless criticises those people of a purely material disposition who cannot hold themselves open to wonder.

The emphasis on the exotic should be viewed as anticipating some of the concerns that feature in Chapter 3 of this volume: tropical plants serve to emphasise not just difference but the geographical extent of colonial possessions and British imperial power. The article also makes it clear how fine the margins were in ensuring that the Exhibition opened on time. Evidently not all exhibits had arrived, including many from France and America; of those that had, not all had been unpacked and put on display.

Journal of Queen Victoria (1 May 1851)[17]

This day is one of the greatest & most glorious days of our lives, with which, to my pride & joy the name of my dearly beloved Albert is for ever associated! It is a day which makes my heart swell with thankfulness. We began the day with tenderest greetings & congratulations on the birthday of our dear little Arthur. He was brought in at breakfast & looked beautiful with blue ribbons on his frock. Mama & Victor were there, as well as all the Children & our dear guests. Our little gifts of toys were added to by ones from the P^ce & P^cess. ___[18]

The Park presented a wonderful spectacle, crowds streaming through it, — carriages & troops passing, quite like the Coronation Day, & for <u>me</u>, the same anxiety. The day was bright, & all bustle & excitement. At ½ p. 11, the whole procession, in 9 state carriages, was set in motion. Vicky & Bertie were in our carriage (the other children & Vivi did not go). Vicky was dressed in lace over white satin, with a small wreath of pink wild roses, in her hair, & looked very nice. Bertie was in full Highland dress. The Green Park & Hyde Park were one mass of densely crowded human beings, in the highest good humour & most enthusiastic. I

never saw Hyde Park look as it did, being filled with crowds as far as the eye could reach. A little rain fell, just as we started, but before we neared the Crystal Palace, the sun shone & gleamed upon the gigantic edifice, upon which the flags of every nation were flying. We drove up Rotten Roe [*sic*] & got out of our carriages at the entrance in that side. The glimpse through the iron gates of the Transept, the waving palms & flowers, the myriads of people filling the galleries & seats around, together with the flourish of trumpets, as we entered the building, gave a sensation I shall never forget, & I felt much moved. We went for a moment into a little room where we left our cloaks & found Mama & Mary. Outside all the Princes were standing. In a few seconds we proceeded, Albert leading me; having Vicky at his hand, & Bertie holding mine. The sight as we came to the centre where the steps & chair (on which I did not sit) was placed, facing the beautiful crystal fountain was magic & impressive. The tremendous cheering, the joy expressed in every face, the vastness of the building, with all its decorations & exhibits, the sound of the organ (with 200 instruments & 600 voices, which seemed nothing), & my beloved Husband the creator of this great 'Peace Festival', inviting the industry & art of all nations of the earth, all this, was indeed moving, & a day to live forever. God bless my dearest Albert, & my dear Country which has shown itself so great today. One felt so grateful to the great God, whose blessing seemed to pervade the whole great undertaking. After the National Anthem had been sung, Albert left my side, & at the head of the Commissioners, — a curious assemblage of political & distinguished men, — read the Report to me, which is a long one, & I read a short answer. After this the Archbishop of Canterbury offered up a short & appropriate Prayer, followed by the singing of Handel's Hallelujah Chorus, during which time the Chinese Mandarin came forward & made his obeisance. This concluded, the Procession of great length began which was beautifully arranged, the prescribed order, being exactly adhered to. The Nave was full of people, which had not been intended & deafening cheers & waving of handkerchiefs, continued the whole time of our long walk from one end of the building, to the other. Every face, was bright & smiling, & many even, had tears in their eyes. Many Frenchmen called out 'Vive la Reine'. One could of course see nothing, but what was high up in the Nave, & nothing in the Courts. The organs were but little heard, but the Military Band, at one end, had a very fine effect, playing the March from 'Athalie', as we passed along. The old Duke of Wellington & Ld Anglesey walked arm in arm, which was a touching sight. I saw many acquaintances, amongst those present. We returned to our place & Albert told Ld Breadalbane to declare the Exhibition to be opened, which he did in a loud voice saying 'Her Majesty Commands me to declare the Exhibition opened', when there was a flourish of trumpets, followed by immense cheering. We then made our bow, & left.

All those Commissioners, the Executive Committee, &c. who had worked so hard & to whom such immense praise is due, seemed truly happy, & no one more so than Paxton, who may feel justly proud. He rose from an ordinary gardener's

51

boy! Everyone was astounded & delighted. The return was equally satisfactory, —
the crowd most enthusiastic & perfect order kept. We reached Palace at 20 m.
past 1 & went out on the balcony, being loudly cheered. The Pce & Pcess were quite
delighted & impressed. That <u>we</u> felt happy & thankful, — I need not say, — proud
of all that had passed & of my beloved one's success. I was more impressed by
the scene I had witnessed than words can say. Dearest Albert's name is for ever
immortalised & the absurd reports of dangers of every kind & sort, set about by a
set of people, — the 'soidisant' fashionables & the most violent protectionists, —
are silenced. It is therefore doubly satisfactory that all should have gone off so
well, & without the slightest accident or mishap. Phipps & Col. Seymour spoke
to me with such pride & joy, at my beloved one's success & vindication, after so
much opposition & such difficulties, which no one, but <u>he</u> with his good temper,
patience, firmness & energy could have achieved. Without these qualities his high
position alone, could not have carried him through. — Saw, later in the evening
good Stockmar after having had a little walk & he rejoiced for & with me. There
was but one voice of astonishment & admiration. The 'Globe' had a beautiful
article, which touched me very much. — I forgot to mention that I wore a dress
of pink & silver, with a diamond ray Diadem & little crown at the back with 2
feathers, all the rest of my jewels being diamonds. The Pcess looked very handsome
& was so kind & 'herzlich'. An interesting episode of the day was the visit of the
good old Duke on his 82nd birthday to his little godson, our dear little Boy. He
came to us at 5 gave little Arthur a gold cup, & toys, which he had chosen him-
self. Arthur gave him a nosegay. — We all dined 'en famille', the Children staying
up a little longer, & then went to the Covent Garden Opera, where we saw the 2
finest acts of the 'Huguenots', — given as beautifully as last year. — Was rather
tired, but we were both so happy & full of thankfulness for everything.

The Times (2 May 1851), p. 1

There was yesterday witnessed a sight the like of which has never happened before,
and which, in the nature of things, can never be repeated. They who were so for-
tunate as to see it hardly knew what most to admire, or in what form to clothe the
sense of wonder, and even of mystery, which struggled within them. The edifice,
the treasures of nature and art collected therein, the assemblage, and the solemnity
of the occasion, all conspired to suggest something even more than sense could
scan or imagination attain. There were many there who were familiar with mag-
nificent spectacles; who had seen coronations, fêtes, and solemnities; but they had
not seen anything to compare with this. In a building that could easily have accom-
modated twice as many, twenty-five thousand persons, so it is computed, were
arranged in order round the throne of our SOVEREIGN. Around them, amidst
them, and over their heads was displayed all that is useful or beautiful in nature or
art. Above them rose a glittering arch far more lofty and spacious than the vaults of

even our noblest of cathedrals. On either side the vista seemed almost boundless. Under it was enthroned a youthful matron, the QUEEN of this land, surrounded by her family, her Court, her Ministers; by the representatives of other countries, and by all who had any share in the suggestion or management of this great under-taking. The minister of religion was there to ask a blessing on the work; the song of loyalty and the anthem of praise rose from the whole assemblage. This is but a bare enumeration of particulars, which to those who were present made one vast whole. It was felt to be more than what was seen, or what had been intended. Some saw in it the second and more glorious inauguration of their SOVEREIGN; some a solemn dedication of art and its stores; some were most reminded of that day when all ages and climes shall be gathered round the throne of their MAKER; there was so much that seemed accidental and yet had a meaning, that no one could be content with simply what he saw. A taste of no common order can be attributed to the illusion, not to say the reality of the scene. The fresh foliage of two lofty elms dwarfed by the height of the dome, the numerous tropical plants that served to tell the extended reign of the SOVEREIGN whose throne they adorned; splen-did fountains, and the brightness of the decoration, all contributed to an effect so grand and yet so natural, that it hardly seemed to be put together by design, or to be the work of human artificers.

Such has been the ceremony of the 1st of May, the subject of such long anticipa-tions and so many apprehensions. Fortune has at length favoured the courageous and persevering little band who originated and resolved to carry through this undertaking. If in the result we see even more than they were conscious of design-ing, and if we sometimes suspect that they looked too exclusively or too much to the mere advancement of art, we cannot, on the other hand, be blind to the great industry and judgement they have displayed. We say it advisedly,—we believe that the Royal Commissioners of the Great Exhibition have had more than the usual proportion of difficulties to contend with. So vast a building was not to be built and adapted for the purpose; so many exhibitors were not to be invited and provided for; so many objects were not to be accepted and arranged; so many smaller affairs were not to be despatched without an amount of hard work and harass which it is fearful to think upon. Good temper and honesty, diligence and method, have overcome them all. It is true that some of our principal exhibitors and nearest neighbours have found themselves sorely belated. The 1st of May has surprised not a few who refused to give the Englishman credit for his proverbial punctuality. The grand avenue of the nave, indeed, is even more than sufficiently stocked and deco-rated. Nothing is wanting anywhere to the general view. But when we leave the broad walk, with its endless succession of magnificent trophies, and pass under the galleries into the numerous by-paths of the Exhibition, we find ourselves sometimes in vacant areas, surrounded by unfinished cases, unopened boxes, and preparations which it will apparently take weeks to conclude. But what of that? It may be unfor-tunate for the country that does not come in for the high tide of interest and the

freshness of curiosity; but, even with these deductions there is already far more than it is possible for any ordinary man to master within a moderate time. It has been estimated that thirty visits will hardly be sufficient for those who wish to 'get up' the whole Exhibition, and make the best profit of this rare opportunity. To visitors of this serious class it can matter very little whether the subjects of their thirtieth day's study are already open to the view, or are hidden in packing-cases. The partial backwardness of the exhibitors, then, is as little to the injury of the result as it is to the disparagement of the Commissioners, who have done their own part in good time. Their success to the last in minor arrangements is evident from the fact that 25,000 ladies and gentlemen yesterday assisted, with comfort, at a grand ceremonial, that a multitude of several hundred thousand persons surrounded the building without any disorder, that a string of carriages, reaching from Charing Cross to Kensington, set down their occupants easily and quietly, and that, in a word, hardly a blow was struck or a temper ruffled during the whole day. Such a result reflects credit on the character of the country, and proves the deep fund of good nature and self-government in the mass of the people.

Notes

1 The two had previously met in 1842 when Cole was an assistant keeper at the Record Office (Hobhouse, 2002: p. 4)

2 At this point the idea of support for an exhibition through public subscription alone was evidently not foremost in either man's thinking, an irony noted by Jeffrey Auerbach in the way 'commentators would later laud the exhibition as a symbol of the benefits of laissez-faire government, and as a testament to what could be accomplished through voluntarism and public subscription' (1999: p. 20).

3 The metalwork exhibition, actually organised by Augustus Pugin and John Hardman, took place in Birmingham in the autumn of 1849.

4 The idea of financial incentives was soon abandoned and the decision to award medals adopted instead. A Medals Committee, under Lord Colbourne, was established to select a design, while decisions on allocation were made by the juries overseen by Lyon Playfair.

5 The actual number and make-up of visitors was recorded in Appendices 16 and 17 of the *First Report* of the Commissioners made to Parliament in 1852 (pp. 85–91).

6 The *Illustrated London News* was the first weekly newspaper to carry regular illustrations which helped enormously in giving the Exhibition its visual identity through the weekly column that recorded the building of the Crystal Palace, the preparations and the exhibits.

7 The Act enabled an inventor to 'exhibit his invention in the Building, and publish accounts of its details in newspapers, catalogues, and otherwise, without prejudice to the validity of any letters patent he might obtain within one twelvemonth from the date of the registration of the certificate. He [has] power to sell his invention, though not the article invented' (*First Report*, p. 109).

8 A *lixivium* is a solution obtained by separating soluble from insoluble substances by dissolving the former in water.

9 A gobemouche is a gullible person, translating literally as 'fly swallower'. W. M. Thackeray adopted the name for his fictional French journalist who provided an 'Authentic Account of the Exhibition' (1851). An extract features in section 3.4 in this book.

10 Thalaba was a self-righteous figure from a poem of the same name by Robert Southey. Here, the name indicates the writer's level of indignation.

11 Peter Stuyvesant was the last Director General of the colony of New Netherland (which became New York) and notorious for authorising acts of religious persecution.

12 This word is untranslated and, unfortunately, I can shed no light on what is concealed here.

13 Chance Brothers also contributed a number of illustrations of coloured glass windows to the Exhibition (*Official Catalogue*, 2, p. 705).

14 For the fate of the Palace see section 6.2.

15 This report (p. 445) carried the first image of the prospective glass building and a much simpler floor plan than the one eventually adopted for the Exhibition, split into four sections showcasing Albert's taxonomy.

16 The pair had quarrelled when Wellington recalled Anglesey from his position as Lord-Lieutenant of Ireland for his leniency towards Catholics.

17 Queen Victoria Diary extract, from Fay (1951: pp. 46–9).

18 The Prince and Princess of Prussia.

2

Display

According to Barton and Bates, 'the Victorians understood cultural identity as and through the collection, display and labelling of an array of objects' (2013: p. 59). What was put on display in the Crystal Palace indicates something about what was materially valued by the Victorians but also about Victorian self-confidence in an ability to understand and portray the world around them. The commodities may not have been for purchase, and the Commissioners forbade pricing in the Palace, but there is no doubt that objects on display at the Great Exhibition focalised the material aspirations of the middle classes. The Exhibition made it apparent to many that, as Nicholas Shrimpton has it, 'There were ... more things than there had been in previous centuries, and more people had them' (2013: p. 19). Luxury items were increasingly the province of the many rather than the few. While for Judith Flanders (2006), Susan Buck-Morss (1990) and Thomas Richards (1990), the Great Exhibition was consequently partly responsible for inaugurating a new era of consumer culture, John Burris has gone further and argued that 'there was no better forerunner than the Crystal Palace to those hallmark features of modern society – the department store and the shopping mall' (2001: p. 35). This was certainly true for a young William Whiteley, godfather of the department store, whose visit to the Palace prompted dreams of large retail complexes with plate glass fronts.[1]

Mass production, as much as artisanship, was showcased at the Exhibition and much of the rhetoric of the *Official Catalogue* concerned the way mechanisation could save time, expense and labour. An automatic envelope folding machine, which produced 2,700 envelopes per hour (Gibbs-Smith, 1951: p. 93), was particularly popular, while a brick-making machine from N. Adams of New York openly aimed to 'substitute mechanical for manual labour' (*Official Catalogue*, 3, p. 1,469). Each spoke of advancements in industry, but inventions that hinted at domestic labour-saving devices to come, such as a patent knitting machine and machines for washing and ironing clothes, indicated that the home was also now a site of technological progress.

For the first time too, domestic comfort was, as Flanders has explained, a prominent concern of the middle classes and objects generated a discourse of longing and desire (2006: p. 15).

The nature of display, with its apparent endorsement of the wonders of technological progress and materialism was not, however, without its critics. William Morris called the Crystal Palace 'wonderfully ugly' and refused to enter. Along with Ralph Nicholson Wornum, who attacked mass production in his essay 'The Exhibition as a Lesson in Taste' (1851), he protested against mechanisation and the shrinking importance of skilled artisans (Paxton's prefabricated building was itself an example of mass production). The benefits of industrialisation came at the expense of aesthetic quality for the Arts and Crafts movement. Evidence of the conspicuous nature of consumption and the notion that the Palace was a temple to embryonic consumer culture also meant that the Exhibition came under fire from various religious quarters. As Geoffrey Cantor (2011) has demonstrated, the Exhibition was frequently compared to Belshazzar's feast where 'the gods of gold, and of silver, of brass, of iron, of wood, and of stone' (Daniel 5:4) were worshipped. This biblical story formed an apt parallel to the culture of materialism apparently being celebrated in the Crystal Palace.

2.1 Classification

The objects exhibited in the Crystal Palace were separated in two ways. In the eastern nave foreign exhibits were organised by country rather than category leading to the impression of miscellany and incongruity in some sections, such as the North German one (Gibbs-Smith, 1951: p. 68). British products displayed in the western end of the nave were, in keeping with the Victorian mania for taxonomy, categorised by a thirty-point class system, devised by Lyon Playfair, that aimed to impose some sort of logic on the object matter displayed. The Commissioners discovered it was, however, logistically impossible to organise the space in such a way that visitors could move from Class 1 (Metallurgy and Mineral Products) seamlessly through to Class 30 (Plastic Art), not least because the power sources for displays of large working machinery (including those from other nations) – Machines in Motion – were confined to the north-west corner of the building. The numerical classification system and the floor plans of the Crystal Palace, incorporating the galleries, demonstrate that imposing theoretical order on the actual space of the Exhibition was fraught with problems (Figure 5).[2] This was more successfully achieved by the *Official Descriptive and Illustrated Catalogue* published by W. Clowes and Sons, 'a book of reference' for every item exhibited, which I discuss in the Introduction to this volume.

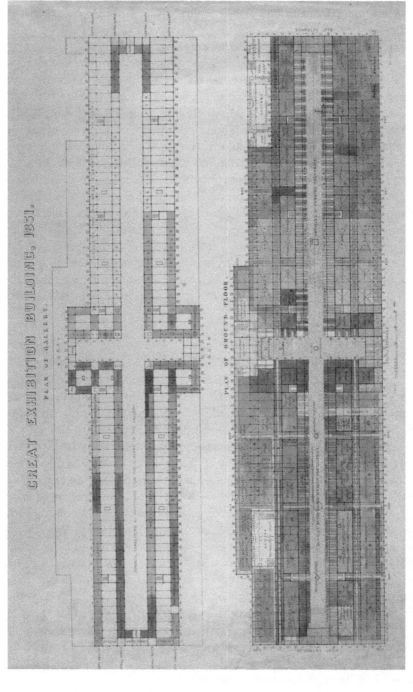

5 Plan of Floor and Galleries at the Great Exhibition, 1851, from Royal Commission, *First Report* (1852)

The thirty-class taxonomy

RAW MATERIALS:—
1. Metallurgy and Mineral Products.
2. Chemical and Pharmaceutical processes and products generally.
3. Substances used as food.
4. Vegetable and Animal Substances used in manufactures, implements, or for ornament.

MACHINERY:—
5. Machines for direct use.
6. Manufacturing Machines and Tools.
7. Mechanical, Civil Engineering, Architectural, and Building Contrivances.
8. Military and Naval Engineering, Structure, &c., Armour, and Accoutrements.
9. Agricultural and Horticultural Machines and Implements.
10. Philosophical Instruments and miscellaneous Contrivances, including processes depending upon their use, Musical and Acoustical Instruments.

MANUFACTURES:—
11. Cotton.
12. Woollen.
13. Silk and Velvet.
14. Linen.
15. Mixed Fabrics.
16. Leather, Skins, Fur, and Hair.
17. Paper, Printing, and Bookbinding.
18. Printing and Dyeing of woven, spun, felted, and laid Fabrics.
19. Lace and Embroidery, Tapestry, fancy and industrial Works.
20. Articles of Clothing for immediate, personal, or domestic use.
21. Cutlery, Edge Tools, and Surgical Instruments.
22. General Hardware.
23. Working in precious Metals, Jewellery, and all articles of luxury not included in the other juries.
24. Glass.
25. Ceramic Manufacture, China, Porcelain, Earthenware, &c.
26. Decoration, Furniture and Upholstery.
27. Manufactures in Mineral Substances, used for building or decorations, as in Marble, Slate, Porphyries, Cements, Artificial Stones, &c.
28. Manufactures from Animal and Vegetable Substances, not being woven, felted, or laid.
29. Miscellaneous Manufactures and Small Wares.

SCULPTURE:—
30. Models and Plastic Art.

2.2 Phantasmagoria

It is well known that the Victorians had a taste for new scopic experiences and optical drama. The nineteenth century saw a craze for magic lantern shows, phantasmagoria and camera obscura, and advancements in the technology of the camera, telescope and microscope. In 1858, David Brewster, the inventor of the kaleidoscope, published a book about the history and construction of his optical toy that used multiple reflection to generate fantastic patterns. At the Exhibition, T. W. Richardson contributed 'A reflecting telescope, for observing the sun's surface', one of many telescopes which jostled for space in a section that included new designs for opera glasses, microscopes, medical instruments for inspecting eye and ear, Daguerreotype panoramas, and spectacles of the sort worn by Sir Isaaac Newton.[3] The significance of the eye was everywhere, and it would be no exaggeration to say that the objects around them were changing the way that the Victorians viewed the world.

Contributing more than anything else to the impression of ethereal splendour in Paxton's Palace was the substance out of which it was made: this was a temple made of glass, but equally a temple made to glass. As Isobel Armstrong, in her monumental study *Victorian Glassworlds*, has argued, the combination of increased production and falling prices meant that glassware created 'a new glass consciousness and a language of transparency' (2008: p. 1) which can be seen, for example, reflected in Tallis's *History and Description of the Crystal Palace* (1851–52) which devotes a full chapter to glass, its origins, production and display at the Exhibition. Tallis is rhapsodic on the subject of Osler's Crystal Fountain (Figure 6), the majestic glass centrepiece of the Exhibition that stood at the intersection of the main avenue and transept: 'England seems to have gained the palm for white, Austria for coloured glass. The gigantic English fountain, upwards of thirty feet high, whose waters diffuse throughout the transept of the Crystal Palace a delightful freshness, is a masterpiece' (2, p. 60). He also praised the dazzling chandeliers and mirrors, the many reflective surfaces that contributed to the feeling of phantasmagoria or what Armstrong has called the 'disruption of the sensoria' (2008: p. 66). The experience of reflection should be likened to, but also distinguished from, the 'language of transparency', which is typically rendered in Lady Emmeline Wortley's poem 'On the Approaching Close of the Great Exhibition' (1851), wherein the Palace 'shows both Earth and Heaven, and faint, strange outlines it displays, / That scarce seem so much the shapes of things, as scattered beams and rays'. For Armstrong the effects of the nature of glass meant that it was often unreadable: both 'insistently spectral' and 'insistently material' (2008: p. 58).

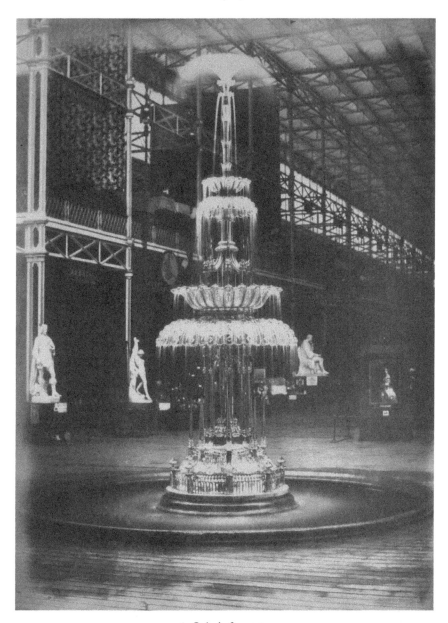

6 Osler's fountain

The near omnipresence of glass at the Exhibition is explained by new technological advancements in its production. Older optical discourses were, however, also pertinent and it is worth recalling that the word phantasmagoria has the same etymological root as fantasy. It was common to describe

Paxton's design as a fairy palace, enshrining fantastical possibilities, and in *Little Henry's Holiday at the Great Exhibition* (1851) by Samuel Newcombe, the Crystal Palace was described as rising involuntary 'like some fairy scene' (p. 15). The discourse of the sublime and the beautiful was also operative in attempts to account for the shimmering brilliance that threatened to overwhelm the senses. Thackeray's Mr Maloney describes his experience of visiting the 'sublime musayum' as, in a state of amazement, he passes 'from glass to glass'.[4] One writer who found the assault on the senses of so much lavish display too much to cope with was Charles Dickens, who, exhausted from a visit, wrote 'I find I am "used up" by the Exhibition ... I have a natural horror of sights, and the fusion of the many sights in one has not decreased it' (House *et al.*, 1965–2002: 2, p. 327). The effect was echoed by Newcombe, whose little Henry is overcome by the galleries complaining, 'I cannot look at them very long – they dazzle my eyes!' (p. 130), and in the article from the *Daily News*, included here, which begins its account of exhibits by considering the overwhelming impression of light and colour in the Palace.

Tallis's History, vol. 1, pp. 80–1

The subject to which they introduce us is unquestionably the most important of any connected with the history of the Great Exhibition, not only as respects the building itself, whose fairy structure owed its chief attraction to the surprising adaptation of so glittering and fragile a material to the combined purpose of lightness and solidity, but also in the vast variety of articles it contributed, useful alike to science, to the fine arts, and to domestic comfort and adornment. Indeed, it is quite certain that however we may be inclined to yield the palm to the foreigner for beauty of design and delicacy of workmanship in other branches of ornamental manufacture, the British workman need fear no competitor in the various applications of glass, that most beautiful of chemical combinations. The gallery devoted to the work of his hands glittered like a fairy palace, and was every day visited by increasing crowds, more particularly of strangers, who were all unqualified in their admiration. In noticing the articles in this class, the place of honour belonged of right to the Messrs. Osler, whose far-famed Crystal Fountain was the gem of the transept, and won for itself a European celebrity.

The basin of concrete in which the fountain itself was placed, was some 24 feet in diameter, and afforded a goodly surface for the falling spray. The structure of glass stood 27 feet high, and was formed of columns of glass raised in tiers, the main tier supporting a basin from which jets of water could be made to project, in addition to the main jet at the top. As the structure arose it tapered upward in good proportion, the whole being firm and compact in appearance, and presenting almost a solidity of aspect unusual with glass structures. A central shaft with a slightly 'lipped' orifice finished the whole, and from this the water issued in a broad well-spread jet,

forming in its descent a lily-like flower before separating into a spray, which in the sun-light glittered and sparkled in harmony with the fountain itself. Altogether this was a unique and magnificent work, and many difficulties of construction had to be overcome before the structure presented itself in its perfect form. The principal shaft was strengthened by means of a rod of iron passing through it, but concealed from observation by the refracting properties of the fans. Upwards of four tons of crystal glass were used in the construction of this fountain. The principal dish was upwards of eight feet in diameter, and weighed previous to cutting nearly a ton. The shafts round the base weighed nearly 50 lbs. each previous to cutting.

The same firm also exhibited a magnificent pair of candelabra, in richly cut glass, each to hold fifteen lights, and standing eight feet high. Her Majesty was the purchaser of these truly regal ornaments, and it was by her gracious permission they were exhibited. The other contents of Messrs. Osler's case were, a large crystal candelabrum, supported by three griffins in dead or frosted glass, the figures of which struck us as being well executed, considering the material; some richly mounted lustres; and several portraits in frosted glass, including those of her Majesty, Prince Albert, and some of the national literary and political celebrities. The collection was handsomely arranged in a large glass case, and afforded every facility for inspection. Next in rotation, but second to none in excellence or beauty, came the beautiful specimens of Mr. Apsley Pellatt.[5] This gentleman, not contented with carrying on his manufacture merely as a trade, has devoted much time and attention to vitreous chemistry, and to the history of glass from the time of its apocryphal origin on the coast of Syria down to the palmy period of Venetian art, and thence to the processes and discoveries of the present day. The results were the beautiful Anglo-Venetian services in gilt glass, which had all the fragile delicacy of form so much prized by connoisseurs—whether they have the imputed quality of detecting poison is a question which it is happily not necessary to discuss at the present day. Mr. Pellatt also made a bold attempt at restoring the lost Venetian art of frosting glass, and certainly the articles exhibited had a wonderful resemblance to ice, the thing intended to be represented. A curious feature in this collection was what the manufacturer called the "Koh-i-Noor," consisting of several lumps of the purest flint glass, cut diamond-wise, and quite rivalling in brilliancy the two million original down stairs.[6] We are certain that if the largest of these specimens had been placed on the velvet cushion, surrounded by an iron railing, and attended by a reverential policeman, it would have received a much larger meed of public wonder and approbation than the real eastern gem. As a specimen, however, of the purest and most beautifully cut flint glass, it afforded an excellent opportunity for observing the difference between that material and the true diamond. It had the advantage of the gem in entire absence of colour, and produced the prismatic changes with nearly equal effect. But it was deficient in specific gravity, and in that wondrous power of radiating light which gives to the diamond its value, and is its unique peculiarity. The mode of cutting these specimens proved

the workmen to be first-rate lapidaries. The other prominent feature in this collection was a magnificent centre chandelier in highly refractive cut glass, which glittered like the valley of diamonds. It was of graceful and original design, and the purity of the glass might at once be detected by contrast with other specimens in the neighbourhood. This magnificent ornament was 24 feet high, and adapted for 80 lights. It was a prominent feature in the Exhibition, being easily seen from the nave below, and reflecting the sun's rays (on fine days) with extraordinary brilliancy. There were other chandeliers in coloured glass, in what the manufacturer pleased to call the Alhambraic style; but the taste of these was questionable, at least in our opinion, and rather marred the effect of the chandeliers, which were constructed solely with a view to prismatic effects.

Contents of the Glass Palace, *Daily News* (2 May 1851), p. 5

Few sights have been accounted fairer or more striking than that of the Crystal Palace when illumined by the rays of the morning sun, diffusing its light through the brilliantly decorated facades, or glistening on the swelling ribs of the transept as of old on the armour of knighthood. The prospect is almost too dazzling to the sight, and both a change and relief are sought below the sobered light, and in the bluey vistas of the interior of the building. Beneath the vanishing perspectives of the azure vault are arrayed a host of sculptured forms, a perfect army or avalanche of heroes, in marble, in stone, and in metal. Their forms stand forth prominently from the gorgeous hues and varied objects which surround them. The whole is blended in one vast harmony, over which the blue colouring of the girders has albeit a predominating influence. Mr. Owen Jones deserves no less credit for the admirable way in which his principal views have been carried out, than for the tact displayed in abandoning the more objectionable features of his scheme.[7] The partial reduction of the yellows is gratefully acknowledged, and though the same can scarcely be said of the virulent reds, with which the under parts of the girders are mapped out, still we notice with satisfaction that the nature of the structure itself has in no slight measure served to counteract the noxious introduction of red into shadowy beams. All will acknowledge with pleasure that the most has evidently been made of the intricate iron tracery of the spanning roof, as well as the fretwork of the galleries; and a seemingly satisfactory solution found of the system to be adopted in decking out limited surfaces and spare forms: this is especially noticeable where the sun, unimpeded by the linen covering, sheds its own quaint chequer-work of light and shade on the traceries of the iron palace.

2.3 Gazing and spectatorship

One of the consequences of the absence of price tags, according to Burris, was that the Exhibition suggested 'this cultural experience was about gazing'

(2001: p. 35) rather than buying. The proliferation of reflective surfaces inside the Palace gave people the opportunity to examine not just things but other people. And there were plenty of opportunities. In his journal of a visit to London in 1851, Zadock Thompson reflects on 'a moving mass of humanity, almost as varied as the objects of the Exhibition' (p. 95). The correspondent of the *Manchester Guardian* of 7 May observed 'Few who reached the western end of the building omitted to survey themselves and the *coup d'oeil* of the interior reflected in the large mirror of the Thames Plate Glass Company'. In volume 2 of his *History*, Tallis celebrated the drama of the crowd: 'There is a magnetic power about large masses gathered in one vast edifice, and swarming in happy excitement along spacious avenues, – where their numbers tell upon the eye, which eclipses every other spectacle, however splendid or interesting. Man is superior to the choicest examples of his handiwork, and never were vast assemblages seen in a situation more imposing' (p. 94).

Osler's fountain (Figure 6) provided one point of orientation for many visitors. It became 'a trysting place "to many a youth and many a maid" who had wandered up from the country to enjoy a sight of the "World's Wonder," as well as a point of general rendezvous for those who were desirous to meet their friends at "the appointed hour"' (*Tallis's History*, 1, p. 30). As with Hyde Park's Rotten Row, the Palace became a fashionable place to be seen. In many accounts, as Louise Purbrick has it, 'visitors are the viewer and the viewed' (2001: p. 13). The language of the gaze has, as always, political implications and, for Tony Bennett, it meant the Palace was emblematic of the incorporation of surveillance within spectacle that, according to Foucault, produced self-policing individuals. The power dynamics of the gaze, in a building where the vantage points for viewing were myriad, meant that 'The crowd itself [was] the ultimate spectacle' (Bennett, 1988: p. 81). The extract from *Tallis's History* concerning a romantic encounter in the Russian section of the Exhibition needs perhaps less heavy theorising, but it nevertheless demonstrates the centrality of spectatorship. The voyeuristic narration is less self-conscious than the dynamics of watching and being watched that constitute the 'third language' of the flirting couple.

Viewing is of course as much a function of time as of space and it was something of an irony that the Crystal Palace appeared to encourage idleness rather than work (the verity it proclaimed to celebrate). According to Thomas Richards, the 'Crystal Palace turned you into a dilettante, loitering your way through' (1990: p. 35). At the centre – or perhaps margin – of the practice of spectatorship was the figure of the *flâneur*, for Walter Benjamin the paradigm spectator of modern urban life. While the Exhibition undoubtedly encouraged visitors to take their time in pondering its displays, to enjoy the experience of looking, it also produced a literary version of the *flâneur* in the figure of the reporter who saunters uninterestedly through the exhibits, commenting

on whatever caught his eye. The mode is captured by the regular feature, 'Wanderings in the Crystal Palace', which featured in the *Art-Journal*. Self-consciously amateur – an important counterweight to 'expert' art criticism, as Rachel Teukolsky has argued (2007: p. 85), the author makes no pretence to comprehension but rather offers 'a few impressions of the things that happened to strike me'. Often the issue at stake is the nebulous one of good taste, and this report is notable for the author's view that high art ought not to be viewed in the same context as industrial machinery.

Cut from a similar cloth was another figure self-conscious of the importance of display, the overprivileged and idle gentleman, the dandy whose day at the Exhibition is expertly captured, and satirised, in the figure of 'St. James' in volume 3 of *Tallis's History*.

A Romance in the Russian Department, *Tallis's History*, vol. 2, p. 96

We remember an instance of this kind. It was just before the Exhibition opened,whilst most of the foreign departments were in a state of indescribable confusion. The Russian division was in the incipient stage of development; curious drums and trumpets, glittering ware and articles of northern *vertu*, had been delivered out of their boxes, and lay heaped about till the rest of the consignment should have arrived. There was a lull in the work; the men entrusted with the business were out, probably unpacking in the park; and the Russian chamber, in that condition of rich disorder, was left to the charge of a young girl. She was dressed town-fashion, and had none of the marks of the peasant about her, except a bright glow on her cheeks. She was handsome that is to say, round-faced, with lively eyes, capable of a profound sentimental expression, (which seems, indeed, more or less common to all lively eyes,) and of a 'comely shape.' You would have almost guessed her country from the cast of her features; yet, notwithstanding the Russian snow she came of, she gave you to understand at the first glance, that there was blood in her veins as warm as ever danced in Italy. If one could make anything substantial out of such a fancy, we might have imagined that she was a neighbour of that river, 'whose icy current flows through banks of roses.' There she stood, keeping watch over the goods, and pretending to read a book. It was a mere pretence. From behind a temporary curtain suspended at the back, there peeped every now and then an English youth of one or two-and-twenty, with a dash of the juvenile *roué* in him, extremely well-looking, and fairly set out for conquest. He appeared to be connected with some of the adjoining states, but it was evident that while his business called him to one place, his love of adventure had fascinated him to another. The coquetry that went on between them, would have had a telling effect upon the stage. Young as they were, they understood how to flirt books and curtains as skilfully as any senhorita of Seville or Madrid ever flirted a fan. Her look aside, to show her consciousness, as it were unconsciously, was perfect; and the

way the young gentleman affected to be looking very seriously at something else, while he was all the time directing an intense focal light upon her ringlets (which she felt as palpably as if it had lifted them up), was a picture which, with the lady in the foreground, might be recommended to the consideration of Mr. Frank Stone, who always hits off these exquisite inchoate sensations with the most charming truthfulness.[8] They did not understand one word of each other's language, yet had already contrived, by the aid of a third language, with which they were both familiar, to get up a tolerably intimate acquaintance. We are sorry we cannot tell our readers how it ended; we hope happily for both parties, and that the lady did not leave her own inclement climate to find a more wintry region here! When the Romances of the Exhibition with the Crystal Fountain for a frontispiece, as the trysting-place for lovers who wished to lose other people and find themselves come to be published, perhaps we shall have the sequel of this little incident.

Wanderings in the Crystal Palace, *Art-Journal* (June 1851), p. 180

WHEN the English build solely with a view to ornament, they almost always produce something hideous; witness so many palaces, arches, pillars, and other monstrosities which afflict our eyes. When they build for utility, they generally produce something eminently original, striking, and handsome. The cause of this lies in the genius of the adaptation of means to ends which distinguishes the English people. Give an Englishman a definite purpose to accomplish, and do not fetter him with rules of art wholly inapplicable to the case, and he will imagine something as new as the exigency; and rendered beautiful by that exact coincidence between the ends and the means which affects the senses with the same sort of satisfaction the solution of a problem gives to the mind.

What new forms of architectural beauty have been brought into being by the necessities of railroads! What strength and lightness in the vast and delicate roofs of the chief stations! What ingenuity and beauty in the adaption of bridges, viaducts, and other constructions, to the nature of the ground. I went last year to visit the Museum of Practical Geology with an eminent French sculptor,—a man of consummate taste; looking around and upwards at that admirable building, he exclaimed with energy, 'How I admire the originality of English architects! Here is a certain end to be accomplished,—the maximum of space and light to be obtained. The architect does not ask whether such a roof as this was ever seen before; he sees that it is the thing required, and he builds it, and how admirable is the effect! The eye and the mind instantly recognize the congruity of the whole design.'

The great, imposing, and satisfactory beauty of the Crystal Palace is, I think, to be explained in the same manner. To effect what it does, it could be no other than what it is; and those long lines, which would produce a weary feeling of monotony in any other building, are there suitable, harmonious, and beautiful. Even the

necessity of preserving the trees, turns to the account of beauty; nothing, indeed, is more graceful and grand than the roof over-arching the old elms. How often is this so in life! How often are our noblest qualities and best graces the result of necessities or restraints, at which we murmured!

The first sentiment on looking round is,—Yes, this is exactly what was required. From a feeling of general assent, one proceeds to examine the details, and the result is the same; all is in its place, and all for the best. There is an admirable *ensemble*, and there is the most perfect accommodation for the study of minutiae.

Considering the vast extent one traverses, the fatigue is much less than was to be anticipated; I was amazed to find myself so little exhausted by what had appeared to me an impossible exertion. Is this not to be attributed to the size, the ventilation, the comparatively pure air? Most places of resort, such as theatres, picture-galleries, &c., are pestiferous, and lower the vital powers so that one is prostrate with fatigue, after a tithe of the exertion demanded by the Great Exhibition.

You must not expect from me any detailed description, or regular criticisms, of the works I saw. I can pretend only to give you a few impressions of the things that happened to strike me in the course of two visits.

I am inclined to agree with M. Janin about the sculpture;[9] I fear the effect of the introduction of statues is rather to degrade sculpture to a level with the mechanical arts. And this is so true, that one cannot think of seeing the god-like works of the best age of Greek sculpture in such a place, without a sort of shudder, as at an act of impiety. There is something so holy and elevated in the highest arts, that its productions seem to deserve and demand a sanctuary. A marble statue, representing the human form, in its highest and purest dignity, ought to be looked at with reverence. White, cold, and motionless, its august repose assorts ill with the motley assemblage of objects, and worse with the motley assemblage of men and women by which it is surrounded at the Great Exhibition. If the statues were somewhat more refined and ideal than they are, I should be fain to fall on my knees and ask their pardon for the humiliation to which they are exposed. This has no application to sculptured portraits, which, being representations of mere common humanity, are at home in the crowd. Shaking off this feeling as one may, there are things to admire among the statues. The 'Greek Slave' is a slave in nothing but her fetters, which are a *hors d'oeuvre*;[10] but the turn of her head is noble and beautiful; and there is an austere and chaste beauty in the face which is very rare in modern Art. The artist has been quite proof against the infection of fashion, which demands an imperfect or diseased structure of the female frame. The beautiful body rests on legs attenuated to meet the modern notions of beauty. The Greeks, especially the unapproachable masters, knew better; they never separated grace from strength. Mr. Rietschell's little bas-relief of a Cupid on a panther, is full of life and vigour, and conceived in the spirit of an antique gem. We regret, however, that the English public should not see some of the works of this admirable artist, in which

he appears to us still more excellent. Casts of the bas-reliefs on the staircase of the King's Library at Dresden would have better shown his high and peculiar merits of composition and expression. In the Italian (so-called Austrian) sculpture room, the eye is not offended by incongruous objects, but there is nothing that powerfully arrests the attention, except 'Ishmael,' a work full of originality and vigour, but so painfully applied, that we can hardly consent to admire. There are some chimney-pieces which enchant the eye by their true Italian grace. One feels inclined to take them up in one's arms and carry them across the room to the domain of their natural mother, Italy. But such regrets are vain and unjust; Italy has other arts to learn, and other qualities to cultivate, before she can 'hold her own;' till then, she and her works are the doomed prize of firmer natures.

St. James, *Tallis's History*, vol. 3, pp. 52–3

As becomes his gentility, St. James, upon his particular morning, gets up late, and ringing for his valet, looks over the morning packet of cards and letters, announcing 'at home,' and, in the vernacular, 'dancing teas,' when, after profoundly meditating on how he intends to employ 'each shining hour'—whether he will lounge away the day in the club or the sweet shady side of Pall-Mall, or whether he has any pasteboards to leave, or whether he shall fly from the gauds of the world, which are vanity, and solace himself with a quiet stroll through country elms branching over the greensward, winding up with a dinner at the Toy or the Star and Garter, which is also vanity, but never mind that—the brilliant idea perhaps strikes him that he will order out his cab, or saunter across the park, and while away the hours in the 'Palace:' as he imagines, so does he act. Loungingly and list-lessly does he mark that singularly tall flagstaff, with that very small flag—large pocket-handkerchief size—which graces or does not grace the southern summit of the transept. Loungingly and listlessly does he saunter across the magic threshold, and leave behind him the treasure of his autograph, in a beautifully-gentlemanly scrawl, backed by a high-life flourish or an aristocratic blot; and then gazing around with a calm grace of patronizing dignity, and an expression indicating that, 'by Jove, the thing is very well in its way,' he silently loses himself in the lightly rustling, and gaily but lowly-talking throng of promenaders. No eagerness, mark you; no flutter of curiosity; no immediate plunge into one of the departments, irresistibly seduced by malachite, or statues with lace on their faces, or beds which look like young cathedrals. Why, he has seen all these things before. He has not missed a single day, from that on which her Majesty walked forwards and the Lord Chamberlain walked backwards from England to Canton, and from Canton to New York, until—of course—until the irruption of the shillingers broke into what were becoming his daily habits, and for a space turned him out. Do not let us lose him, however. Mark how the saint, in his light paletot and glazed boots, saunters observingly through the perfumed throng. He has already nodded to a

score of people, and said—'How do? Fine day!' to a dozen. Then he strays from party to party of the gayest lady-birds under the glass. He loses himself in the accustomed ocean of small-talk about balls, and parties, and concerts, and operas, and all the *piquant* scandal, and all the staler gossip of the world. He wonders what they are going to do with building; he wonders whether they will let people ride in it. He don't suppose they'll stand drags. He wonders if they'll keep the organs in, and the crystal fountain. He wonders where that sparrow is that they say is in the Exhibition.[11] He wonders whether any new things have come in since last Saturday. He understands that So-and-so has purchased so-an-so, and that Thingamy has given an order for a duplicate of what's-its-name. He wishes that they had made the building all arched, like the transept. He'd have done it, if he had had anything to do in the matter. He finds it very hot; but believes they say it is hotter in the gallery; and wonders why Mr. Paxton didn't find some means of cooling the air, icing the fountains, or driving a cold blast through the organs, or something of that sort. Now and then, with a couple of ladies on his arm, he may saunter carelessly into France and Austria, to see the prettiness of furniture and decoration. Lady Jane wants to look at a candelabrum for the dining-room in Park-lane; or the Hon. Mrs. de Smythe wishes to secure a glittering piece of *marqueterie* for the drawing-room in Belgravia or Tyburnia. In some cases the jewellery has still lingering charms. The nose of the unhappy Koh-i-noor has been dreadfully put out of joint; but there are Hope diamonds and black diamonds, and marvelous emeralds and amethysts, which still reflect in their precious depths the translucent eyes which sparkle over them. Or does he—does mincing St. James encounter a county family 'up to the Exhibition,' and naively staring and wondering at all around them, then, perhaps, he good-naturedly unbends, and for some brief space becomes pilot and Cicerone. He points out the geographical localities in which he is notably aided by the placards, and knows where the French room, the Gobelius, tapestry-room, and the Austrian furniture-room where the young cathedral is, and the medieval-court, in which if, as is possible, he be affected with the moral and mental tinge which was once young-Englandism, he discourses with tolerable learning of ecclesiology, of vestments and stoles, screens and fonts, and becomes in his discourse highly picturesque and medieval, to the great bewilderment of the county family, who don't in the least understand the difference between the early English and the *flamboyant* styles, and wonder whether the *Renaissance* is anything to eat. And talking, by-the-by, of eating (or rather that genteel apology for eating which is provoked by ices and wafers), St. James and his kindred five-shillingers much affect the refreshment departments, where they lounge upon the softest benches getatable, and turn their stomachs into arctic regions, with small strawberry and lemon icebergs; or make the climate milder with floods of coffee, more or less sublimated by the chicory beloved of the chancellor of the excheq-uer.[12] And so the day wears on. Nobody looks at anything in particular—unless it be somebody else. Ladies let the steam-engines alone, but criticise ladies' bonnets.

Pretty things in handy places come in for languid inevitable praise. People ask whether they will meet other people at balls and operas in the evening. People point other people out. Here and there a single lady and gentleman wander cooingly down love alleys of broad-cloth, or streets of glittering guns and pistols—not, however, criticising the excellence of either. The sitters in the Bath chairs are almost the only active inspectors. Round and round they go, pushed by perspiring Frenchmen, and eagerly making the most of their limited time. They do not like to brave the grand crush, but wander in aisles and compartments, and continually pull up to gaze and admire. Meantime, the grand crowd still ebbs and flows, and circles round the fountains, and the statues, and the organs. Look at it from the gallery. What a glancing bed of peripatetic flowrets—pinks and roses, and lilies and carnations—all a-blowing, all a-growing, and, what is stranger still, all a-moving, all a-fluctuating, hither and thither in eddies and streams, and counterstreams—a kaleidoscopic *parterre* of bright hues and tints, shifting and blending, and intermingling like living shot-silk—the congregated essence of a half-score thousand male and female St. James's.

2.4 Graven images

Exhibitions are intrinsically associated with popular culture, but one display that provided an ostentatious visual contrast to the modernity signalled by Paxton's glass building was Augustus Pugin's Medieval Court (Figure 7).

7 Pugin's Medieval Court, from *Dickinsons' Comprehensive Pictures* (1854)

Indeed, discussion of the court focalised several key issues for those who pro-
tested against the rampant commercialism to which the Exhibition appeared
to point.

Victorian medievalism was an 'inconsistency in the narrative of progress'
(Teukolsky, 2007: p. 93) that otherwise dominated 'a cathedral to the glories
of industry' (Flanders, 2006: p. 3). Pugin, as Asa Briggs puts it, 'lingered
contentedly in the fourteenth century' (1988: p. 39) and his court displayed
Gothic furniture and ecclesiastical ornaments, deliberately figuring Catholic
worship and liturgy. Pugin had converted to Catholicism in 1834 and two
years later published *Contrasts*, a work which argued for a revival of the
medieval architectural style. Pugin was criticised for promoting Catholicism
through the vehicle of the Exhibition and letters from Albert and Lord
Granville show that he was asked to reduce the size of a large, prominent
crucifix (RC/H/1/6/36). Nevertheless his views, including an antipathy
towards Paxton's utilitarian building, chimed with those of Morris and
Wornum. In each case the objections were more about aesthetics, however,
than belief.

Geoffrey Cantor has recounted at length the kinds of objections raised
against the Exhibition by some – though by no means all – religious com-
munities. In what was perceived by many to be a largely secular occasion, the
'graven images' cautioned against in Exodus 20:4 were one biblical motif used
to suggest that 1851 marked a 'godless celebration of material wealth' (Cantor,
2011: p. 6). Here the letter from one offended Christian to the *Record* explains
why the entire Exhibition was an example of popery. These sentiments were
not shared by all, and in *The Great Exhibition Spiritualized* (1851), Henry
Birch wrote 'Our business is to make some spiritual improvement of this
dazzling display of human ingenuity' (p. 22). Taking up this challenge, the
inviolable relationship between material and spiritual experience is invoked in
The Lily and the Bee (1851), one of the paeans to the Exhibition that embraced
a sacred interpretation.

Letter from George Rochfort Clark to the *Record* (12 May 1851; RC/H/1/6/57)

Sir—As you reported in the last *Record* what passed respecting the indecent and
superstitious imagery at the Great Exhibition, the naked men and women, the
crucifixes, and superstitious rubbish, I will not repeat those arguments and obser-
vations. But the subject is one which requires to be steadily pursued; for, unless
it be effectually dealt with by the pulpit and the press, the voluptuousness, the
excesses and the sensuality of Greece and Rome, pagan and Papal, will make a
fearful breach in the chastity, the moderation, and the spirituality of this Christian
people.

There are persons who have loaded their walls with iniquity; who have introduced their filthy, their profane, and their superstitious picture and sculpture from those walls into the public galleries; who patronise young men in a waste of time, labour, and genius, to produce works fitted only for destruction. These are the corruptors of the public taste; these lead thousands of weak people to fancy that, for fashion's sake, they must profess to admire, or at least to put up with, such pictures and sculptures as in their secret judgment they condemn, and perhaps detest.

How long will the Church of God tamely submit to this thraldom? The Church of Rome has tried to make a compromise with the world. It melted down the head of Jupiter Capitolinus, and brought out another head and called it Peter; it melted down the hand that held the thunderbolt, and brought out another hand that held a key, and gave it to its Peter. It has cast a cloak over the naked Venus, and calls the image in its new dress Mary. For every God that Rome Pagan would furnish, Rome Papal can supply a saint.[13] What has been the result of this compromise? The perpetuation of heathenism. If you would see Venus in perfection, go to apostate Rome, that corruption of the universal Church, where the priests have such crooked ideas of chastity, that they esteem fornication a less offence than marriage.

But the Church of Christ has another office. Israel of old had this commandment—'Ye shall destroy all their pictures, and destroy all their molten images, and quite pluck down all their high places.' And at this time, the Church has to walk not according to the course of this world. I would, therefore, stir up some to preach, to speak, to write, and to contend against this heathenish brood of naked men and women, and superstitious crucifixes. I would recommend that the report which appeared in last Friday's *Record* should be published in other periodicals, and that your readers should endeavour to induce the conductors of such periodicals to do so, and to take up the subject.

We have now a favourable opportunity for giving the world battle on this subject, for informing women that there are men who turn away their eyes from such objects, and shun those places where they are exhibited. A flood of imagery has been for some time setting in upon the kingdom of a most corrupting tendency. Our public exhibitions, galleries, and museums, are defiled with filthy, indecent and superstitious objects. Things are preserved because they are old and strange, or well executed, which are only fit for the fire or to be broken in pieces. Let us, therefore, entreat others to speak out plainly, decidedly, and promptly; and then, whether we succeed or fail in driving the indecent and superstitious images out of the public thoroughfares of the Great Exhibition, we shall at least make it plain that the Church in this kingdom does not sanction the evil, but abhors it, protests against it, and actively resists it.

As example confirms precept, I may mention, that it is now about twenty years since I looked carefully through my collection of prints, and committed to the

devouring flame every one, however well done or costly, which was evidently contrary to godliness. The mythology of Rome, Pagan or Papal, received no mercy in that day. Mary and Venus fell together; Jupiter and Peter vanished in their smoke. If I had had sculpture of the same kind, doubtless it would have paved the roads. Twenty years' subsequent reflection and experience have confirmed my judgment in the propriety of that act. It has been as a beam taken out of the eye: it enabled me to see clearly and feel so strongly the blasphemous character of Murillo's picture of the Trinity in the National gallery, that when a print of it was published, I purchased one for two guineas, and tore it up at a full meeting of the Society for Promoting Christian Knowledge; pronouncing it blasphemous, amidst the almost unanimous approbation of the meeting; and thereby did something perhaps to stem that tide of Scripture imagery which then threatened to deluge the Church. Painting and sculpture may have their legitimate objects; but indecency, blasphemy, and idolatry are not to be endured, however exquisitely delineated in alabaster or portrayed on canvass.

'He that walketh righteously, and speaketh uprightly, he that despiseth gain of oppressions, that shaketh his hands from holding of bribes, that stoppeth his ears from hearing of blood, AND SHUTTETH HIS EYES FROM SEEING EVIL; he shall dwell on high: his place of defence shall be the munitions of rocks: bread shall be given him; his water shall be sure.' (Isaiah xxxiii., 15, 16.)

<div align="right">Your faithful servant,
GEORGE ROCHFORT CLARKE.</div>

Samuel Warren, *The Lily and the Bee*, pp. 22–5

——Day, in The Crystal Palace!

There was music echoing through the transparent fabric. Fragrant flowers and graceful shrubs were blooming, and exhaling sweet odors. Fountains were flashing and sparkling in the subdued sunlight: in living sculpture were suddenly seen the grand, the grotesque, the terrible, the beautiful: objects of every form and color imaginable, far as the eye could reach, were dazzlingly intermingled: and there were present sixty thousand sons and daughters of Adam, passing and repassing, ceaselessly; bewildered charmingly; gliding amid bannered Nations—through country after country renowned in ancient name, and great in modern: civilized and savage. From the far East and West, misty in distance, faintly echoed martial strains, or the solemn anthem!—The Soul was approached through its highest senses, flooded with excitement; all its faculties were appealed to at once, and it sank, for a while, exhausted, overwhelmed.

Who can describe that astounding spectacle? Lost in a sense of what it is, who can think what it is like? Philosopher and poet are alike agitated, and silent; gaze whithersoever they may, all is marvellous and affecting; stirring new thoughts and emotions, and awakening oldest memories and associations—past, present,

future, linked together mystically, each imaging the other, kindling faint suggestion, with sudden startle.—And where stood they? Scarce nine times had the moon performed her silent journey round the earth, since grass grew, refreshed with dew and zephyr, upon the spot on which was now a crystal palace, then not even imaged in the mind of its architect—now teeming with things rich and rare from wellnigh every spot of earth on the terraqueous globe, telling, oh! grand and overwhelming thought! of the uttermost industry and intellect of MAN, in every clime, of every hue, of every speech, since his Almighty Maker placed him upon earth; MAN, made in His own image, after His likeness, a little lower than the angels, and crowned with glory and honor; given dominion over all the earth and sea, and all that are in them, and in the air—that move, and are; ever since the holy calm and rest of the first Sabbath: since the dark hour in which he was driven, disobedient and woe-stricken, out of Eden—doomed in the sweat of his face to eat bread, in sorrow, all the days of his life, till he returned into the ground, cursed for his sake: the dread sentence echoing in his ears, Dust thou art and unto dust shalt thou return!

—I faintly breathe an air, spiritual and rare; Mind all around diffused; MAN rise before me, every where, man! in his manifestation and misfortune, multiform; mysterious in his doings and his destiny.—Yes, I, poor Being, trembling and amazed, am also man; part of that mighty unity; one, but one! still one! of that vast family to whom belongs the earth; still holding, albeit unworthily, our charter of lordship. Tremble, child of the dust! remembering from Whom came that charter, wellnigh forfeited. Tremble! stand in awe! yet hope; for He knoweth thy frame; He remembereth that thou art but dust; and, like as a father pitieth his own children, even so is merciful to them *that fear Him*.

Notes

1 Whiteley was the founder of Whiteley's department store in 1867 but dated the origin of his ideas to his visit to the Crystal Palace.
2 For a discussion about the incongruity see the Introduction to this volume.
3 Found in Class 10, which included Philosophical, Musical, Horological and Surgical Instruments.
4 *Punch*, 26 April 1851.
5 Pellatt was a glassware maker who patented the production of sulphides or Cameo Incrustations. He was later MP for Southwark.
6 See 3.3.
7 Jones was an architect responsible for the interior decoration of the Crystal Palace. He later played a significant part in the formation of the South Kensington Museum.
8 Self-taught painter from Manchester. He led opposition within the Royal Academy to the Pre-Raphaelites.
9 Jules Janin wrote a regular feature in the *Journal des Débats* (see 3.5).

10 The *Greek Slave* by Hiram Powers (see Figure 8).

11 The story of the sparrow in the Crystal Palace was bound up with the legend of Wellington. Prior to the opening, a number of sparrows had found their way into the building. Wellington's solution, which may or may not be apocryphal, was to send in sparrowhawks.

12 Sir Charles Wood spoke in Parliament allaying fears about the adulteration of coffee with chicory. The speech led indirectly to the Food Adulteration Act of 1860.

13 Compare the attitude to Roman Catholicism with the views of Claude in Arthur Hugh Clough's *Amours de Voyage* (1849).

3

Nation, empire and ethnicity

The Great Exhibition, as is often the case with events of national significance, offered Britain an opportunity to reflect on her position in a global context. For Auerbach and Hoffenberg it 'put the nation on display and served as a forum for discussions of Britishness' (2008: p. x); it also afforded a chance to rethink shared cultural and moral values and the national character, relationships with other nations, the future of the empire and the colonies, and 'The images that the English constructed of themselves' (Daly, 2011: p. 5). All were issues fundamental to understanding Victorian notions of Britishness or Englishness, two terms which, while often appearing interchangeable at the time, have subsequently been remarked upon for their subtle differences in the context of nationalism.[1] Raphael Samuel has argued that the associations of the word British are largely 'diplomatic and military rather than literary, imperial rather than – or as well as – domestic' (1989: 1, p. xiii), while perhaps more significantly, David Cannadine believes that 'The history of Britain was ... the history of England as and when it took place elsewhere' (2008: p. 16). It appears that representations of Britain and Britishness were more likely to include the nation's sense of its global currency, whether that be military or commercial, while Englishness instead evoked the past, contributing to an image of a nation that was 'the font of freedom and the standard of civilization, a place of virtue as well as of beauty' (Kumar, 2003: pp. 7–8).

From the outset, as we saw briefly in Chapter 1, Albert's vision for the Exhibition was one of international pacifism, incorporating the best of art and industry from all exhibiting nations. Nevertheless, John Burris is partly right in commenting that 'It was Britain itself that was for sale inside the Crystal Palace' – its values as much as its goods – and 'judgment of the world's cultures based on industrial capacity' (2001: p. 26) – a healthy spirit of competition – was one of the organisers' declared principles. Acting as host as well as curator, Britain could organise an exhibition that would set itself at best advantage, confirming the image of civility, moral rectitude, endeavour, duty and respectability that Edward Bulwer Lytton had promoted in *England and the English* (1833). It was a Britain, according to

Joseph Turner in *Echoes of the Great Exhibition* (1851), to which 'Free Truth, free Thought, free Word, such glory clings' (p. 12). Crucially, it was a Britain that could also assert its cultural superiority over other nations through an exhibition that, granting the organisers' stress on international cooperation, was largely Anglocentric in nature.

If the official line was one of domestic confidence in a harmonious international context, it could not disguise the many cultural anxieties that the documents included in this chapter bear witness to. For one, as Lara Kriegel argues, 'The Great Exhibition gave "palpable" evidence of the unsettling truth that other European nations excelled Britain in many industrial arts' and it was widely acknowledged that 'The spectre of France' (Kriegel, 2007: p. 130) loomed over English manufacturers. France was the largest contributor to the international section of the Exhibition, providing exquisite examples of Sèvres porcelain and Lyons silk. English goods were characteristically cheap and mass produced, and whilst both durable and affordable, they were perceived to lack the luxury and quality of French design, and the anonymous author of *The Exhibition Lay* (1852) was perhaps overly optimistic in addressing 'FRANCE! noble, sensitive! our ancient rival, now our proudly splendid, emulous friend!' (p. 30). If France was one thing, much more shocking to English self-confidence was the realisation that far-flung places like India were also producing more sophisticated, aesthetically pleasing commodities. International trade meant not only new export markets, but also new competitors. It became apparent too that Britain's colonial possessions were providing an increasing amount of the raw materials necessary for industrial development: India, for example, represented the 'combination of the gifts of nature with the creations of art' (*Official Catalogue*, 2, p. 857). More than ever, the future prosperity of the nation depended on Britain's overseas relations as much as its domestic affairs.

The discussion of nation at the Great Exhibition also reflected the acceleration of a global system – later theorised by Immanuel Wallerstein – whereby core economic powers develop in inverse relation to peripheral ones.[2] The need to vindicate the values of the developed Western world by contrasting them favourably to foreign or savage 'others' was paramount and can account for much of the xenophobia we can identity in the bulk of the literature in this chapter. It is important to note, however, that there were also more progressive voices, such as George Augustus Sala (see 3.2), who were prepared to satirise jingoism and prejudice where they found it. Sala was just one of those who recognised that Britain's attitude to those foreign nations exhibiting, and to the behaviour of those foreigners who descended on London during the summer of 1851, helped to shore up as many assumptions about English identity as they did demonstrate the characteristics of other countries.

3.1 Patriotism

That the Great Exhibition provided an arena wherein 'Britons found an outlet for their nationalistic sentiments' (Auerbach, 1999: p. 165) is manifestly true when one considers the number of patriotic outbursts prompted by the Crystal Palace. *The Exhibition Lay* (1852), one of the commemorative poems published on the subject of the Exhibition, is typical in consecrating British values of liberty and autonomy, counselling visitors to 'Remember what our England is, / and what she long hath been. / A land where Freedom's eye unbent, / hath met Oppression's frown' (p. 30). For the author of *The Lily and the Bee*, many of the values of British national identity met in the figure of Britannia who was depicted walking the aisles of Paxton's Palace where she might 'greet you fondly; embracing with a sister's tenderness'. The spirit of Britannia was embodied by Victoria who was one of the most frequently represented figures amongst the statuary on display. *The Lily and the Bee* proudly proclaims: 'See, then, our Queen. She wears a crown, and holds a sceptre: emblem of majesty, of power, of love, alone.—See, see, embodied to your sight! England's dear Epitome, and radiant Representative! all hearts in hers; and hers, in all: Britain, Britannia: Bright Victoria, all!' (p. 29). *The Exhibition Lay* radiated the same sort of patriotic warmth that chimed with the voice of the people, endowing Albert's vision with the force of prophecy:

Then rose a quick and fruitful thought
Into a thoughtful mind—
What if all industries of earth
were in one place combined?
The time was ripe, and still the thought
To fuller purpose grew,
Its greatness over every mind
a sense of wonder threw.
The noblest in the realm approved,
And royal favour lent,
And England echoed back her will
By voice of Parliament.

(p. 5)

In *Recollections and Tales of the Crystal Palace* (1852), Carolyn Gascoyne followed suit declaring 'Away with chains! – Britannia's flag unfurled, / Speaks Peace and Freedom to th' assembled world!' (p. 7).

The image of the island nation championing freedom in the face of oppression was used particularly to distinguish British values from those of the United States of America. One issue more than any other dominated the USA's representation at the Exhibition: slavery. In 1807 an Act of Parliament had abolished the slave trade in the British Empire, although it was not until

the Emancipation Act of 1833 that slave ownership was made illegal. Britain exerted its status on the world stage to influence other nations to follow suit, and by 1851, slave-owning America looked increasingly out of step. As Richard Huzzey puts it, in distancing itself from America over the contentious issue of slavery 'Britain had reasserted its identity as a land of freedom' (2012: p. 2), explaining the frequent discourse of broken chains in nationalistic cant. The London press took every opportunity to castigate America on the subject of slavery, most notably in the case of the sculpture by Hiram Powers of a Greek slave in ivory, chained at the wrists (Figure 8). *Punch*, who

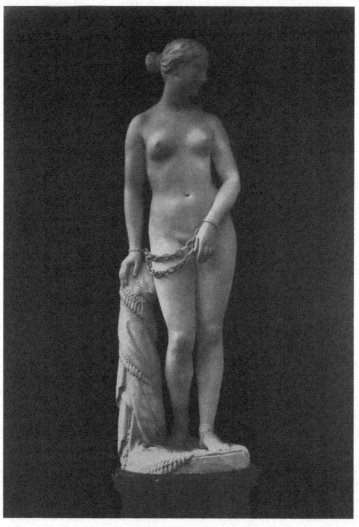

8 Hiram Powers, *Greek Slave*

included a satirical cartoon by John Tenniel representing a Virginian slave imitating the posture of Powers's, was keen to protest at the irony: 'Why not have sent some specimens of slaves. We have the Greek captive in dead stone – why not the Virginian slave in living ivory. Let America hire a black or two to stand in manacles, as American manufacture' (7 June 1851, p. 236). Powers's sculpture was largely well received by the public but *The Lily and the Bee* went so far as to dramatise a scene on the subject of the statue appealing to Britain, land of liberty and justice: 'Sweet slave! Turn from our Queen beloved that agonizing look! / No chains, no bonds, Her myriad subjects bear, / They melt in contact with the British air: / Her sceptre waves – and fetters disappear' (p. 51).[3] As Geoffrey Cantor notes, the *Anti-Slavery Reporter* 'addressed an open letter to a number of religious organizations urging them to bar from their pulpits and from fellowship with their churches any visiting Americans who supported slavery' (2011: p. 177).

For Auerbach, many of the objects on display 'created and diffused' (1999: p. 113) a national image. At the approach was a huge equestrian statue of Richard Coeur de Lion by Baron Marochetti. Once inside, spectators could marvel at the gold enamelled and jewelled vase by Watherston & Brogden of Covent Garden which depicted Britannia as part of a group emblematical of Great Britain surmounting a depiction of the Battle of Hastings and reliefs and busts of celebrated men, including Nelson, Wellington, Shakespeare and Newton. J. Wyatt contributed a model of a Quadriga carrying Britannia attended by allegories of Peace and Industry. There was a watch claimed to be the property of Henry VIII and sculptures of Alfred the Great, Elizabeth I, the Duke of Wellington and even Cromwell.[4] Victoria was one of the most represented figures in the Palace – featuring alongside Albert in an equestrian statue by Wyatt – but she also loaned many of her own possessions with national overtones, including the boxwood cradle symbolising the union of England and the Royal House of Saxe-Coburg that showcased the royal insignia surrounded by friezes of roses, poppies, butterflies and birds (*Official Catalogue*, 1, p. 109).

The first extract below is taken from volume 1, chapter 26 of *Tallis's History* and is an interesting example both of its tub-thumping attitude to the spirit of British male endeavour, and of the way in which mechanisation could be gendered female ('she rises … her handmaid'). It suggests that patriotism is a matter of industrial confidence and the triumph of free trade. This is followed by a short section from volume 1, chapter 37, which is part of a letter from the Frenchman, Monsieur Blanqui. It leaves the reader in no doubt about the awe in which the continent held Great Britain's industrial achievements in the 'tournament' of all nations, but should be compared with the French assessments of Jules Janin in *Journal des Débats* (see 3.5). The extract taken from *The Times* bemoaned the utilitarian nature of British products but championed the nation's advancements in mechanisation.

Tallis's History, vol. 1, pp. 165, 234

The genius of Great Britain is peculiarly mechanical, and the steam-engine and the loom divide between them the glory of her industrial triumphs; for, to relieve the sons of labour from their severest toil, and to substitute iron and steam for bone and muscle, is the peculiar office of machinery. Stand we in the department devoted to machines in motion. Do the immense collection of contrivances to lighten toil convey no moral – the interesting objects there shown read us no lesson? 'In the Crystal Palace we discover,' says an eloquent writer, 'how mechanism is extending her dominion over the whole empire of labour; how she rises in textile fabrics to the manufacture of the most delicate and intricate lace; how from wood she aspires to fashion iron into the most exact proportions; how, with steam as her handmaid, she works the printing-press and navigates the ocean, and outruns the swiftest animal in her course. Turn into the agricultural implement department, and we find everything now done by machinery. By it the farmer not only sows and reaps, but he manures and hoes. By it he threshes out and grinds his corn, and prepares the food for his cattle. He can even drain by machinery, and it is difficult now to find a branch of his business into which it does not largely enter. In our manufactures the mechanical genius of the country reigns supreme. Those beautiful fabrics are nearly all evidences of its power.'

[...]

The more we examine in the Crystal Palace the portion devoted to English industry, the more we perceive that the English have neglected nothing to appear to the utmost advantage at this memorable tournament. They are completely equipped, armed at all points. They only, perhaps, amongst all the competitors, are in a position to be judged without appeal, for they have unreservedly put forth all their strength. When the Exhibition had once been determined upon, the fiercest protectionists, who had most strongly opposed it, made every effort to appear to the greatest advantage. They yielded with good grace, and not a manufacturer of any importance failed to respond to the summons: they were all ready on opening day. They occupy, as we have already stated, one-half of the entire space devoted to the Exhibition, and they have established themselves methodically and in admirable order. All their machines are in operation in a series of bays, to which the steam required to put them in motion is conveyed under-ground in tubes. Whether from motives of economy, or for the purpose of avoiding the terrible din caused by so much machinery, each machine is only worked at intervals, so that a portion of the machinery is at rest while the other is at work. The overlookers everywhere explain the processes to the public; there is spinning, weaving, embroidering, stocking-weaving, lace, riband, and cloth manufacturing. It is a veritable acting industrial encyclopaedia. The steam is conveyed to machines of 20-horse power,

and to small models the size of a card-table. Have a care how you pass unheeded these innumerable instruments of production: not one of them but which presents some novel amelioration or some improvement in the details.

The Times (20 October 1849), p. 4

As far as it is possible to estimate a design of almost formidable novelty and magnificence, we are of the opinion that the country is indebted to Prince ALBERT for an important move in the developement [*sic*] of its genius and resources. The pacific congress which he has proposed to the world is, on many accounts, the thing we are in want of. Supposing it to be conducted with ordinary judgment, and to meet with moderate patronage and success; supposing also that other nations take up the idea, and that every year sees a great congress of arts in one metropolis or another, we anticipate benefits peculiarly fitted to our national deficiencies. We are an island and want international communication. Our merchants and gentry go abroad upon business and pleasure; but the great bulk of the people know the nearest nation of the continent only by name. Industrious and ingenious as our countrymen are, they want some of the qualities which contribute not only to intellectual elevation, but even to commercial success. Large sums are annually lavished in the vain attempt to create a school of taste, yet at this moment our manufacturers are obliged to pilfer French patterns, and think themselves eminently successful when they disguise the inventions of Paris and Lyons without spoiling them. As a general rule, our native manufacturers have no resources except a beggarly dependence on foreigners, a servile adherence to classic and other conventional forms, and the merest imitation. Our position, our mineral wealth, our machinery, our commerce, and the inexhaustible energy of our race, enable us to carry all markets before us, and to force our commodities on the world; but the want of native taste is a continual drag on our efforts, and entails severe losses in a market continually affected by the caprices of fashion. Now, just as manners are learnt in good society, and morals among the virtuous, so taste in all its branches can only be acquired by communication with those who possess the precious gift, and by familiarity with their works and ideas. No amount of solitary thought, no effort of unassisted industry, can make a good man a Christian, a good poet, a good artist, or a good anything else. He must condescend to be helped; and if this is true of the relation between man and man, it is not less true of the intercourse of nations.

There is scarcely an article that could be mentioned in which our sterling qualities do not turn to less account than they should do—all for want of the graces. Our manufactures are cheap and good—often too good, as they only perpetuate ugliness. Our furniture is calculated to last for centuries, but is generally insipid and heavy. The wood may be well seasoned, the lines may be straight, and the corners right angles. The drawers may fit, and doors may be well hung. What is more, the lock and key may do their duty. But the whole is a mere stupid

repetition, line for line, of some vulgar model, of which there are ten thousand too many in the world already. In any third-rate French town there are dozens of cabinet-makers whose politics may be rather loose, and whose workmanship may not be always trustworthy, but who at the price of the London article will turn out a real work of imagination. For comfort and for use we might prefer the home goods, but if we wish for the occasional refreshment of an agreeable object, or covet a poetical air for our apartments, we should find it much cheaper to import. It is the same with every other sort of manufacture. From milliner to men of war, from rockets to lighthouses, from cookery to tactics, from *bon bons* to triumphal arches, our neighbours surpass us in the science and the taste necessary to bring these things to perfection. As for us, it must be confessed that we live by 'sucking their brains.' The tortoise beats the hare. Our dogged resolution serves us for genius, and we reap the crop which others have sown. Such we say is our case for the most part. We have amongst us extraordinary instances of science, genius, and taste; but as a general rule, there is more of these qualities in a French operative than in an English employer.

It is evident, however, that the gain will not be only on our side. The Frenchman has more to learn than the Englishman. Why is the Frenchman, in spite of his science, driven to import our machinery? Why is the smallest article of English manufacture a treasure in France? There cannot be a more acceptable present to a Frenchman than an English penknife or corkscrew; or to a Frenchwoman a paper of English pins. When an English lady residing in France sends her dress to a milliner the latter carefully abstracts every English pin she can find in the dress, in order to use it in the process of dress-making and fitting, for which its superior sharpness and smoothness render it invaluable. Whatever can be done by machinery, whatever requires steady industry, capital, or the co-operation of numbers, is better done here than in France. Our fields of iron and coal have given an extraordinary developement [*sic*] to our mechanical faculties. Our insular position and command of the seas have made us good practical navigators. Our climate, our soil, and our social state have made us good agriculturalists. On all these points France can easily repay herself from the advantages we derive from her artistic superiority. Such is the prospect of mutual gains suggested by the comparison of this country with its nearest neighbour. Our relation with Germany, Italy, and other countries promises only a less degree of the same useful results.

It is with great delicacy and even hesitation that we advert to the political benefits of such international reunions. The causes of war are too deep-seated, too permanent under the surface, and too ready to start above it, that we are forced to look with little faith on the mutual civilities of *savans* or manufacturers as a means of averting the beginning of war. Such is the proneness of mankind to grab at shadows, that it is oftener our duty to expose the flimsy devices of the peacemongers than to encourage the hope of a universal pacification. Thus much, however, we may say with confidence:—It is in the nature of peace to be forwarded by indirect and

unobtrusive means. He is no real peacemaker who rushes in between two jealous and sensitive neighbours, and cries out, 'Good neighbours, pray do not quarrel. What reason have you to hate one another? Pray tell me what are your differences? I will set you all right.' Such a man only keeps the sore open, if any exists. The tendency to war is an insanity which requires not so much direct argument—for who thinks of arguing with a madman?—as diversion to other pursuits. Bring the nations of Europe to a joint exhibition of their several works in Hyde-park or the Champs Elysees and they will be the more likely to forget their old grudges. They will, in fact, be thinking of something else, and entertain another sort of rivalry—the rivalry of civilized art, instead of the old rivalry of strategic skill and brute force.

3.2 'The foreign question'

Playing host to an international exhibition was a complex affair. The logistics of soliciting and receiving exhibits, along with managing the anticipated influx of foreign visitors to the capital, needed careful attention and, much like the local committees at home, the Executive Committee adopted a system of central commissions to do much of the organisational work. A circular of the American Central Committee of June 1850, sent to all interested parties, announced 'Our object in addressing you, is to request that you will confer with Societies and individuals in the State of ****, and appoint a local committee', in order that 'your citizens be enabled to avail themselves of the advantages promised by the Exhibition' (RC/H/1/5/38). Many concerns were raised about the amount of space available to participating countries and, as late as March 1851, Cole wrote to Colonel Grey advising him to do 'everything possible to conciliate the foreigners' (RC/H/1/6/32). In a similar spirit on 7 March, Edgar Bowring wrote to all foreign committees requesting that they nominate 'Gentlemen qualified and willing to act as Juror' (RC/H/1/6/29) to ensure that the juries responsible for judging exhibits and awarding medals were not perceived to be dominated by British jurors. In this section, the memorandum of the Executive Committee from November 1850 concerns the part that the transport and receipt of foreign packages played in the decision to group international exhibits by country in the east nave, rather than attempting to follow the more complicated thirty-class taxonomy used in the display of domestic exhibits in the west. The pressure of space and time meant that only a gesture could be made towards Albert's original four-point division of Raw Materials, Machinery, Manufactures and Plastic Arts (see Introduction and 2.1). Reassurance was also sought on a variety of odd subjects: included here is a letter from the Swiss Commissioner on the subject of the appropriate display of cheeses.

If organisers found the need to reassure the committees of countries, whose manufactures were already perceived to be at a disadvantage in comparison

to their British counterparts due to the sheer distance over which many exhibits had to be transported, they also had to overcome objections at home. Anxieties about foreigners fomenting radical insurrection, crime, damage to property, and even the spread of atheism or popery were common.[5] For example, on 10 April, Lord Normanby wrote to Lord Palmerston on the subject of French Socialism and the 'Seduction of Socialist Eloquence': 'I continue to receive numerous communications some anonymous, and some from secret sources of information as to the projects of the Revolutionary party, which has no doubt a most extended European organization, giving warning of various Characters as to the use of which is intended to be made of the promiscuous Assemblage of Foreigners to be collected within the next few months in England' (RC/H/1/6/59). The Metropolitan Police felt the need to call on French intelligence to identify potential criminals. 'The Foreign Question', as Sala termed it, was inflamed by the conservative press and included here is a typically provocative article from *John Bull*, champion of the Tory right, which anticipates the Exhibition will host a 'Gathering of All Vagabonds', hell-bent on finishing the job they began in 1848. They conclude, quite literally, with all guns blazing, appealing to the Duke of Wellington to mobilise the military and introduce, if necessary, martial law.[6]

In 'The Foreign Invasion', first published in Dickens's *Household Words*, in October 1851, Sala reflects on the earlier paranoia, mocking those like *John Bull*, who had predicted a new Babel or something even worse. In Sala's hands the promised cosmopolitanism – and accompanying dangers – of the Exhibition turn out to be a damp squib. 'Where are the fezzes?' asks his disappointed observer. London, he concludes, has swallowed them all up, a modern Dragon of Wantley, and his commentary becomes a reflection on the vastness of the metropolis. The official statistics of the real number of foreign visitors to London during the period of the Exhibition, recorded by Alexander Redgrave, are included here as a reference point.

Executive Committee Memorandum (November 1850; RC/H/1/5/68)

Up to the present time only five Foreign Commissions have transmitted statements of the quadripartite division of space which they had respectively allotted to the Four Sections of Raw Produce – Machinery – Manufactures, and Fine Arts, although they had been invited to send such information on or before the 1st of last September.

Still, the Executive Committee, in accordance with the Decisions of Her Majesty's Commissioners had hoped to have been able to assign definite spaces in the Building for the reception of the Articles belonging to the sectional divisions of the principal Foreign Commissions. They had prepared the rough sketch of a

ground plan on this principle, together with a list of Rules for Foreign and Colonial Exhibitors, requesting that such packages sent from abroad should be marked with the name of the Exhibitor, and the section to which its contents belonged, so that upon its arrival at the Building it might at once be taken to the appointed place in the particular section to which it belonged. They submitted these Rules to the Russian Commissionaire, who is in London, the Custom-House authorities, and the several Custom-House Agents for Foreign Countries, and these parties unanimously agreed it would be impossible either to have the packages marked with the section to which it belonged, or to prevent articles belonging to several sections arriving in the same package, or to give the Exhibitor's name; and that the utmost they could hope for would be to mark the packages with the name of the country from which it had been sent. Every particular on which arrangement depends, must, therefore, be learned after the opening of the package by the Custom-House officers in the Building.

Under these circumstances as the Commissioners have appointed the 1st of January to receive articles at the Building, the Executive Committee submit that the only course now open for adoption is to assign one particular location of the Building to each Nation, into which must be brought, examined and sorted all the various articles contributed by it.

The Executive Committee submit that it will be impossible to consider any international classification, even into the Four Sections, until all the articles of each Nation have been received, sorted, and their bulk and character ascertained. The Executive Committee cannot hope that this information will be obtained completely until some time after the 1st of March. The Building will then be filled, and assuming that the productions of each of 30 Foreign Commissions, and of 35 Colonial Committees to which space has been allotted, were sorted into the Four Sections only, it would be necessary to transport from one part of the Building to another the whole productions arranged into 260 divisions. If, instead of the Four Sections, Foreign and Colonial productions were sorted into the 30 Classes, already adopted as the divisions for Juries, and into which British articles will be arranged, there would be nearly 2,000 Classes to be rearranged. If each Class had only 7 Exhibitors, 14,000 places would have to be marked out, and this must be done and carried out wholly by the Executive Committee itself. It cannot be safely calculated that there will be 40 clear days for attempting such a rearrangement:— looking to the shortness of time, the inadequate vacant space, and the general magnitude of the works, the Executive Committee apprehend that they would fail in their duty if they expressed any hopes of being able to effect this rearrangement and open the Exhibition on the 1st of May.

They submit, therefore, that it is an inevitable necessity that the first arrangement should be viewed as the final one, susceptible only of a few slight modifications. This arrangement would be geographical as its basis—but each Nation would be instructed to arrange its productions in a given order—Machinery

would be placed at the entrance North side of the Building—and Raw Produce at the South side—Manufactures and Fine Arts would stand in the centre—and if packages were made parallel to the central avenue, and also at right angles to it, it would be possible to examine the Exhibition, both in each of its Four Sections separately, or in its geographical divisions. All Machinery in motion would have to be collected near the emotive power, and many articles of Fine Art, which, whilst they exhibited, would be made at the same time conducive to the decorations of the Building—such as stained glass, fountains, wall decorations &c.

In allotting spaces in the Building to the several Nations, the following principles have been regarded and are submitted for the consideration of the Commissioners.

The Transept being assumed to be the chief point of attraction, it has been thought desirable to place near the centre Nations to which only moderate allotments of space have been given. Nations having the largest allotments have been placed furthest from the centre, in order that the attractions of the Exhibition may be equally spread over the whole of the Building—and they have been placed on both the North and South sides, as well as in the positions of the Gallery over their respective allotments, because in case there should be any preference as to lighting, the superior advantages of the North would be the more equally distributed. By far the greatest amount of Machinery will be contributed by the United Kingdom, and therefore all its heavier Machinery has been placed near the source of the Steam Power.

It is proposed to place the lighter articles in the Galleries.—

George Prevost to Secretaries of Royal Commission concerning arrangements in Switzerland (18 October 1850; RC/H/1/5/2)

Sir,

The Government of Switzerland having at the request of the Swiss Commission sent me the following questions, I shall feel obliged if you will put me in a position to answer them.

1st Whether arrangements will be made at the Exhibition of 1851 to place cheeses in cellars or other rooms adapted to their preservation.

2nd Whether in case no such provision should be made, the proprietors will be allowed to withdraw their specimens the moment they may begin to show symptoms of deterioration.

3rd Whether it would not be possible to have the survey of cheeses completed during the two or three first minutes of the Exhibition.

<div align="center">

I remain

Sir

Your most obedient

George Prevost

</div>

The Gathering of All Vagabonds, *John Bull* (29 March 1851), p. 201

Under the auspices of Free Trade, such as they are, there is to be, within less than six weeks of this time, a gathering of all nations and languages in this mighty metropolis. The ancient precedent of Babel is to be revived, on a scale which was not so much as dreamed of in the plain of Shinar. We do not underrate the various and numerous evils, sanitary, social, moral, political,—to say nothing of the religious aspect of the affair,—which are certain to result from such a conflux of holiday folks of all nations, in the present unhinged condition of the English and the European mind.[7] To these, however, we must now resign ourselves. It is too late to countermand the show, however much reason even those with whom it originated, or from whom it received a too facile countenance, may see to regret that it was ever thought of. Nothing remains for us but to make the best of a bad bargain of our own seeking, and to do all that lies in our power to extract from the unpropitious assemblage of all nations that *modicum* of good, which, even though it be a *minimum*, is ever mingled with evil in this world of mixed existence.

But it does not follow, that we are not to use our best efforts to avert a collateral mischief and danger of the most serious character, which is totally distinct from the original design of the 'Exhibition,' and which has been adroitly engrafted upon it by the enemies of social order, of morality and religion, throughout Europe. We followed up previous warnings on this subject, last week, by calling attention to the fact that this country has within the last few months obtained probably the lion's share of upwards of ten thousand political adventurers who have been exported from Switzerland, their only asylum and resting-place on the Continent. Singularly enough the foreign intelligence received this week, contains among others the announcement, on what is *prima facie* good and competent authority, that the English Socialists have solicited from their brethren on the Continent a supply of some ten thousand '*hommes d'action*,' in plain English, political desperadoes, against the time when the Exhibition is to open—when in the crowd of foreigners, the *mauvais sujets* will be less observed, and when the congregation of immense masses in London will fully occupy the attention of the authorities, and afford ample opportunities for mischief. Some of our political adversaries will probably laugh at this, while others will attribute our anxiety to call attention to the danger, to mere spite against the Exhibition itself, which has never found much favour in our eyes. For this we are prepared. Nevertheless we shall do our duty, trusting that it may not be too late to impress the public mind and those in authority with a sense of that danger which, in spite of the jeers and jibes of the Free Traders, is unquestionably impending.

So far from there being any extravagance or improbability in the supposition that some such sinister design is on foot among the English and foreign Socialists, every moral probability is in favour of it. As regards the English Socialists and republicans, they are fully conscious of their inferiority to their Continental

brethren, in the art of rebellion. Their imbecility and impotence was sufficiently manifest on the memorable 10th of April, three years ago, when they did their best to imitate the mobs of Paris and Rome, of Berlin and Vienna, but found themselves miserably foiled.[8] They naturally, and not unreasonably, think that if the direction of a *coup de main* in London were taken by adepts in the science of barricades from the Continental cities, there would be a better chance of success. A sufficient number of foreign Red Republicans have long had their headquarters in Leicester-square, and lived in close intimacy with English Socialists, to have afforded an opportunity for acquiring the necessary local knowledge, and preparing the general outline of a revolutionary organization. As for the foreign vagabonds still abroad, whose importation into this country can, after all that has transpired, hardly be a matter of doubt, they have every inducement to fall in with such a plan. In the first place, they are desperate in character and purse, and always up to mischief. Compared with Continental cities, London must present to their eyes a glorious field for gratifying their appetites, and recruiting their finances; while the absence of an armed police, and of a large military force,—such as the armies of occupation by which peace is preserved in the capitals of the Continent,—must appear to them to hold out more than ordinary facilities for the accomplishment of their lawless designs. Add to this, that the example of a revolution in London, if it could be achieved, would infallibly set all Europe in a flame,—which is the very thing they have so long and eagerly coveted; and, moreover, that the semi-Liberal part enacted by our Foreign Secretary and his agents, during the convulsions of the Continent three years ago, and the subsequent abandonment of the cause of European revolution by *la perfide Albion*, has increased the hatred against England; England's Church and England's Aristocracy, which is rankling in the breasts of foreign democrats, whether infidels or Papists.

All these considerations put together may well convince the most incredulous that the danger to which we are pointing is not a visionary one. And if we can only arouse ourselves to a sense of it, that very fact will, if not put an end to the danger, at least effectually stop the mischief. In the first place, let the Alien Act, which has been so foolish and unseasonably suffered to expire, be revived; not for the purpose of inconveniencing our *bona fide* visitors, but for the purpose of empowering the Government to deal summarily with foreign rogues and vagabonds.[9] Let clauses be introduced into the Act which will enable the Metropolitan Police Commissioners to ascertain the numbers, quality, condition, and antecedents of all foreigners who come to London during the ensuing spring; and let heavy pecuniary penalties visit those who give housing-room to foreigners shall refuse to comply with the police regulations for obtaining and maintaining a census of that temporary portion of the population. Lastly, let all measures of self-defence be at once organized, as shall place at the disposal of Government, not only ordinary military and police force, but a special constabulary, armed,

not with truncheons, which will do well enough for an English mob, but with fire-arms and side-arms to meet the pistols and stilettos of foreign desperadoes. Above all, let the Horse Guards and the Ordnance so concert their measures, as to insure upon the first attempt at mischief, the wholesale annihilation of those who may feel disposed to convert a festive meeting into a scene of carnage. If there is to be bloodshed, by all means let our streets flow with the blood of foreign revolutionists and domestic traitors, rather than with that of honest citizens and of harmless visitors. If it should come to a conflict, let there be no trifling, no truncheons and blank cartridges, but a sufficiency of grape-shot to nip the gigantic mischief in the bud.

We appeal to Field Marshall the Duke of WELLINGTON. His Grace, we believe, is not blind to the danger; none knows better than he how to meet it by that terrible decision which on such emergencies is the truest humanity. He will not shed one drop of blood more than is necessary; but, let English and foreign Socialists rest assured, he will not shrink from doing just enough in that line to give a heavy blow and discouragement to their mischievous designs. Let Ministers put themselves, and the safety of the country, in to his Grace's hands. Let there be a power, if necessary, to proclaim martial law. Unused as we are to it, better that than barricades, arson, rapine, and other atrocities to which we are likewise unused, and with which a certain class of our proposed guests are but too familiar. If such precautions as these are not taken, and mischief ensue, woe be to the Ministry which shall, though forewarned, wantonly expose the metropolis of the British empire to the desperate machinations of the scum of foreign revolutionists.

[George Augustus Sala], The Foreign Invasion, *Household Words*, 4 (81) (11 October 1851), pp. 60–4

But the foreign question! The foreigners! *That* was the *cheval de bataille* of the prophetic brigade. The nasty, dirty, greasy, wicked, plundering, devastating, murdering, frog-eating, atheistical foreigners! Here was a subject for a Delphic 'pick' for a Sibylline 'tip.' National Guards marching on London! The Madonna of Rimini winking in Lamb's Conduit Street; General Haynau delivering lectures on military discipline to the young ladies' seminaries at Blackheath. The foreigners in London! The *grand Lor Maire de Londres* blacking the Czar Nicholas' jackboots, while a corps of Austrian Uhlans amused themselves with ball practice in Guildhall, with Gog and Magog for targets, and Mr. Daniel Whittle Harvey for setter up.[10] The foreigners in London! war, ruin, and desolation! Middlesex the *département de la Tamise*, and three regiments of Cossacks bivouacking at Price's Patent Candle Manufactory. Pestilence, of course; the plague, the yellow fever, the *vomito nero*, and the cholera morbus. The wicked Exhibition Building made useful as a lazaretto; and all the omnibuses turned into plague-carts. The foreigners

91

in London! England unchristianised; the Archbishop of Canterbury guillotined in Lambeth Walk; and Dr. Cumming sewed up in a sack with Cardinal Wiseman, the head Rabbi of the Portuguese Synagogue, and the Chief Elder of the Mormonites, or Latter-Day Saints, and cast into the Victoria Sewer. Atheism, pantheism, polytheism, deism, Mahommedanism, Buddhism, everywhere. England, of course, nowhere. The foreigners in London! Fire, famine, and slaughter; Popery, brass money, and wooden shoes!

[...]

Where are they? How has room been found for them, as well as for the huge body of provincials also sojourning in the metropolis? I myself (and the confession is humiliating, after my invective on the soothsayers) must admit having previously indulged, to some extent, in the prophetic line about these same foreigners. I predicted Regent Street blocked up, and Pall Mall rendered impassable. My friends and acquaintances, joining me, saw, *in futuro*, a crop of fezzes in the streets, rivalling the poppies in a wheat field. I and they babbled of the confusion of tongues—the polyglot dynasty of dialects—septentrional, meridional, oriental, and occidental, which were to reign in places of public resort. We heard a myriad of voices at Her Majesty's Theatre calling on Mr. Balfe for the '*Marseillaise*,' the 'Hymn of Pio Nono,' '*Was ist der Deutscher Vaterland*,' '*Viva la Constitucion*,' the Romaic war song, 'Tambourgi, Tambourgi,' and 'God save the Emperor Francis.'[11] 'Yes,' we said, 'we shall see them.' The mercurial Gaul, with beard unkempt, and *chapeau à la Robespierre*. The German, meerschaumed, kraut perfumed, and thumb-ringed. The Yankee, in his rocking chair at the window of Morley's hotel, walloping 'his own nigger' in the face of the Anti-Slavery Society, and bowiekniving the last British traveller who has published his impressions of America. The Mexican careering through Barbican, lassoing the cattle coming from 'Smiffel.' A council-fire of the Duckfoot Indians held in Covent Garden market, and '*La allah, il allah: resail allah!*' resounding through the no-longer deserted halls of the Arcade of Lowther. In our mind's eye, Horatio, we saw these things. Also, churches for all nations and all creeds, from fire-worshippers to Obeahmen. Also eating-houses, providing a curriculum of comestibles from stewed dog to potato salad. Also, taverns, where the Tartar might take his modicum of quass and mare's milk, and the water-carrier of Bagdad his fill of Raki.[12]

The Exhibition is now nearly over; but the actual state of affairs has not, I must further confess, quite come up to what I consider the mark. Thus, my friends and acquaintances have been apt, lately, to fall, what is nautically termed, 'foul' of me; reproaching *me* (and, doubtless, in private themselves) as regards the discrepancies existing between what I fancied would be, and what really *is*. 'Where are the fezzes?' they impetuously demand. 'We have seen but

three to-day. One, to our knowledge, belongs to an Egyptian youth, walking King's College Hospital, and who, if his father wasn't a negro, might certainly apply for a criminal information against his lips and shins for libel; while the other appertains to a commercial traveller in the dry-goods line, who has just returned from a three weeks' holiday in Paris.'

'Where is the Bedouin in his bernouse?—the Iberian in his sombrero?— where the fierce Suliote in his "snowy camise and shaggy capote?" Is not all this that you (and we) have predicted—"bosh"—and have you not laughed at our beards? I say, sir, that there are, and have been, comparatively, *no* foreigners in London.' To which I answer, that they have been, and are, here. 'Then, where are they?'

[...]

The fez is here. I know where to find the sombrero and the bernouse; and I can put my hand on the snowy camise and the shaggy capote. There are immense numbers of foreigners in London; but shall I tell you the truth about them, dear reader?—LONDON HAS SWALLOWED THEM ALL UP! This Moloch of a city—this great Dragon of Wantley—holds them all in her capacious maw, and would hold twice as many.[13] I never had such an idea of the immensity of London as now, knowing, as I do, how many foreigners there are in it; for when I had left off seeking them in the places I most expected to find them in, they started up by thousands in localities where I never had the least idea of seeing them. They beset me at public dinners. I came across them in hospitals and prisons. They beleaguered me in markets and shops. In the next pew of the chapel served by the minister I sit under, there were no less than eight Norwegians, who behaved themselves as decently throughout the service and sermon as though they had been Christians.

I dined at Greenwich. Young France sat beside me, gorged with white-bait, and steeped in brown bread and butter. A fez—two fezzes—three fezzes, were deep in some iced drink. I hope it wasn't cider cup. As I came out of the door I found Columbia smoking on the threshold: and at the railway station there was a collision between two Hidalgos, with blue blood at least in their veins, and a porter. Young France sang songs in the carriage to us, all the way to town; and I lost my heart irrevocably to young (female) Germany. I shook hands with old Belgium (grey-headed and silver snuff-boxed) on parting. I confess that he spoke much better English than I did French; and that he knew a great deal more about the Navigation Laws and the Cotton Manufacture than I shall ever do.

I went to the Derby; and the Grand Stand had quite an irruption of fezzes in it. Carriages-and-four passed me on the road full of foreigners; and, to say the truth, I myself lunched on what a French acquaintance called a '*cosh foreinan,*'—which was indeed an ancient mailcoach, with the letters painted over, laden with no less than

four-and-twenty male and female French people. On coming back, the Cock, at Sutton, offered a very good model, on a small scale, of the Tower of Babel; and I think I must have heard tea called for in at least twenty-two languages. They ought to have secured George Borrow, Elihu Burrit, or the Ghost of Pic de la Mirandole, as waiters.[14]

[…]

But I must make an end of it, as regards the foreigners, and as regards this paper too. My readers may not have been so curious as I have on the subject. They may have taken the large number of foreigners for granted, and thought no more about the matter. Others again, from a constitutional dislike to 'furriners' on principle, may have disdained to inquire, and would rather not know any thing about them. Yet even these, I think, must acknowledge that our foreign visitors have neither burnt our houses about our ears, nor endeavoured to overturn our government, nor run away with our daughters. They have behaved themselves peaceably and good-naturedly, and have borne with our little peculiarities amiably. Moreover, they have paid for what they have had, like honest men. May I be permitted to surmise, that from this mutual sight-seeing and metropolis-visiting, this interna-tional-fête-giving, and hand-shaking, some little, some trifling good may arise? Is it too wild a thought to hope that our children will not *quite believe* that the French necessarily eat frogs, and are all dancing-masters—that every Italian gentleman carries a stiletto in his bosom, and a bowl of poison in his left-hand pocket—that German babies are weaned on sauer-kraut—that revenge is the one inevitable passion with which all Spaniards are possessed—and that the unvarying fate of all Turkish ladies is to be sewn up in sacks, and cast into the Bosphorus? Is it really impossible that our grandchildren may discard those legends altogether? On the other hand, it strikes me that our continental neighbours will not henceforward be quite so decided as heretofore in their notions and impressions respecting us. I don't think we shall be called 'perfidious Albion' quite so frequently. I am of opinion that the editors of foreign newspapers will no longer declare that we live on raw beef-steaks, and occasionally eat the winners of our Derbies; that every nobleman takes his 'bouledogue' to court with him; that we are in the daily habit of selling our wives in Smithfield market; and that during the month of November three-fourths of the population of London commit suicide. Altogether, I think that a little peace, and a little good-will, and a little brotherhood among nations will result from the foreign invasion; and that it will in future be no longer a matter of course, that because fifty thousand Frenchmen in blue coats and red trousers meet fifty thousand Englishmen in blue trousers and red coats, they must all fall to, and cut or blow each other to atoms.

Report of Mr. Alexander Redgrave on the Visits of the Working Classes (9 December 1851; *First Report*, Appendix 24), p. 114

COUNTRY	Number of Arrivals	Population	Proportion of Arrivals to 10,000 In-habitants
Holland	2,952	3,128, 841	9.43
Belgium	3,796	4,335, 319	8.75
France...................................	27,236	35,400, 486	7.69
Germany.................................	10,440	15,813, 022	6.60
Switzerland...........................	734	2,113, 248	3.47
United States........................	5,048	23,138, 454	2.18
Spain and Portugal	1,744	15,699, 441	1.13
Norway, Sweden, and Denmark	648	6,650, 938	0.97
Prussia	1,489	16,171, 564	0.92
Italy (including Lombardy) ..	1,489	22,740, 344	0.65
Austria.................................	672	32,862, 770	0.20
Russia and Poland	854	60,362, 315	0.14
Turkey and Egypt.................	86		
Greece	94		
China....................................	8		
Not ascertained.....................	1,107		
Total.....................................	58,427		

3.3 The exotic exhibition

Exhibits within the Crystal Palace were separated into two sections – the west end of the nave housed domestic contributions, while the east contained all objects of foreign provenance. One of the obvious attractions of the Exhibition was the opportunity to see the exotic produce of distant lands in propinquity with British manufactures: this was to be a whistle stop tour of the globe. The result, however, was that certain objects, usually those most popular with the public, became, as Message and Johnston have argued, 'fundamentally illustrative' (2008: p. 46) of nations and even national character. The American section was, for example, dominated by large agricultural machinery that seemed to embody the pioneering spirit of the US, while the colonial produce from the Caribbean consisted almost exclusively of raw materials, the absence of manufactured articles indicating the unsophisticated nature of the people. The Dickinson Brothers' pictorial guide to the Exhibition (1854), compiled by Joseph Nash, Louis Haghe and David Roberts, reflected many of the inferences drawn about national character from the type and quality of a country's exhibits. While they praised the Indian contributions – even

though India was not an 'ontologically coherent entity' in 1851 (Daly, 2011: p. 4) – and lamented that 'The greater part of [these] articles were not suitable to European taste', their evaluation of the Chinese department was scathing. The Chinese were characteristically devious and crafty and, while the abundance of their silk put them at an advantage, their workmanship indicated a 'strange wildness which appears to be inherent to Chinese taste' (vol. 2). Rather than indicating cultivation, Chinese fabric 'bears witness to the sort of instinctive learning which the Chinese have for the most difficult and delicate manual labour' and they conclude 'we need envy nothing they have' (vol. 1). Their view is endorsed by the strikingly indifferent communication from the Chinese Commission, represented by Frederick Harvey, to the Emperor, of 22 June 1850: 'If such of the Chinese, as are skilled in the arts, be willing to trade in their works with your Excellency's nation, they are of course at liberty to do so' (RC/H/1/5/6).

According to the Dickinsons' guide, the Austrian section had 'one grand characteristic – a neatness of arrangement by general congruity in all the specimens exhibited' (vol. 1), and an imperial confidence (perhaps considered to echo that of Britain) indicated by its military statuary, such as the statue by Fernkera of Field Marshal Joseph Radetsky (subject of Strauss's famous march). The Turkish section, particularly the ornate carpets, resembled a bazaar in one of their great trading ports, suggesting a nation of shrewd commercial entrepreneurs. In contrast, it was more difficult to know what to make of Canada's offering, which appeared to combine evidence of English cultivation with the works of a more savage population represented by canoes and the trophies of big game.

It is an irony that it was the Indian Court, according to Burris, that was recognised most readily for its 'cultural exotica' (2001: p. 35), because its contributions actually came exclusively from the British trading East India Company. Indeed many of the exhibits weren't nearly as exotic as they appeared. The celebrated howdah – a spectacular caparison used for travel on the back of an elephant or camel – could only be displayed once a stuffed elephant of suitable size had been procured from a museum in Saffron Walden (Figure 9). Another exotic exhibit from closer to home was the legendary Koh-i-Noor diamond (translated as 'Mountain of Light'), which was valued by some at almost £2,000,000 and owned by Queen Victoria. The key to understanding the appeal of the Koh-i-Noor lay not just in its great value, but in its mysterious provenance and Tallis makes much of the 'Hindoo legend' of the precious stone. Objects with a history cultivated great interest at the Exhibition, but Tallis notably neglects to explore the ethics of the diamond's colonial appropriation from Lahore, in favour of his fantastic oriental narrative and the part played by Runjeet Singh in the history of the 'ill-gotten gem'. The Koh-i-Noor was perhaps the most eagerly anticipated object of all those

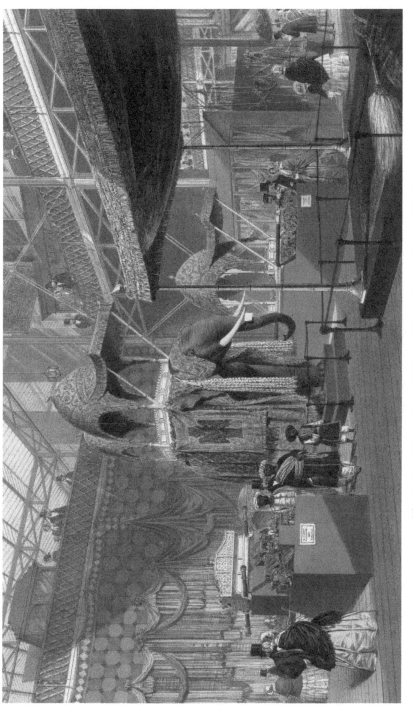

9 The Indian Gallery, from *Dickinsons' Comprehensive Pictures* (1854)

on show in the Crystal Palace and yet it was frequently to disappoint eager visitors. The stone itself was poorly cut and displayed, described by one viewer as 'like a bit of glass' and by Christopher Hobhouse as 'an ungainly lump of stone', as under 'ambient lighting the diamond did not sparkle' (1937: p. 102). As Cantor records, the Commissioners eventually placed it under two spotlights in a darkened chamber (2011: p. 118). Tallis concludes his account in briefly acknowledging some of the problems surrounding its display and the fate of the unfortunate Italian lapidary said to have cut the stone.

Tallis's History, vol. 1, p. 35

The Koh-i-Noor, then, our readers must be informed, is one of the most valuable diamonds that are known to exist in any part of the globe; two others only are supposed to be of greater value—the Russian sceptre-diamond, valued at the enormous sum of £4,800,000! and one belonging to Portugal, uncut, but supposed to be of still greater value. The Koh-i-Noor, however, has been long celebrated both in Asia and in Europe, and lays claim to our respect for its traditionary, as well as its historic fame. Hindoo legends trace its existence back some four or five thousand years, and mention is made of it in a very ancient heroic poem, called *Mahabarata*, a circumstance which gives us reason to suppose that it is the most ancient of precious stones that have come down to modern times. The poem states that it was discovered in the mines of the south of India, and that it was worn by Karna, the King of Anga, who was slain in the great Indian war, the date of which there is good evidence for believing to be in the year 3001 before Christ, consequently nearly five thousand years ago. A long silence then takes place on the subject of this jewel, which is not again mentioned in fable or in history till fifty-six years before Christ, when it was stated to have been the property of the Rajah of Nijayin, from whom it descended to the Rajahs of Malwa, and was possessed by them until the Mahommedans overthrew their principality, and swept away this priceless gem, and other spoils of immense value from the subjugated territory. The Mahommedans, in their turn, were obliged to bow their necks to their fierce invaders, for we find that in the beginning of the fourteenth century, they were constrained to yield up the territory they had won, the noble diamond and all their spoil, to the victorious armies of Ala-adin, the Sultan of Delhi, in whose dynasty the diamond remained for a lengthened period.

The modern history of this precious stone may be said to commence about two hundred years ago, when an eminent French traveller, skilled in diamond lore, visited India with the object of effecting purchases in those matters, and being favourably received at the court of Delhi, he was allowed to inspect the imperial jewels, and the account he gives of the one that surpassed all the rest in size and beauty, warrants the supposition that the diamond he describes was actually the great Koh-i-Noor. We next trace it to the possession of Baber, the Mogul emperor, through

the right of conquest, and eventually to that of the ruling family of Kabul. Nadir Shah, on his occupation of Delhi in 1739, seized upon all that the imperial treasury contained, and also compelled his poor vanquished foe, Mahommed Shah, who wore this precious gem in the front of his headdress, to exchange turbans with him, pretending to do so in testimony of his exceeding friendship and regard. It was at this period that it obtained the name of the Koh-i-Noor. After Nadir's death, it is generally believed that Ahmed Shah, the founder of the Abdali dynasty, prevailed on the young son of Nadir Shah to show him the diamond, and then kept possession of it, the youth having no means to enforce its restoration. The subsequent history of this diamond is free from all doubt and mystery; it descended to the successors of Ahmed Shah, and when Mr. Elphinstone was at Peshawur, he saw it on the arm of Shah Shoojee, surrounded with emeralds. The fortune of war drove the unhappy Shah to seek the hospitality of Runjeet Singh, who treacherously made him his captive, and partly through importunity, and partly through menace, in the year 1813, wrested from him his diamond, presenting the wronged monarch with a paltry sum in alleged consideration. So that after all, the gem has in it the greatest possible flaw, that of having been dishonestly obtained,—

> 'Asleep and naked as an Indian lay,
> An *honest* factor stole his gem away;'

and were we disposed to play the part of Cassandra on the occasion, we should venture to predict that the enjoyment of it would not be without its corresponding alloy. O! for those days of chivalry and honour, when the glittering bauble would be restored to its rightful owner, even at the expense of the paltry millions at which its worth might be estimated.

But to return to our history. The traitorous Runjeet, on the principle, we suppose, that 'stolen waters are sweet,' exhibited on all occasions, and with the greatest satisfaction, his ill-gotten gem, which he wore as an armlet on all state occasions. Death, however, who, as Sancho says, levels all distinctions, threatened him at last with the loss of his stolen jewel, and there were not wanting Hindoo jesuits about him, who endeavoured to persuade him that he might quiet his conscience by bequeathing it to the great Indian idol Juggernaut. The sick monarch appeared to be struck with the idea, but he was too far gone to articulate, and could only signify his assent by nodding his head. As, however, no other warranty could be produced in favour of the grim idol, the king's successors kept fast hold of what they had got. With the ordinary quick transition of property in these countries, the gem next became the property of Rhurreuk and Shu Sing; and after the murder of the latter, also a frequent occurrence among Indian princes, the jewel remained in the Lahore treasury, until the annexation of the Punjab by the British government, when the East India Company contrived to get possession of it, on the plea that it was right and proper to seize upon all the property of the state, in

part payment of the debt alleged to be due by the Lahore government, and also for the expenses of the war. It was then agreed that the Koh-i-Noor, being a state jewel, and not easily convertible into cash, should be presented to the Queen of England, which was accordingly done. Such is the history of this extraordinary jewel; but, besides these various acts of rapine and fraud, a more sanguinary deed, in cool blood, is connected with its history; for it is related that the Italian lapidary by whom it was cut, having performed his task in a manner unsatisfactory to his employer, he was forthwith ordered to immediate execution. True it is that the facets of this diamond are cut in a very unartist-like manner. The situation, too, in which it was placed, and the crimson cloth with which it was surrounded, were very unfavourable for a full display of its beauty and splendour.

3.4 Racial and cultural difference

There is a fine line between national pride and xenophobia. The fear of ethnic and cultural difference was rampant in Exhibition literature. As Paul Young puts it, 'In contradistinction to accounts of John Bull's ... friendly cosmopolitanism ... ran representation of foreigners informed by Victorian fascination, fear and loathing' (2008: p. 22). A clear dichotomy existed in the popular consciousness – exemplified in the conservative press – between civilised British values and the savage otherness of non-Christian cultures. Thomas Onwhyn's humorous sketchbook, *Mr. and Mrs. Brown's Visit to London to see the Great Exhibition of All Nations* (n.d. [1851]), was particularly vituperative and subtitled *How they were astonished at its wonders, inconvenienced by the crowds, and frightened out of their wits, by the foreigners.* In one notorious illustrated episode, Onwhyn depicts the Browns's cross-cultural encounter with a group from the 'Cannibal Islands' at an open-air restaurant. Their black skin, simian countenances, jewellery and headdresses are a stark contrast to the bonneted Mrs Brown and her party. One islander conceals a knife below the table and the caption reads: 'a party from the Cannibal Islands after eyeing little Johnny, in a mysterious manner, offer a price for him'.

It has become commonplace since the post-colonial work of Edward Said in the 1970s to consider cultural difference as being as much a matter of discourse as of actuality and the same goes for the Great Exhibition. For John Burris, 'The world of colonies and "savages" as displayed inside the Crystal Palace were not about those worlds themselves. They were about Western representations of those worlds' (2001: p. 47). And the way that otherness was perceived within the Crystal Palace extends to some of the oddest texts written about it. One of these is Henry Sutherland Edwards's *An Authentic Account of the Chinese Commission, which was sent to report on the Great Exhibition; wherein the opinion of China is shown as not corresponding at all with our own* (1851). The poem purports to represent the perspective of the Chinese on

British achievements, but largely shows the British attitude to the 'barbarous' Chinese. The plot is simple: the Chinese Emperor, aiming to better understand Western culture, sends two representatives to the Exhibition. The first, Congou, travels as punishment for killing four generations of his family; the second, Sing-Song, a philosopher and physician, chooses to avoid execution by accompanying Congou on his mission. The section of the poem quoted here is taken from the reports of the two men. Sing-Song's initial reverie is tempered by the Emperor's threats and he is eventually sentenced to death. Congou's dismissive report, on the other hand, sees him made a mandarin. The poem is here a comment on Chinese despotism; as Auerbach argues, the Chinese are represented as 'bloodthirsty and inhumane', 'They rehabilitate the murderer and hang the enlightened scientist' (1999: p. 177). Rather than condemn the British, the accounts of Sing-Song and Congou actually affirm their civilised outlook in comparison with the cruel and malevolent Chinese. Sing-Song cannot fail to be impressed by the advancements in rail travel, for example. And yet there is more direct criticism of Western values in the text than Auerbach admits; while Sing-Song's inability to appreciate the glass Palace is a sign of unrefined taste, Edwards registers several palpable hits on female vanity. He also pokes fun at imperialism – 'brazen Englishmen' who have stolen the Koh-i-Noor – and the contradictions of the juries who give the same medals to 'promoters of death' as to innovators in medicine.

The supposed distance between the civilised and the savage was queried more extensively by some observers, including William Whewell in his lecture 'The General Bearing of the Great Exhibition on the Progress of Art and Science', published on behalf of Prince Albert and the Society of Arts in the volume *Lectures on the Results of the Great Exhibition of 1851* (1852). Whewell considered that while some nations were labelled 'rude and savage', 'yet how much is there of ingenuity, of invention, of practical knowledge of the properties of branch and leaf, of vegetable texture and fibre, in the works of the rudest tribes!' He goes on to further narrow the gap between primitive and advanced craftsmanship: 'How much, again, of manual dexterity, acquired by long and persevering practice, and even so, not easy! And then, again, not only how well adapted are these works of art to the mere needs of life, but how much of neatness, of prettiness, even of beauty, do they often possess even when the work of savage hands!' (p. 16).

The coarseness and peculiarity of foreigners was not an accusation merely reserved for so-called 'barbarous' countries, of course, and the alleged poor hygiene of the French was ridiculed in *Punch*'s cartoon 'A Hint to the Commissioners' (Figure 10), where three swarthy Frenchmen stand baffled before a washbasin. Thackeray used a similar technique to Edwards in adopting the guise of a French visitor, M. Gobemouche, to the Exhibition in the final extract included here, wherein French arrogance is satirised and

A HINT TO THE COMMISSIONERS.

" Mon Dieu, Alphonse ! Regardez-donc. Comment appele-t-on cette Machine-là ? "
" Tiens, c'est drôle—mais je ne sais pas. "

10 'A Hint to the Commissioners', *Punch*, 26 April 1851, p. 185

the most notable occurrence is an encounter with the French celebrity chef, Alexis Soyer.

If, as in J. C. Whish's Prize Essay, the Exhibition was sometimes idealistically referred to as 'a kind of compensation for the Tower of Babel', and 'the means of promoting the brotherly union, the peace and prosperity of mankind!' (1851: p. 8), this section demonstrates that there were many who made creative mileage out of the clash of cultures and tongues.

Henry Sutherland Edwards, *An Authentic Account of the Chinese Commission, which was sent to report on the Great Exhibition,* **pp. 23–32**

REPORT BY THE MOST LEARNED SING-SONG MADE,
PHYSICIAN AND PHILOSOPHER BY TRADE.

'One morn the Crystal Palace gate
I entered most disconsolate,
And when I heard the organ's peal,
And watched the Crystal Fountain flowing,
And viewed the Koh-i-Noor so softly glowing,
While Sax's horns at one end they were blowing,
And steam-engines in other parts were going,
I felt in such a scene, there was no knowing
With which great wonder first to deal.
But slowly from surprise recovering,
I quickly set about discovering
What object among such a host
Seemed to attract attention most.
This was the diamond, which the poor
Benighted folks called Koh-i-Noor;
As if an Eastern language could
By them be ever understood!
And at this 'Koh-i-Noor' they'd stare,
 As round it all day long they'd hem,
And, need I say, of all things there
 That stone was literally the gem.
How strange, though, in a spot designed
For works of industry, to find
This diamond as chief object placed,—
That is, unless 't was made of paste!
But, No! 'T was from the East it came,
And now barbarians, without shame,
Boast of their theft; and feel a pride
In that which wiser men would hide.
Others might veil the crime, and that which shows it,
The brazen Englishmen themselves expose it!
In fact, the Englishmen seem friends to stealing,
And there was no attempt made at concealing
The admiration felt for a young man,
Who, it appeared, had hit upon a plan
For opening any sort of lock at will.
All to his touch appeared to yield, but, still
One happy lock, by Indian Bramah blessed,
Some charm against his instruments possessed
But still he opened it, though, people say,
'T was not till fourteen days had passed away.
And if to open it it took so long,

103

In opening it there could n't be much wrong;
Since men, whose locks a burglar tries to pick
For fourteen days, at last suspect the trick.
And, mighty sovereign, let me tell you now,
That all locks can be picked—if you know how.
And human hearts are locks, and you may see
How each one answers to a different key.
To open them at once, the only thing
Is first to find out, then to touch, the spring.
We meet with hearts so weak, that we may say,
A straw's enough to turn them either way.
Some old ones, clogged with rust, 'twere vain to try;
Some young ones yield directly to a sigh.
If nought will move the heart of some proud fair,
Apply the oil of flattery with care—
'T will open of itself! The key is known
Which acts on all hearts, even hearts of stone;
Of course, the Emperor scarcely need be told
The *passe partout* to all hearts is of gold.'

As Sing-Song paused an instant to take breath,
The Emperor threatened him with sudden death
If he indulged again in disquisition,
And quickly, thus, continued the Physician:—

 'Having spent in the sculpture department an hour,
I can speak very well of the Greek Slave by Power.
To the Yankees, perhaps, it presents this objection,
It's suggestive of rather a mournful reflection:
One thinks of the national absence of heart,
 When admiring the genius by Power displayed.
For, while he takes a slave as a subject for art,
 His country takes thousands as objects of trade.[15]
No doubt but the Emperor's observed it before,
But here I'll take leave to repeat it once more:
The American sculpture of course should be great;
For at chiseling the Yankees were always first-rate.

From the female barbarians, I hardly need mention,
The mirrors attracted a deal of attention.
Which I grieved for; since girls may be hurt by the glass,
As man, by the bottle, is oft made an ass.

104

What strange contradictions were seen in each place;
For instance, to go into one single case,
In her surgical instruments France had rewards,
While she also gained prizes for muskets and swords.
To promoters of death the same medals they give
As to those who enable sick mortals to live.

If the affair, we sum up it must be allowed
To be one of which England may justly be proud;
It's a barbarous land, but you find there much good,
Though the uses of opium are not understood.
Still e'en in that matter the next generation
Will doubtless improve, for a late calculation
Proves that myriads of children drink laudanum each day,
So the country is now in a promising way.
And I found they ate dogs, when I ventured to try
A thing which they sold as a mere mutton pie.

To speak candidly, England's becoming a nation,
And presents a few points worth our close imitation.
I think the barbarians have not a bad notion
Of what they affectedly call locomotion:
For instance, they've roads on which men have the power
Of travelling dozens of miles in one hour.
No doubt that the tales which they tell of the place
Have been much overstated in every case;
But I'm certain that engines of very great force,
Reach a speed which is greater than that of the horse.
They've a telegraph, too, which they skilfully use,
For transmitting in no time a great deal of news;
And, although it proceeds from a barbarous clime,
If you did introduce it, you perhaps would save time.'

'Enough!' said the Emperor, 'now Congou can tell
If he saw aught abroad which he liked half as well.'

THE REPORT OF OLD CONGOU, IN WHICH HE EXPLAINS
THAT THE ENGLISH ARE RATHER DEFICIENT IN BRAINS.

'My opinion,' said Congou, 'is quickly expressed;
You will soon hear which country I think is the best.
The organs and pianos, which made such a noise,

105

Compared with our tam-tams, are nothing but toys.
Excepting the objects from China, in short,
There was nothing worth naming in any report.
Their "palace" is built like a hot-house, I'm told,
Because they have summers so dreadfully cold.
Then the plan of the building is truly absurd—
This is not my opinion alone, for I've heard,
From natives of France, Italy, Germany, Spain,
That they could have made it as handsome again.
And, in England itself, the best men in the land
Say the whole is a scheme they can't understand.
There's Sibthorpe the Colonel, and Laurie the Knight,
Who opposed the concern from the choice of a site
To the very last day; and, e'en now, they declare
That a famine or plague may still end the affair.[16]
And then, when the building was opened, a blunder
Was committed, at which our great sovereign will wonder—
For when the barbarians saw their Queen pass,
As she went through the Park to the Palace of Glass,
They shouted and screamed in so noisy a way,
That in China a man who awoke the next day,
And discovered his shoulders still carried a head,
Would have sworn that all justice and law must be dead.
But then they've a Sovereign with such a faint heart,
That although there was uproar in every part—
Though the streets in all places with rabble were filled,
She sentenced not one of the lot to be killed.
The opening, in short, was as dull as could be;
There was no execution whatever to see;
There was no one impaled, and the use of the saw
Is not even mentioned in Englishmen's law;
And the last thing (whatever a miscreant might do)
Which they'd think of, would perhaps be to saw him in two.
The classes called upper, appeared not to know
That the nails of their fingers they ought to let grow.
'T is thus we Chinese tell the men who ne'er work
From the low-minded brutes, who from labour can't shirk
Yet, in England, they've classes which sneer at all trading,
While trade sneers at labour, and thinks it degrading.
And to show that the Englishman's only a fool,
He has not yet adopted our finger-nail rule!
They've however one merit—I'll praise them for that—

They've some turtle-fed Aldermen, wondrously fat;
But although they are fat, when you once leave the city,
The general thinness quite moves one to pity.
Altogether, this England showed nothing worth showing,
And the English know nothing at all that's worth knowing;
The best things in London, I saw all along,
Were some lanterns, and tam-tams, a junk, and a gong.
Wisdom ceases with us, and, howe'er they may try,
The barbarians will be but barbarians for aye!'

William Makepeace Thackeray, 'M. Gobemouche's Authentic Account of the Grand Exhibition', *Punch* (20 May 1851), p. 198

IN the good town of London, in the Squars, in the Coffees, in the Parks, in the society, at the billiards, there is but one conversation; it is of the Palace of Industry; it is of the Queen and Prince Albert; it is of the union of all nations. 'Have you been there, my friend?' everyone says to everyone.

Yes, I have been there. Yes, I am one of the myriads who visited the Palace of Industry on the first of May, and witnessed the triumph of France.

Early in the day, following in the track of the myriads who were rushing towards the romantic village of Kinsington, and through the Bridge of Chevaliers, I engaged a cabriolet of place, and bidding the driver conduct me to the Palace of all Nations at Kinsington, sate in profound reverie smoking my cigar, and thinking of France, until my driver paused, and the agglomeration of the multitude, and the appearance of the inevitable Poliseman of London, sufficiently informed us that we were at the entrance of the Industrial Palace.

Polisemen flank the left pillar of the gate surmounted by a vase, emblem of plenty; polisemen flank the right pillar decorated by a lion (this eternal Britannic lion, how his roars fatigue me; his tail does not frighten me; his eternal fanfaronnades regarding his courage makes me puff of to laugh!)—and as nothing is to be seen in England without undoing purse, a man at a wicket stops the influx of the curious, and the tide cannot pass the barrier except through the filter of a schilling.

O cursed schilling! He haunts me, that schilling. He pursues me everywhere. If a Frenchman has to produce his passport, there is no moment of the day when an Englishman must not produce his schilling. I paid that sum, and was with others admitted into the barrier, and to pass the outer wall of the Great Exhibition.

When one enters, the sight that at first presents itself has nothing of remarkable—a court, two pavilions on either side, a chateau, to the door of which you approach by steps of no particular height or grandeur, these were the simple arrangements which it appears that the Britannic genius has invented for the reception of all people of the globe.

107

I knock in the English fashion—the simple baronnet gives but one knock, the postman, officer of the Government, many and rapid strokes, the Lord Mayor knocks and rings. I am but the simple baronnet, and Sir Gobemouche wishes to be thought no more singular than Sir Brown or Sir Smith.

Two pages—blond children of Albion—their little coats, it being spring-time, covered with a multiplicity of buds—fling open the two beatings of the door, and I enter the little ante-hall.

I look up—above me is an azure dome like the vault ethereal, silver stars twinkle in its abysses, a left-hand lancing thunderbolt is above us—I read above, in characters resembling the lightning—'*Fille de L'orage*' in our own language, and 'Symbolium of all Nations' in English.

Is the daughter of the tempest then the symbol of all nations? Is the day's quiet the lull after yesterday's storm? Profound moralist, yes 'it is so' we enter into repose through the initiation of the hurricane—we pass over the breakers and are in the haven! This pretty moral conveyed in the French language, the world's language, as a prelude to the entertainment—this solemn antichamber to the Palace of the World, struck me as appropriate as sublime. With a beating heart I ascend further steps—I am in the world's vestibule.

What do I see around me? Another magnificent allegory. The cities of the world are giving each other the hand—the Tower of Pisa nods friendly to the Wall of China—the Pont Neuf and the Bridge of Sighs meet and mingle arches—Saint Paul, of London, is of accord with his brother Saint Peter, of Rome—and the Parthenon is united with the Luqsor Obelisk, joining its civilisation to the Egyptian mysteries, as the Greek philosophers travelled to Egypt of old;—a great idea this—greatly worked out, in an art purposely naive, in a design expressly confused.

From this vestibule I see a staircase ascending, emblazoned with the magic hieroglyphics, and strange allegoric images. In everything that the Briton does lurks a deep meaning—the vices of his nobility, the quarrels of his priests, the peculiarities of his authors, are here dramatised:—a Pope, a Cardinal appear among fantastic devils—the romancers of the day figure with their attributes—the statesmen of the three kingdoms with their various systems—fiends, dragons, monsters, curl and writhe through the multitudinous hieroglyphic [sic], and typify the fate that perhaps menaces the venomous enemies that empoison the country.

The chambers of this marvellous Palace are decorated in various styles, each dedicated to a nation. One room flames in crimson and yellow, surmounted by a vast golden sun, which you see, in regarding it, must be the chamber of the East. Another, decorated with stalactites and piled with looking-glass and eternal snow, at once suggests Kamschatka or the North Pole. In a third apartment, the Chinese dragons and lanterns display their fantastic blazons; while in a fourth, under a canopy of midnight stars, surrounded by waving palm-trees, we feel ourselves at once to be in a primeval forest of Brazil, or else in a scene of fairy—I know

not which;—the eye is dazzled, the brain is feverous, in beholding so much of wonders.

Faithful to their national economy, of what, think you, are the decorations of the Palace? 'Of calico!' Calico in the emblematic halls. Calico in the Pompadour boudoirs. Calico in the Chamber of the Sun—Calico everywhere. Indeed, whither have not the English pushed their cottons? their commerce? Calico has been the baleful cause of their foreign wars, their interior commotions. Calico has been the source of their wealth, of their present triumphant condition, perhaps of their future downfall! Well and deeply the decorators of the Palace meditated when they decorated its walls with this British manufacture.

Descending, as from a vessel's deck, we approach a fairy park, in which the works of art bud and bloom beside the lovely trees of Spring. What green pelouses are here! what waving poplars! what alleys shaded by the buds and blossoms of Spring! Here are *parterres* blooming with polyanthuses and coloured lamps; a fountain there where Numa might have wooed Egeria. Statues rise gleaming from the meadow; Apollo bends his bow; Dorothea washes her fair feet; Esmeralda sports with her kid. What know I? How select a beauty where all are beautiful? how specify a wonder where all is miracle?

In yon long and unadorned arbour, it has been arranged by the English (who never do anything without rosbif and half-and-half) that the nations of the world are to feast.[17] And that vast building situated on the eastern side of the pelouse, with battlemented walls and transparent roof, is the much-vaunted Palace of Crystal! Yes; the roof is of crystal, the dimensions are vast,—only the articles to be exhibited have not been unpacked yet; the walls of the Palace of Crystal are bare.

'That is the Baronial Hall of all Nations,' says a gentleman to me—a gentleman in a flowing robe and a singular cap, whom I had mistaken for a Chinese or an enchanter. 'The hall is not open yet, but it will be inaugurated by the grand Sanitary dinner. There will be half-crown dinners for the commonalty, five-shilling dinners for those of mediocre fortune, ten-shilling dinners for gentlemen of fashion like Monsieur. Monsieur, I have the honour to salute you.' And he passes on to greet another group.

I muse, I pause, I meditate. Where have I seen that face? Where noted that mien, that cap? Ah, I have it! In the books devoted to gastronomic regeneration, on the flasks of sauce called Relish. This is not the Crystal Palace that I see,—this is the rival wonder—yes, this is the Symposium of all Nations, and yonder man is Alexis Soyer![18]

GOBEMOUCHE.

3.5 The empire (&c.) writes back

The international reaction to, and assessment of, the Great Exhibition is one area that has recently been given lengthy treatment by Auerbach and Hoffenberg (2008). The logistics of transporting often extremely heavy exhibits over very long distances put many countries at a disadvantage in comparison to British manufacturers, and much of the space allotted to countries such as the United States and Russia was consequently empty on opening day. Goods continued to arrive throughout the first few weeks and the immense effort involved in ensuring the Exhibition opened on time is captured by Jules Janin in his regular column for *Journal des Débats* which provides a French perspective on the excitement surrounding the forthcoming opening. There is nothing jaundiced or ironic here: Janin is enthused by Paxton's glass house and, despite many of the French exhibits being still under wraps, he evinces a confidence that all will be ready by the following day. It is interesting to note that much of the imagery and rhetoric of the English press is also present here: the building is no Tower of Babel but a fairy palace; industry is deified; the preservation of the elm trees (Janin mistakenly calls them oaks) recorded; peace and international cooperation are emphasised. Indeed the whole article reads like an endorsement of Albert's vision.

Other nations, however, viewed the Exhibition in a different light to Albert. For the US, it was undoubtedly seen as a commercial opportunity rather than a platform for promoting peace. The letter from Edward Riddle, the US Commissioner, to the *Weekly North Carolina Standard* places emphasis squarely on the commercial possibilities for American manufacturers and he recounts a list of inventions set to supersede or improve European products and processes. In his published lecture of 1851 on the lessons that America could take from the Great Exhibition, Horace Greeley, prominent socialist and editor of the *New York Tribune*, strikes a less triumphant tone. Greeley acknowledged that the US was at a disadvantage due to its distance from 'the commercial centers of Western Europe' (p. 21), but had the benefit of huge natural resources. He argued that free trade, the dominant political ideology of the Commissioners, would keep the worker 'in vassalage and debt to the "merchant princes"' (p. 22). Greeley, echoing Marx, anticipated that the future effect of machinery would be to further disenfranchise workers and necessitate welfare reforms. He also takes the opportunity to redress some of the mockery visited on American exhibits such as the Virginia Reaper by the English press.

Jules Janin, *Journal des Débats* (2 May 1851), p. 2[19]

Around this fairy palace stretch the lawns of this enchanted Park and your gaze is drawn to great wonders. One enters and is met in this fairy land by an ancient

oak tree, contemporary of Queen Elizabeth, and a newer more dignified guardian is met at the portal of a great temple. Above this tree, where each branch has sheltered a fresh generation, falls light and greatness scarcely glimpsed. With a step you are in the middle of this glorious transept, similar to that of the Panthéon,[20] but with a roof losing itself in the highest skies, and the interior penetrated by, and sheltered from, daylight. From each side of this airy vault, to the right, the left, at your feet, at your head emerge zones, latitudes, spaces, deserts, sands and the oases of this chaos of machines, of undertakings, of miracles where, little by little, order comes to light. Industry, also, has taken this word 'order' as its starting point; in these gulfs, she has said with her supreme voice: 'let there be light' and light is there; in the convoys gathered from all parts of civilisation is established a rule, a disposition, a single law, a gathering so perfect you would have said they were different parts of a great poem hatched in the mind of a single man. A great work. The work advances with giant strides. You have seen, in the tepid rain of March, the bare tree covered from one day to the next in unfurling leaves; one says that you can actually see the greenery growing. Well, at the Crystal Palace, one sees from its great walls, at the angle of each avenue, a harvest of beautiful works, concealed by the cloth and paper of the packers. One would say 'done' with the wave of a wand — above all in the French quarter. An empty square a little earlier, pass by an instant later, you meet — France. She has waited until the last moment, as usual, before going ahead.

At present nothing is ready, however nobody is bothered, such is the feeling we will be ready tomorrow. It is our strength. And this our motto 'Always ready.' The most advanced section at the moment is the American: it is complete to a large extent and well established. Order rules. It can be said some goods are lacking. They have sent a great number of wigs and felt hats; among other hats happens to be Genin, the hatter, celebrated throughout the world for having bought at the highest price possible, the first ticket to Jenny Lind's first concert!![21] There is glory and a great name. A great name for 1,200 francs. There is pleasure.

I am not going to talk about the English exhibits: they are formidable, represented by a mass of machinery in place. There are printing presses providing 7,000 examples an hour, and one is astounded at consequences for the future; a novelty worthy of interest is that all the stationery machines work at the first signal! These powers are placed on a floor below this circular platform of these unmoving wheels, and the same breath would bring them to life — it is the name of each nation written in its own language. Germany and Spain have used an alphabet correct for them. One can read in beautiful Greek letters the inscriptions of Athenian craftsmen. The traders of Athens. Gods and Goddesses. Athens has sent fabric and scarves to the same place where languish under a sky of clouds the imperishable marbles of the Parthenon. Who would have said that of the homeland of Homer and Phidias.

Not far from the Greek exhibit is the art of the Turk. He is, in effect, an artist. He speaks with his eyes. He seeks above all sparkle and richness: he leaves the useful to England and grace to France. He believes in embroidery, in the crimson,

in diamonds and pearls! He would give all the coral in England for that famous diamond — the Koh-i-noor, the Mountain of Light! I have seen this good-natured Turk, sitting sadly in his little compound of amber, musk and carpet, eyes half closed in an attitude of resignation. Without doubt he is wondering why he is among infidels, Christians, Protestants, Jews, idolaters, renegades, new prophets, old prophets of each people! What good will it do him in this competition. He doesn't want conflict. What good will all these machines and inventions do him? He doesn't want any of it: he leaves us to our jobs, our hammers and anvils and the needs which represent all these labours. What good is all this steam? He has the sun. The wine. Opium. Newspaper. He has his dream! Poetry! He has his tobacco!

But this worthy man has, at this moment of eternal celebration, sacrificed his life and beliefs. Labels and rules have taken from his hand his elegant artefact with its scented steam, his sign of hospitality and friendship, his pipe. 'No smoking here': such is the law of this gathering of industrial humanity. And so that no nation should avoid this message — it is written in all languages 'On ne fume pas ici', 'No smoking allowed', 'Non e permitto de fumare' and so on — and the poor Turk is forced to obey. God wishes it! The English wish it! If the exhibition of industry has its martyrs — there is one of them.

This Crystal Palace has been carried here, carried is the word, and each part adjusted to its neighbour by a man of genius, gardener of the Duke of Devonshire, named Paxton. Mr Paxton has spent part of his life among the most rare and delicate flowers of the world: the experience has taught him the great art of placing into exquisite light these frail masterpieces of the good Lord. He was using sun and shade, turn and turn about, in the garden; and he understands the all-powerful influence of a beautiful day upon tropical plants. When the noise of the Exhibition began to fill England the great obstacle to resolve was: where to find a convenient site? and what structure to give to this chosen site once found? who and how to construct it? and what materials to choose — plaster and wood, brick and stone? and if we find in our way several old trees, the pride of our park and witnesses to years gone by, what will we do with these ancient trees? So many questions, so many problems. In vain an open competition couldn't find the answers — palaces for the good of all, eternal edifices, works from the highest schools of architecture? they hadn't found an ephemeral monument, walls light and diaphanous, clear roof, the opposite of Gothe's song 'Do you know the country where the orange tree flowers?'[22] Briefly, one couldn't construct what couldn't be constructed: alone, perhaps, among rivals our compatriot, M. Horeau, inventive and passionate spirit, had approached the will and inspiration of the brief, but, unfortunately, it was the only brief he did not want.

In these difficult circumstances and problems Mr Paxton was struck by the demands of the project and how to overturn the problems. It isn't a great house/edifice needed here said Paxton, it's a greenhouse. We will carry my greenhouse to the most beautiful part of Hyde Park, and the oaks will be respected and treated

like flowers. All will be iron or glass, and my iron will come ready forged and my glass ready to be installed; my great work will be put up in this happy place and will prove itself to be brilliant, airy and protected by its beautiful exterior. Immediately our man stood with his project, and indicated, in a rapid and lively manner his hopes and wishes. And the next day following this famous day, 14th June, one saw Mr Paxton arrive carrying in his head and on a piece of paper all of this palace, destined one day to contain 100,000 intelligent heads in this structure: and such is the force of truth, so grand the splendour of right, 'splendour veri', that as soon as it was shown, the project was adopted with calm transport which is only apparent in great nations equally capable of understanding great works, and worthy of accomplishing them.

I would try in vain to describe the noise, the tumult, the cries, the attention, the activity, the zeal. Unlike the tower of Babel, no rivalries between the different nations and each one, on the contrary, helping to the best of his ability. All day the building is open to visitors and the curious, mixing with the workers, not disturbing anything or anyone; the soldiers of engineering, the only ones admitted to this peaceful place are occupied in sorting out all the fools who arrive in such haste. One nails down, one removes nails, one deploys, one adjusts, one tightens, one paints, one rubs, one polishes, one writes out labels and one rushes about. At the transept, the most beautiful place, between two oaks, is a large area of rhododendrons and new roses, and here is raised the throne to her majesty the queen. From each side of the throne a jet of water gushes and falls again into a marble pool; a range of statues set in procession in the avenue, a tiered amphitheatre covered in velvet await the spectators of this festival which will signal the month of May: such a joyful month in England. One loves May here as we love the beauty of the spirits and of youth who we have never seen but smile on us down the distant centuries: Aglaé, the youngest of the Graces, Lais, Lastherie, Tyndoride the graces of Spring that the poet Horace was watching dance under the gentle light of the May moon, and the poet Thackeray mentions in 'The Times' today: 'Gratia cum Nymphis, geminisque sororibus, auder Ducere nuda choros'.[23]

Tomorrow the Queen arrives, ever popular, and other marvels with all the brilliance of the throne and all the majesties with secular crowns. She will come, and we will hear ring out the glorious hymn that happy nations address to the sons of gods, as states La Bruyère. Yesterday, the Queen came incognito: and without other device, another queen came to the Exhibition, queen of the great French people who adore her and who, however, have let her go, she and the King, her spouse, and her children, and children's children. O august majesty! She stayed, and she will be our queen to the end! Each one saluted her passage. All foreheads inclined in front of this benevolent majesty, the superhuman courage. One has to say, however, in the crowd one or two voices coarsened by gin wished to murmur several verse of *La Marseillaise*! Indignation silenced them and the crowd's contempt was punishment.

Yesterday also some miserable émigrés, who have abandoned their homeland and search out their bread in other lands, came to the gates of the Exhibition; the gates opened and these old people, these children, the destitute — these ragged people and rootless youths — would have been less able to glimpse, before leaving their birthplace, this pile of marvels that, not one of us, living in this exhausted century will ever see again.

Was this benevolence, was this cruelty, in showing these unfortunates the astounding spectacle of so many grandeurs, at the same instant they have come to mutter, on the banks of some unknown Euphrates, the plaintive elegy where the heart bleeds, where eyes fill with tears, because one remembers Zion.

Such is the first impression which the spectacle of the great things had produced for me: I am writing about them as I always inform my readers who trust me, because if they have often found me failing in accuracy, they have always found me truthful and sincere.

Tomorrow I shall attend the 'investiture' of the industry and I will tell you about it.

The American Contributions to the Great Exhibition, *Weekly North Carolina Standard* (5 November 1851), p. 2

A letter from Mr. Riddle, U. S. Commissioner at the great Exhibition, dated London, October 26, gives the following interesting statement of the estimate of value placed upon the contributions from the United States, by the people of the Old World:

'Our cotton gins will be introduced into two countries of Asia, two of Europe, and one of Africa. Our means of cleaning the long staple cotton of the sea islands will be introduced into Egypt. Grain reaping by machinery will become in a few years universal in every country in Europe. Our saving machines will supersede hand labor in many branches in England, France, and Belgium. Our new method of lapping cotton is within the last month introduced from the Exhibition into the mills of Lyons. Our candle mould machines will cause the old process to be entirely superceded. The Anglesea leg, known and used over the world for twenty-five years, according to the acknowledgement of every eminent surgeon of England and the Continent who has examined it, must now give place to the infinitely superior mechanism of Palmer's patent limb. The revolving pistols of Colt, a contraband article in England, and incapable of being sold here, have, by order of the Lords of the Treasury, been furnished to every officer who has recently gone to the Caffra war.[24] The gun primer of Maynard, the most efficient and practical improvement upon the musket and carbine yet invented, rendering the same body of men more than twice as powerful in action as before, though here less than a week, is already exciting much attention from officers connected with the ordnance. The mineral paint of Houston, of Virginia, will supplant white lead

114

for many purposes where it has hitherto been used. In fact, there are few articles which we have sent here which have not brought with them a new or improved idea. To say nothing of the endless purposes for which we are using caoutchouc and gutta percha[25]—subjects of constant surprise to visitors—the wood planing, tonguing and grooving machine of Woodworth, the centrifugal pump of Gwynne, the stone dressing machine of Moray, the presses of Dick, the fire safe of Herring, the lathe and loom from Lowell, the bell telegraph of Brooks, the piana-fortes of Chickering and Hewes, the rail wheels of Shattuck, the surpassingly accurate measuring instruments of Professor Bache, and the new motive power of Ericson, are all destined either to be brought into immediate use on this side of the ocean or to suggest in arts and manufactures ideas of great practical utility.

These are but samples of what we have brought, and which are now beginning to be appreciated. I might specify many others equally important, and as practically useful. But I mention these to confirm what I say, that I can find in no department in this great Exhibition, either in number, importance, or degree, and comparison in labor-saving, ingenious and perfect machinery, in useful invention, or in new principle, among all that each exhibits, with that which is exhibited by our contributors.'

Horace Greeley, *The Crystal Palace and its Lessons*, pp. 8–10

[W]e will enter one of the three or four doors at the east end, and find ourselves at once in the excessive space devoted to contributions from the United States, and which thence seems sparsely filled. Before us are large collections of Lake Superior Native Copper, as it was torn from the rock, in pieces from the size of a bean up to one slab of more than a ton, though still but a wart beside some masses which have been wrenched from the earth's bosom, cut into manageable pieces of two or three tons, and thus dispatched to the smelting furnace and a market. New Jersey Zinc, from the ore to the powder, the paint, the solid metal, is creditably represented; and there are specimens of Adirondack Iron and Steel from Northern New-York which attract and reward attention. Passing these and various cabinets or solitary specimens of the Minerals of Maryland and other States, we are confronted by abundant bales of Cotton, barrels of Wheat and of Flour, casks of Rice, &c.; while various clusters of ears of our yellow and white Indian Corn remind the English of one valued staple which our climate abundantly vouchsafes and theirs habitually denies. The 'Bay State' Shawls of Lawrence, the Axes of Maine, the Flint Glass of Brooklyn, the Daguerreotypes of New-York and Philadelphia, (whose excellence was acknowledged from the first by nearly every critic,) next salute us; and near them are the specimens of various Yankee Locks, and in their midst the invincible Hobbs, a small, young, shrewd, quiet-seeming Yankee, but evidently distinguished for penetration, who would have made fewer enemies in England had he proved less potent a master of his calling.[26]

And now we are at the Grand Aisle, across which is the U. S. Commissioner's office, with that much ridiculed 'pasteboard eagle' displayed along its front, and certainly looking as if its appetite would overtax any ordinary powers of digestion. In front of the office are Yankee Stoves, Safes, Light Waggons, and Carriages, Plows and other agricultural implements, including the since famous 'Virginia Reaper,' which was for months a butt of British journalistic waggery, having been described by one Reporter as 'a cross between an Astley's chariot, a flying machine, and a treadmill.' They spoke of it far more respectfully after it had been set to work, with memorable results; and it must in fairness be confessed that beauty is not its best point, and that, while nothing is more effective in a grain-field, many things would be more comely in a drawing-room.

But let us return to the main aisle, and, starting at its eastern end, proceed westward.

A model Railroad Bridge of wood and iron fills a very large space at the outset, and is not deemed by British critics a brilliant specimen of Yankee invention. (One of them, however, at length candidly confessed that its capacity of endurance and of resistance must be very great, or the weight of ridicule heaped upon it must inevitably have broken it down long before.) Upon it is a handsome show of India Rubber fabrics by Goodyear; while beyond it, toward the west, in a chosen locality in the center of the aisle, stands 'the Greek Slave' of Powers, one of the sweetest and most popular achievements of the modern chisel, here constantly surrounded by a swarm of admirers; yet I think it not the best of Powers's works—I am half inclined to say, not *among* his best. He has several stronger heads, possessing far more character, in his studio in Florence; and yet I was glad this statue was in the Exhibition, for it enabled the critics of the London press to say some really smart things about Greek and American slaves, and the Slave as a representative and masterpiece of American artistic achievement, which that heavy metropolis could not well have spared. Let us not grudge them a grin, even at our expense; for mirth promotes digestion, and the hit in this instance is certainly a fair one. 'The Dying Indian,' just beside the slave, by a younger and less famous American artist, is a work of power and merit, though the delineation of agony and approaching death can hardly be rendered pleasing. Is it not remarkable that a chained and chattelized woman, and a wounded, dying Indian, should be the subjects chosen by American sculptors for their two works whereby we shall be most widely known in connection with this Exhibition?

Notes

1 Both Scottish and Irish exhibitors were, however, very keen to show that their products offered local expertise which was not English (see Louise Purbrick's 2008 discussion of Irish exhibitors).
2 See Wallerstein (1974).

3 For an American response, see the extract from Horace Greeley's *The Crystal Palace and its Lessons* (1851) at 3.5.

4 Richard James Wyatt was an English sculptor working in Rome. He died in 1850, but his work won numerous medals at the Exhibition.

5 Fears of popery were increased by the recent reestablishment of the Catholic Hierarchy in Britain in September 1850.

6 For Wellington's part, his letter to Lord John Russell of 2 April 1851 demonstrates that he took the matter seriously (Wellington Papers 2/168, pp. 82–4).

7 Revolution had spread across Europe in 1848, particularly in France where Louis Philippe was deposed and the Second Republic founded. In London, Chartist insurrection had been suppressed but was still considered a radical threat to democracy.

8 See note 7.

9 The Aliens Act of 1793 regulated immigration, particularly from France, following the Revolution, whereby immigrants were required to register with a local justice of the peace. It lapsed in 1826. The Aliens Act of 1848 expired without ever being invoked (Shaw, 2015: p. 4).

10 Julius von Haynau was an Austrian general who aggressively suppressed radicals in Italy and Hungary during the insurrections of 1848; Harvey founded the *Sunday Times* in 1821 and, in 1839, became the chief regulator of taxis in London, presumably explaining his inclusion here.

11 Michael William Balfe was an Irish composer who directed opera at Her Majesty's Theatre on Haymarket.

12 Raki is a spirituous liquor flavoured with aniseed.

13 'The Dragon of Wantley' was a tale included in Thomas Percy's influential collection of tales *Reliques of Ancient Poetry* (1767). The dragon swallowed a church and picked its teeth with the steeple.

14 Borrow was renowned for his European travelogues; Burritt wrote about the Irish peasantry; Giovanni Pico della Mirandola was a Neoplatonist of the Italian Renaissance.

15 For discussion of the *Greek Slave* by the American sculptor Hiram Powers see Figure 8 and section 3.1.

16 MP for Lincoln, Colonel Charles Sibthorp was one of the most vocal opponents of the Exhibition and spoke regularly on the subject in the Commons. Sir Peter Laurie, who had been Lord Mayor of London in 1832, was governor of the Union Bank.

17 Half and Half was a mixture of two malt liquors, most usually ale and porter.

18 The French Soyer was the most famous chef in Victorian London. His 'Universal Symposium of All Nations' was opened opposite the Queens Gate of Hyde Park in 1851.

19 Free translation of this article by John Shears.

20 Not the Roman Pantheon, but the cathedral in Paris, built to St Genevieve which was modelled in the same style. It is now a secular mausoleum.

21 John Nicholas Genin famously paid \$225 in auction for the first ticket to see Jenny Lind, the Swedish Nightingale, on her tour of America in 1850.

22 The allusion is to a song in Goethe's *Wilhelm Meister's Apprenticeship* (1795–96). In 1866 it was adapted into a popular aria by Ambrose Thomas.

23 'The naked Grace with the Nymphs and her twin sisters dare to lead the crowds'.

24 The Eighth Xhosa War (1850–53) in South Africa.

25 Gutta percha is a natural latex that was used as an insulating material in the nineteenth century before the advent of vulcanisation. Caoutchouc is a French word for natural or India rubber.

26 The American locks intrigued many visitors. Alfred Hobbs was a well-known American locksmith. At the Great Exhibition, he famously picked the locks of Chubb and Bramah, which forced British manufacturers to reconsider their designs.

4

Gender

In Chapter 1 we saw that the Exhibition was often presented as a triumph for what Auerbach (1999) has termed 'sophisticated organisation' and a group of 'capable men'. This was part of a careful strategy designed to reassure the press and public. The physical arrangement of objects within the Crystal Palace, however, could not match the theoretical system. The mismatch between design and realisation suggests to Isobel Armstrong that 'an anxiety of taxonomy is evident throughout Exhibition rhetorics, acknowledging that it could not be a monologic event' (2008: p. 192). As we saw in the Introduction, Eileen Gillooly goes further than this and argues that it is the breakdown of such organisational tropes that is responsible for the generation of other categories that readers have constructed and used to map the spaces of the Exhibition (2007: p. 25). Having explored display and empire, the next category in this list is gender.

One of the challenges in opening up discussion of gender in relation to the configuration of public spaces has been to move attention away from physical construction and design, to the ongoing process of making and experience: an area that involves not just a few 'capable men' but 'an engagement with the anonymous and, to some extent unknowable woman: the factory worker, the shop clerk, the housewife' (Darling and Whitworth, 2007: p. 2). Paxton may have designed the Palace, and Samuel Peto's money enabled its construction, but the semantics of the Exhibition are as much female as they are male.

As we will see in this section, the presence of women at the Exhibition raised several issues. For the organisers, safety and security were paramount, not least due to the presence of Queen Victoria at the opening ceremony. Women equalled risk: respectable ladies attending the Exhibition might be forced to physically rub shoulders with the East End poor or even high class prostitutes. Exhibits tailored specifically to female consumers also raised the prospect of overcrowding, fainting and hysteria. Displays of lace, silk, embroidery and jewellery could raise female desire (articles representing domestic interiors and the role of the housewife were more functionally laid out). Women also faced the prospect of being objectified, particularly in the

119

open space of the nave. In *Victorian Glassworlds*, Armstrong records a frustrated romantic liaison in 'The Looking-Glass Department' where the 'erotics of multiple reflection' cause the disorientation a woman feels on seeing herself blush from many angles. The threat of being 'seen' was exacerbated, Armstrong argues, by the 'dominant red in the decoration' of the interior, suggesting 'the play of desire on the surface of the building' (2008: p. 100).[1]

The feminising of the Exhibition was not only a matter of physical display but also an issue of textuality. As Erika Diane Rappaport has argued, the emergent Victorian consumer culture situated in the West End of London demonstrated that 'public space and gender identities were, in essence, produced together', and that a careful balance was required between stimulating and constraining female 'pleasures' (2001: p. 5). This is evident in the reporting on the Exhibition, some of which targetted a specifically female readership. As section 4.4 demonstrates, both the *Illustrated London News* and the *Lady's Newspaper* ran regular features, written by ladies for the edification of ladies, that could be trusted to offer suitable advice on the best exhibits to visit. Other publications, such as *Punch*, showed less interest in governing female taste, and more in satirising the kind of advice offered to women visitors, or finding comedy in the popular press's anxieties about the 'mixing' of the sexes (see 4.5).

Another way that gender was implicated in the portrayal of the Exhibition in the popular press did not actually involve feminisation at all. Rather, the appropriateness of a masculine rhetoric of ambition and achievement became, for a time, the focus of dissenting voices such as those of the London Peace Society who objected to the glamorisation of weapons of war. An anxiety was felt that the display of military exhibits would undermine the message of peace and international unity, something which dominated the meeting at the Mansion House on 25 January 1850, when the subscription lists were opened. It is with this subject that our material on the subject of gender begins.

4.1 A triumph for man?

Auerbach notes that 'The overarching tenor of the Great Exhibition was pacifist internationalism' (1999: p. 161), while G. M. Young has described it as a 'pageant of domestic peace' (1936: p. 69). James Ward linked egalitarian politics with technological development in *The World and its Workshops* (1851), arguing that the machinery on display exhibited 'The epitome of man's industrial progress – of his untiring efforts to release himself from material bondage' (p. 1). The emphasis on brotherhood and fraternity in such reflections is one that subscribes partly to the liberal politics of Cole and the Commissioners. Cole played the key role not only in organisation but also, as Louise Purbrick reminds us, in reflecting on the extraordinary success of the

Great Exhibition as a symbol for peace and international unity (2001: p. 8). While the Tory protectionists and press strongly opposed the notion that 'free trade would foster peace' (Auerbach, 1999: p. 162), Cole shared the *laissez-faire* beliefs of Lord John Russell's Liberal administration.

Despite placing such an emphasis on goodwill and friendship, however, the manner in which the Exhibition was reported in the daily press and guide-books often reveals a tension that dates back to the competitive origins of the Exhibition (see Chapter 1). In the case of Tallis's *History and Description of the Crystal Palace* (1851–52), the celebratory tone is one that partakes of a rhetoric of rivalry and opposition, often indicative of machismo, and even at times, war-mongering (see 3.1). Tallis was a London cartographer, and he put together this most significant of the unofficial guidebooks to the Exhibition in a lavish three-volume edition, containing engravings of 'scenes' from the Palace, statuary, metalwork, machinery, embroidery, weaponry and many other exhibits, published by his own company. The document gives an exhaustively detailed account and appraisal of exhibits, delivered through anecdotes and short narrative chapters. The patriotic edge is observable on occasions, such as in the defence of the Staffordshire potters who lacked the state patronage of their French and German competitors (3, pp. 150ff), and the introduction of the correspondence of the 'naïve' Frenchman Monsieur John Lemoinne (3, pp. 146–50 and pp. 157–62).

The extract chosen in this section derives from a letter written by a Quaker to the *Art-Journal* in June 1850 and is indicative of the particular concerns and debate that arose amongst radical groups over the ostentatious display, and glamorisation, of weaponry. Geoffrey Cantor tells us that in 1850 the London Peace Society pressurised Prince Albert to 'ban all instruments of war from the Exhibition' and they were supported by religious publications such as the *Nonconformist* and the *British Friend*. The pacifists' views went largely unheard and the Exhibition resembled, according to Cantor, 'a well-stocked armoury' which included 'a whole class – Class VIII, "Naval Architecture, Military Engineering, Guns, Weapons, etc." – that included numerous swords, sabres, rifles, pistols, double-barrelled guns, air rifles, and even a waterproof gun' (2011: pp. 181–2). The *Art-Journal* correspondent, invoking the speech that Prince Albert gave at the Mansion House on 25 January, represents the voice of many who warned of the dangers of celebrating military aggression and achievement.

M. C. J., The Great Exhibition—Weapons of Warfare, *Art-Journal*, (June 1850), p. 192

RESPECTED FRIEND,[2] — Wouldst thou kindly spare me the needful space for a practical hint to those who will have the arrangement of the great Exposition?

From one end of the kingdom to the other — and, I doubt not, throughout the whole civilised world, this vast 'Exhibition of the Industry of all Nations' has been welcomed as a real international boon. In fact, all parties — prince, peer, prelate, and peasant — point to this industrial jubilee as a great 'practical Peace Congress.' They hail it as calculated to animate the visitors with more friendly feelings towards each other, and thus promote, in a collateral but most effectual manner, the brotherhood of nations — as bringing together into harmonious concord the various nations of the world, and withdrawing the attention from that feeling of international jealousy which leads to sanguinary wars — as a means of promoting that intercommunication of knowledge which will increase our respective powers of adding to the comfort of our fellow-creatures — as a plan of industrial and inventive competition which may, at least for a time, engage all nations to abandon the struggle of warfare for peaceful and civilising emulation in the works of industry and art. And I think I am safe in assuming that the *art* of war is less accordant with the 'end and aim' of the *Art-Journal* than is the *art* of peace.

But it is not needful, by further extracts, to show that the elements of international discord have 'neither part nor lot in this matter,' and are to hold no place in this amicable exhibition of amicable international rivalry. I must, however, make two brief quotations from the admirable speech of the Prince Albert at the Mansion House. A contemporary journal, referring to this, and the various speeches throughout the country, has well observed:— 'Many of them are such decidedly peace-speeches, that they might have been delivered at the Annual Meeting of the Peace Society, bating an occasional sarcasm, which the orators think it decorous and genteel to drop in passing upon the principles and labours of that institution. No such sneering allusions, however, fell from the lips of Prince Albert, in the beautiful speech which he delivered at the Mansion House, at the dinner recently given by the first magistrate of the City of London to the mayors of the principal towns in the United Kingdom.' The Prince observes:— 'Nobody who has paid any attention to the particular features of our present era, will doubt for a moment that we are living at a period of most wonderful transition, which tends rapidly to accomplish the great end to which indeed all history points — *the realisation of the unity of mankind;* not a unity which breaks down the limits, and levels the peculiar characteristics, of the different nations of the earth, but rather a unity the result and product of those very national varieties and antagonistic qualities.' And again — 'I confidently hope that the first impression which the view of this vast collection will produce upon the spectator will be that of deep thankfulness to the Almighty for the blessings which He has bestowed upon us already here below; and the second, the conviction that they can only be realised in proportion to the help which we are prepared to render to each other; therefore, only by peace, love, and ready assistance, not only between individuals, but between the nations of the earth.'

It will, doubtless, be universally admitted, that in a temple expressly dedicated to the demon of discord, the sword and the tomahawk, the spear, the musket,

and the bayonet, bombshells, cannons, and scalping-knives, would hold a meet companionship. The presiding genius of the temple would shed over them 'his selectest influence.' And, were the 'end and aim' of this coming exhibition, not the unity, but the *disunity* of mankind, the admission of implements of war would be specially appropriate. Now, to some minds (would that they were more in number!) it is equally apparent that in an exhibition, the design of which is peace, and amity, and unity of nations, the admission of weapons of war would be singularly inappropriate; as incongruous as, in the supposititious *Disunity* Exhibition, would be the display of the calumet, or the flag of truce, or the dove and its olive-leaf, or other similar emblem; or those implements of peace, the plough-share and the pruning-hook, into which the word of prophecy has declared that the sword and the spear shall one day be transmuted.[3]

I therefore venture to suggest, with a solemnity due to the occasion, and in words, I hope, of befitting deference, but with the emphasis of a full conviction of the propriety and congruity of the proposal, that *no weapon of international warfare shall be admitted* into the coming Exhibition, one great aim of which is allowed to be the promotion of international union, brotherhood, and peace. Such an exclusion would indeed gladden the hearts of thousands who rejoice in believing that the number does increase of those who have a growing faith in the powers of moral force; and in the subduing efficacy of Christian principle. It has recently been declared, by no mean political authority, that opinions are stronger than armies; and statesmen, men of renown, have not concealed their conviction that the venerable classic adage, *Si vis pacem, para bellum*, is more renowned for its antiquity than for its political sapiency.[4]

Earnestly desiring that these convictions may more and more prevail on the earth; and that the nations professing Christianity may, in the exercise of 'peace, love, and ready assistance to each other,' give evidence of their faith by their works; and thus hasten forward the sure progress of that blissful era, when, in the anticipatory language of the poet—

'The warrior's name would be a name abhorred
 And every nation that should lift again
Its hand against a brother, on its forehead cursed
 Would wear for evermore the curse of Cain,'[5]

I am, thy sincere friend,

Fifth Month, 1850 M. C. J.

4.2 Committee women

With Prince Albert as its President, the Royal Commission boasted some of the most important names in society and industry, all of them men (see 1.2). But aristocratic women were not content to sit idle as their fathers,

husbands and brothers planned an Exhibition to celebrate the triumphs of men (see 4.1). On 1 March 1850, Stafford House in London played host to a starry gathering, coming together at the invitation of the Duchess of Sutherland, a friend of Queen Victoria and some time Mistress of the Robes (the most senior of the Queen's ladies in waiting). These women formed themselves into a committee, emulating the structure of the Royal Commission, and resolved to raise funds by subscription to 'further [the] design' of the Exhibition. It was hoped the 'Women of England' would follow suit and offer donations, and this call was justified on the grounds of women's vested interest, for many of the exhibits in the Crystal Palace would also display 'womanly skill and ingenuity' (see 4.4). The committee was successful and in 1850 they were able to donate £975 to the Exhibition (Auerbach, 1999: p. 66). The list of members was organised into a hierarchy of rank, from Duchesses to Honorable Ladies, and included the wives of some Royal Commission members (such as Lady John Russell, Countess Granville and Lady Peel) and the wives of leading politicians (such as Viscountess Palmerston, wife of the Foreign Secretary and future Prime Minister).

Meeting at Stafford House, *Illustrated London News* (9 March 1850), pp. 161–2

We have the gratification of pourtraying [*sic*] to our readers the very interesting Meeting of Ladies held in the grand saloon of Stafford House, at the invitation of her Grace the Duchess of Sutherland, on Saturday week, to consider the best means of forwarding the objects of 'the Great Exhibition of Industry of All Nations, in 1851.'

The Duchess of Sutherland presided in the chair; and the undermentioned ladies agreed to form themselves into a committee for the purpose in this district of the metropolis; appointed Lord Edward F. Howard, Lord Dufferin, and Colonel Malcolm, to act as secretaries; and passed the following resolutions:—

1. That this Committee, in respectful sympathy with motives which have influenced her Majesty in graciously promoting an Exhibition for the Industry of All Nations, thinks it desirable to invite the assistance of the Women of England to further a design in which womanly skill and ingenuity must occupy so distinguished a position.

2. That this Committee recommend that subscriptions be received from One Shilling upwards.

3. That subscriptions may be paid to the persons named in the list.

The Marchioness of Ailesbury took a very active part in the proceedings, and is understood to have written the resolutions passed by the meeting. The Duchess of Sutherland, the Countess of Waldegrave, and other ladies present were desirous of contributing £50 donations to the fund; but the majority of the meeting were

in favour of smaller sums, which they considered as examples the more likely to be followed.

THE COMMITTEE

Duchess of Norfolk	Viscountess Palmerston
Duchess of Sutherland	Viscountess Jocelyn
Marchioness of Clanricarde	Lady John Russell
Marchioness of Londonderry	Lady Caroline Lascelles
Marchioness of Kildare	Lady Mary Stanley
Marchioness of Ailesbury	Lady Foley
Marchioness of Westminster	Lady Dover
Countess Granville	Lady Ashburton
Countess of Clanwilliam	Lady Stanley
Countess de Flahault	Hon. Mrs Charles Grey
Countess Grey	Hon. Mrs Anson
Countess of Shelburne	Lady Peel
Countess of Waldegrave	

11 'Meeting of the Ladies' Committee at Stafford House in Aid of the Great Exhibition of Industry of All Nations, in 1851', *Illustrated London News*, 9 March 1850

4.3 Queen Victoria

Unlike the Prince Consort, Queen Victoria was not involved in the organisation of the Great Exhibition, but her presence at the public opening of 1 May 1851 was hugely important in symbolic and political terms. Although Victoria played a mainly ceremonial role on the day – delivering an opening speech, receiving the Commissioners' report from Albert and providing a blessing alongside Archbishop Sumner (see 1.5), her presence was significant in fuelling feelings of pride and patriotism in the general public and the press. Cantor argues that Victoria's address helped to endow the Exhibition with 'providential meaning', portraying progress in 'the arts, sciences, and manufactures' (2011: pp. 64–5). Amongst other things, she invoked 'God's blessing' that the undertaking might 'conduce to the welfare of my people and the common interests of the human race', encouraging 'the arts of peace and industry' and 'strengthening the bonds of union among the nations of the earth' (Cantor, 2011: p. 64).

Her unifying function was accentuated by the warm glow of female virtue that she appeared to radiate on proceedings. An engraving appeared in the *Illustrated London News* on 3 May 1851 showing Prince Albert reading from his opening address: this became the basis for the famous oil painting *The Opening of the Great Exhibition by Queen Victoria on 1 May 1851* (1851–52) by Henry Selous, which depicted – at the centre of the grand setting and religious and political dignitaries – a particularly domesticated royal party in soft focus. As the *Art-Journal* put it, Selous allowed for 'as much picturesque display as the subject would permit' (August 1852).

Victoria's patronage of the Exhibition was of particular importance in placating the objections of the right wing press. Although less noisy, and with fewer readers than in its heyday of the 1820s and 1830s when under the editorship of Theodore Hook, *John Bull*'s opinions on Victoria's involvement are indicative. The first extract below is taken from an article of 19 April, responding to the fresh news of Victoria's involvement. Although the tone is reluctant and disingenuous, particularly as regards safety concerns, the Queen's presence encourages patriots to lay down their 'bow-strings', immediately elevating Paxton's design from a 'Glass House' and monstrosity (as Ruskin had termed it) into the feminised space of the 'Crystal Palace' that we see in Selous's painting. The second extract – from the *Lady's Newspaper* of 28 June – describing an unexpected visit from the Queen in which she 'passed out of the public entrance through the midst of the people' is altogether more celebratory. It suggests something of the ever-present thrill of a potential encounter with the royal family and that Victoria's concerns for security were less pressing than those of *John Bull* and some other publications (see 4.5).

Her Majesty at the Crystal Palace, *John Bull* (19 April 1851), p. 249

We have, as our readers know full well, no more partiality than Colonel SIBTHORP for the Glass House in Hyde Park. We looked upon the scheme from the very first with misgivings. It was too manifestly a crafty device for propping up the falling cause of Free Trade. The illustrious patronage paraded on its front was too evidently a shield cunningly displayed as a defence against shafts from loyal bow-strings. We have been, and we continue, alive to the pernicious effects which it will undoubtedly produce upon native industry; nor have we ceased to keep a watchful eye upon the incidental dangers which the undertaking has attracted and accumulated around us.

But great as is our hostility to the famous Glass House, our loyalty to the QUEEN is greater. Her MAJESTY has signified her pleasure by her august presence to give to the structure — whether grotesque or not, is not now the question — a title to the name which it has hitherto borne by usurpation — to convert Mr PAXTON'S monster Glass House into a Crystal Palace. This determination of Her MAJESTY none of her loving and devoted subjects can do otherwise than applaud. The undertaking had proceeded too far, before its questionable character was sufficiently developed. We have reason to believe that if the subject had been presented to the Royal mind in all its bearings, as it was the duty of Her MAJESTY'S advisors to have done, the consent of the QUEEN and the patronage of the PRINCE CONSORT would never have been obtained. But it is too late now to recede, and Her MAJESTY and her faithful people must be content to make the best of a bad bargain. This Her MAJESTY is about to do with all the graciousness and all the grace by which She has so long endeared herself to her subjects; and it is not from us that an ill word shall come, to mar the happy effects of her condescension.

Since the QUEEN is graciously pleased, as the Head of the nation, to inaugurate by her presence an undertaking which, whatever it may have been in its origin, is in outward character and appearance, at least, national, let all unite to support Her MAJESTY in the execution of her benevolent intentions. For Her MAJESTY'S personal safety we confess we entertain no fear. The necessary precautions to keep the avenues clear, and the building itself free from the intrusion of foreign or domestic traitors, and from an inconvenient throng, will, we take it for granted, not be lost sight of. We should be sorry to answer for the lives of the Officers of State who are responsible for the QUEEN'S safety, if by their neglect Her MAJESTY were to come to harm, or be subjected to insult. Indifferent as our opinion of Her MAJESTY'S Ministers is, we believe they are both alive to this part of their duty, and personally attached, as well as they may be, to their SOVEREIGN.

The Great Exhibition. Pencillings by a Lady, *Lady's Newspaper* (28 June 1851), pp. 355–6

On Tuesday morning her Majesty, during her visit to the Exhibition ... seemed much surprised and pleased by the magnificence and gorgeousness of the jewel-studded ivory throne, which she had not seen before.[6] She concluded her visit on Tuesday by an act of grateful condescension which will be appreciated and long remembered by all those who had the good fortune to be present on that occasion. Although thousands of visitors had entered the building during the first hour, and were congregated near the points where she was expected to pass with the Prince and the King of the Belgians, she, as if animated by the presence of so many of her loyal and unaristocratic subjects, passed out of the public entrance through the midst of the people, whose delighted excitement is more easily imagined than described.[7] Next to the opening it was probably the most impressive sight which the great Crystal Palace has yet presented, and which the foreigners present seemed to admire as much as the English. The Queen, leaning on the arm of the King of the Belgians, and accompanied by some of the executive committee of the Exhibition, left the Indian collection, and, only preceded by two gentlemen who cleared a small space for her, passed through the living walls formed by the thousands of people, stopping for a moment to admire the beautiful crystal fountain, and left the building by the public door. The surprise and pleasure which this impromptu event caused to all present was visible on every face, and though the impropriety of indulging in loud demonstrations of gratified loyalty was universally felt, it was still not possible to keep the delight of the people within bounds, and a cheer and a hurrah would burst forth now and then, in spite of all the endeavours at calmness. We hope the respectful behaviour of the crowd on Tuesday may induce her Majesty to repeat such scenes, which only serve to endear her and her family more to her people.

4.4 A palace for women

There is one aspect of the Great Exhibition that, more than any other, shows distinctions made along gender lines. These are the exhibits themselves. While displays of weaponry, machinery and industrial products were designed to appeal primarily to male visitors, the attractions aimed at women – particularly those associated with domestic interiors and the arts – and the strategies used to cultivate this interest, are noteworthy. Colin Cunningham has argued that design was itself considered a gendered practice in the Victorian period: 'until the end of the nineteenth century, the role of women in design was principally that of "amateurs" involved in directed labour or as consumers' (Cunningham, 1999: p. 189). Gill Perry notes that within the arts, too, distinctions were drawn: 'decorative art ... requiring less intellectual

skill', was considered 'more "amateur" and "feminine" than a more elevated "high" or "fine" art' (Perry, 1999: p. 193). Women were important consumers, whose needs and desires necessitated particular attention, even while their taste required cultivation.

With an awareness of the importance of a female readership in mind, the *Illustrated London News* ran a series of articles between early July and late October 1851, purportedly written by a female columnist and titled 'A lady's glance at the Great Exhibition'. The subject matter was specifically 'those branches of manufacture which address themselves peculiarly to the use and tastes of ladies' (25 October). From early May to October, the *Lady's Newspaper* also ran a similar recurring feature – 'The Great Exhibition. Pencillings by a Lady' – in which the anonymous author cast her eye over a range of items such as fabrics, embroidery and lace from various countries; carriages (16 August); artificial flowers; exotic Indian palanquins (28 June); and provided entertaining anecdotes such as the commotion surrounding Queen Victoria's use of the public entrance (see 4.3) and the disarray of the French section in the opening week (10 May).

It is not possible here to reproduce each of the pieces in full, but the selection below gives some flavour of the way each series positioned its female narrator – and, by extension, its female readership – as legitimate commentators on the Exhibition. In the *Illustrated London News*, 'Z.M.W.' adopts a strikingly apologetic tone, excusing the audacity of a woman's attention given over to womanly objects, denigrating the latter as 'less important' than the tools of masculine manufacture. But this stance belies the assured command of technical vocabulary as demonstrated in her precise, methodical accounts of the articles and exhibits in the Crystal Palace. By contrast, the 'pencillings' in the *Lady's Newspaper* offer no such apology. The narrator claims for women a full share in participation, noting their presence as exhibitors, consumers and producers. Her sympathetic engagement with the objects shaped by women's labour – such as the lace '[taking] shape and form and [issuing] from her hands' – resists the urge to fetishise 'things' at the expense of human industry. The result is a call to sisterhood comparable to the fraternal rhetoric discussed above (see 4.1) and through which female producers and consumers could be brought together across the class divide, connected by bonds of 'fellow-feeling'. Yet lurking behind these accounts are certain anxieties. In the *Lady's Newspaper*, any utopian sorority is unsettled by fears that foreign sisters may outperform 'English ladies' in terms of skill and ingenuity with the needle. The *Illustrated London News* presents an uncomfortable vision of emasculation as gender lines become blurred and men begin to share in the feminine desire for beautiful things, falling prey to the luxury on display.

The final extract chosen in this section derives from the *World of Fashion*, a monthly magazine concerned with 'fashionable living' and culture (Brake and

Demoor, 2009: p. 690). An article from *The Times* is cannibalised to provide a tasty titbit aimed at a readership hungry for exotic and fashionable items drawn from the corners of empire. Journalism combines with advertising and here suggests the importance of women as consumers subject to a distinctly sensual and flattering rhetoric.

Z.M.W., A Lady's Glance at the Great Exhibition, *Illustrated London News* (5 July 1851), p. 19

Although by no means disposed to undervalue the interest which attaches to patent ploughs and improved steam-engines, or to depreciate for a moment the beauties of the Bavarian Lion, or the utility of Messrs Taylor's Jacquard loom, still, as I am 'only a woman,' and cannot be expected to appreciate their details, I am content to leave their description to those whose experience renders them more competent to grapple with such mysteries; and, seeking in the retired byways of this Temple of Industry objects of a more congenial, if less important character, to view the Exhibition with a woman's eyes alone. I have the less hesitation in claiming a brief space for the examination of objects more peculiarly attractive to ladies, when I remember that there was perhaps scarcely ever a great work commenced in this country in which they have so fully participated. They began at the commencement with the Subscription Committee at Stafford House, as well as with the less aristocratic, but even more productive, meeting of ladies at the Mansion House; and at the final completion of the great work, their contributions to the adornment of the Building were found to have been neither few in number nor uninteresting in character. The objects in the Crystal Palace which address themselves especially to the predilections of ladies, are so numerous and so varied, that I am almost overwhelmed with the *embarras des richesses*; and not being of a mathematical turn of mind, I scarcely know where to begin; but the following may be instanced as among the most prominent:—

To silks, as occupying so important a position in our own toilet, I must certainly give the precedence. They are offered for our inspection in every variety—damask, brocade, tabbinet, glacé, striped, checked, watered, shaded, and clouded; some valuable from their brightness; some, the merit of which consists in their dullness alone. Many specimens are interesting not only from beauty of design and delicacy of manufacture, but from the histories which attach to them of the wearisome months of labour and anxiety employed in their manufacture and of the obstacles which have been overcome by the skill and perseverance of the mechanists. As, however, I propose, on some future occasion, enlarging on these fabrics, I will proceed to what may be regarded as a humbler feature of the same department, and glance at the different specimens of ribbons. There are gauze, satin, sarsnet, velvet and lute-string—plain, figured, flowered, stamped, and open in pattern as well as in texture; with edges plain, scalloped, pearled, and vandyked. These are

present in every variety of width, quality, and colour. There is also a description peculiarly adapted for trimming; it is goffered and quilled in the process of manufacture, and with a regularity that the most skilful hand could never emulate. It is easy to prophesy for this invention a welcome from dressmakers as well as from their employers. To the former it will save many hours of ill-requited labour, whilst to the favour of the latter class its novelty will be a sure passport.

Z.M.W., A Lady's Glance at the Great Exhibition, *Illustrated London News* (23 August 1851), pp. 342–3

Whilst each of the many examples of the works of nature, of science, and of art comprised in the various classes into which the Exhibition of the Industry of All Nations is divided, attracts its own peculiar circle of votaries, there is one which is found to claim successfully the admiration of every description of visitor, although addressed for the most part to the tastes and predilections of the female sex. I allude to the magnificent specimens of jewellery and precious stones with which the Crystal Palace abounds; to an extent, indeed, that half enables us to realise in our minds the wildest wonders of an Arabian tale; to believe that the hall of Vathek might not have been wholly imaginary; and that Sinbad's diamonds may find a local habitation after all. Whatever grave objects may attract grave people to this temple of concord, there are few even of the gravest who will depart from it altogether without paying a prolonged visit to the departments of Class 23.[8] The most learned of *savans*, the coldest of utilitarians, the political economist, the bishop and the Quaker, may there be found side by side patiently awaiting their turn for a passing glimpse at its marvels; half ashamed of an admiration they are unable to conceal or to disguise. There doth the philosopher arrest his steps to analyse the component parts of those wonderful substances, and endeavour to calculate the succession of ages that must have been demanded for their development. There, too, stands the sturdy labourer, with his wife by his side, gazing at them with looks of undisguised astonishment, and anticipating in imagination the advantages which even a passing acquaintance with such marvels will give him over the less fortunate companions of his toil at home; whilst the *millionaire* on his left is vainly endeavouring to compute the money value of the objects before him, and lamenting that so vast an amount of capital should be so unproductively employed.

Z.M.W., A Lady's Glance at the Great Exhibition, *Illustrated London News* (25 October 1851), pp. 530–1

Our attention having been directed to the chief of those branches of manufacture which address themselves peculiarly to the use and tastes of ladies, the subjects of my present paper will be selected from features of minor importance, selected from the same class. Of these, however, I must again distinguish merely

the more prominent, as their number is great, and the interest attaching to each is far from slight.

The first claim on our attention is undoubtedly presented by a branch of elegant industry, which, as applied to certain articles of dress, has found favour with ladies of all nations, although the relative degree of its importance in their adornment has varied at different periods according to the capricious dictates of fashion. I refer to that description of embroidery which may be generally termed muslin-work, in contra-distinction to the many varieties of gold, silver, silk, wool, chenille, &c., which afford less distinctive features of interest for a description, however brilliant an effect they present to the eye. The marvellous perfection attained by several European nations in the art of working on muslin, is proved by the exquisite beauty of many specimens contributed to the Great Exhibition. Patience and labour have indeed produced, in all the instances to be found there, but especially in the dresses, an effect which must strongly recommend them to the favour of those whose chosen style is an elaborate simplicity. Embroidery on muslin and net, applied to every purpose for which delicate ornament is suited, forms the principal attraction of the Swiss department. Our attention on entering it is first arrested by the curtains, which are displayed to great advantage on the partitions which enclose this territory. They are principally of that description generally known by the name of Swiss curtains, which have for some years been held in general estimation here; but they are, both as regards design and execution, infinitely superior to those ordinarily offered for sale in this country. On the specimen to which the place of honour is allocated, a complete *tableau* is worked, the ground consisting of coarse net. In the distance we see a chain of lofty mountains, at the base of which lies a little Swiss village: in the foreground is a placid lake, across which a girl in the picturesque costume of her country is about to guide her boat; whilst trees, figures, and animals are effectively grouped around. Thus we see the more humble arts successfully borrowing from the higher; and the everyday accessories to our comfort, no longer contented merely to serve a purpose, becoming mediums for conveying to us agreeable impressions and associations. Second only in elegance to the pattern I have described is one composed of palm trees and other tropical foliage, which, as being less elaborate in character, is, perhaps, better adapted for general manufacture: could it be frequently reproduced by the loom, and thus applied to curtains of a less expensive description, it would infallibly become extremely popular. Amidst the variety of white muslin and net draperies are interspersed a few embroidered with coloured worsted, which will doubtless find admirers and patrons.

The Great Exhibition. Pencillings by a Lady, *Lady's Newspaper* (24 May 1851), p. 288

No inconsiderable proportion of the exhibitors to the Great Exhibition are females, who have not hesitated to enter the lists and answer to the summons made to the

producers of the world's necessities and luxuries. What, though many of the articles exhibited by women be not of the stern utilitarian character of much of man's productions, they are, therefore, not much less important in an age when habit has made many luxuries absolute necessities, and when it is no longer feasible to apply the *cui bono* argument everywhere. Not only Englishwomen, but also foreigners in considerable numbers, have sent in their contributions, consisting of specimens of sewing, embroidery, patching, wax-flower making, lace-making, &c. The largest pieces of embroidery in the Exhibition are the carpets; among them is one worked for the Queen by a number of ladies, and which was spread beneath the chair of state at the opening of the Exhibition; another which is exhibited for the Industrial School of Dublin, and which is worked in squares principally consisting of groups of flowers; one worked by some Irish ladies, also in squares, but which is not so elegant as the first named carpet, nor so tasteful as the latter, inasmuch as the squares are not divided by difference of colour or any stripe separating them, and the different groups of animals, figures, and flowers are dispersed over the carpet without any systematic arrangement. In the other Irish carpet the grounding of the squares is in two colours, and these are arranged in diagonal stripes. The only fault we can find in this very neat and tasteful carpet is that the very few landscapes and figures which are introduced would have been better omitted, as the floral designs have a much better effect. The next in size and importance to the carpets is a magnificent state bed, exhibited by Messrs. Faudel and Philipps, of New-gate street, which is almost entirely composed of tapestry work. At the foot is a framed design of embroidery, the cornice is an imitation of drapery embroidered in rich colours, and the hangings, pillows, and quilt are of satin and velvet, richly embroidered with gold and silver. This bed is a great attraction, from the beautiful workmanship expended upon it, and stands in the English gallery. The same exhibitors also display some very beautiful patterns for needlework which we can recommend to our friends.

Along the walls of this gallery hang numerous other specimens of embroidery, some of which are very well executed. Among them are two copies of the Lord's Supper, very elaborate pieces, and in which the faces are better managed than usual in this style of work; also a lady and gentleman playing at chess, who seem not to be so intently engaged with the game as to be unable to interchange a very affectionate glance, extremely unlike the generals of two *hostile* armies. Among the other very well-executed embroideries the most striking are a piece of medieval embroidery by Miss King, embroidery in silk and gold on velvet; a new style of embroidery exhibited by Heilbronner, of Regent street, and various other pieces including a large screen, worked by Mrs. Marsh, in which the flowers are made of leather; a folding screen of elaborate workmanship; an occasional table, which is embroidered with different colours of cloth sown ou [*sic*] with braid, beads, &c. and of which the general effect is very pleasing; another table, worked with silk and braid on white flannel, of which the frame and foot are composed of massive gimp; a crochet screen, representing the royal arms, beneath which a guirlande

of roses, shamrock, and thistle hangs suspended, the flowers likewise made of crochet; a screen of raised flowers of chenille and crape on white silk; a map of England embroidered on canvas, the names of the principal towns being inserted by a little girl of fourteen. We believe we have enumerated the principal articles of embroidery in this style; but should we have inadvertently committed any oversight, owing to the difficulty of selecting where all is excellent in its way, we shall endeavour to repair the error on its being pointed out to us. The foreigners have not contributed very largely in canvas embroidery, knitting, or crocheting; their specimens consist mostly of embroidery on silk with hair, fine black silk or coloured silk, cambric work, cashmere and other embroidery, lace work, and some beautiful specimens of netting from France. In the hair embroidery to imitate line engraving the English ladies have also contributed some very good specimens; but there is this difference between the English and the foreign, that the former imitates the long lines of wood engraving, the latter the fine points of steel engraving, and is consequently much more laborious, though it well repays the additional work by the finer appearance. The English embroiders have also put in the dark parts of their pictures, which are confined to architectural designs and landscapes, by pieces of grey, even of black, silk; while in German ones, for instance those from Hamburg, representing portraits of the Queen and Prince of Wales and the Exchange in Hamburg, the dark effects are produced entirely by the needle. The English hair or silk embroidery represents some of the large cathedrals of England—York, Lincoln, and Canterbury. Out continental sisters have not confined themselves to imitating paintings and engravings in *black* silk: they have several embroideries of coloured silks which accurately resemble oil paintings— one from Italy, a beautiful copy of a ruined castle and bridge; one from Bavaria representing the parting of Hector and Andromache.

Another species of work deserving attention comprises some specimens of darning from Hamburg. A piece of old lace which was in an extremely dilapidated condition, and the identity of which is attested by the official seal of the Hamburg committee, has been so skilfully darned by a Miss Gompertz, of that town, that it is impossible now to detect where the holes could have been. This is a valuable accomplishment, as it is often very desirable to keep old lace which has been in families as an heirloom for years in a presentable condition; and we have no doubt the young lady would find full employment for her needle here, if she would come over to England. The same young lady has darned a damask table-napkin with equal skill, so that the restored part is scarcely to be distinguished from the original material when held to the light. There are also some specimens of quilting which deserve honourable mention; but, if we were to enter into that and the lace department to-day, we should be carried beyond our limits, and we must reserve them for a future visit. Such of our readers as employ their leisure in fancy work will find several useful hints and novel designs given them in many of the contributions exhibited in this class, XIX.[9]

The Great Exhibition. Pencillings by a Lady, *Lady's Newspaper* (31 May 1851), p. 302

And not the least interesting point in the contemplation of the embroidery and lace here exhibited is, that it gives employment to a very large number of females, and forms one of the most lucrative occupations of the poor girls capable of executing the work; a circumstance which, in itself, should be sufficient to enlist our sympathies and excite our fellow-feeling, even if we were not so largely interested in the fruits of this branch of industry; and, that we may be enabled to form some idea of the manner in which these fine and delicate textures are fabricated, several specimens of partly finished work are included in the collection, by which we may see the manner in which the pattern is pinned on the cushion and worked in one piece with the grounding by the innumerable little reels of marvellously fine thread, which are twisted to and fro with magical rapidity by the experienced workwomen until the lace gradually takes shape and form and issues from her hands an almost finished piece of lace.

The World of Fashion: Monthly Magazine of the Courts of London and Paris Fashions, Literature, Music, Fine Arts, the Opera and the Theatres (1 May 1851), p. 60

THE 'TIMES' informs us that the Bey of Tunis has forwarded to the Great Exhibition several dresses of extraordinary richness, as worn by the ladies of the East.[10] Among them are the beautiful dresses worn after leaving the bath, which, the same authority (the 'TIMES') anticipates will be eagerly inspected by those loveliest denizens of the wide world—Englishwomen. Doubtless they will; but the dress after the bath will necessarily suggest the accompanying toilette, and remind them that throughout the East universally, the exquisite preparations for beautifying the hair, complexion, and Teeth, by the Messrs. Rowland, are held in unbounded esteem. To these they have recently added that quintessential, most fragrant, and most invigorating cordial Esprit, 'The Aqua D'Oro.'[11] Ladies, who visit the Great Exhibition, will have their attention arrested by a Golden Fountain erected in Class C, No. 29, Gallery, by the Messrs. Rowland, which flings out a perpetual stream of the 'Aqua D'Oro.' And in the handsomest manner they have published an invitation to the fair sex to dip the corners of their handkerchiefs 'en passant.'

4.5 Order and disorder

While Victoria was typically portrayed as a figure who brought refinement, elegance and feminine authority to the opening of the Exhibition, the female populace, particularly those within the working classes, caused some specific

anxieties for both the organisers and the press. The anticipated presence of women descending to Hyde Park *en masse* raised genuine concerns about security and safety. The unease was twofold: it focused on women under threat and women as threats to the carefully ordered arrangements of the Exhibition. *The Times*, reporting in the week leading up to the public opening, reassured its readers that not only would ladies be well catered for, but that their presence would ensure the good behaviour and gentlemanly conduct of the crowds: 'It has been decided that there shall be two rows of seats all round the centre aisle in front of the stalls, and by this means, in that vast area, accommodation will be provided for about 5,000 people. These seats will, we imagine, be occupied by ladies, and will thus form a graceful and effectual barrier to the crowds of the male sex collected in close column behind them' (26 April 1851).

Once underway, the potential for unruly and threatening behaviour became the focus of several publications. In June, the *Examiner* recorded the effect of celebrated attractions such as the Koh-i-Noor diamond on women and the need to adequately regulate them: 'The toilettes were, as a rule, gay and fashionable, and there was the same crowding round those objects which are supposed to interest the higher classes almost exclusively. The Queen of Spain's jewels were regularly besieged, and the Koh-i-noor knew no repose. The Dresden chamber was impassable, and in the Milan sculpture-room, the "pass on, ladies" of the policeman was a never-ending ditty' (21 June 1851). Auerbach notes that policing was not, however, an exclusively male province and that the 1,750 attendants comprised members of both sexes (1999: pp. 106–7). In the same article, the *Examiner* also draws its readers' attention to a threat that appears to have crossed the gender divide: nervous or hysterical reactions to the overwhelming spectacle of the Palace. Fainting was not confined to women alone – 'Several cases of fainting occurred, among which were two or three from the stronger sex', hinting at the potential for a loss of manly self-control.

One publication to poke fun at the common fears about order and disorder was *Punch*. The first illustration included below (Figure 12) focuses specifically on the decorative and decorous function of women. The title – 'Her Majesty, as She Appeared on the First of May, Surrounded by "Horrible Conspirators and Assassins."' – cuts ironically against the fact that women are here portrayed as a force for order. Ringletted and bonneted women surround the royal party and the only faces visible are female. Male visitors are, as *The Times* predicted, screened behind this barrier of women, their presence only signalled by distant hats raised in approval. The second illustration I have chosen (Figure 13) depicts a similar group of women, this time as a phalanx in close order brandishing shield-like parasols with stiletto tips raised aggressively like bayonets. The police look noticeably under-equipped in comparison.

HER MAJESTY, as She Appeared on the FIRST of MAY,
Surrounded by " Horrible Conspirators and Assassins."

12 'Her Majesty, as She Appeared on the First of May, Surrounded by "Horrible
Conspirators and Assassins."', *Punch*, 10 May 1851, p. 192

THE LADIES AND THE POLICE.—THE BATTLE OF THE CRYSTAL PALACE.

13 'The Ladies and the Police. – The Battle of the Crystal Palace', *Punch*, 17
May 1851, p. 192

4.6 Ageing and eccentricity

The careful planning used to allay fears concerning the mixing of genders
within the space of the Crystal Palace could only go so far. Even so, unantici-
pated and unforeseen events were the source of as much good publicity as bad.
One of the most striking examples of this was the story of Mary Callinack's
visit to the Exhibition and her meeting with the Lord Mayor. Callinack was
an octogenarian 'fish-woman' from Penzance who travelled to London on
foot, carrying her basket on her head. Her stay in London was longer than
anticipated as she became a minor celebrity and something of an exhibit
in her own right due to the frequency of her visits to the Exhibition. Her
extraordinary story was first reported in *The Times* but soon spread to many
other publications; she was still resident in London, at Marylebone, a month
after her arrival.

Callinack fits neatly into traditions of eccentric old age, of the type
demonstrated by Wemmick's Aged Parent in Dickens's *Great Expectations*
(1860–61), and often associated with unconventional female behaviour in
later life, as in the case of Elizabeth Gaskell's female community in *Cranford*
(1851). Yet Callinack's significance lies not only in her eccentricity but also
in the opportunity she afforded for a demonstration of patronage, charity and

goodwill. The chosen extracts below describe her visit to the Mansion House and the display of paternal benevolence on the part of the Lord Mayor. Her presence was still worthy of note one hundred years later in Patrick Howarth's centennial study *The Year is 1851* (p. 227).

The Times (24 September 1851), p. 5

THE GREAT EXHIBITION.—Yesterday among the visitors at the Mansion-house was Mary Callinack, 84 years of age, who had travelled on foot from Penzance, carrying a basket on her head, with the object of visiting the Exhibition and of paying her respects personally to the Lord Mayor and Lady Mayoress. As soon as the ordinary business was finished the aged woman entered the justice-room, when the Lord Mayor, addressing her, said, 'Well. I understand, Mrs. Callinack, you have come to see me?' She replied, 'Yes; God bless you! I never was in such a place as this. I have come up asking for a small sum of money. I am 84.' The Lord Mayor,—'Where do you come from?' Mrs. Callinack,—'From Lands-end.' The Lord Mayor,—'What part?' Mrs. Callinack,—'Penzance.' She then stated that she left Penzance five weeks ago, and had been the whole of the time walking to the metropolis. The Lord Mayor,—'What induced you to come to London?' Mrs. Callinack,—'I had a little matter to attend to as well as to see the Exhibition. I was there yesterday, and mean to go again to-morow.' The Lord Mayor,—'What do you think of it?' Mrs. Callinack,—'I think it's very good.' (Much laughter.) She then said that all her money was spent but 5½d. After a little further conversation, which caused considerable merriment, the Lord Mayor made her a present of a sovereign, telling her to take care of it, there being a good many thieves in London. On receiving it the old woman burst into tears, and said, 'Now I shall be able to get back.' She was afterwards received by the Lady Mayoress, with whom she remained a long time, and having partaken of tea in the housekeeper's room returned thanks for the hospitality she had received, and left the Mansion-house for one more visit to the Exhibition, before returning to her home. It is probable that if the poor old woman's address were known ample means would be provided by the charitable to enable her to return in comfort to Cornwall.

Longevity at the Great Exhibition, *Illustrated London News* (25 October 1851), p. 522

Amongst the many remarkable circumstances in connexion with the Great Exhibition, is the extraordinary number of persons of great ages who have journeyed long distances to see the World's Fair. Much might be said upon the reflective results of these patriarchal visits: the delight which the good old people received from the industrial spectacle may have, in many instances, been akin to the vivid impressions of youth; at the same time that it may have given rise

to comparisons of the perfections of the present times with the shortcomings of the past. We leave these general reflections, however, for a special portrait of one of these aged visitors, whose presence on the morning of the 23rd ult., at the Mansion-house, by her harmless eccentricity, relieved the dull routine of the police report. The circumstances were thus related in the ILLUSTRATED LONDON NEWS for September 24:——

[Article here reproduces material adapted from The Times*, 24 September 1851, with the addition of a final anecdote:* 'She was afterwards received by the Lady Mayoress, with whom she remained a long time, and having partaken of tea in the house-keeper's room, which she said she preferred to the choicest wine in the kingdom, and which latter beverage she had not tasted for sixty years, returned thanks for the hospitality she had received, and left the Mansion-house for one more visit to the Exhibition, and then to her native home.'*]*

14 'Mary Callinack, Aged 85, The Cornish Fish Woman, Who Walked from Penzance to the Great Exhibition in Hyde Park', *Illustrated London News*, 25 October 1851

Our portrait of the Cornish fish-woman has been sketched from life, at her abode, Homer-place, Crawford-street, Marylebone. She was born in the parish of Paul, near Penzance, on Christmas day, 1776, so that she has nearly completed her 85th year. To visit the present Exhibition she walked the entire distance from Penzance, nearly 300 miles; she having 'registered a vow,' before she left home, that she would not accept assistance in any shape, except as regarded her finances. She possesses her faculties unimpaired; is very cheerful; has a considerable amount of humour in her composition; and is withal a woman of strong common sense, and frequently makes remarks that are very shrewd, when her great age and defective education are taken into account. She is fully aware that she has made herself some-what famous; and, among other things which she contemplates, is her return to Cornwall, to end her days in 'Paul parish,' where she wishes to be interred by the side of 'Old Dolly Pentreath,' who was also a native of Paul, and died at the age of 102 years. 'Old Doll' signalised herself as the last person who could converse in the old Cornish language. Mary Callinack will also be remembered as having been the most remarkable of all the visitors to the 'Great Exhibition of 1851.'

On Tuesday the 14th, when the Queen visited the Exhibition, her majesty, in taking her departure, with her usual kindness and condescension, noticed the old Cornish pedestrian fisherwoman, who had been placed in her way, and with hearty emphasis exclaimed 'God bless your Majesty!'

Notes

1 Compare Tallis's 'Romance in the Russian Department' at section 2.3.
2 A standard Quaker greeting. I am indebted to Geoffrey Cantor for alerting me to this.
3 See Isaiah 2:4. The biblical reference was a common one. See, for example, Henry Cole's Mansion House speech of 17 October 1849, where the passage is cited by a clergyman (section 1.1).
4 'If you want peace, prepare for war'.
5 A reference to Henry Wadsworth Longfellow's poem, 'The Arsenal at Springfield' (1845).
6 This throne and footstool, carved in ivory and studded with diamonds, emeralds and rubies carried the Travancore crest and was designed to display the skills of Travancore in Southern India. It is now held in the Royal Collection Trust.
7 Belgium had declared independence from the Netherlands in 1830. Part of the House of Saxe-Coburg and Gotha, Leopold I, the first King of the Belgians, was popular in England (partly due to his earlier marriage to Princess Charlotte) and he played a large part in arranging the marriage of Victoria and his nephew, Albert.
8 'Working in precious Metals, Jewellery, and all articles of luxury not included in the other juries'.
9 'Lace and Embroidery, Tapestry, fancy and industrial Works'.
10 Ahmad I ibn Mustafa, the reigning King of Tunisia.

11 Rowland & Sons of Hatton Garden, London, produced Aqua D'Oro which was marketed as a reviving perfumed beverage. An advert in the *Globe* runs as follows: 'This fragrant and Spirituous perfume refreshes and invigorates the system during the heat and dust of summer, and will be found an essential accompaniment for the opera, the public assembly, and the promenade. In all cases of excitement, lassitude, or over-exertion it will prove of great advantage taken as a beverage, diluted with water. Price 3s. 6d. per bottle' (26 May 1852).

5

Class

Increased concern for the welfare of the working classes is one dominant motif of political debate in the mid-nineteenth century with which the organisers of the Great Exhibition could not avoid engaging. In *The Condition of the Working Class in England in 1844* (1845), Friedrich Engels wrote about the impoverished and demoralised state of provincial workers that he had witnessed first hand, famously proclaiming, 'Thus are the workers cast out and ignored by the class in power, morally as well as physically and mentally' (p. 144). In 1842, Edwin Chadwick, who had earlier worked on the reform of the controversial Poor Law, published *The Sanitary Condition of the Labouring Population*, publicising the extent of suburban poverty. To tackle the social issues perpetuating squalor, the Public Health Act of 1848 pledged to improve urban sanitation and establish local boards of health, while the housing crisis in London was managed by the Metropolitan Association for Improving the Dwellings of the Industrious Classes (see 5.2). Engels encapsulated the desperation of the working man and the inevitability of his recourse to crime: '[The worker] is poor, life offers him no charm, almost every enjoyment is denied him, the penalties of the law have no further terrors for him; why should he restrain his desires, why leave to the rich the enjoyment of his birthright, why not seize a part of it for himself? What inducement has the proletarian not to steal?' (p. 145) Not only were living standards unacceptable, but the poor were also denied political representation. The radicalisation of the working class in the 1830s and 1840s was given prominent fictional representation in George Eliot's *Felix Holt* (1866) and Elizabeth Gaskell's *North and South* (1855). Yet despite the demand for a People's Charter granting universal male suffrage, the Chartist uprisings of 1848 had largely been ineffective, at least on a national scale, as a way of mobilising change.

Political unrest had been quashed but nobody was under the illusion that it had gone away and several of these factors were felt to impinge on the organisation of a public exhibition in 1851. In a negative sense it was commonly perceived as a potential platform for further Chartist insurrection as well as a hotbed for crime and even for the spread of diseases such as cholera

(as the pamphlet *The Philosopher's Mite* makes abundantly clear). On 22 June 1850, Colonel Lloyd wrote to Lord Granville about 'a strong and selfish feeling pervading amongst these [working] classes', which might lead to 'an undue opinion of their own importance and power'. The result was potential insurrection; 'a vast power which may not be reducible again' was anticipated (RC/H/1/4/12). Such trepidation explains why, from an early stage, Cole and the Executive Committee recognised the need to associate the Exhibition with contemporary discourses of reform. Matthew Digby Wyatt's second resolution, distributed to local committees in 1850, stressed that 'the exhibition will be of great advantage to all classes, whether as producers, distributors, or consumers, and is especially calculated to promote the welfare of the working classes by offering examples of excellencies and stimulating production' (RC/H/1/A/11). 'In certain areas the organizers promoted the exhibition', according to Auerbach, 'by emphasizing its benefits for workers and its ameliorative effect on class relations' (1999: p. 65), often echoing the title of Samuel Wilberforce's address to the first meeting of the local committee of Westminster, 'On the Dignity of Labour' (RC/H/1/A/13).[1] Of a like mind, Albert, who since 1844 had been patron of the Society for Improving the Condition of the Labouring Classes, initially felt that a separate committee to represent, and oversee the arrangements for, the working classes should be formed. The Central Working Classes Committee (CWCC) was headed by Wilberforce, and included Charles Dickens, Cole and Lord Shaftesbury, along with Chartists such as Henry Vincent, Francis Place and William Lovett. Its remit was 'to enable and encourage members of the working class to attend the Exhibition, organise and monitor cheap accommodation, and facilitate orientation' (Clemm, 2009: p. 19). Unfortunately the CWCC failed to receive official recognition from the Commission – perhaps demonstrating the degree to which the organisers felt the need to distance themselves from any associations with Chartism – and the Committee was quickly dissolved, with Dickens recalling that in the absence of any official recognition the CWCC could not hope to represent the working class in any meaningful way (House *et al.*, 1965–2002, 6, p. 57). Eventually it was Alexander Redgrave, best known as a factory inspector, who was charged with 'superintending the arrangements to be made in the metropolis for the Working Classes visiting the Exhibition' (Lord Granville to Colonel Grey, 30 June 1850; RC/H/1/4/24). His role included providing the Commission with information, some of which is included in section 5.2, about the impact of the (largely impeccable) behaviour of the working classes on the metropolis during 1851.

As the other documents in this chapter demonstrate, the question of how best to accommodate the working classes never received a straightforward answer. Reconsiderations of the actions of the Executive Committee have often been cynical. For Sabine Clemm, the organisers frequently adopted

a discourse of strategic elision in their representation: 'The middle classes' concerns about the inclusion of the workers among the spectators were mirrored by the omission of labour from the spectacle itself. Although the Great Exhibition displayed modern machinery, the workers who operated the machines did not appear alongside them' (2009: p. 21). She identifies a 'contradiction in the professed and actual aims of the Exhibition', although it undoubtedly served the purposes of the Commission to present an image of an industrial nation 'devoid of any struggle between labor and capital' (Auerbach, 1999: p. 67). It is true that the grounds on which the Exhibition was promoted were often devoted as much 'to making the middle-classes feel more secure about the working classes' (Auerbach, 1999: p. 67) as they were to truly assisting the labourer, and inevitably Cole and others needed to be careful in the way they represented their aims to the country. It is also the case that there was 'a certain hollowness behind "dignity of labor" discourse' and the celebration of labour, and industrial exhibits, shorn of their context, hid the real conditions of work (Auerbach, 1999: pp. 133–4). Yet the evidence is that the aspiration to 'diffuse a high standard of excellence among our operatives' ('Second Resolution'; RC/H/1/A/11) was not merely empty rhetoric but a fundamental principle of the Commission and the Executive Committee whose prize medals bore the motto *Pulcher et ille labor palma decorare laborem*.[2]

5.1 Welfare

Constructing an 'image of workers as industrious patriots' (Auerbach, 1999: p. 67) was vital to the way in which the organisers bestowed a narrative of benevolent industrial progress upon the Exhibition. They found support for their vision in many different areas of the press. On 18 May 1850, G. Godwin wrote in the *Builder*: 'Now I believe that an Exhibition such as that proposed, which shall bring masters and men together, and provide a holiday for the whole world, where all may enjoy as well as learn, must do a vast deal of good, not only in the improvement of manufacture and art, but in beating down these false notions which induce the operative and the capitalist to consider their interest antagonistic, and not as they really are, coincident and mutual' (pp. 232–3). Henry Cole and Albert realised that the establishment of an image of peace, progress and prosperity in which employers and workers had one common goal and the welfare of all was foremost would help allay fears of militant workers descending on Hyde Park in their masses. Their cause was assisted not only by the display of industrial and mechanical exhibits but also by a number of the fictional representations of the Exhibition that appeared in prose and verse during 1850 and 1851.

In both extracts included here the emphasis is on welfare, social improvement, the cultivation of good taste and a reconsideration of the cultural

contributions of the working man. The first is taken from Henry Mayhew's satirical sketch of a working class family's excursion to the Great Exhibition, *1851; or, the Adventures of Mr. and Mrs. Sandboys* (1851). Mayhew adopts the position of Wilberforce – and indeed the tenor of the whole Commission – on the 'dignity of labour' question, arguing for the 'intellectual', rather than mechanical, quality of modern craftsmanship. Beauty, according to Mayhew, has been too long subservient to utility in design, and the workman consequently viewed as a mere operative. The Great Exhibition, he argues, will be the first step towards recalibrating toil as honourable and dignified.

Equally optimistic, the second extract is taken from Robert Franklin's poem *Wanderings in the Crystal Palace* (1851), wherein the British workforce, or 'Brave sons of Vulcan', are urged to 'claim their birthright', and the wonders of technological and industrial progress such as the locomotive and the diving bell are lauded. Franklin's awe-struck cadence chimes nicely with the Exhibition's stress on invention – mutual 'discov'ries' are being made by manufacturer and viewer, while his verse flits lightly across the Exhibition's categories of raw materials, machinery and their products. Labour and the working man are ennobled and glamourised by mechanisation, particularly by those exhibits that speak of a new age of mass production – 'printing presses of uncommon power / Are passing off their thousands in the hour', which are envisaged as easing the labourer's burden. No mention is made of the possible price of unemployment – a feature of Horace Greeley's report, *The Crystal Palace and its Lessons*, where labour, in the face of mechanisation, 'shivers at the approach of winter' (p. 25; see 3.5), nor of the fact that most exhibits on display were actually handcrafted rather than produced by machines. The scene is both one of display and of pulsating mechanical action, although we might agree with Sabine Clemm (2009) that human sweat and endeavour are here largely written out of the picture. Indeed Franklin's focus on 'artisans' and 'engineers' serves to elide the labourer somewhat and adds weight to Auerbach's (1999) view that the terminology surrounding class could often be purposefully ambiguous.

Ironically collapsing the distinctions between labour and display, the illustration from *Punch*, in which operatives are exhibited under giant glass bell-jars while Prince Albert ponderously strokes his chin, demonstrates the ongoing nervousness about class perceived by some to be motivating the actions of the organisers. Mr Punch's stoutness and waistcoat deliberately contrasts the lean, grimy and dishevelled workers.

Henry Mayhew, *1851; or, the Adventures of Mr. and Mrs. Sandboys*, pp. 129–32

THE Great Exhibition of the Industry of all Countries is the first public national expression ever made in this country, as to the dignity and artistic quality of labour.

Our 'working men,' until within the last few years, we have been in the habit of looking upon as mere labourers—as muscular machines—creatures with whom the spinning-jenny and the power-loom might be brought into competition, and whom the sense of fatigue, and consequent demand for rest, rendered immeasurably inferior 'as producers,' to the instruments of brass and iron.

It is only within the last ten years, perhaps, that we have got to acknowledge the artistic and intellectual quality of many forms of manual labour, speaking of certain classes of operatives no longer as handicraftsmen—that is to say, as men who, from long habit, acquired a dexterity of finger which fitted them for the 'automatic' performance of certain operations,—but styling them artisans, or the artists of manufactures. It is because we have been so slow to perceive and express this 'great fact'—the artistic character of artisanship—that so much intellectual power has been lost to society, and there has been so much more toil and suffering in the world than there has been any necessity for.

Had we, as a really great people, been impressed with the sense of the heavy debt we owe to labour, we should long ago have sought to acknowledge and respect the mental operations connected with many forms of it, and have striven to have ennobled and embellished and enlivened the intellect of those several modes of industry that still remained as purely physical employments among us. Had the men of mind done as much for the men of labour, as these had done for those, we might long ago have learned how to have made toil pleasant rather than irksome, and to have rendered it noble instead of mean.

The ploughman, at the tail of the plough, has been allowed to continue with us almost the same animal as the horses in front of it, with no other incentive to work but the craving of his stomach.

Had we striven to elevate ploughing into an art, and the ploughman into an artist—teaching him to understand the several subtle laws and forces concerned in the cultivation of every plant—and more especially of those with which he was dealing—had we thus made the turning up of the soil not a brute operation, but an intellectual process, we might have rendered the work a pleasure, and the workman a man of thought, dignity, and refinement.

As yet, the art-exhibitions of this country have been confined solely to the handiworks of artists-proper. We have been led to suppose, by the restricted sense which we have given to the term *artist*, that Art was confined solely to the several forms of pleasing—pictorially, musically, or literarily. A more comprehensive view of the subject, however, is now teaching us that the different modes of operating on the intellectual emotions, of attracting attention, of exciting interest, of producing a feeling of astonishment, beauty, sublimity, or ludicrousness in others, are but one species of Art, for not only are the means of affecting the intellect, of inducing a sense of truth and causation an equally artistic operation, but, assuredly, the affection of material objects in a desired manner is just as worthy of being ranked in the same category. Whether the wished-for object be to operate

upon mental, moral, or physical nature—whether it be to induce in the intellect, the heart, or the unconscious substances around us a certain predetermined state, such an end can be brought about solely by conforming to the laws of the object on which we seek to operate.

Art, literally rendered, is cunning, and cunning is 'kenning,' or knowing. It means, simply and strictly, intellectual power. *Ars* is the power of the mind, in contradistinction to the *In-ers*, or power of matter.

Art, therefore, is merely the exercise of the mind towards a certain object— that express operation of the intellect which enables us to compass our intentions, no matter what the object may be—whether to convince, to astonish, to convulse with laughter, to charm with beauty, to overwhelm with the sense of the sublime, or even to extract metal from the ore, or weave the fibres of a plant into a cover- ing for the body—each of these processes differs, not in the intellectual operation, but solely in the nature of the substances operated upon, every one requiring the knowledge of a different set of laws, and thus, in most instances, necessitating a distinct operator.

Such are the marvellous effects of some of the more ordinary arts of civi- lization. Art, it has been said, lies simply in the adaptation of the means to the end—the more cunning or knowing this adaptation appears—that is to say, the greater the knowledge, intuitive or acquired, that it evinces, or is felt to require, the greater, of course, is the art, or, in other words, the more *art-ful* the process becomes.

As yet, but few modes of industry in this country have been rendered artistic; our handicraftsmen have remained pure mechanics, because wanting that knowledge which alone could convert their operation into an art; they have merely repeated, mechanically, the series of acts that others had performed before them, while such processes which had been elevated into intellectual exercises had been rendered so by mere scientific knowledge.

By means of Mechanics' Institutes and cheap literature, we had so extended the discoveries of our philosophers, that the truths of science were, in many instances, no longer confined to the laboratory, the observatory, or the library, but made to permeate the mine, the forge, the workshop, the factory, and the fields.

Still, it was only science that reached our working men.

Taste, as yet, was scarcely known to them.

A knowledge of the laws of nature might make better and more cunning handicraftsmen, but a knowledge of the laws of pleasing could alone render their works more elegant in design; and, since every material object must necessarily partake of form and colour, it is surely as well it should be made to please as to displease the eye in these qualities.

As yet we have sought to develop only the utilities of art—the beautiful, as an essential element of all manufacture, we have entirely neglected. As a stranger

recently come among us, this defect appears to have forced itself deeply into the mind of Prince Albert; for, as far back as 1846, his Royal Highness urged upon a deputation that waited upon him from the Society of Arts, that the department of that Society 'most likely to prove immediately beneficial to the public, was that which encouraged, most efficiently, the application of the Fine Arts to the various manufactures of the country;' and, added the Prince, after speaking of the excellence and solidity of British manufactures generally, 'to wed mechanical skill with high art is a task worthy of the Society of Arts, and directly in the path of its duty.'[3]

The Great Exhibition of the Works of Industry and Art of all Nations is, then, the first attempt to dignify and refine toil; and, by collecting the several products of scientific and aesthetic art from every quarter of the globe into one focus, to diffuse a high standard of excellence among our operatives, and thus to raise the artistic qualities of labour, so that men, no longer working with their fingers alone, shall find that which is now mere drudgery converted into a delight, their intellects expanded, their natures softened, and their pursuits ennobled by the process.

When mining becomes with us a geological art—when the agricultural labourer is an organic chemist—when the feeder and breeder of cattle is an experimental physiologist—when, indeed, every handicraft is made both a scientific and aesthetic operation—then, and then alone, will the handicraftsmen hold that high and honourable position in the country, which, as the producers of all our wealth—as those to whom we owe our every comfort and luxury, they ought most assuredly to occupy.

The Great Exhibition is a higher boon to labour than a general advance of wages. An increase of pay might have brought the working men a larger share of creature comforts, but high feeding, unfortunately, is not high thinking nor high feeling.

Anything which tends to elevate the automatic operation of the mere labourer to the dignity of an artistic process, tends to confer on the working classes the greatest possible benefit.

Such appears to be the probable issue of the Great Exhibition!

Nor can we conceive a nobler pride than that which must be felt by working men when they behold arranged all around them the several trophies and triumphs of labour over the elements of the whole material universe. The sight cannot fail to inspire them with a sense of their position in the State, and to increase the respect of all others for their vocation.

Robert Franklin, *Wanderings in the Crystal Palace*, pp. 15–17, 19–22

Who has not witness'd in fair time of peace
How much invention and the arts increase?

A few short years have only pass'd away,
And here's for working men a great display.
BRITISH machinery—what a world is here,
Of moving pistons and their travelling gear;
Engines adapted for the rolling main,
A giant one to crush the sugar cane,
Whose oscillating movements greatly please,
Working so sweetly with uncommon ease;
Disk engines too, to suit the smallest rooms,
And larger ones that work the num'rous looms;
In looms you witness on your right and left,
See weaving first process, the warp and weft;
In little time your wonder will increase,
To find the very thing brought out in piece.
Here spindles whirl around, and shuttles fly;
Envelopes form'd, and medals fresh from die;
And printing presses of uncommon power
Are passing off their thousands in the hour.
Water in column thrown amazing height
Would turn the mill broad sheet in downward flight;
And here, in something like an open well,
You view the merits of the diving bell;
Machines and implements to till the soil,
And greatly aid laborious works of toil;
Something for artisans in every part,
From coach to wagon, down to lightest cart.
Here's much to see and learn in every trade,
Here's all the new and last discov'ries made.
Amongst the rest some most stupendous things,
Large railway locomotives, iron kings;
And one stands here, that courts approving smiles
Whose great projector terms the Lord of Isles,
A wayward monster, which at utmost speed,
Dragging a ponderous load, amazing power!
And passing sixty miles within the hour.
Fit emblem of the war horse running wild,
Yet made obedient as a little child.
Great engineers are here, who really raise
Works of such magnitude beyond all praise—
Perhaps in pity to the horse abus'd,
Or mercy to the toiling race misus'd,
Those gifts to man by gracious Heav'n assigned,

Have been to ease the horse, and bless mankind.
Brave sons of Vulcan, claim your birthright here—
No other land can give you title clear.
What other land can bring from brightest flame
The plastic metal forth so stout in frame?
What other land, from genius or from lore,
Can turn to such account the liquid ore?
As smiths might become your flag unfurl'd—
England's the noblest workshop of the world.
Yet, tracing objects nearest to their goal,
Say, what were those without your handmaid coal?
All hail! thou British diamond of the mine,
Oh! what a debt of gratitude is thine!
To state thy worth in no outrag'd degree,
Golgonda's mines are poor, compared to thee.[4]
Throughout the year thou art a gen'ral good,
Fitting the temp'rature of our blood;
Midst fogs and damps, in cold, in frost and snow,
Who but delights to feel thy genial glow!
Oft the chill traveller beyond the sea
Sighs for enliv'ning flames that spring from thee;
Many, indeed, throughout the world admire
Old England's social hearth and bright coal fire.
From thee comes forth our truly radiant gas,
Thy agency in ores and forming glass;
Thy virtues might become a lengthen'd theme—
Thou art the chief propelling power of steam.

[...]

Your wand'ring muse was perplex'd and cross'd,
In labyrinths of treasure almost lost;
Yet, midst anxiety, amongst the rest,
Found out our Yorkshire worthies from the West,
Where dwell the numbers in their busy rooms,
Seat of industry and the land of looms,
Fam'd Manchester—for such thou really art,
The great emporium of the cotton mart.
Here mark'd your poplins and your silk brocades,
Your muslins too, in all their varying shades;
Beheld your chintzes, and those beauteous prints,
Of richest patterns and the fairest tints.

Oh, could some venerable heads laid low
Behold the fabrics we have witness'd now,
How they would gaze, and bless their early thought—
Their fit designs—to such perfection brought.
Half-century back, and these were scarcely known—
Their place supplied by stuffs of woolsey gown.

Good men of Leeds, your merits will be told
In pilot cloths, when comes the winter's cold;
Your broad cloths, too, we found them in our track,
Some well befitting lord or lady's back—
Material sound, well wove, and nicely dress'd—
For durability will stand their test.

And Huddersfield is scarce distinguish'd less,
For vestings and for articles of dress.
Dewsbury, Bolton, Halifax, from space,
In goods untold, alike adorn the place.

Old Sheffield well supports her ancient name,
Or rises higher on the list of fame;
Her polish'd steel and her electro plate,
Might ornament the sideboards of our great.
Hardware and cutlery so good and sound,
'Tis doubtful if her equals can be found.
Our modern Birmingham, reaps new renown,
In world of articles almost her own;
Although her fame had reach'd to lands afar,
For guns and various implements of war,
In precious metals she has much to do,
Rich in design, and manufacture too.
And Wolverhampton, here her genius tries,
A fair competitor to win some prize.

And ancient Nottingham looks well in place,
For hosiery and great variety of lace.
Derby and Leicester too, adorn these scenes,
Norwich, for gloves, for crapes, and bombazines.
Fair Coventry, in every shade and hue,
In rainbow arch of ribbons, meets your view;
And we beheld amongst the various stalls,
Bradford's best woollen goods, and Paisley's shawls.

For glass, for china, and for earthenware,
We point you to a world of beauty there;
And using here superlative degree,
Great Staffordshire, how much is due to thee.
And rugs and carpets here are also shown,
As soft for foot, almost as beds of down;
And here is one to great perfection brought,
That three-times fifty British ladies wrought;
Yet what most pleased us from the charming fair,
Their own initials grace the border there.[5]

Genius belov'd most where'er thou art—
Lincoln and Louth have each display'd their part;
Tea service, just arriv'd, you may behold,
Compos'd entire of Californian gold;
And we might almost term those fairy bowers—
The rich display of artificial flowers.

The muse on busy wing, seeks England west,
For finest broad cloths and the very best.
Though doom'd to leave behind towns great and small,
Our heart's best wishes here include them all;
Yet name one fav'rite spot of ancient growth,
From our kind homes, a point the west of south.
Hail, LONDON, hail! all hail thou mighty mart,
The honest pride of every British heart;
For wealth, for beauty, and for most that's fair,
For sterling worth, perhaps beyond compare;
There's scarce a gem in this bright place we see
But faithful type might still be found in thee.
A noble city, held in high esteem,
Of all our wonders thou art one supreme!
Thy Spitalfields, though deem'd a common place,
Still represents a long distinguished race;
Here silken trophy crowns their latest fame,
And stamps their genius with a lasting name.
Still further, mark the bright resplendent ore,
In gold and silver, what a boundless store;
What skill, what beauty, you may here discern,
From tall calabrium, to the rich epergne.

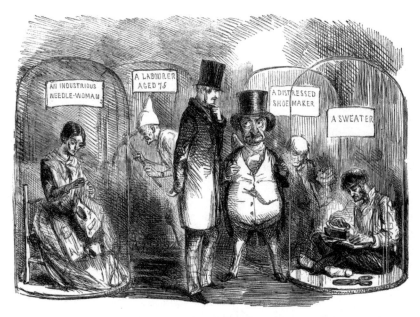

SPECIMENS FROM MR. PUNCH'S INDUSTRIAL EXHIBITION OF 1850.
(TO BE IMPROVED IN 1851).

15 'Specimens from Mr. Punch's Industrial Exhibition of 1850 (To be Improved in 1851)', *Punch*, 13 April 1850, p. 144

5.2 Shilling Days and holidays

The Exhibition was conceived partly as a celebration of industry, but the anticipated flood of the visitors who were primarily responsible for that industry needed to be carefully managed. Three issues predominate in the organisers' plans for creating accessibility for the working classes: travel, accommodation and affordability.

Throughout 1850 the Executive Committee communicated with the local committees encouraging the arrangement of co-operatives, the first of which was formed at the Hope and Anchor public house in Bradford in March. Members would contribute monthly subscriptions to a fund which would enable the club to travel *en masse* to the capital. Many manufacturers in the regions allowed specific, subsidised, holiday time so that their employees could visit the Exhibition and afford to stay for several days. On 15 March, *The Times*, somewhat patronisingly, carried notice of this first of many co-operatives as 'a curious illustration of the forethought of the working classes'. To encourage participation in the co-operative schemes, the large railway

companies agreed, on the instigation of Redgrave, to offer cheap tickets only to members of travelling clubs. This was one way in which the organisers aimed to control the number of visitors to the Exhibition. The evidence of rail tickets, alongside admissions, later enabled Redgrave to monitor with some accuracy the number of working-class visitors to London during the period of the Exhibition, the length of their stay and their impact on trade – and crime rates – in his report to the Commission, part of which is included here.

Ticket pricing for the Exhibition itself was also carefully calculated to avoid overcrowding – and to keep the classes segregated, particularly during the first month when the number of visitors expected to be in attendance was unclear (RC/H/1/2/81). Season tickets, of which 773,766 were sold in total, were priced at £3 3s for men and £2 2s for women. The first day the Exhibition opened to season ticket holders only and, for the following two days, entry was £1. This dropped to five shillings until 26 May when the price during the week was reduced to a shilling, except on Fridays (2s 6d) and Saturdays (5s). The 'Shilling Days' were designed to promote the social inclusiveness of the Exhibition, although it was also a manoeuvre partly intended to keep the classes apart. *The Times* was not unusual in predicting that once 'the aristocratic element retires ... King Mob enters' (23 May 1851), while *Punch* weighed into the issue with an eye-witness account of the first Shilling Day, which mocked the extra security that had been put in place and exploded the idea that an unruly working-class mob would descend on the Exhibition. Contrary to expectation, in *Punch*'s view, it is the lower classes who have shown the 'superior classes' how to conduct themselves with propriety. Also included here is the report in *The Times* of 13 June of the party of agricultural labourers hailing from Godstone, Surrey, who are treated as an object of curiosity. The rhetoric of patronage is particularly condescending.

Temporary accommodation – its standard and cost – in the capital was another issue monitored by the Commission, as is apparent from the Executive Committee's announcement of accommodation for artisans and publication of a form of application for registry of lodgings (Figure 16). The action needs to be set in the context of the wider concern for the living conditions, particularly the sanitation, of the lower classes. The extract from *The Times* (26 May 1851), is written in praise of Prince Albert's project for the erection of model houses, designed by Henry Roberts and built by the Society for Improving the Condition of the Labouring Classes. *The Times* gives details of the interior arrangements of these cottages, intended to provide comfortable and affordable tenements for the working class, the first of which was originally placed outside the Crystal Palace before being dismantled and reassembled on the edge of Kennington Park (where it can still be seen today) in 1853. At the end of the Exhibition the model house was awarded a Great Medal, the most prestigious of prizes.

Working Man's Holyday in 1851, *The Times* (15 March 1850), p. 8

The following which has already been issued in Bradford, is a curious illustration of the forethought of the working classes:— 'The public are respectfully informed that a money club will be established on Wednesday, March 13, at the Hope and Anchor Inn, Market-street for the purpose of accumulating the funds to enable the members to visit the Exhibition of the Works of industry of all Nations in 5*l* shares, to be paid by monthly subscriptions. Members to take one or more shares. Parties desirous to become members are requested to attend at the above place at 8 o'clock in the evening, when rules and other requisite information will be provided. Similar clubs will be commenced at various inns in the town and neighbourhood, of which further particulars may be had of the printer. The promoters of these clubs earnestly entreat all artisans and others who can make it convenient to become members, which will be conducted on the most economical principles, so that they may secure necessary funds to enable them to visit the great exhibition to be held in London in May, 1851, which is so well calculated to improve the moral and intellectual condition of all classes.— Bradford, March 11, 1850.'

Railway Travelling Clubs, *The Times* (14 December 1850), p. 5

The following circular has been issued to the local committees by the Executive Committee:—

'Office for the Executive Committee, 1 Old Palace-yard
Westminster, Nov. 25.

'Sir,—With reference to the copy of the resolutions of certain railway companies recently transmitted to you, we beg to call your particular attention to resolution No. 2, by which you will observe that the facilities proposed to be afforded for enabling the working classes to visit the Exhibition next year are confined exclusively to those associated in clubs.

'The expediency of promoting the formation of travelling clubs has thus become a subject which in our opinion deserves serious consideration, and we will request that you bring this resolution before your committee, with our earnest recommendation that they should use their weight and influence for the formation of such associations as shall be acceptable to the working classes. In towns, however, where such associations are already in active operation we would suggest that your committee might express their readiness to promote the establishment of additional clubs, should the wants of the town or any other circumstances be found to render them desirable.

'We would also suggest that resolution No. 2 should be widely circulated in your district.

'We should be glad to be advised from time to time of the progress made in these arrangements.

'We are, Sir, your most obedient servants,

'W. REID.

'A. REDGRAVE.'

The Shilling Days at the Crystal Palace, *Punch* (7 June 1851), p. 240

On being informed on the best American authority that the first shilling day was to be the downfall of the Crystal Palace, we went to the spot, determined to take out chance of being buried in the rubbish, cut down with the glass, or left a miserable survivor to moralise, like MARIUS, over the ruins. Leaving our office at eight o'clock, we expected to find the tide of population already rushing down Fleet Street with fearful impetuosity; but the tide was not up, for scarcely any one was stirring, and we were therefore obliged to tow ourselves, or rather to trust to our heels, in making our way to Knightsbridge. On reaching the doors of the Exhibition, we found massive barriers intended to contain the multitude; but the multitude consisted of so few that they could scarcely contain themselves, for they kept bursting with laughter at the ponderous preparations for resisting their expected violence. It was quite evident that JOHN BULL has no need for barricades in any shape, and on this occasion, the monstrous wooden break-waters, intended to resist the anticipated human torrent, excited only his playful ridicule.

On reaching the interior of the building, we had been led to believe, or rather we should have been lead to believe, that the mob of shilling visitors would at once proceed to a sort of Fine Art distribution by declaring a dividend—among themselves—of all the precious assets within the Crystal Palace.

Communism was to have been put into practice—according to our American informants—on the first of the shilling days; the jewellery was to have been seized by a *coup de main*, while England was to have been declared a Republic under the wings of the United States Eagle. The Koh-i-noor diamond, especially, was to have become the subject of a community of goods; but how this was to be done we know not, unless by breaking it in pieces, grinding it to dust, reducing it to powder, and scattering it over the whole world, with a due regard to the equal rights of all people. As to the clocks and watches, those were to have been dealt with after the same fashion; the principles of Communism being applied, probably, by giving a hand to one, a number to another, a wheel to this one, and a spring to that, for the purpose of carrying out the grand Socialist idea of an equal distribution of property. Even the authorities seem to have been influenced by some such delusion, for the Koh-i-noor was guarded by an extra policeman, whose office was an invidious sinecure; for the intelligence of the shilling visitors caused them to pass with indifference the rather uninteresting object, which attracted the vulgar and stupid gaze of the guinea and five shilling visitors at the opening of the

Exhibition. The 'superior classes' must begin to look about them, if they would retain the epithet assigned to them; for there is no doubt which class has shown itself to be the superior, in the view taken of the Great Exhibition.

The high-paying portion of the public go to look at each other, and to be looked at, while the shilling visitors go to gain instruction from what they see; and the result is, they are far better behaved than the well-dressed promenaders who push each other about, and stare each other out of countenance on the days of the high price of admission. These people, however, have received a noble lesson from THE QUEEN, who, throwing overboard the vulgar prejudice of exclusiveness, has visited the Exhibition on the shilling days, with a graceful reliance on the masses, which their admirable behaviour has well merited. HER MAJESTY has furnished an excellent example, also, by the manner in which she views the contents of the Crystal Palace; looking at every department in its turn with an intelligent eye, and thus setting a fashion which it is a real glory to lead, instead of being merely the royal dummy, or lay-figure, from whose dressing-up the female world may take the shape of a sleeve, the form of a robe, or the colour of a ribbon. The QUEEN and the shilling visitors are actuated by the same rational desire for instruction, and the extremes in the order of society have met on the intellectual ground that has been thrown open to all by the Great Exhibition.

The Great Exhibition, *The Times* (13 June 1851), p. 5

A remarkable feature of yesterday's experience in the interior of the Exhibition was the appearance there, at an early hour, of nearly 800 agricultural labourers and country folk, from the neighbourhood of Godstone, in Surrey, headed by the clergymen of the parishes to which they respectively belonged, and organised for the occasion into companies like a regiment of militia. They paid 1s. 6d. each towards the expenses of the trip, the rest being defrayed by the gentry of the neighbourhood; and, notwithstanding the weather, they were conveyed to the Exhibition and back again to their homes in a very expeditious manner, and with the utmost care for their comfort. The railway station was reached by wagons and from London-bridge terminus to Westminster they were brought up by steamer. Thence, after seeing Westminster-hall, they proceeded on foot and in marching order to the Crystal Palace, and, having spent several hours there in exploring the wonders of art and industry, at 4 o'clock they took their departure, returning as they came. The men wore their smartest smockfrocks, the women their best Sunday dresses, and more perfect specimens of rustic attire, rustic faces, and rustic manners could hardly be produced from any part of England. The town portion of the assemblage gathered round them as they mustered before departing in the transept, with looks full of curiosity, not unmingled with a species of half-pitying interest; and many were the questions put to them as to what they thought of the Exhibition? what were they most struck by? whether they understood what they

had seen? and if they would like to come again? After some little marshalling they left the Exhibition in close order, moving three abreast—an affecting array of young and old, male and female, in which each observer might read with his own eyes the evidences of a laborious life, little relieved by intelligence or education, but simple, unpretending, and not unaccompanied by domestic virtue and happiness. They were chiefly, we understand, from the parish of Lingfield, and their rector, the Rev. Mr. Hutton, who attended them, deserves great praise for this truly benevolent and pastoral act, which ought to be extensively imitated.

The Great Exhibition: Model Houses, *The Times* (26 May 1851), p. 8

In connexion with the Great Exhibition we have several times drawn attention to the model house for the labouring classes erected by his Royal Highness Prince Albert at the Cavalry Barracks, Hyde Park. The subject is one of great importance, and a visit to the building, which is now completed, will be found very instructive. For some time past a lively interest has been taken in this matter by the most philanthropic men of the age, for in both town and country the sanitary defects of the dwellings of the poor were felt to be a reproach upon our civilization. There were obstacles, however, in the way which it was found extremely difficult to overcome. In the first place, the question of expense presented itself. Cottages were erected very pretty to look at, and a vast improvement in their internal arrangements on the old forms of dwellings in use, but when they were completed it was found that the cost, as compared with the ordinary rates of wages, precluded the idea of their extensive adoption, and that as trade speculations they would not answer. Considerate landlords have nevertheless provided in many instances convenient and comfortable accommodation for their workpeople, actuated by a laudable desire to see them comfortable; and the Society for Improving the Condition of the Labouring Classes has erected model lodging-houses in different parts of the metropolis, which, being constructed on a large scale, have returned a fair profit on the money invested in them. So far success had been achieved, but it was necessary to carry the experiments made much further before any permanent or extensive effect could be produced in the objects contemplated. It was requisite to show that at a cost, if not smaller certainly not larger than, that at present incurred for building the very inadequate houses which workmen and their families inhabit, houses could be erected giving them the benefit of sanitary arrangements, and providing for their increased comfort, cleanliness, and domestic decency. The rate of wages in this country, whether in the rural or town districts, leaves but a small margin over, after the purchase of food and clothing, for rent and the other expenses attached to it. This sets limits to the outlay in building labourers' tenements which cannot be transgressed, and the consequence has hitherto been that they have been compelled to live in abodes totally unfit for human habitation, and which have led to an immense amount of preventable mortality among them.

Accommodation for the working Classes 169

EXHIBITION OF 1851.

ACCOMMODATION FOR ARTIZANS.

REGULATIONS under which a Register of Persons disposed to provide ACCOMMODATION FOR ARTIZANS, &c., from the Country, whilst visiting the EXHIBITION OF 1851, will be opened by the Secretary of the Executive Committee of the Exhibition under the direction of Her Majesty's Commissioners :—

1. No fee will be charged for registration.

2. The names of persons of good character only will be received, and parties must be prepared to produce references to character, if required.

3. Authorised persons to be admitted to inspect all registered houses.

4. Accommodation for married couples and families, for single men, and for single women, must be distinct. In no case can single men and single women be lodged in the same house.

5. In case of lodgings for females, the arrangements must be superintended by a married woman.

6. The prices charged for accommodation to be fixed up in every room.

7. A form of application, to be obtained at No. 1 Old Palace Yard, Westminster, must be filled up and signed by every person desirous of being registered.

8. If any person refuse to conform to these regulations, or others which may be found necessary, his name will be erased from the Register.

The object of the Register is explained in the following " Decisions of Her Majesty's Commissioners" (Nos. 60, 61), to which particular attention is desired :—

ARRANGEMENTS FOR THE VISITS OF THE WORKING CLASSES.

61. With the view of affording information, a register has been opened at No. 1 Old Palace Yard, Westminster, by the Secretary of the Executive Committee for the Exhibition of 1851, in which will be entered the names and addresses of persons disposed to provide accommodation for artizans from the country whilst visiting the Exhibition next year. Copies of the Register of Lodgings may be had on application. Other arrangements are under consideration for guiding the Working Classes on their arrival by the trains to the Lodgings they may select. The Register contains a column in which the particulars, &c. of the accommodation each party proposes to afford will be entered. All applications for participating in these arrangements must be made through Local Committees.

62. It must be clearly understood that whilst Her Majesty's Commissioners are desirous of collecting the fullest information likely to be serviceable to the Working Classes, they do not propose to charge themselves in any respect with the management, but simply to afford information.

(*Signed*) M. DIGBY WYATT,

16 Registration form for 'artizan accommodation'

165

EXHIBITION OF 1851.

FORM OF APPLICATION FOR REGISTRY OF ACCOMMODATION FOR ARTIZANS, &c., VISITING THE EXHIBITION.

1. *Name of Street and No. of House*

2. *Is the Accommodation,—*
 a. *For Married Couples* - - -
 b. *For Single Men* - - - -
 c. *Or for Single Women* - -

3. *No. of Bedrooms* - - - - -

4. *No. of Beds* - - - - - - -

5. *No. of Sitting or Mess Rooms* -

6. *Price of Lodging per Night, including all charges for attendance, linen, water, soap, lighting and firing in a public room, &c.*

7. *If Meals be provided,—*
 a. *Price per Meal—Breakfast* -
 b. „ *Dinner* -
 c. „ *Tea* - -
 d. „ *Supper* - -

SIR,

 I request that you will insert the above particulars in the Register of Lodging-Houses, &c., for Artizans, whilst visiting the Exhibition of 1851; and I undertake to conform to the Regulations laid down for the management thereof.

I am, Sir,

Your obedient Servant,

M. Digby Wyatt, Esq., Secretary of the Executive Committee of the Exhibition of 1851.

[*Turn over.*

Damp walls and floors did one part of the work of destruction, and overcrowded rooms, where cleanliness, decency, and comfort were impossible, the rest. At this stage in the sanitary movement it is superfluous to say more on these subjects, as their evil influences are admitted on all hands. The question remained how were they to be dealt with, how was the working man to be provided with a suitable home at a rent which his wages permitted him to pay? It was found that the inferior bricks of which his humble tenement was constructed held water like a sponge, and that from one of them as much as a pint of moisture could be extracted. He and his family, therefore, were constantly undergoing, night and day, a species of hydropathic treatment which doomed them to inhale damp air, wear damp clothes, sleep in damp beds, and suffer all the complicated miseries which arise from walls streaming with water, and absorbing the rain from without, and the heat of the fire from within. That was one great difficulty to be overcome, and it has been accomplished in a very successful and ingenious manner. The bricks used in the construction of the Prince's model houses are hollow, whereby their strength is preserved, at the same time that the necessity for lath and plaster is removed, and perfect dryness secured. Their form renders them applicable, not only for side and partition walls, but floors and roofing, and by glazing their surfaces the most ample facilities are given for cleanliness. Each room can be washed out as thoroughly when thus constructed as an earthenware dish, and fuel is not uselessly expended in warming a solid mass of material saturated with moisture. By this species of wall ventilation, which, singularly enough, appears to have been practised among the ancient Romans, the close fetid smell so offensively present in apartments that have been overcrowded for some time after they are vacated is entirely got rid of. Other advantages also present themselves, for buildings thus constructed obviously become fireproof, and hollow bricks are found to be excellent non-conductors of sound. In small confined tenements there is no greater source of discomfort than that which arises from the manner in which the slightest noise penetrates through partitions and floorings, and a simple inexpensive arrangement, which protects the quiet and privacy of the poor man's family, is a boon of immense value to him. The use of hollow bricks is thus recommended by a variety of considerations, but the chief benefit which it confers remains to be stated. By it a saving of at least one-third is effected in the expense of ordinary construction, and quite as much in fuel and annual repairs and insurance. We shall revert to this point again, and in the meantime proceed to other matters worthy of special notice in the arrangements of the model houses. One peculiarity which strikes the visitor is the avoidance of expensive woodwork and the employment of few and cheap materials to do all that is required. The plasterer and the carpenter are almost entirely dispensed with, and mineral manufactures, in one shape or other, are resorted to. Everything is of durable material, and little liable to go out of repair. There are some obvious improvements which might be made in the construction, and some economies that might be effected, for the building is, of

course, experimental in its character, and does not claim perfection, being undertaken by his Royal Highness principally to stimulate the efforts of those whose position and circumstances enable them to carry out similar undertakings. Viewing it as a whole, however, the visitor will not fail to observe that it is a good working model, not a mere prettiness expensively got up and inapplicable to practice, but a sincere, honest, and sensible attempt to supply a design for the style of architecture suitable to the labouring classes and within their means to command and pay for. It is adapted for the occupation of four families of the class of manufacturing or mechanical operatives residing in town or near it. Each tenement is arranged on precisely the same plan, having a well-lighted lobby or porch, a living room, a scullery, a watercloset, and three sleeping apartments, all simply but effectively provided with convenient fittings for domestic comfort. The separation of the sexes and parent and child is complete. Closets, dustbins, sinks, safes, shelves, &c. are included in the plan. The ventilation is carefully attended to, and, above all, the water-supply is not neglected. Some varieties exist in the manner of finishing the different rooms, and the public will form a better conception of the care with which the whole has been got up when we mention that nearly a dozen well-known manufacturers and makers have been laid under contribution for suitable materials. Thus Clayton's tile-machine turns out the hollow bricks. Ridgeway supplies the earthenware, and the whole has been under the direction of Mr. Roberts, honorary architect to the Society for Improving the Condition of the Labouring Classes. We come now to the questions of expense and profit,—from rent, upon which of course the success of the experiment turns. The calculation on this subject is that a building of the kind can be erected for 400*l*., or about 100*l*. for each tenement, and that payment of 1s. per week for each room, or about 3s. by each family, would pay 7 per cent. and cover all contingencies. Now, any one who knows what the house-rent of the labouring classes in London is regard this a very successful result. In Church-lane, St. Giles's, 3s., 4s., and 5s. per week are paid for single rooms of the same size, and in these abodes of vice and misery malignant fevers, and every form of epidemic disease, are constantly at work, doing frightful havoc. Let anyone who wishes to understand, in its true significance, the importance of that movement for improving the condition of the labouring classes over which Prince Albert so appropriately presides, after paying a visit to the model house at the Knightsbridge barracks, go direct to Carrier-street, or Church-lane, or Kennedy-court, St. Giles's, and he will learn an instructive lesson from the contrast thus presented to him. He will be moved with compassion at the spectacle of such squalid misery, and with gratitude that at the Great Exhibition of the world's industry the hard lot of those who toil in the lowest grades of labour is not forgotten. At present the model houses are only accessible by order, but we trust soon to see them unreservedly thrown open to all comers. It is only in that way that those whose comfort they chiefly provide for can see them properly, and until the humbler classes themselves enter into the

schemes and plans for the social improvement entertained by those above them in station little real progress can be made.

Report of Mr. Alexander Redgrave on the Visits of the Working Classes (9 December 1851; *First Report*), pp. 111–26

NUMBER OF VISITORS

From inquiries I have made as to the duration of the visits of the Working Classes, I am led to believe that, with the exception of the 'day excursionists,' it was seldom less than three days and frequently nearly a week. The visits of the middling classes certainly lasted a week, and were generally extended to the limits of their ticket (the ticket varied on different lines, from one to three weeks being allowed according to circumstances). If the arrivals were spread over the whole period of six months, they would amount to 23,540 per day, but they were much more numerous during the last three months, and if the whole of the increase were thrown upon these three months, the arrivals would average 29,290 per day: assuming this latter calculation to be nearly correct, and that each passenger of the extra number who arrived in town (1,035,100) spent on the average one week in London, the permanent addition of visitors to the population of the Metropolis, during the whole of these three months (the *ordinary* arrivals being equalized by the departures) would amount to 80,000.

LODGING, FOOD, CONVEYANCE, &c.

[…] After making some inquiries on this subject, I was not encouraged by the probable results to pursue it further, being satisfied that if a positive increase had taken place it would have been known from other sources.

STATE OF EMPLOYMENT AND PRICES

The various grades and classes of society in the Metropolis are so closely united, and their mutual dependence is so interwoven, that the fluctuation of pauperism and of abundant or scanty employment is, with few exceptions, only in seasons of *general* prosperity or depression. So long as the price of provisions is moderate, so long will there be employment for the labouring classes in the Metropolis, and a consequent diminution of pauperism. In manufacturing towns and in purely agricultural districts, a sudden rise or fall in the price of the raw material, or of agricultural produce, at once affects the condition of the labouring poor; but in the Metropolis these sudden changes are rarely known. The modes of gaining a livelihood are so various, and the directions in which employment can be sought are so manifold,

164

that it is very seldom a partial depression is felt. During the last two years the price of bread, meat, and clothing has continued moderate, and the supply has been abundant, especially in the Metropolis. The condition of the labouring man is therefore in many respects satisfactory, and no very marked difference will be found in the number of poor dependent for relief upon the metropolitan parishes.

The following is a statement of the number of paupers relieved in the Metropolitan Unions on the 1st of July 1850, and on the 1st of July 1851.

	1850	1851
In-door paupers . . .	14,362	14,588
Out-door	43,206	38,552
Total	57,568	53,140

The prices of the chief articles of consumption exhibit but little difference during the past summer, as compared with 1850. Bread remained at the same price during the two periods; meat has varied but little; of poultry or fish no record of price can be consulted. The following are returns of the average prices at Smithfield market, and of the contracted price of the several kinds of provisions required in poor-houses of the Unions forming the Metropolitan District

Average Price of the best descriptions of Meat in Smithfield market in

	1850	1851
Beef . . .	3/6½	3/6
Mutton . .	4/0¼	4/0¾
Veal . . .	3/8¼	3/9¾

Average Prices of Provisions in 36 of the Metropolitan Unions.

	1850	1851
Meat . . .	4/11¾	5/1 per stone of 14 lbs.
Bread . . .	10/2¾	10/0¾ per cwt.
Flour . . .	30/1¾	30/6½ per sack.
Milk . . .	1/3½	1/3 per gallon.
Cheese . .	36/2½	35/9¾ per cwt.
Potatoes . .	86/11½	77/1¾ per ton.

STATE OF CRIME

An uninterrupted succession of arrivals or large numbers of all classes, both from the provinces and abroad, the absence of experience as regarded their conduct under circumstances so new and unprecedented as those of the present year, and the impossibility of conjecturing the course which might be taken by unscrupulous agitators, led many most intelligent persons to anticipate these arrivals with

anxiety and even with alarm; and although their fears have not been realized, yet there were many considerations pregnant with doubt, if not apprehension; the recent revolutionary movements on the Continent, the freedom of access to this country to men proscribed in their own, and the temptations to the increased activity of our own disorderly population, were matters which, at the time, required serious attention as affecting the public tranquillity.

[…]

The following returns have been prepared from the monthly reports of the Police Magistrates to the Secretary of State for the Home Department, and they represent the actual condition of the Metropolis in regard to crime, disorder, &c., with greater accuracy than the returns prepared by the Commissioners of the Metropolitan Police, inasmuch as the jurisdiction of the Police Courts is nearly co-equal with the limits of the Metropolis, and extends to every description of charge which appears in the Metropolitan Police Returns, while a large proportion of cases are brought before the Police Courts by summons, &c., of which the police have no cognisance, amounting to more than 10,000 cases in the year.

The total number of persons included in the returns from the Police Courts, and from the City Police, for the period of six months from the 1st of April to the 30th of September was in

1850	1851
44,075	45,294

The presence of a large body of trained and efficient police, and the exercise with promptitude of the duties which have been required of them, would have tended to deter from the commission of many offences which a less numerous or active body of men would have been unequal to prevent; and when it is considered that a multitude of all classes and countries assembled in the Metropolis during the past summer, that a large addition had been made during that period to the strength of the police force, adding greatly to the means and opportunities of apprehending offenders, these figures are certainly not the least among the many gratifying incidents of the Exhibition.

But this satisfactory condition must not be attributed to the exertions of the police or to the judiciousness of the regulations they were instructed to enforce. It is to the mass of the people themselves that is due chief praise for sobriety, good feeling, and propriety of conduct under the greater temptations in which they may have been placed during the present year.

5.3 The radical press and local committees

Evidence of middle-class concerns about working-class participation in the Exhibition is abundant, but what were the concerns of the working class

themselves? This is a narrative that needs to be incorporated into any study of the Great Exhibition and can only really be told by evidence gleaned from the regional and working-class press and associated correspondence.

The *Northern Star*, first published in Leeds in 1837 by Feargus O'Connor, was the most successful of the Chartist newspapers, promoting its owner's radical political views even during the period in which he was imprisoned for libel in 1840. By the time of 1851, the *Star*'s circulation had dwindled, and O'Connor sold the paper in 1852, but the extract included here still provides an insight into the objections of the radical press to an Exhibition tainted by 'aristocratical hauteur'. The *Star* attacks the Commissioners over their plans to exclude the populace on the opening day. An even more scathing view of the same subject comes from G. Julian Harney, a prominent Chartist, who openly proclaimed that the Exhibition was designed to serve the interest of the ruling classes and 'exploiting capitalists' rather than the proletariat. His letter is taken from his newspaper, *The Friend of the People*, which was named after Marat's radical periodical and it echoes many of the concerns that we have already seen in the broadside, 'The Great Job of 1851' (see 1.3).

There are myriad accounts from regional sources about the flurry of activity in the run-up to the Exhibition; representative is the extract included here from the *Leeds Mercury*. The *Mercury* had been a prominent supporter of the liberal agenda of the Exhibition, strongly endorsing, for instance, Paxton's short-lived proposal that admission should be free. The edition of 1 March 1851 gives a good flavour of the logistics, and cooperative nature, of the active local committees without which the Exhibition would not have been possible. It is notable for demonstrating the regional response to the Executive Committee's plans for travel clubs and the suspicion that a cartel of railway companies would overcharge travellers. They demand to know the precise nature of the 'conditions of transit'. Significantly two local committees, Bingley and Knaresborough, carry reports of talks given by Thomas Cook, pioneer in tourism, designed to reassure prospective travellers on the Midland Railway. Along the same lines, Figure 17 shows an advertisement for a lecture on the Exhibition given at the Leigh Mechanics' Institute in August 1850.

Other reports demonstrate the degree to which Yorkshire had embraced the Commissioners' emphasis on innovation and ingenuity, especially in textiles and engineering. The committees for Huddersfield and Holmfirth report proudly on fabrics including an entirely new material called 'Crape Chiné Royale', a royal blue heavyweight crêpe-de-chine. The representation of industrial process is foremost in the account of a miniature steam engine submitted by Holmfirth and the exhibit of the miniature, working colliery from Wakefield. In Knaresborough extra incentive to provide exhibits was evidently given to local manufacturers by the contribution of £50 by the

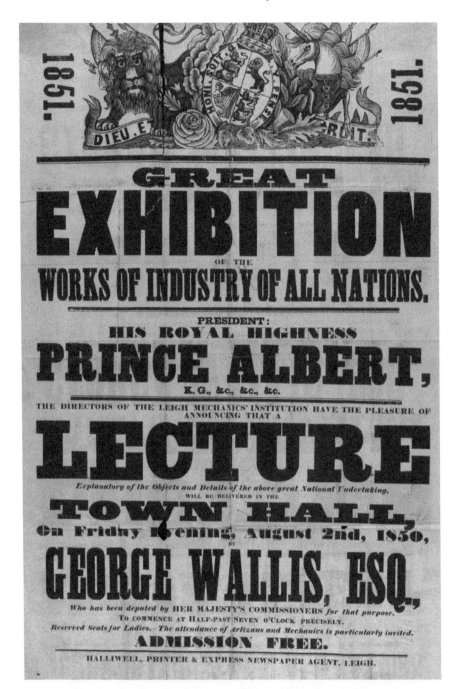

17 Advertisement for a lecture on the Great Exhibition at Leigh Mechanics'
Institute, 2 August 1850

local M.P., J. P. B. Westhead – regional pride was at stake. Amongst all this industry, it is worth remembering that the reception of goods for the Exhibition had only begun on 12 February, emphasising the rapidity with which the local committees were working.[6]

If the *Mercury* suggests a happy consensus, the final extract in this section presents another dissenting voice from the field of manufacture. Signed anonymously by 'A Mechanic', the letter written to *The Times* cautions against his experience of a 'London mob', echoing the earlier comments in *The Times* about 'King mob'. Redolent of Uriah Heap, the author humbly proposes his own way of ensuring security for exhibits by careful management of entry prices. The conclusion of the letter makes it clear that it has been prompted by the prospect of free admission, which the *Mercury* and others had so firmly supported.

Opening of the Great Exhibition by the Queen, *Northern Star* (19 April 1851), p. 4

By a decision of the commissioners of the Great Exhibition, it appears that we are to make an exhibition of aristocratical *hauteur* and exclusiveness at its opening, which will make us look excessively ridiculous and contemptible in the eyes of our visitors. The Glass Palace has been raised by voluntary subscriptions. The whole of the expenses attendant upon its construction and maintenance are expected to be paid for by those who visit it. If ever there was a building or an object that ought to have been kept free from favouritism and exclusivism, the Hyde-park Exhibition should have been undefiled by both. Not so think the Commissioners. They have solemnly decreed that it should be opened by the Queen, in the presence of themselves, the members of the royal household, the government, and the diplomatic corps. They may mean this regulation as an honour to the sovereign, but in reality it is a reflection both on her character and that of her people. Whatever may be the differences of opinion in this country as to the operation of our political system, we believe that in no class of party does there exist any other feeling than that of high respect for the lady who now fills the throne of these realms. During her numerous journies [*sic*] in all parts of the country this has been unequivocally demonstrated; and they are no friends of QUEEN VICTORIA who make arrangements that imply distrust, suspicion, or alienation on her part towards the people. With the exception of the conduct of such miscreants as Oxford, and others, to which not the slightest political *animus* was ever attached by any party, the QUEEN has, at all times, experienced the most generous, cordial, and respectful reception from them. She will continue to enjoy that respect, and to receive that cordial welcome, as long as she treats them in the same frank and hearty spirit of mutual confidence which has heretofore distinguished her public appearances. The inauguration of the Crystal Palace by a few white sticks, grandees, and foreign ministers, to the

exclusion of the public, as proposed by the commissioners, will not only be an insult to the people of this country, but an insult to the SOVEREIGN herself, and an incident calculated to lower both her and the nation in the eyes of the world at large. It would almost seem as if the alarmists who have concocted such unfounded reports as to the contemplated outbreak of the associated Socialists and Red Republicans from all parts of the globe, have had influence enough to persuade the commissioners to give colour to these dastardly fabrications by the adoption of such a course.

We trust, however, that if the SOVEREIGN does open the Exhibition, it will be in such a manner as to show that she trusts in the intelligence and honour of the people, and will not be driven into the adoption of a course that may suit the execrated despots of some small Continental Principalities, but which is wholly unjustified by the relations of the QUEEN and the People of England to each other.

G. Julian Harney, *The Friend of the People*, 22 (10 May 1851), p. 152

[…] The 'pageant', such as it was, was essentially aristocratic. Confined to the interior of the Exhibition, performed by the Queen, her courtiers, chief priests, and soldiers, and witnessed only by the representatives of 'the golden million', it wanted all that was needed to make it really national. The works of art and industry exhibited in the building may be looked upon as so much plunder, wrung from the people of all lands, by their conquerors, the men of blood, privilege, and capital. The ceremony of opening the Exhibition has been called the 'Festival of Labour'. It was, in truth, the festival of a horde of usurpers, idlers, and sybarites, met to exult over the continued prostration of Labour, and the conservation and extension of their own unholy supremacy. I can imagine a fête worthy of an Industrial Exhibition, in which the people at large should participate. I can imagine artists and artisans, workers from the field, and the factory, the mine and the ship, summoned to take their part in a Federation of Labour, — combining Industry, Art, and Science. I can imagine Hyde Park our Champ de Mars, and see the trades of London marching in their thousands, with their banners and emblems, from all parts of the metropolis, accompanied by deputations from the agricultural producers, the miners, and all trades and crafts throughout the island. I can imagine the Exhibition opened, not in the presence of the richest, but of the worthiest of the nation, selected by popular election, to represent not a class, but all. I can imagine a rich array of material wealth, which would testify to the enjoyment, as well as to the skill and industry of the workers; and of which the profit and the glory would be theirs, untouched by useless distributors and exploiting capitalists. Lastly, I can imagine that such a fête —such an Exhibition — will be only when the working classes shall first have renounced flunkeyism, and substituted for the rule of masters, and the royalty of a degenerated monarchy, — 'the Supremacy of Labour, and the Sovereignty of the Nation'.

Preparations making in the Leeds district for the Great Exhibition, *Leeds Mercury* (1 March 1851), p. 2

THE preparation of machinery, goods, &c., from the Leeds district is going most favourably. We understand from Mr. Cawood that upwards of 500 ends of cloth are already applied for to be admitted. These, of course, will have to undergo the ordeal of the local jury, before they can be received into the Exhibition.

The warehouse, No. 12, Bishopgate-street, where the goods are at present deposited, is carefully watched day and night by the police. The property is insured by the executive committee, and every arrangement made, as far as can be foreseen, for the proper charge of the articles entrusted to their care. A jury for general purposes, consisting of C. G. Maclea, George Leather, R. S. Church, and Wm. Osburn, jun., F.S.A., Esqrs., has been appointed, whose duty it will be, along with the secretary, to pass the articles not included under machinery, woollens, stuffs, and blankets; for which separate juries have already been appointed.

The estimate for the setting up of the counters has been given to Messrs. Fox, Henderson, & Co. and we believe they will be fitted in the manner suggested by the executive in London, viz., of rough deal boards, and covered with suitable paper, calico, or cloth. In all our varied branches of manufacture we believe that our town and district, the most important and populous in the large county of York, will be amply represented. The amount of space granted to us (although far below our wants) exceeds that of any other town in the county to a large extent. The Woollen Jury will meet next week, and we doubt not will exercise a sound discretion in selecting such goods as will do credit to the district.

RAILWAY TRANSIT AND LODGINGS FOR THE WORKING CLASSES

The gentlemen appointed by the executive of the Leeds District Exhibition Committee to superintend this agency, have, we understand, been endeavouring to carry out the object of their appointment. Impediments, however, have arisen, which are not yet removed. At the second public meeting, held in the Court-house, considerable doubt was expressed as to the finality of the arrangements made by the railway companies, and communicated to the public through the Royal Commissioners; and a strong opinion was expressed as to the desirableness of an early settlement of the two questions—1, of the rate of charge, and 2nd, of the conditions on which the companies would treat with clubs, or other associations, desirous of availing themselves of the cheap trains. The committee accordingly placed themselves, forthwith, in communication with two of the companies having a terminus at Leeds, and then learnt, to their great surprise, that these companies did not admit the construction put on the circular of terms issued to the public by the Royal Commissioners to be correct, namely, that 'only persons associated in clubs would be entitled to travel by the cheap trains.' As The Leeds Exhibition

Committee had been induced to take part in urging the formation of clubs, and also to connect with the lodgings' agency, an agency for railway transit, in the belief that this construction of the railway tariff was correct; they felt at once that it was important to have the question settled, both for their own vindication, and also in order that the public at large might know what the railway companies really meant by their tariff. They accordingly drew up a statement of all the circumstances of the case, and transmitted a copy to the Royal Commissioners. A second copy was placed in the hands of a director of the Midland Railway Company, to be laid before a meeting of representatives of several companies in London. It was strongly urged upon the companies in this document, that they should at once set the whole matter at rest by an authoritative declaration of the terms and conditions of transit after July, and it was at the same time intimated to them that the working classes considered the *rates* too high. No answer having been returned to this statement, further than a verbal communication from the director already named, that the matter was under consideration; the committee met on the 19th, and passed a series of resolutions, in which the material facts of the case were embodied, expressing, in strong terms, their conviction that a good understanding betwixt the several companies would be of great moment to the safety and convenience of the public during the Exhibition season, and declaring their 'unreserved opinion' that the companies were bound by what had taken place betwixt them and the Royal Commissioners and themselves 'to make an immediate settlement of the tariff of prices, and the conditions on which the same shall be available to the working classes; and that further, the railway companies were bound to enter into some mutual guarantee with each other and the public, that the terms and conditions finally announced will be honourably abided by.' Copies of the resolutions were sent to the Royal Commissioners, and to the directors of the Midland, the Great Northern, and the London and North-Western Companies. The resolutions have been acknowledged by the companies, as under consideration, and so the matter rests at present. The Leeds committee feel, that until the decision of the companies is made known, the agency has no basis, and cannot work. What is desired is a clear understanding what the companies intend to do, and then the committee can adapt the machinery of the agency so as to serve the working classes; or, if the terms and conditions announced render it useless, they will be enabled, perhaps, to point out in what manner the great end of the agency, namely, the facilitating of the arrangement for lodgings and transit, can best be effected.

[...]

BINGLEY.—A public meeting upon this subject was held in the New Odd Fellows' Hall, on Thursday evening week. Mr. Thomas Cook, of Leicester, agent of the Midland Railway Company, gave an account of the arrangements entered into for securing the comfort of cheap trip passengers to London and during their

stay there, which gave great satisfaction to the audience. Mr. Cook suggested a system of registration in place of the present clubs, and also that cheap trip passengers be admitted into the Exhibition during their stay upon the payment of one admission fee. On the motion of Mr. Wm. Binns seconded by Mr. John Shackleton, these plans received the approbation of the meeting. Several questions were put by Mr. William Scott, Mr. John Brown, Mr. John Cowburn, &c., which Mr. Cook answered in a very satisfactory manner. Thanks were then given to Mr. Cook and Mr. James Lambert (the secretary of the Bingley Exhibition Club), who acted as chairman, and the meeting separated. There was a very good attendance of the working classes at the meeting, who seemed to take much interest in the proceedings.

HUDDERSFIELD.—We have this week had shown to us a splendid specimen of manufacture in silk for ladies' dresses, intended for the great Exhibition. The manufacturers are Aaron Peace and Co., waistcoating and plaid manufacturers, of Clayton West and Huddersfield, and the name given to the new material is 'Crape Chiné Royale.' It is exceedingly rich in appearance, will apparently be very durable, and comparatively economical.

HUDDERSFIELD.—On Monday morning a number of intending exhibitors in the Crystal Palace, met the Huddersfield Exhibition Committee at the railway station, for the purpose of having their articles examined by the committee prior to their being transmitted to London. There was not a very numerous attendance on either side, but such articles as were produced generally met the approbation of the committee present, and during the day many of them were dispatched for London. We have not yet been able to procure a list of the articles which are to be sent from Huddersfield, but as soon as they have been definitely decided on, we hope to be able to furnish our readers with a correct list.

HOLMFIRTH.—During Friday and Saturday last, great crowds of eager spectators assembled at the house of Mr. James Haigh, the Shoulder of Mutton Inn, to behold a mechanical gem which was being exhibited there in the shape of a miniature steam-engine, weighing only three-quarters of an ounce, yet completing 3,600 revolutions in a minute. Added to this curiosity, too, was a piece of flannel, spun and wove by hand, containing 140 picks in the inch, and manufactured of Stayley-wool, by one William Redcliff. It is said to be the finest fabric ever made out of wool. Of course, these articles are expected to figure at the coming Exhibition.

WAKEFIELD.—There has been exhibited for the last few days, in a warehouse at St. John's, a model of a colliery, intended for the world's show, in May next, and which, we are informed, has been made by a party of enterprising mechanics in the town. This piece of mechanism is a perfect model of a colliery, showing the works of a mine underground, as well as the air shafts, main shafts, and the engine and machinery on the surface requisite for raising the coal. In fact it is one of the most interesting things we have seen for some time, and does great credit

to the parties who have had the making of it, and we doubt not that it will excite a fair share of curiosity when shown in the Crystal Palace.

BARNSLEY.—Amongst the articles sent from this town to the great exhibition is a large carved frame for a looking glass, the workmanship of Mr. Amos Hold, a house painter. The glass, which is 74 inches by 50, is surrounded by carving in pine of exquisite workmanship. This design combines the correctness of the naturalist with the fancy of the poet. Birds, fruits, moths, caterpillars, and butterflies are here represented in happy accuracy. Nothing could be added without crowding, nor anything subtracted without deteriorating the whole.

KNARESBRO'.—The various articles to be forwarded to the Crystal Palace from Knarsebro' were shown to the inhabitants, free of charge, in the national school-room, on Saturday last. The contribution of £50 from J. P. B. Westhead, Esq., M.P., to be awarded to the producers of the best specimens of the manufactures of the borough, was given, by the juries chosen for the purpose, to the following parties:—FOR LINEN—to Messrs. Walton, for ducking sheeting, best ticking, linen sheeting, and huckaback; to George Henshall, for the best fine sheeting, and for the manufacture of a shirt woven in tie, without a seam; to James Leeming, for fine shirting, second best ticking, and for a chemise manufactured without a seam; to Thomas Hibbert, 1st and 2nd prizes for diaper. For WOOL RUGS, &c.—to Jame Robinson, 1st prize for hearth-rug, 2nd for carriage rug, a prize for carriage slippers, and extra prize for muff and boa; to Mrs. Elizabeth Hartley, 2nd prize for hearth-rug, 2nd do. for muff and boa, 2nd do. for table mat or urn stand, and 2nd do. for bonnet; to John Clapham, 1st prize for muff, 1st do. for victorine, and 2nd do. for table mat or urn stand. The juries also awarded extra prizes to William Pearson for a stalactite table, made from dropping well stone; to James Young, for a time-piece upon an improved principle; and to Richard Ellis, for a carved ornamental mahogany case, containing the various mineral waters of Harrogate. Some elegant designs were also exhibited by Mr. P. Pullan, of Manchester, for the decoration of a palace, and also designs for altar pieces; likewise specimens of stone from all the quarries around Knaresbro', all of which are intended for the forthcoming Exhibition. The specimens of taste and ingenuity displayed by all the exhibitors was highly spoken of, and during the afternoon the room was visited by several hundred persons.

HARROGATE.—On Thursday, Feb 20th, a meeting of the Harrogate Improvement Commissioners took place in the Royal Pump Room, for the purposes of receiving from the hands of the contractor, Mr. R. Ellis, the case which has been made to contain specimens of the mineral springs of this district for exhibition in the Crystal Palace. After comparing the article with the plan, the commissioners who were present unanimously expressed their satisfaction with the manner in which the design had been executed. It was afterwards exhibited gratuitously for the public for two days, and was the means of attracting a great number of the inhabitants, the majority of whom appeared well pleased with the design on its execution.

The case is formed of polished mahogany, elaborately carved, and divided into eleven compartments, wherein are placed bottles containing specimens of the following different springs, the chemical analysis of all, with the exception of three, being inserted:—Old sulphur well, Harrogate Kissengen spring, saline Chalybeate, Montpelier sulphur spring, sulphureous alkaline spring, mild sulphureous spring with magnesia, strong sulphureous saline spring, strong sulphureous non saline spring, pure saline spring, old Chalybeate well, and Starbeck spa.

KEIGHLEY.—A public meeting of the inhabitants of this town was held in the hall of the Mechanics' Institution last night week, when Messrs. Cooke, of Leicester, and Calverley of Wakefield, agents of the Midland Railway Company, entered into and explained the arrangements of the company, for the conveyance of passengers to London during the exhibition, and recommending the formation of clubs, or registering the names at the registration depot, to be opened shortly in this town. Before the close of the meeting the following resolution was passed, with a request that the chairman, Mr. Crabtree, would forward the same to the Royal Commissioners:—'That it is the unanimous opinion of this meeting that it would tend greatly to the comfort and accommodation of the working classes visiting the exhibition in companies or clubs, and would not materially affect the receipts, if the Royal Commissioners would admit them on payment of one shilling each, such payment to entitle them to a restricted or even an unlimited number of visits during their stay in London, and that the railway tickets might be made available to act as checks against fraud.' Upon inquiry we find there are already several clubs formed in the town. One in connection with the Mechanics' Institution, numbering about fifty members; another belonging to the Odd-Fellows' Society of about seventy members; and one at the Crown of nearly forty; besides other smaller ones. It is also in contemplation to form a club in connexion with the Temperance Society for the purpose of visiting the exhibition at the time of the intended Grand Temperance Demonstration in London, in July next.

'A Mechanic', Letter to the Editor of *The Times* (24 January 1851), p. 3

Sir,—In common with all well-disposed persons, I am truly concerned at the suggestion of Mr. Paxton for opening the Exhibition of Industry free to all comers. Surely Mr. Paxton can have very little knowledge of a "London mob," for to such, most assuredly, would the Exhibition be delivered over.

Nor could there be a greater blow and discouragement to the preparations now making to visit the Crystal Palace by thousands, to whom the admission fee, compared with their other expenses, is of the most trifling moment, insuring, as it would, a comparatively free and uninterrupted inspection.

What the exhibitors will think of Mr. Paxton's proposition I don't pretend to say, but, for myself, were I an exhibitor of any valuable articles, such as jewellery,

gold and silver workmanship, shawls, &c., I should be inclined to withdraw my application for space, preferring my name as an artisan or manufacturer remaining in obscurity to trusting my handiwork to the tender mercies and chances of a 'free' public.

Sir, I am one of the humbler class, and, unfortunately, am somewhat acquainted with the character of a 'London mob,' a *materiel* once incited (and there will be no want of inciters), and good-bye to all rules of *meum* and *tuum*.

Again, how many of the gentler sex, and the exemplary wives and daughters of our honest artisans, are looking forward to this treat but would, or even could attempt it, if 'free' to 'his majesty the mob?'

I abstain from all allusions to foreigners' visits—their good opinion of the English would, I fear, be somewhat shaken.

Undoubtedly, great care is requisite in arranging the admission, and, if you consider the following humble suggestions worthy a space in your valuable paper, they are at your service.

The first week 20s. each, the second week 10s., the third week 5s., the fourth week 2s. 6d., thereafter, or say from the 1st of June, 1s.

I would have offices for the issue of the tickets for admission, for several days in prospective, and no more should be issued for any one day than from ascertained experience could be conveniently accommodated. This, by a pre-arrangement, would entail no loss of time at the visits of the several local clubs.

There are many other points of detail that would, and no doubt will, suggest themselves to the practical men on the commission: I would only observe, in conclusion, that if it is thought desirable to give days for free admission, it should be towards the end of the period, and even then by tickets judiciously distributed by appointed authorities.

I am Sir, yours, &c.,

A MECHANIC.

5.4 Broadsides and ballads

As the editors of *Ballads and Broadsides in Britain* have it, the ballad is simultaneously ephemeral and significant, 'culturally light-weight' (Fuller *et al.*, 2010: p. 1) and yet illuminating. Ballads were cheaply produced and sold, traditionally associated with lowbrow oral culture, but due to their transience and unreflective nature they offer a snapshot of a cultural moment with more clarity and immediacy than most forms of literature. Ballads, and associated broadside publications (large-sheet papers published on one side only), are often viewed as being a litmus test of popular opinion and the examples included here, taken from the archives of the National Library of Scotland and the Bodleian Library, are characteristically jaunty, vernacular accounts of the Exhibition related from a working-class perspective.

The ballads on the Great Exhibition, represent the working class as an impoverished but colourful group, revelling in their leisure time, with the Exhibition an opportunity for 'larks and sprees', a chance to see exotic foreigners and marvellous exhibits. The Shilling Days are depicted as an opportunity for professions of all kinds – 'Sailors, Labourers, Masons, Bricklayers and Tailors' – to rub shoulders with the aristocracy. But these ballads share with more sophisticated accounts of the Exhibition a need to seek out classical and biblical analogies to communicate the spectacular experience of the Crystal Palace – the tower of Babel, Noah's ark, Jonah and the whale being foremost. The ballad titled 'Crystal Palace' is typical in capturing the visual impact and enormous scale of the Exhibition through gossip, exaggeration and amplification, where a lady's bustle is 'Nine times as thick as Old St Pauls', a cheese mite is 'Five times as big as a donkey' and even the refreshments – in this case a 'halfpenny roll' – are as big as Covent Garden. The implied poverty of those visitors from the lower classes is, however, never far away, and the chance to see the Exhibition while it is 'a bob a head', in 'I'm Going to See the Exhibition for a Shilling', necessitates pawning a coat and trousers to see a diamond worth 'seventy million pounds'. The contrast is perhaps the most striking example of the kind of social commentary that threatens to disrupt the cheerful tone.

Variant spellings and typographical errors – including the title 'The Exhib!tin and Foreigners' – have been retained from the originals.

THE EXHIB!TIN AND FOREIGNERS (*NLS.* Crawford.EB.2527)

Look out, look out, mind what you're about,
 And how you do go on sirs,
Mark what I say in the month of May,
 Eighteen hundred and fifty one, sir.
In London will be all the world.
 Oh! how John Bull will shrill then,
The Russian, Prussian, Turk and Jew,
 And the King of the Sandwich Islands,
Of all the sights was ever seen,
 In all the days by gone, sirs,
Such never was as will be in,
 Eighteen hundred and fifty one, sirs.

Well Neighbour, can you tell me the meaning of
the Great Exhibition they are so looking forward to
held in Hyde Park next May? Tell, to be sure I
can. Don't you know there is to be every body in the
world, aye, and everything in the world, and all cut of the

world, aye, and everywhere else? The devil there is.
Aye, and the devil there ain't! There is to be Noah's
Ark, and Devil's Harp, Solomon's Temple, the Tower
of Bibil, the Den of Lions, the Whale who swal-
owed Jonah, Queen Anne's Farthing, and the man
who struck Mick Buckley!

There'll be Noah's Ark, King David's Harp,
 And the Mermaid with her tails, sir,
Likewise the man we understand,
 Who swallowed up the Whale sirs;
Some great Baboons with maids in bloom,
 So charming, gay and handsome,
And the famed, alas! jaw bone of an ass,
 That was in the wars with Sampson.

 There will be a prize given to the old women who
can drink strong gunpowder tea out of a washing tub,
and the most boiling hot soap suds out of the red hot
spout of an iron, brass copper, wooden tea kettle.
Well I'm blowed! Bet if you won't win the prize for
I'll bet a bushel of cinders that you can drink twenty
seven water butts full of blazing boiling hot tea made
of Gunpowder, no matter if there was an Artilleryman
in it, three great guns and two bushels of cannon balls
any morning before breakfast!

There'll be carrols, parrots, crocodiles,
 Orangoutangs and men dye,
With buffaloes and elephants,
 Hyenas pigs and donkeys.
With plums as big as Highgate Hill
 Blues black and whites so many
Ginger pop a kick and a hop,
 And sticks there throws a penny.

 Every Cobblers stall will be turned into a lodging
house for foreigners. There will be the King of
Prussia, the Emperor of Russia, the Queens of Spain
and Portugal, the Prince of Hamburgh, the Prince of
Scorenburgh, the Brewers Baker Mant u Makers,
Beefeaters, Jews and Quakers, the dying speech of

the Undertakers, Farmers, Butchers, Ploughmen and
Sailors, Labourers, Masons, Bricklayers and Tailors,
B and Fleas, with Hives of Bees, one Maids with
Petticoats up to their knees and there will be seen
Price Al and the Queen, Ireland's Harp and the
Shamrock Green, Cats playing hey down diddle, Girls
with bayband, round their middle, Scotchmen rubbing
up against the trees in Hyde Park singing curse the fid-
dle & the Great Hyde Park Exhibition in the bargain.

There'll be candy for the ladies sweet,
 Ready made up in the tents, sirs,
With cigars and mackintoshes for
 The Ladies and the Gents, sir;
There'll be Barbers shaving donkeys too,
 And Ladies riding pigs, sirs;
And Monkeys in a carriage making,
 Petticoats and wigs, sirs.

Well Dick, I must acknowledge that Hyde Park
will beat all the world and no mistake, but I fear of
the Foreigners are all permitted to triumph over old
John Bull he will be where he has often been before
—put in the hole—but let us say Old England for
ever and may she do as she always did,—beat the
world and shout triumphantly Victory and Liberty.

There'll be lollipops and mutton chops,
 And large Bergami pears, sirs,
And ladies velvet breeches,
 Double lined with curly hairs, sir:
There'll be Bantum Cocks and Turkey Cocks,
 And more then I can tell, sirs,
And private, rooms for Ladies,
…For to play at bagatelle, sir.

Such larks and sprees beneath the trees,
 In Hyde Park will be seen, sir:
In eighteen hundred and fifty one,
 In May God save the Queen, sir.

E. Hodges, Printer from Pitts' 31, Dadley st. Seven Dials.

CRYSTAL PALACE (*NLS.* Crawford.EB.2300)

In great Hyde park like lots of larks,
　　They work with expidition,
Like swarms of bees amongst the trees,
　　At the great Exhibition.

Talk of Mount Vesuvius,
　　Or the tower of Babylonia,
It is nothing to it or Noah's ark.
　　Or the whale that swallowed Jonah,

There I beheld some panes of glass
　　So beautifully stained sirs,
As thick as Nelson's monument,
　　And as long as Salsbury plain sirs.
I saw a man with seven heads,
　　With face as black as tinder
And five and twenty wooden legs,
　　A peeping through the window.

I saw the tail of a woman's smock,
　　Which made folks pull wry faces,
Would cover the West India Docks,
　　And reach to Epsom races.
I saw a ladies bustle too,
　　The females to adorn there,
Nine times as thick as Old St Pauls,
　　And as wide as Hyde Park corner

The prettiest thing I did behold,
　　My friends depend upon it,
Was a little woman without a head,
　　Who did not wear a bonnet.
Her husband led a quiet life,
　　aeppy was his position,
He thinks to surely gain a prise,
　　At the National Exhibition.

I saw a pig on thirteen legs,
　　Around the Palace did run,
I saw a tea pot seven times,

As big as the Tower of London:
I saw a mouse brought from canton,
 As big as a russian monkey,
And I saw a mite in a glos'ter cheese,
 Five times as big as a donkey.

I saw a lass none can surpass,
 They call her Madame Chambert,
She had eleven Kids in seven months,
 As big as old Daniel Lambert.
I saw a pie it is no lie,
 With the crust together Knocked hard,
Made of shrimps and sloes & pigeon toes
 As big as Woolwich dockyard.

I saw a pair of babies shoes
 Believe me what I say now,
I'll take on oath they were as big
 As any brewers dray now.
saw a handsome Frying pan-
 The sise of half a farden,
And I saw a stunning halfpenny roll,
 As big as Covent Grarden.

I saw a Jew's harp made of gold,
 And a silver copper fiddle,
I saw a ladies thing embob,
 All hairy down the middle,
I saw a dandy victorine,
 With yellow blue & green coal,
And a pair of ladies earings,
 Seven times as big as a steamboat.

I have not told you half I saw,
 The palace going over,
It would take a sheet of paper that
 Would reach from here to dover,
I saw a man who had seven wives,
 And fed them all on mondays,
He had one for every day in the week,
 And fourteen left for sundays,

CHORS.

Have you been to see as well as me,
 The wonders in each station,
In great Hyde park among the trees,
 The Exhibition of all nations.

 E. Hodges, Printer from Pitts' 31, Dadley st. Seven Dials.

I'M GOING TO SEE THE EXHIBITION FOR A SHILLING (Bodleian. firth b.25[154])

Let all the world say what they will,
 I do not care a fig,
The Exhibition I will see,
 If I don't dash my wig
If I sell the pig and donkey,
 The frying pan and bed,
I will see the Exhibition,

While it is a bob a head.
 Never mind the rent or taxes
 Dear Polly come with me.
 To the great Exhibition all
 The wonders for to see.

There's the dustman and chummy,
 Costermonger and snob
And every one in England
 That can only raise a bob,
From Manchester and Liverpool,
 Eleven millions strong,
With clever girls from————,
Nine feet three inches long
 Pull up your stockings charlotte
 And toddle off with me
 Behind nor yet before love,
 You never such did see.

There's up and downs and ins and outs,
 Trafalger and the Nile,

182

Down stairs and up, and round about,
 Is twenty-seven miles:
There's coachman John, and footman Bill,
 And cookey on will trip,
While Bet, the housemaid, cuts along with
Cabbage-nose, the snip.
 Clap on your bustle cookey,
 And haste along with me,
 To the great Exhibition love,
 A dripping pan to see.

There you may see king Alfred,
 And Billy Rufus bold,
Prince Albert all in silver,
 And Victoria made of gold;
Queen Anne made out of bees' wax,
 On a wondrous pillar perched,
With her nose stuck in a gin shop,
And her rump against the church.
 Come to the Exhibition,
 Sweet Catherine with me
 And for a bob a piece my love,
 Such funny things we'll see.

There's old king Hal, and old king George,
 Faith, Charity, and Hope,
There's old queen Bess on horse-back,
 Going to fight the Pope;
There's old king Ned in armour,
 King Stephen, and king jack,
jane Shore, and old king Richard,
With a bible on his back.
 Put on your linen trousers, Bell,
 And come along with me
 It is only love a shilling all,
 The wonders for to see.

Then syllabubs and sandwiches,
 Bath buns and nice cheese cakes,
Sew up your trouser's pocket Tom,
 Some people make mis-takes!
Nanny, hold your bustle up,

And do not let it drop,
Its only twopence halfpenny for a
Bottle of ginger pop.
 Come to the Exhibition,
 Dear Mary Anne with me,
 And I will show you such a
 Stunning Rhubarb tree.

To tell of all the wonders
 That come from far away,
No one in England can repeat
 In a twelvemonth and a day;
I saw a shining diamond
 Worth seventy million pounds,
And a pair of spiders breeches
All flounced unto the ground.
 Tie up your garters, Caroline,
 The Exhibition for to see,
 I have pawned my coat and trousers, love
 To pay for you and me.

Now is the time or never for
 To banish care and pain,
I'll bet a farthing cake you'll
 Never the chance again;
The price is but a shilling,
 To raise it spout your shoes,
Here's farmer Chubb and Dolly,
Cock a doodle doo.
 Isabella, love get ready,
 Along with me to trip,
 And you shall see the foreigners,
 With their funny hairy lips.

And when that you have been to see
 The Exhibition grand
Every class and all degrees,
 From every distant land;
Your eyes will be so dazzled,
 That will affect your sconce
You will ne'er be able for to sleep
A wink for seven months

Hold up your bustle Fanny,
 And push along with me,
And tell the folks when you get home,
 What wonder you did see.

Disley, Printer, Arthur-street, Oxford-street.

Notes

1 Wilberforce was Bishop of Oxford and a renowned orator.
2 'To award labour with a palm is a beautiful act'.
3 Albert's words can be found in Cole's *Fifty Years*, 1, p. 106.
4 Actually Golconda (or 'Shepherd's Hill'), capital of the medieval Golconda Sultinate. It is famous for its mines which produced, amongst other valuable gems, the Koh-i-Noor diamond.
5 See 4.4 where the virtues of women's needlework are discussed.
6 One further item worth noting from the *Mercury* (not included here) is an official advertisement for season tickets, signed by Digby Wyatt, which follows the accounts of the local committees. Its presence gives an indication that the readership of the *Mercury* was not confined to the working class and that the Commissioners were targeting middle-class, as well as working-class, visitors outside the capital.

6

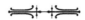

Afterlives

By anyone's reckoning, the Great Exhibition was an immediate commercial and critical success. Official figures show that around six million people visited the Crystal Palace during the summer of 1851, more than 25,000 season tickets were sold and over 7,000 British and 6,500 foreign exhibitors had participated. The highest number of visitors in a single day reached 109,915 on 7 October. The juries had considered over a million exhibits and awarded 2,918 Prize Medals. Receipts totalled more than half a million pounds leaving a profit to the tune of £186,437 (*First Report*). As a result, the Commissioners and members of the Executive Committee were honoured: Joseph Paxton, William Cubitt, Charles Wentworth Dilke and the contractor Charles Fox received knighthoods; Colonel Reid was made Knight Commander of the Bath, and Henry Cole and Lyon Playfair Companions of the Bath. In addition Paxton was awarded £5,000 and Cole £3,000 for their part in the design and organisation.

Evaluating the cultural legacy of the Great Exhibition, however, involves much more than crunching numbers. The Exhibition had both a short-term impact and a more lasting relevance that went way beyond the event itself. Of the former, two issues dominated discussion in the aftermath of the closing ceremony: the disposal of the surplus accrued and the future of the Crystal Palace. Both are discussed separately in this chapter (see 6.2 and 6.3). Of the latter, the perceived achievements of the Exhibition ought firstly to be measured against the original aims of the Commission, which were to promote peaceful internationalism through commercial enterprise, to stimulate British design and to capitalise on free trade by creating new markets abroad.

In reviewing these ambitions in 1937, Christopher Hobhouse was typically scathing: 'As to the importance of the Crystal Palace, it had none. It did not bring international peace; it did not improve taste. Imperceptibly it may have promoted free trade: a few manufacturers may have learned a few lessons from their foreign rivals' (1937: p. 149). On the subject of international peace, he is undoubtedly correct: the second half of the nineteenth century saw military conflict in the Crimea, revolution in Italy and India, and the American Civil

War. Manifestly, the Exhibition did not, as was often predicted, herald a new age of peace. The role that the Exhibition played in stimulating industry and design is, however, generally acknowledged to be much more positive. A report commissioned by the Society of Arts in 1861 demonstrated that commerce had grown in the previous decade. Hobhouse's glib remarks also neglect to account for the fact that 'The Exhibition helped propagandise a set of positive beliefs conducive to further economic development' (Davis, 1999: p. 244). In other words the Exhibition helped to accelerate the arguments for free trade to such an extent that even prominent Protectionists such as Disraeli had to admit that, following the Great Exhibition, trade restraints were now impracticable. Some commentators, such as Lyon Playfair, found chastening lessons in the Exhibition, echoing *The Times*'s judgement that 'while other countries have been studying chiefly to render their products artistic, we have been struggling to render ours cheap and serviceable' (6 June 1851). But if the first step towards reinvigorating British design was to acknowledge its deficiencies, then the Exhibition had made these starkly apparent and set in motion the wheels of change.

The cultural afterlife of the Exhibition can and should, of course, be measured in ways other than economic and it is important to remember that Albert's motivations were more numerous than commercial imperative. One of the most significant legacies of the Exhibition was the reshaping of both the topography of London and the nation's attitude to Art and Science, and to education and leisure. In a memorandum of August 1851 (see 6.3), Albert made it clear that the Exhibition should not be a 'transitory event' but used to stimulate a lasting legacy through a new centralised educational institution. In this respect, the success of the venture is unparalleled and chimes precisely with the Commissioners' desire to educate manufacturers and the public. Albert laid out ambitious plans to use the surplus to buy the land around Kensington Gore to create a 'New Industrial University' – a highly visible legacy – that would ensure that the Arts and Sciences would 'not again relapse into a state of comparative isolation from each other' (Memorandum, 10 August 1851). In this regard it could be argued that rarely has one event contributed so much to the intellectual and cultural life of a nation: the profits of the Exhibition generated – amongst other things – the foundations of Imperial College London, the Victoria and Albert Museum and the Royal Albert Hall (see 6.4).

As the first truly international exhibition, the Great Exhibition also set a precedent for, and was the yardstick against which were judged, almost every subsequent domestic and international fair that was to follow in the nineteenth century– and these were not to be in short supply. In 1862, a new Exhibition – intended as a decennial celebration of 1851 but delayed due to political unrest in Europe – was held in South Kensington. The brick building,

designed by Francis Fowke along the lines of Brunel's original plans for 1851, was never embraced by the public in the way that Paxton's glass palace had been. Mindful of 1851, the 'New York Crystal Palace Exhibition' of 1853–54 was held in an enormous iron-and-glass structure in Bryant Park, deliberately referencing Paxton's celebrated building. The Paris International Expositions (from 1855 to 1900) imitated, but never quite matched, Albert's vision. Later, as John Findling remarks, 'a major international exposition was held almost annually somewhere in the world between 1893 and 1916' (Findling, *Encyclopaedia Britannica Online*), when the First World War brought the movement to an end. Each owed a debt to the Exhibition of 1851.

No doubt the Exhibition reflected wider social, political and cultural trends as much as it instigated them, but there can be no doubt that its influence was felt on what John R. Davis has called Britain's participation in the process of modernisation. 'The Exhibition was significant in providing a new basis for future action', he argues, 'a sort of social contract – resting on broad acceptance of principles such as material consumption, good design, international cooperation, industrial development, and commercial liberalism' (Davis, 2007: p. 242). The advancements of Victorian liberalism helped to ease some of the class tensions – between emergent socialism and the landed aristocracy – that were simmering throughout the 1840s. The Exhibition played a part too in ushering in a new age of consumerism, helping to focalise middle-class values and ambitions, and raising debates about the future of labour in an age of increased mechanisation in agriculture and industry. Paxton's Palace, showcasing new advancements in engineering, came to embody the progressive values on which the Exhibition had been established.

The symbolic afterlife of the Exhibition should also not be underplayed. It was undoubtedly at the forefront of new questions raised about British national identity, imperialism and the future of the colonies, and it still resonates today in debates about patriotism. It has also, rightly or wrongly, come to represent an age of faith: faith in a religious sense, but one coupled to, rather than opposed by, material, technological and scientific progress which modernism was to later question and unpick. For many, it symbolises British self-assurance – perhaps drawn from the fact that 'London was at the centre of an unrivalled empire' (Clayton, 2007: p. 272), something which, as Jay Clayton has argued, was conspicuously absent in the tentative organisation of another of the Exhibition's successors, the oft-criticised Millennium Dome, over which the shadow of 'faded glory' (2007: p. 270) hung. If the Exhibition is treated with nostalgia in some quarters – and the Crystal Palace has adorned many a commemorative tea towel and china cup in its time – then that nostalgia needs to be tempered by the knowledge that this was not a quality of the Exhibition itself, which was always more concerned with the future than the past. Every time the nation is put on display – from the 1951

Festival of Britain to the opening ceremony of the London Olympics in 2012, the Great Exhibition is invoked, whether this be positively or negatively. And despite the fact that the recent revival of interest has been partly due to a desire to show that the Exhibition was 'protean' (Auerbach, 1999: p. 2), and its significance contested, the achievements of 1851 have an appealing coherence and purpose that is often felt to be absent from later, equivalent events.

6.1 Closing ceremony

On 11 October 1851, the Great Exhibition closed its doors to the public. By all accounts – including that of *The Times* incorporated here – the event was a strangely moving one. At 5 p.m., after a day of warm autumn sun, the great crystal fountain of Osler (see Figure 6) was switched off for the final time and the assembled visitors crowded into the nave and galleries. The eerie silence was punctured by an organ which accompanied a rather raucous rendition of the national anthem before a great peal of bells instigated a round of patriotic cheers and the crowd dispersed in good mood. *The Times* reflected on the achievements of 'the greatest metropolis and the most powerful empire in the world'. The contrast with the official closing ceremony of 15 October couldn't be more pronounced. As the *Morning Chronicle* makes clear, and unlike the opening ceremony, it was a drawn-out, dull, 'unmeaning' event. The organisers assembled on a raised dais in the nave to read the reports of juries and recite a list of medal winners; Bishop Blomfield blessed the occasion with a prayer. The main problem was that hardly any of the assembled audience, crammed, tens deep, into the galleries to get a view, could hear anything being said. As the *Chronicle* rightly points out, the winding-up of business was never going to match the pomp and ceremony of the opening anyway. Despite the underwhelming valediction there were many who shed a tear in acknowledgement of what was recognised as a remarkable national achievement. Of the number of verses published to mark the Exhibition's closure, 'The Lounger's Tear' is characteristic.

Final Day, *The Times* (13 October 1851), p. 5

On Saturday the Great Exhibition closed its wonderful career, and the public took their last farewell of its splendours. After being open for five months and 11 days and concentrating in that time a larger amount of admiration than has probably ever been given within the same period to the works of man, the pageant terminates, the doors of the Crystal Palace no longer yield to the open sesame of money, and in a few days hence thousands of hands will be busily engaged in removing all those triumphs of human skill, and those evidences of natural wealth which the world was assembled to behold. It was natural that such an event

should be regarded by all who witnessed it with no ordinary degree of emotion. Feelings of gratified curiosity, of national pride, and of enthusiasm at the public homage paid to industrial pursuits, were tempered with regret that a spectacle so grand and unique should ever have a termination. The ephemeral existence assigned to the Exhibition has all along been fully recognized, yet it was impossible that so marvellous an undertaking could run its brief career without gathering around it many attachments, sympathies, and associations which at the last it proved difficult to sever. Each person that had visited the building had found therein some objects that, by appealing to his imagination or his tastes, had gradually grown into favourites. With a large proportion it was the edifice itself which took the firmest hold upon their hearts. Its vastness, its simplicity and regularity of structural details, and a certain atmosphere of mysterious grandeur which pervades it, are features which harmonize so perfectly with our character as a people, that they must have left a strong impression. If the whole country does not now protest against the wanton and aimless destruction of the Crystal Palace we shall be very much surprised. It is only when we are about to lose them that we begin to find the values of objects which have insensibly become endeared to us. As with the building, so it was also with many of the works of art, the treasures of wealth, and the examples of ingenuity which it contained. The 'Amazon,' Van der Ven's 'Eve,' Strazza's 'Ishmael,' the two French bronzes, and many other contributions of the highest artistic merit were, for the last time, to be gazed at by the admiring multitude. All had wondered over the *chefs d'oeuvres* of Sevres and the Gobelins, who, in Tunis had spent pleasant hours examining everything, from the richly brocaded dresses to the tent hung with wild beasts' skins; or who in India had feasted their eyes on the splendid evidences of an ancient civilization— all had to take a final farewell of what had interested and moved them so strongly. The mechanical wonders of the palace were about to be withdrawn from public view. The card-making machine, the circular wool-comb, Appold's pump, and Whitworth's tools, were to be seen no longer. The gratuitous distribution of envelopes and soda water was to cease, and the alarm bedsteads were to do duty before admiring groups of chambermaids and cooks no longer. Even the time of that king of diamonds, the Koh-i-noor, was up; and, after having attracted more curiosity and inflicted more disappointment than anything of its size ever did since the world was created, the period had arrived when it must cease to shine its best before the public. Under such circumstances, and with the mingled feelings which they could not help suggesting, the crowds of half-crown visitors bent their way to the Crystal Palace on Saturday. The weather was splendid, and the sun looked down warmly upon the only great building in the world, which does not inhospitably exclude his rays. At 9 o'clock visitors began to arrive, and they continued to pour in steadily almost until the closing-bells had commenced to ring. All who came remained to the last, and, although the numbers present were not so great as some had anticipated, they rose higher than on any previous

half-crown day, and were amply sufficient to make the death scene of the Exhibition worthy of its unprecedented popularity. There were 53,061 visitors altogether, and as might have been expected, they busied themselves during the entire day in examining once more all the objects which on former occasions had chiefly attracted their interest. Some few were strangers taking at one view their first and last look of a spectacle which in grandeur they may not hope soon to see equalled. There was also a slight sprinkling of the humbler orders present, and among them a band of hop-pickers with wreaths of the plant around their hats. In the main, however, the assemblage belonged to the middle and wealthier classes, and consisted of *habitués* of the Exhibition, or, at least, of people who had been there several times before. Faces that had not been seen in the interior since the first month after the opening were recognized among the crowd, and it was evident that every rank and grade of society was fairly represented upon an occasion interesting alike to all. An eager desire was manifested, especially in the French department, to purchase mementos of the great display, and, in consequence, everything but an open sale was in progress. As the day wore on, a remarkable concentration of people in the nave began to be discernible. The side avenues and courts were deserted, and from end to end of the building nothing was to be seen but a great sea of human beings filling up the centre, and agitated by a thousand different currents of curiosity, which kept the mass in motion without progress. Time passed, and the circulation in the transept became rather impeded. The people seemed to be taking up their position there, and the galleries, as far as the eye could reach, were occupied by spectators, who, as they gazed on the vast assemblage beneath, evidently appeared to expect that some public demonstration was about to be made. The organs, which had been played constantly during the early part of the day, were now silent, and even that wonderful man Herr Sommer, with his still more wonderful instrument, sent forth no longer those astonishing volumes of sound which have rendered him, *par excellence*, the trumpeter of the Exhibition.[1] Nothing was to be heard but that strange and mysterious hum of voices which, rising from all large assemblages, is imposing, but which in the Crystal Palace, swelling upwards from more than 50,000 people, leaves an impression upon the mind not soon to be forgotten. It was drawing near 5 o'clock, [and] from the top of Keith and Co.'s Spitalfields silk trophy, the whole nave, east and west, the area of the transept, and the galleries might be seen packed with a dense mass of black hats, through which at intervals a struggling female bonnet emerged here and there into light. The vast multitude had now become stationary, and were evidently awaiting, in silent but intense excitement, the last act of a great event, immortal in the annals of the 19th century. It was a most solemn and affecting scene such as has rarely been witnessed, and for which an opportunity cannot soon again arise. Words cannot do it justice, and fail utterly to convey the mystery and the grandeur thus embodied to the eye. Let the reader fancy what it must have been to comprehend within one glance 50,000

people assembled under one roof in a fairy palace with walls of iron and glass, the strongest and the most fragile materials happily and splendidly combined. Let him, if he can, picture to himself that assemblage in the centre of that edifice filled with specimens of human industry and natural wealth, from every civilized community and the remotest corners of the globe. Let him tax his imagination to the uttermost, and still beyond the material magnificence of the spectacle presented to him—let him remember that the stream of life on which he looks down contains in it the intellect and the heart of the greatest metropolis and the most powerful empire in the world—that strong feelings, such as rarely find utterance in a form so sublime, are about to find expression from that multitude, and that in heathen times, even when liberty was still a new power upon the earth, the voice of the people was held to be the voice of God. Not only the days, but the minutes of the Great Exhibition were numbered, and the first sign of its dissolution was given by Osler's crystal fountain. Just before 5 o'clock struck the feathery jet of water from its summit suddenly ceased, and the silence of the vast assemblage became deeper and more intense. The moment came at last. Mr. Belshaw appeared at the west corner of the transept-gallery on the south side, bearing a large red flag in his hand. This he displayed as the clock struck, and instantly all the organs in the building were hurling into the air the well-known notes of the National Anthem. At the same moment the assembled multitudes uncovered; and those who witnessed this act of loyalty from an advantageous position will long remember the effect which it produced upon their minds. Where just before nothing was visible but a mass of black hats stretching away until lost in the distance, immediately there appeared a great sea of up-turned animated faces, and to the solemn silence of expectancy succeeded a volume of sound in which the voices of the people were heartily joined. The Crystal Palace is not adapted for organ music, and, notwithstanding the number of them exhibited, they cannot, from the size of the building, be played in concert. The consequence was that, as a musical performance,—there being no proper organization in the matter,—the singing of 'God save the Queen' was a very discordant demonstration of loyalty. Herr Sommer did everything in his power and in that of his instrument to keep the people in tune, but he was only partially successful. Some professional singers also gave their aid upon the occasion, and inspired the assemblage with courage to follow. On the whole, however, foreigners would have managed this matter better; and, though it is useless now to express regrets, it does seem a pity that proper steps were not taken to make the performance of the National Anthem as effective as it might have been. About the feeling which accompanied it there could be no mistake, for as soon as it had closed there arose such cheers as Englishmen alone know how to give. These were continued for several minutes, and when the last of them died away there passed over the entire building, and with an effect truly sublime, a tremendous rolling sound, like that of thunder, caused by thousands of feet stamping their loyalty upon the boarded floors.

Closing Ceremony, *Morning Chronicle* (16 October 1851), p. 4

If we are at one with many of our contemporaries as to the fact that the Great Exhibition has closed in a hurry and confusion, we are not prepared altogether to accompany them in their complaints on this head. Mean and commonplace enough, so far as externals go, was yesterday's ceremonial—which, in fact, had in it but little of order, and nothing of pomp. A few gentlemen in morning costume seated round a table—itself perched unmeaningly on a platform—reading reports, which nobody heard; a solitary ecclesiastic reciting something, which the spectators—the terms 'audience' or 'congregation' being totally inapplicable—were assured was a prayer: 'GOD save the QUEEN,' and a single chorus, not over well sung, in a place so remarkably unfit for the conveyance or condensation of sound that the loudest organ tones are inaudible over three-fourths of the building; a Court shorn of its ceremony, religion unaccompanied by much apparent reverence, and cheers that were better in purpose than execution—these are not elements of a successful pageant, if such were all that the closing of the Exhibition aimed at.

The component parts were not very grand in themselves, nor did they fuse well; and therefore, such as were prepared to be disappointed with the spectacle were not entirely baulked in their expectations. Such, however, is not our case. We suspect that little can be made of a closing, and that, in the nature of things, it must be informal. Sure we are that those that measure a closing ceremony by the standard of an opening one miss the point and the real condition of both. An introduction is naturally ceremonious—a leave-taking is naturally abrupt. Parting always suggests the notion of incompleteness and hurry—of something which it is well to get over. A host welcomes us to his house in state, and with bows and holiday looks; but custom dispenses with martialling the servants at the end of a visit. A house-warming is common—a feast at the fall of a roof-tree would be as awkward as it is rare. If a gala salutes a ship-launch, we never heard of wine being shed when the proudest hull is dismantled or broken up. And just as we 'welcome the coming, speed the parting guest' with different feelings, it were affectation to adopt the same manner on either occasion.

Of such, then, as complain of the slovenliness of yesterday's proceedings, we ask what could ingenuity make of the occasion? A procession was out of the question. Anthems and chorales are not quite in character with the sobriety of regret. Had the Court been present in courtly guise, there would have been nothing for the QUEEN to do—unless, indeed, that occasion had been deemed the most fitting one for conferring on Mr. PAXTON, Mr. FOX, and Mr. CUBITT, that well-merited honour of knighthood which, as our readers will elsewhere see, is about to be bestowed upon them. The great officers of State are hardly to be paraded as lay figures. Most men of name and mark are in the country. The presence of the Exhibitors and of their achievements was the real thing; but even their presence was of a practical rather than ornamental character. On the

whole, therefore, we are glad that no more was attempted—especially as, with such a deluge of rain, failure would have been unavoidable. Cloudy skies, mud, storm, and tempest, the withered grass and the fading leaf—these, nature's signs of departure—these, the silent teachers of the perishable character of all human things—were most in accordance with that melancholy with which so many tens of thousands trod yesterday, for the last time, those stately aisles, and dwelt with lingering looks on that airy roof. The day and the scene fitted the occasion well. If it were pleasant to linger in recollection on that May day's 'glorious morning, kissing with golden face' this surpassing scene, it may be equally profitable not to shrink from

> 'That ugly rash on his celestial face,
> Which from the forlorn world his visage hides,
> Stealing unseen to west with this disgrace'—

which was the characteristic of the Exhibition at sunset of the fifteenth of October. In truth, the closing of the Exhibition wanted no obsequies of pomp—its accomplished purpose is its most fitting epitaph, and its results will be a monument more lasting than marble and brass.

All that, in point of fact, was done at the formal closing was strictly limited to business details. It was but the making up of the day-book before the shutters were put up. The Royal Commissioners had delegated certain duties to certain juries, and it was to receive their reports that the Commissioners met yesterday. Properly speaking, it was a committee meeting held in public. The working of the jury scheme demands a word of explanation for those who are not familiar with its curiously complex arrangements. First, there was, in each department, the jury appointed to deliberate on the respective merits of contributions; but their decision was not final. Ingeniously enough—whether judiciously or not, is a very different question—a Court of Appeal or Revision had been constructed, consisting of an aggregate or group of those cognate juries whose labours had been concerned with productions of a kindred nature. Above the connected groups of juries was ranged a Council, consisting of the chairmen, or foremen, of the juries; and interspersed among the jury groups were Special Commissioners, especially informed upon the subjects submitted to the award of the respective juries. The juries, according to the well known principle of the English law where aliens are concerned, were of a mixed constitution—half Englishmen, and half foreigners—wherever that arrangement was practicable. So much for the judicial organization which the Commissioners deemed best fitted to ensure verdicts in accordance with truth and justice. It was impossible, however, not to see that considerable difficulties, owing to the want of any uniform standard among the jurors of different nations, would arise in coming to sound decisions, however great might be their anxiety to act with perfect fairness and impartiality.

It remains to state the principle which has been adopted as to the assignment of prizes. One error in this respect, which was committed at starting, was early retrieved by the judgment of the Commissioners, aided chiefly by the politic wisdom of the late Sir ROBERT PEEL. It was at first intended to reward with extraordinary pecuniary honour whatever looked like an extraordinary achievement. But this principle, however pretty in theory, was found to be defective or impossible in practice. A MILO, who only appears occasionally in the course of the centuries, may certainly achieve more—but he does not necessarily merit more—than each sturdy athlete who succeeds in turn to the Olympian prize. The mistake consisted in setting up at once an abstract standard of this very abstract nature. To combine an abstract and comparative standard was not thought of. Either might work tolerably well by itself; but the adjustment of the two was regarded as impossible. But even with an abstract standard, the Commissioners, we think, did wisely in departing from this portion of their plan, which was intended to meet the exceptional cases of perfection—the cream of the cream—pre-eminent and overwhelming success as such, without regard to invention, material, purpose, or utility. Had they retained their original intention, their labours must have taken merely a philosophic form; and their selection would have amounted substantially to a scientific preference of the *summum bonum* or το χχλου. But even as it is, by rejecting the Continental, and comparatively commonplace, standard of comparative excellence, the Commissioners have added to their labours, and, as it is easy to foresee, to their troubles, by a double classification of medals. As announced, the principle of award is, of course, excellence only as such, without regard to competition. But this excellence may be of two kinds. First, where an average attainment is gained, under certain not very strictly defined conditions, there a medal is given; and this award marks the excellence chiefly of workmanship and craft. But, in cases where novelty or originality is pre-eminent, a larger, or Council medal is awarded. As we have said, in the one case the criterion is mostly mechanical, in the other it is scientific. The smaller medal is intended as a material award—the larger as a moral, or spiritual one; the object apparently being that both the hand and head, the craftsman's handiwork and the inventor's thought, shall be recognized and honoured.

On paper, this scheme of prizes has a very attractive, reasonable, and thoughtful look; and, on the whole, if it has been perfectly carried out, it may be found to have worked well. That, however, is a point which still remains to be settled, and we have heard not a few discordant opinions on the subject. We will at present only add that we think the Committee did very wisely in making the medals honorary. A few sprigs of parsley, or a twig or two of olive, were enough to awaken the enthusiasm of Greece; and it is something to know that, in more commercial days, and in matters of trade, a counter of bronze is enough to accredit that honourable enthusiasm which is its own exceeding great reward.

195

'The Lounger's Tear: A Last Lay of the Crystal Palace' (RC/I/15/1)

Under the nave he walked,
 To take a farewell look
At the Building where, last summer-time,
 Such frequent strolls he took.

He missed the well-known sounds
 That lingered in his ear;
And he drew his mental cambric forth,
 And wiped away a tear.

Around, where soon shall be
 Restored the naked sod,
Stood thinly scattered two or three
 Where late the thousands trod.

'Twas a mournful sight to him
 That space so vast, so drear:
And again he piped his mental eye,
 And dropped a mental tear!

He sadly left the spot,
 Oh, do not deem him weak!
And Niobean torrents flowed
 Adown his mental cheek.
Go, mourn the Nation's Pet—
 The pride of one short year:
And own that even a SIBTHORP now[2]
 Could scarce deny a tear!

6.2 The building

As Hermione Hobhouse noted, one of the factors that amplified the nostalgia associated with the Great Exhibition was the fact that 'nothing physical remains' (1995: p. 48). The fate of Paxton's building was widely debated in Parliament and in the press in the months following its closure, and several prominent figures – including Cole, Paxton and Francis Fuller – published interventions discussing the advantages of retaining the Crystal Palace as a permanent landmark in Hyde Park. Cole's first concern, in the pamphlet he published under the pseudonym Denarius (meaning 'coal', a Latinate pun on his surname), was that the Exhibition should be recorded with a permanent

monument. His idea was to transform the Palace into a colossal winter garden for public entertainment, which would double as a site for public lectures for the agricultural, horticultural and botanical societies. Likewise Paxton envisaged a new type of pleasure garden under glass, outstripping the gardens at Kew, that would retain the climate and charm of southern Italy all the year round.

It was all to no avail, however, and the efforts of those who wished to preserve the Palace were disappointed. Under the original terms of the contract the Commissioners were committed to return the site in Hyde Park to the Office of Woods and Forests, while ownership of the building reverted to the construction firm of Fox and Henderson. The latter originally intended to retain it as a concert venue or pleasure garden until they were reminded, in a strongly worded note from the Commissioners, to 'comply strictly with the conditions of the covenant entered into by them with Her Majesty on the 26th September 1850' (RC/H/1/9/107). In the end, the building which had taken just under six months to construct, was dismantled in less than three.

The afterlife of the Crystal Palace now relocates to south London. A letter from Charles Grey to Albert of 13 May 1852 announced the sale of the Palace to the Chairman of the Brighton Railway Company, Sir Samuel Laing: it was to be 'transferred to Sydenham in Kent … in condition of its being erected on their railway, 6 per cent on a capital not exceeding £500,000' (RC/H/1/10/4). Rebuilt on a grander scale than in Hyde Park and, as the report of *The Times* for 14 September 1852 records, commanding a spectacular panoramic view of the Surrey hills and Kent downs, it was opened to the public in June 1854. Rather than foreground industry, the contents of the new museum consisted of examples of art, sculpture and architecture from ancient and modern civilisations, an encyclopaedia of the world's cultural achievements. Owen Jones and Digby Wyatt were despatched to collect illustrations of architecture and sculpture from France, Germany and Italy, Professor Anstead procured geological exhibits and Professor Edward Forbes and Mr Waterhouse were responsible for curating a department of natural history. As Auerbach observes, however, the new Crystal Palace suffered from a 'loss of focus' (1999: p. 209): Laing wanted a tourist destination to capitalise on the railways rather than a place of education – the Palace was no longer so much a school as a playground (Auerbach, 1999: p. 200). This did not of course mean that the rebuilt place at Sydenham was without its advocates. One was Harriet Martineau, who wrote rapturously in the *Westminster Review* of a 'phenomenon' rather than an 'institution', a 'magic spectacle' that enchanted the viewer (p. 550).

The reconstructed Crystal Palace played a significant role in a number of aspects of British cultural and artistic life in the nineteenth century, particularly in its function as a concert hall. The extract taken from the *Bury and Norwich Post* reviews the opening nights of the great Handel Festival of 1857,

attended by the royal party, which included legendary performances of *The Messiah* and *Israel in Egypt*. Sydenham also became famous for its pyrotechnic displays, with one commentator in *The Times* going so far as to declare 'the history of fireworks during the last 40 years and the history of the Crystal Palace displays are one and the same' (10 June 1904) in reviewing a particularly lavish event orchestrated by Messrs Brock to celebrate the Jubilee of the Crystal Palace. In the same article, *The Times* confidently predicted that it 'should be able to look forward to an even longer period of greater prosperity'. The Palace played host to Blondin's circus, the Shakespeare tercentenary festival and the 1911 Festival of Empire. By the turn on the twentieth century, however, much of the sheen and novelty that had made the Great Exhibition, and its rebranded cousin, such a success had faded. A letter to the Editor of *The Times* of 23 June 1911 lamented that 'one of the lungs of London' should 'degenerate into a place of popular amusement', a location for football matches and frippery, dog shows and picnics, rather than an abiding monument to intellectual curiosity. Briefly, the Palace was considered as a potential location for the new Science Museum, eventually built in South Kensington, and in 1913 *The Times* could still argue that 'Its reputation in regard to Music, Art, and recreation has made it renowned all the world over' (7 June 1913). But the building and its grounds had fallen into decline and attendances had plummeted from its Victorian heyday.

The end for the Crystal Palace came on the night of 30 November 1936, when a fire broke out in one of the building's offices and the devastating blaze, legend has it, could be seen as far away as Brighton (Figure 18). The report from *The Times* the following day contains eye-witness testimonies to the intensity of the inferno and the fire brigade's failed efforts to save a national icon. Famously, Winston Churchill remarked that the destruction of the Crystal Palace marked 'the end of an age', although in some respects that age was already long gone. The only significant elements of the structure to survive were the water towers – the contents of which were used by the emergency services on the night of the conflagration – designed by Brunel, but these were later demolished during the Second World War for fear they provided a landmark for German bombers.

The site, which now sits in the London Borough of Bromley, is derelict, with only foundations visible amongst overgrown vegetation. There have been numerous plans to restore the site, including those of the Greater London Council in 1981 and the Kuwaiti business consortium which, in 1992, planned a hotel complex.[3] Most recently it was reported that a Chinese company, ZhongRong Holdings, had held talks with the London Mayor, Boris Johnson, about rebuilding the Palace on the north side of the site, but these negotiations were cancelled in 2015.[4] Curiously the original building showed that it too was not quite ready to be consigned entirely to the past: in August

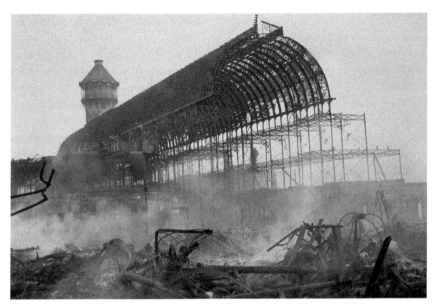

18 Fire destroys the Crystal Palace in 1936

1985, a walkway from the Prince's Gallery of the old palace– material which hadn't been involved in the reconstruction at Sydenham – was discovered at the Royal Agricultural Hall.

'Denarius' [Henry Cole], *Shall We Keep the Crystal Palace?* (RC/H/1/A/12)

The Commissioners of the Exhibition have engaged that any surplus shall be 'applied to purposes strictly in connexion with the ends of the Exhibition, or for the establishment of similar exhibitions for the future;' but they have also engaged, in the most solemn way, to remove the building which has served the purposes of the Exhibition so admirably on this occasion, and likely to do so on future occasions if it were permitted to remain.

The chief difficulty in establishing the present Exhibition was to provide a building. This at the outset involved the risk of finding the necessary funds, the choice of site, the selection of a suitable plan, and the construction of a building consistent with the character of the locality. All these difficulties have been successfully overcome, and the victory has secured advantages, which, costing at least 120,000*l.*, are of the first importance for the establishment of future exhibitions, but which would be thrown away in great measure if the building itself be removed.

The preservation of these advantages affords the greatest security for the establishment of 'similar exhibitions for the future,' at the same time fulfilling the

objects of the Commission, but the performance of their pledge to remove the building stands in the way.

It is true that this pledge was given, and a deed of covenant made between the Treasury and the Commissioners, for the removal of the building before the building itself was erected or its plan known, and when it was conceived that the maintenance of a brick building was inconsistent with the public interests in Hyde Park; and the compact to remove the building, whatever it might be, was the result of an understanding with the House of Commons, when a majority of 166 to 47 affirmed the expediency of using the present site for the purpose of the Exhibition. This vote of the House of Commons fairly represented public opinion on the subject in July 1850; but having experience of the present building, and viewing the singularly unanimous approval of it, its obvious adaptation to other public wants when the Exhibition itself shall have closed, its positive adornment of Hyde Park, and its suggestiveness of new and improved modes of construction, it may be doubtful whether the public would now vote for the removal of it.

[…]

Let us imagine the glass house made a garden and warmed with a summer temperature all winter. It would seem to be a public want as soon as the idea presents itself. When a man has a house and grounds, one of his first thoughts is to secure the beauty and pleasure of vegetation all year round. It would be strange that London should never have provided itself with a conservatory or winter garden, if we did not see that the Excise-duty on glass had been the preventive.[5] Having now got a structure through the Exhibition, we find that the same structure may have a second and scarcely less valuable use. We may consider the building properly supplied with fountains and sculpture, arranged between groves of orange-trees and pathways laid between plantations more or less characteristic of the vegetation of different climates,—being, in fact, a most enjoyable and instructive promenade. With the co-operation of the Agricultural, Horticultural, and Botanical Societies, various popular schools, lectures, and exhibitions connected with the objects of these Societies, would arise naturally out of such an arrangement, and might be made to have a most important bearing both on the productive resources of the country and on our decorative manufactures.

The decoration of the building might be made very conducive to the promotion of Sculpture, at present an art almost purposeless in this country. The garden might be most appropriately connected with an annual exhibition of sculpture, for which subjects might be chosen out of the remarkable events of each year and as memorials of the departed great. The best of these works might be purchased annually to embellish the building itself, and it might be permitted to the artists to furnish casts of them to decorate the town-halls, &c. in the country. A Beginning in this direction might be made by the purchase of a few of the best works now

exhibited, and as better works were collected in course of time, selections might be presented to local institutions. Sculpture might thus be made an art yielding real enjoyment and pleasure to the great mass of the people, who at present have little sympathy with it because it is not *used*.

Joseph Paxton, *What is to Become of the Crystal Palace?* (RC/H/1/A/12)

I cannot but recommend now that we do possess a building like the Crystal Palace, which in its dimensions is the best adapted for such a purpose of anything that has been hitherto attempted, that it should be so appropriated—and especially as its peculiar site between Hyde Park and Kensington Gardens is the best spot that could have been selected; connecting as it does those two great promenades—it appears exactly calculated to concentrate beneath its roof the pleasures of both.

A building like this, if properly laid out, will open a wide field of intellectual and healthful enjoyment; it will likewise, I hope, stimulate the wealthy in large manufacturing towns to a similar adoption of what may now be raised so cheaply; and when judiciously furnished with vegetation, ornamented with culture and fountains, and illustrated with the beautiful works of Nature, how pure— elevating—and beneficial would its studies and exercises be. At present England furnishes no such place of public resort, for although Kew has a splendid Palm-house, where daily are congregated a great number of individuals, yet its warm and humid atmosphere is only calculated to admit of visitors taking a hasty view of the wonders of the tropics, as they pass in their walks through the gardens.[6] On the contrary, in the Winter Park and Garden I propose, climate would be the principal thing studied, all the furnishing and fitting up would have special refer-ence to that end, so that the pleasure found in it, would be of a character which all who visit could share; here would be supplied the climate of Southern Italy, where multitudes might ride, walk, or recline amidst groves of fragrant trees, and here they might leisurely examine the works of Nature and Art, regardless of the biting east winds or drifting snow. Here vegetation in much of its beauty might be studied with unusual advantages, and the singular properties examined of those great filterers of Nature, which during her night season, when the bulk of animal life are in a quiescent state, inhale the oxygen of the air, whilst in the day, when the mass of animal existence have started into activity, they drink in the carbonic supply, given out by man and animals, which goes to form their solid substance, at the same time pouring forth streams of oxygen, which mingling with the surrounding atmosphere, gives vigour to man's body and cheerfulness to his spirits.

In this Winter Park and Garden, trees and plants might be so arranged as to give the great diversity of views and picturesque effect. Spaces might be set apart for equestrian exercise, and for carriage drives; but the main body of the building

should be arranged with the view of giving great extent and variety for those who promenade on foot. Fountains, statuary, and every description of park and garden ornament, would greatly heighten the effect and beauty of the scene.

[…]

The alterations necessary to the Building itself, to produce the effects I have suggested, would not be many or cost much money. Shortly will be published by me a view showing how the whole may be finished so as to do away with all idea of smoke, chimneys, or other kind of nuisance. The details of the alterations necessary I do not propose to treat of now; but I may mention for the information of those who live opposite the Crystal Palace, that I should recommend the wood boarding round the bottom tier of the building to be removed and replaced with glass; the present appearance of it is heavy, and gives anything but the idea indicated by its name; when glass is substituted for wood, the appearance will be marvellously changed; those who drive and ride in the park will even in winter see the objects within as they pass by, and the whole will have a light aerial appearance totally unlike what it has at present. In summer I should recommend the whole lower glass tier be entirely removed, so as to give, from the park and the houses opposite the Palace, an appearance of continuous park and garden.

The New Crystal Palace, *The Times* (14 September 1852), p. 5

There cannot be a doubt that the new Crystal Palace will be a far more splendid edifice than the old, though the wonder which the novelty of the latter inspired may somewhat blunt our appreciation. The site is magnificent, and commands a glorious prospect, in which London, with her far extending suburbs and her population of 2,000,000, forms but a section of the view. Looking south-east, even now, the eye is carried over a smiling and variegated landscape without obstruction, as far as its powers can reach; but no conception can at present be formed of the circuit visible from an elevation of 200 feet, and embracing within its ample verge, not only the panorama of the metropolis, and the course of our greatest river to the sea, but the Surrey hills, abounding in natural beauty, and the rich lands of Kent, the garden of England. Then it must be remembered that the palace itself will not be the least remarkable feature of the scene, shining on its elevated site, and made resplendent by having the sky as its background. Crowning the ridge, it will be conspicuous for many a mile, its towers, arched transepts, and nave, finely breaking up and diversifying its enormous dimensions. The monotonous effect of the old building will be completely removed, and it will rise into the air a noble temple, dedicated to the innocent recreation of the people. The grounds of Penge Park, which it immediately overlooks, are nicely undulated, and the frontage, which has a south-eastern exposure from the way in which the land drops, will be elevated and commanding.

An open colonnade on this side will run along the whole length of the structure, and the arches of the three transepts, recessed to a depth of 24 feet, will, from their great height and the effect of shadow, be singularly imposing. That in the centre will be 200 feet high, and it has just been proposed by Mr. Barry to surmount the whole with three vast domes, the loftiest rising 400 feet from the base.[7] The work of decoration has been commenced externally, the main avenue, the spaces for some of the fountains, and the line of terraces being roughly indicated. The genius of Paxton will soon bring this part of the undertaking into shape and consistency.

Harriet Martineau, 'The Crystal Palace', *Westminster Review*, 62 (October 1854), pp. 535–6, 548

[W]hile looking abroad over the meadows, and plains, and uplands of old England, to see her industrial multitudes come forth and play, we are struck by a magic spectacle, which presently draws the eyes of the whole civilized world to one hill-top. Lo! there rises on a ridge in the richest district of Surrey, a palace of opal,—ruddy in the dawn,—a blue canopy like the air at midday, and golden at sunset,—a palace evoked from nothingness by the spirit of the time, and consecrated to the pleasure of the people. This is not a revival of the ancient games of England; nevertheless, happy are they who witness this rising! It is not Pandemonium,—no exhalation, like our jails and workhouses, from the torture of the damned of this world, lighted up by the flare of their penal fires: it is bright, cool, and clear in its very substance and atmosphere, light as a vision of beauty, strong and durable as the instincts on which it is founded, and the wants which, in a form as new as its own, it is framed to gratify.

[…]

The largest crowd is always to be found in the Natural History department. There children stand, with their thumbs in their mouths, staring at the polar bear and the reindeer, or peeping into the Greenland hut. The labourer in the smock frock wanders with his hands in his pockets, from one group of savages to another, evidently wondering whether all those brown fellows and yellow termagants are really men and women. The same labourer in the Greek Court is a pitiable spectacle. He saunters on, swinging his feet in his thick shoes, looking up vacantly at the 'images,' in which he sees, as yet, no beauty: but when he arrives at the elephant in its rage and pain, or where the wounded tiger and the hunters are confronting each other, his dull face lights up, and he stands for half-an-hour before a single group. It has always been thought a fine thing for the towns-people or villagers when a menagerie has come their way, with a dozen monkeys and half-a-dozen of nobler animals. What a splendid opportunity is this in the comparison—where not only are the animals seen in an appropriate environment, but their human neighbours

also, most accurate and strangely life-like. The rustic, accustomed to live among the dull or the genteel, is profoundly struck by the countenances of the savages which are at war or hunting; and, truly, some of them are thrilling enough to visitors who have read voyages and travels all their lives. There are some visitors who seem scarcely awakened enough to observe the tropical vegetation. The palms do not surprise them, nor the Norfolk Island pines look beautiful in their eyes. They may notice some common flower—as the nasturtium that dangles from the pendant baskets; but the tropical shrubberies at the north-end excite no particular note. It is much otherwise with the music. The band is an inestimable agency, and perhaps the best rallying point for all minds in the whole establishment—the performance being so good in quality as to gratify the trained musical ear, while sufficiently popular, as to subject, to bewitch the dullest listener. It is amusing to sit on the terrace or in a balcony, while polka or waltz is playing, and count the babies that are being danced over the heads of the crowd below. Long may it be before the listeners learn the gentility of abstaining from beating in time!

[...]

Such a place should never suggest, more or less, the idea of a bazaar. In the Exhibition of 1851, the leading conception was that of a display of the industry of all nations; and the whole affair was the Sublime of the Bazaar. There ought to be nothing of the sort here,—no disproportion of the industrial element at all. There is room for plenty of it—for a remunerating amount of it—without its driving out anything else. But how is it? One of the officers was lately pointing out the vast space in the basement intended for the display of agricultural instruments. It was suggested that the exhibition would be of great educational value, if a small portion of space—(for very little would be required)—were devoted to models of agricultural implements used by men, from the rude forked stick, with which the ground was first scratched, to Mr. Samuelson's digger. The reply was, that for this purpose, remunerative display must be sacrificed. The hope is, that the directors will still see that the value of the establishment as property must ultimately depend on its philosophical and social value. As a bazaar, it would probably be ephemeral.

The Great Handel Festival, *Bury and Norwich Post, and Suffolk Herald* (23 June 1857), p. 3

Her Majesty arrived at the Crystal Palace with her usual punctuality, accompanied by Prince Albert, the Archduke Maximillian of Austria, the Prince of Prussia, the Princess Royal, the Prince of Wales, the Princess Alice, and suite; and was conducted by Sir Joseph Paxton and Mr. Ferguson to the Royal box at the angle of the North nave and transept opposite the orchestra. When the plaudits of the assembly ceased, the National Anthem was performed, all standing. At this time

a beautiful photograph of the splendid scene was taken by Messrs. Negretti and Zambra, the photographers of the Crystal Palace, which was finished and presented to her Majesty before the first part of the oratorio was concluded.[8]

The oratorio then proceeded, and its execution was perhaps more perfect than that of the *Messiah*. It would be superfluous to enter into a detailed criticism, but we may state that whether in the deep pathos of the opening chorus, 'Mourn ye afflicted children,' in the pious confidence of 'We come, we come!' or of 'Hear us, O Lord!' which so nobly closes the first part, and 'We never will bow down,' which works up to the highest pitch the resolution of the chosen people at the close of the second part, each was rendered with a truthfulness and force of expression that cannot be too highly commended. Herr Formes exerted himself bravely in 'Arm, arm, ye brave' but even his powerful voice failed to produce its full effect in the vast area; and for Sims Reeves also in the recitative, ''Tis well, my friends,' and the air 'Call forth thy powers, my soul,' we could have wished his perfect execution had been more distinctly heard—although it was impossible not to admire the exquisite taste and truth with which he went through the intricacies of the melody. But if, as a contemporary expresses it, his singing these pieces was 'a display of vocal power under difficulties,' in 'Sound an alarm' he overcame all obstacles, and carried his audience to the extreme pitch of enthusiasm by the marvellous force of his enunciation, and the thrilling power of his appeal, and nobly was his call replied to in the succeeding chorus, 'We hear, we hear.' Nothing could surpass the dramatic force of this part of the performance. Clara Novello and Madame Rudersdorff [*sic*] were brilliant in their respective solos, and in the florid air, 'From Mighty Kings,' Madame Novello's clear, ringing tones were heard distinctly in every part of the crowded space.[9] It added not a little to the enjoyment of the whole to see the hearty manner in which her Majesty entered into the performance, and during the piece of 'See the conquering hero comes,' the Royal fan emulated the conductor's baton in the vigour of its beats, and her Majesty graciously gave the Royal nod of approbation to the unanimous call for its *encore*. But while we dwell with delight and wonder upon the harmonies of the great master, we must not omit to notice the sublime impression produced by the simpler melody of the Old Hundredth Psalm, sung by that great choir; it was truly a noble hymn to Him who gave the powers that day displayed, and it was fitting that they should be so exercised; and while England can collect such an assemblage of talent to render homage to her favourite Handel, may she never forget to 'Sing to the Lord with cheerful voice,' in acknowledgement of those national blessings by which she could keep such a Festival.

Successful as had been the two previous performances, the great triumph was undoubtedly reserved for the *Israel in Egypt* on Friday; and so much was this anticipated from the known character of the oratorio, and its peculiar adaptation to the vast area in which it was to be performed, that instead of 11,000 or 12,000, as on the former days, no fewer than 17,292 visitors were present, at what we do

not hesitate to pronounce the greatest exhibition of the power of music that this nether world has ever witnessed. Her Majesty was not present; but the Duchess of Cambridge, with her daughters, the Duchess of Mecklenburg Strelitz, and the Princess Mary, occupied the Royal box, and in addition to the multitudes conveyed by rail, without the slightest accident or confusion, no fewer than 1,750 carriages deposited company at the doors.

The pervading characteristic of the *Israel in Egypt* is power, in the embodiment of which Handel seems to have exhausted the resources of the art in his time; and to these have been added the organ part of Mendelssohn, and all the appliances which modern improvements in instrumentation could afford. After the simple recitative by which the subject is introduced without instrumental prelude or accompaniment, the performance was one of sustained excellence and gradually rising force to its close. No conception can be formed of the manner in which were realized the ideas of such passages as 'the children of Israel *sighed* by reason of their bondage'—'They *loathed* to drink of the river'—'He sent a darkness which might be *felt*'—'the floods stood *upright as a heap*, and the depths were *congealed in the heart of the sea*'—'They sank into the bottom as a stone'—'the inhabitants of Canaan shall *melt away*; they shall be *still as a stone* till Thy people pass over.' And the more familiar portions of this great work, such as the 'hailstone' chorus— 'He rebuked the Red Sea'—'Thy right hand, O Lord'—'The Lord shall reign forever'—and 'The horse and his rider,' the grandeur of the two thousand five hundred voices and instruments, now in combination, now in fugal intricacy, and now in antiphonal response, cannot be described. Of the solos on the first part, Miss Dolby shewed great skill in her treatment of the somewhat intractable subject 'Their land brought forth frogs:' and in the second part, in the beautiful air, 'Thou shalt bring them in,' did full justice to the loveliness of the melody, which, as Mr. Macfarren's excellent analysis points out, is so distinct in character and expression from everything else in the work. Clara Novello's 'Thou didst blow,' in which her bell-like notes were finely contrasted with the magnificent ground bass of the accompaniment, was an exquisite performance; and her closing declamation, 'Sing ye to the Lord,' rang through the lofty vault with astonishing fullness, but with a departure from the text of the Great Master which was not to be commended. The execution of the air 'The enemy said, I will pursue' by Mr. Sims Reeves, was splendid, and a repetition was so perseveringly called for, that it alone was repeated, and repeated with even increased force; but this does not reconcile us to the propriety of *encores*, to interrupt the unity and action of an oratorio: indeed we think that to the many services which the Sacred Harmonic Society has rendered to the cultivation of sacred music, they would add one of no small value if they could succeed—in what we believe they have attempted—the putting down of the whole practice of applauding. To true taste and right appreciation of the spirit and intention of sacred song, what can do greater violence than the immediate contrast of its sublimest strains with the clapping of hands and the

knocking of sticks and feet? To the more solemn feelings which the theme is calcu-lated to inspire, what can be more opposed than such demonstrations? 'Handel,' it is well known 'when told that one of his finest compositions was not admired,' made answer that he did not write it to be admired but to be felt; and even those who cannot withhold their admiration from the composer or the performer might say, with the poet, though with a lower application, 'Come, then, expressive silence, muse his praise.'

The performances were concluded with a repetition of the National Anthem, which was given with great force by the principal singers, and chorused with mag-nificent effect; and the sight of twenty thousand persons standing in that beaute-ous area, whilst the Ruler of the Universe was invoked to protect the Sovereign and the People, amongst whom this glorious display of His gifts was made, could scarcely fail to excite emotions which will not soon be forgotten.

The performance of each day was followed by a display of the magnificent water works; and the supply of refreshments was ample and excellent, and all the arrangements as compete as could be desired.

The total receipts were about 23,000*l.*, of which the surplus, after payment of expenses, is expected to be about 10,000*l.*

The Crystal Palace. Destruction by Fire, *The Times* (1 December 1936), p. 16

GLOW SEEN AT BRIGHTON

The greater part of the Crystal Palace at Sydenham and nearly all that was in it perished in flames last night. The fire was still burning at a late hour this morning, and even after 2 a.m. crowds were still arriving to watch the spectacle.

About 7.30 last night an outbreak of fire was seen in the main central part of the building; three hours later more than two-thirds of the great structure was a flaring mass of ruins on the ground, and the fire was burning relentlessly, against a fresh wind, through the remaining wing. Only the two high, round towers, one at either end, were spared. So far as could be known last night all of the persons who were inside when the fire broke out were able to leave safely.

When the alarm was given the permanent firemen attached to the Palace did their utmost with the appliances at hand, but it was quickly evident that their efforts were hopeless, and by the time the first motor-pumps arrived from Penge the whole of the central transept was involved.

TASK OF THE BRIGADE

A brigade call was at once circulated, and men and appliances arrived in suc-cession from many parts of London and the suburbs; but they could do practically

nothing more than slightly delay the destruction. The conditions were all against them. The line of the Crystal Palace building runs north-north-east to south-south-west, with the main central transept at right angles. Last night the wind was blowing freshly from the north-west, with the result that the fire, starting in front of the transept, was blown right through it to the back and also down through the south-west wing. Within half an hour of the outbreak all of these portions were ablaze like a vast bonfire, which, set on a great ridge which dominates South London from a height of over 300ft., was visible for miles. Thousands of people immediately recognized the meaning of that great glare, and set out for the Palace by every means of transport, and everywhere could be heard genuine expressions of regret for the end of 'the poor old Palace.'

A TWISTED SKELETON

The scene along the Parade was awe-inspiring. The flames roared up the entire height, perhaps 150ft., to the top of the great round arch of the central transept and along the whole length of this and the south-west wing. Masses of glass dropped continually, and section by section the huge skeleton of ironwork visibly bent and twisted and fell with heavy crashes and in immense showers of sparks; the steady glare spread far beyond the Parade, and shone on the faces of thousands of people ranked along the railway line below.

For some time there was fear that the flames would reach the tower on the south flank, which stands almost on Anerley Hill, for it was reported that there was explosive material inside this structure, which is partly used by the Baird Television Company for experimental purposes.[10] The possible fall of the tower also threatened to involve the destruction of a number of buildings on Anerley Hill, and the occupants of these were warned by the police of the danger. As it happened the fire burned so swiftly and intensively that the south-west wing was brought down to the ground before the flames could reach the tower.

At the north-east end the flames worked steadily against the wind and soon caught the low brick building in front of the Palace proper, part of which was used as a post office, and then spread to the remaining wing. On this wing and on the two towers the firemen, giving up the hopeless fight elsewhere, concentrated their efforts, but the flimsy material inside the wing structure burned farther and farther along, in spite of all they could do.

A STRIKING SPECTACLE

From afar off the great red glow in the sky seemed like an exaggerated sunset, wreathed in huge billowing clouds. Thousands of people hurried to the scene from miles around by car, on foot, and by bicycle. As the press grew these last-named

were to prove an embarrassment, and sometimes a danger, to their owners. Every road nearby was packed with cars, and some drivers got to the top of Crystal Palace Road before the police placed a control across the junction with West Hill and turned back all vehicles attempting to reach the Palace.

Pedestrians could not be so easily handled, although the police were rapidly augmented by special constables. People crowded on to the Parade fronting the Palace until the road was so thronged that firemen stood by helplessly with hose which they could not connect up. A police control car succeeded, by constant pleading and urging 'This road must be kept clear,' in getting the far end of the Parade free enough at any rate for the firemen to work unhampered.

From every window near the Palace the inhabitants gazed out on to the blazing building, and from every fence and tree sightseers watched the leaping flames. It was an impressive spectacle. The main building was silhouetted sombrely against the background of red flames and white smoke. Now and again the fire seemed to subside, but only to break out with renewed intensity.

At midnight the framework of the north wing was still standing, but was enveloped in flame and appeared white-hot. Huge crowds were still gathered at either end of the long Crystal Palace Parade, held back by large bodies of police, and hundreds of motor-cars were packed in all the roads and streets within a radius of half a mile.

Large numbers of people from Epsom and the surrounding district went on the Downs to watch the fire. On Banstead Downs also there were large numbers of onlookers. The glow in the sky could be clearly seen from Guildford, and even as far away as Devil's Dyke, near Brighton. In North London hundreds of people went to Parliament Hill, Hampstead, to see the fire, and the higher points of the Heath were densely packed.

LOSS TO MUSIC

Mr. F. W. Holloway, who has been organist at the Crystal Palace for 40 years, was in the middle of a rehearsal of the Crystal Palace Choral and Orchestral Society when he heard of the fire.

At about 8 o'clock (he said) I was informed that there was a fire, but that there was no need to be nervous, because it would soon be out, and we could carry on with our rehearsal. In less than five minutes the same man who had told me of the fire came back and said that it would be wise if we cleared out immediately. By then the Palace was blazing, but we were able to leave quite quietly by a nearby entrance.

Mr. Holloway lost all his personal music which he kept at the Palace, and the magnificent organ, which is estimated to have been worth £4,000, was completely destroyed. In addition the Handel Festival music, which, in Mr. Holloway's words, was 'worth thousands of pounds,' was also lost.

BAIRD TELEVISION

Valuable plant and instruments from the premises of the Baird Television Company by the south tower were saved by members of the staff and by the Salvage Corps.

At 1.15 Baird Television, Limited, stated, though the research laboratories at the Palace had been destroyed, the main production departments had escaped serious damage.

HOTEL MANAGER'S STORY

The manager of an hotel opposite the Crystal Palace said:—

At about 8 o'clock we saw a small light at the Sydenham end of the Palace. Within a few minutes there was a wild jangling of bells as fire engines came from all parts of South London; but it was amazing to see how quickly the flames spread. Within 20 minutes the centre part of the building fell in a great cloud of sparks and flame. It was like a hellish pillar of sparks that went up into the sky.

At the moment (9 o'clock) so may thousands of people are here that they are blocking the roads, and fire is lighting up the whole of the district. You can see to read a newspaper several hundred yards away. I have been warned that we may have to get out of the hotel if the fire spreads to the north tower. There will then be a risk, I am told, that the tower might fall. Meanwhile the heat is intense—so intense that you cannot comfortably stand on the hotel veranda. Every now and then there is a mighty roar and crackling noise as the flames spread.

A NATIONAL LOSS
SIR HENRY BUCKLAND'S STATEMENT

Sir Henry Buckland, the general manager of the Palace, at the height of the fire looked with tears in his eyes on the ruin of what has been his special care, and in large measure his life.[11]

I can scarcely realize it (he said). Twenty-two years of work, all gone. I haven't any idea how it started, or how it gained so quickly. We have had fires here before—three times—but they were quickly put out.

To-night I was working in my office till about a quarter past 6, and after leaving I had come out of doors to post a letter. Then I saw that the transept was on fire. I went inside, ordered the calling of the fire brigade and the police, and directed the people I saw to the south exits. I opened some of the emergency doors myself.

It is tragic to see it all go like this. We had just finished an immense amount of reconditioning work, including the restoration and rearrangement of the statuary, and were looking forward to a great summer exhibition next year. We had had show stables built, too, in preparation for the Christmas circus. The Palace belonged to the nation, and its end is a national loss.

As Sir Henry Buckland spoke the Chief Officer of the Fire Brigade came up, and Sir Henry told him that there was 1,200 tons of water stored in the South tower for use in an emergency.

FIRE NEWS IN BRIEF

Shortly before 11.45 the Duke of Kent drove up to the Crystal Palace in his car and stepped out to view the burning building. He was given firemen's thigh boots to wear because of the condition of the roads, and remained on the scene until shortly before 2.30 a.m.

Mounted police helped to clear the crowds from the danger zone.

Mr. J. E. Wright Robinson, clerk to the Crystal Palace Trustees, stated last night that the Palace was fully insured.

People living in Anerley Hill, which faces the south tower, hastily collected valuables and hurried from their homes.

The B.B.C. in their news bulletin advised crowds not to go too near the fire because of the difficulties of the police.

Domestic water supplies in the Palace district were reduced to half pressure owing to the requirements of the Fire Brigade.

The new hose lorry of the Fire Brigade, which can reel out one and a half miles of hose at a speed of 15 miles an hour, was used for the first time after being demonstrated only yesterday afternoon.

Captain von Weyrother, a Royal Dutch air liner pilot, saw the glow of the fire when his machine was reaching Margate. He was bringing from Amsterdam seven English passengers just home from India.

Hundreds of birds from the aviary within the central arch were released from their cages before the collapse of the roof. They fluttered through the smoke to nearby trees, and most of them escaped.

During the progress of the fire an aeroplane circled over the palace, as low as it could fly with safety.

A waxworks exhibition was being held in the Palace yesterday.

6.3 The surplus

The full profit of the Exhibition after all costs had been accounted for was £186,436. 18s 6d. (*Third Report*: p. 15). What was to be done with it and how was it to be administered? Following the Exhibition's close, the Executive Committee was discontinued and one working Secretary, Edgar Bowring, appointed along with a Surplus Committee. A Supplemental Charter of 2 December 1851 was granted that enabled the Commissioners to make a decision on the disposal of the surplus. From the word go, Albert was clear in his own mind that the main legacy of the Exhibition should be a centralised

educational institution and in a memorandum of August 1851 he drew up what he called 'a crude scheme requiring mature consideration' to purchase land around Kensington Gore which would house four institutions corresponding to the Exhibition's classification system of Raw Materials, Machinery, Manufactures and Plastic Art. Each institution would provide libraries, lecture rooms, galleries and exhibition spaces. The *Athenaeum* cited Albert's idea for a 'New Industrial University' which would comprise 'a congress of all the colleges of art, science, and labour [...] A museum, laboratories, workshops, lecture-rooms, and library' (RC/H/1/10/70). Bringing together the institutes of learning scattered across London, including the Linneaen Society, Geological Society, Botanical Society, Agricultural Society and Society of Civil Engineers, it was envisioned as an act of modernisation, 'a system more in keeping with the requirements of the age' than the universities of Oxford and Cambridge.

Laudable as the plan appears, in hindsight it was not without its snags and its objectors. Albert's desire to create a new home for the National Gallery – a key component of his vision – was, for example, quickly foiled. The strongest opposition came, however, from the provinces. Because many local committees had contributed subscriptions, they believed that the profit of the Exhibition should devolve to cities across the country. Particularly vocal in relating these objections was the *Daily News*, who campaigned for the improvement of libraries and museums in the industrial north. The issue of 8 April 1852 carried a strongly worded response from the Warrington Committee to the Commission's refusal to spend any surplus on projects of a 'limited, partial, or local character'. What, claimed the Warrington Committee, made a library in the north-west any more of a 'local' – and less of a national – institution than one built in London? Bowring's response fails adequately to answer the question and Albert continued with his proposals undaunted.

Memorandum of Prince Albert (10 August 1851), *Minutes*

It is estimated that after defraying the expenses of the Exhibition, the Royal Commission will be left with a surplus of from £150,000 to £200,000.

The question arises: what is to be done with this surplus?

Schemes abound for its application and a great movement is being made to get it expended upon the purchase and maintenance of the Crystal Palace as a Winter Gardens.

It becomes necessary for the Royal Commission to mature some plan for itself on a careful and conscientious consideration of its position, power and duties, in order not to find itself at the end of its important labours driven into the execution of ill digested projects by the force of accidents or popular agitation.

I take the objects to have been: the promotion of every branch of Human Industry by means of the comparison of their processes and results as carried on

and obtained by all the Nations of the Earth, and promotion of kindly feelings of the Nations towards each other by the practical illustration of the advantages which may be desired by each from the labours and achievements of the others.

Only in a close adherence to the governing idea, and in a consistent carrying out of what has been hitherto done can we find a safe guide for future plans.

But even if this were not the case it will be found that by former announcements to the Public we have distinctly pledged ourselves to expend any surplus which may accrue towards the establishment of future Exhibitions on objects strictly in connection with the present Exhibition.

The purchase of the Crystal Palace for the purpose of establishing a Winter Gardens or a Museum of Antiquities, or as Public Promenades, Rides, Lounging Places, &c. &c. has in my opinion no connection whatever with the objects of the Exhibition. Our connection with the Building has been an incidental one, merely a covering to our Collection and ceases with the dispersion of the latter, and therefore even if we were not bound by legal contracts to remove the Building on a specified day, and the dictates of good faith did not induce us strictly to fulfil our moral engagements towards the Public, should we be released from our legal engagements,—I consider that we have not the power to divest any part of the surplus towards providing London, or even the English Public with a Place of Recreation.

But should the Public wish to maintain the Building we ought not to stand in the way of the Government keeping it up to the 1st May, should they feel it their duty to take such a course.

If I am asked what I would do with the surplus? I would propose the following scheme:

I am assured that from 25 to 30 Acres of ground nearly opposite the Crystal Palace on the other side of the Kensington Road, called Kensington Gore (including Soyer's) are to be purchased at this moment for about £50,000. I would buy that ground and place on it four Institutions corresponding to the 4 great sections of the Exhibition: Raw Materials, Machinery, Manufactures and Plastic Art.

I would devote these Institutions to the furtherance of the Industrial pursuits of all Nations in these four Divisions.

[…]

Hence I would provide each of these Institutions with the means of forming:
1. A Library and Rooms for Study.
2. Lecture Rooms.
3. An acre of glass covering for the purpose of Exhibitions.
4. Rooms for Conversation, Discussion, and Commercial Meetings.

The surplus space might be laid out as Gardens for public enjoyment, and so as to admit of the future erection of public Governments there, according to a well

213

arranged plan. The course might be applicable for a public Conservatory if wished for.

[...]

By a scheme like this we should ensure that the Great Exhibition of 1851 should not become a transitory event of mere temporary interest, but that its objects would be perpetuated, that the different industrial pursuits of Mankind, Arts and Sciences, should not again relapse into a state of comparative isolation from each other, in which their progress is necessarily retarded, and that the different Nations would remain in that immediate relation of mutual assistance by which these pursuits are incalculably advanced and their goodwill towards each other permanently fortified.

The Crystal Palace, *Daily News* (22 March 1852), p. 4

HORACE protested long ago, against the atrocity of a painter appending a fish's tail to the body of a beautiful woman. It would be infinitely worse taste to allow such a proud and beautiful national effort as the great industrial Exhibition, with its Crystal Palace, to terminate in a scandalous and shabby job. The fate of the building in Hyde-park now trembles in the balance—as a letter from the contractors, and the report of the commission, printed in another column, fully show. When the Glass Palace is gone, let us take care that its memory is not tainted by the perpetration of 'a job.'[12]

[...]

Sundry proposals have been made for the beneficial application of [the surplus fund]. Some were of opinion that it was desirable to preserve the Crystal Palace as a monument of the Exhibition, and an instructive specimen of an entirely new kind of architecture; to this purpose they said the surplus fund might be devoted. Against this, the Surplus Committee have positively declared. Others opined that the fund might more usefully be applied to found some model institution for industrial education. This project seems tacitly relinquished; nobody seems to have any clear idea what is or ought to be made of the fund; and all kinds of useless and unreasonable ways of spending it are proposed, having no feature in common but this, that carrying them into effect would put money into the pockets of the proposers. At present the favourite horses entered for these sweepstakes are of that most inveterate class of jobbers, the dealers in stone and mortar, and monstrous architectural designs. As if there were not already enough monuments of JOHN BULL'S folly and gullibility in this way, it is gravely proposed to erect some new, expensive abortion in Kensington Gardens.

214

Whether this egregious device be successful or not, there is reason to fear that the chances of saving a part at least of the surplus fund from misappropriation are slender. The commission which managed the Exhibition—and we own readily, and without grudging, who managed it well—have made money by their show. After deducting all expenses they have a large surplus from the money taken at the doors. Now, is it not very clearly apparent to whom this same commission is responsible for its intromissions. They took all the trouble, most of them without payment; and they not unnaturally conceive that, in addition to the credit they have got thereby, they are entitled to reward themselves by disposing of the money they have earned in the way that seems to them best. It will not be easy to drive this notion out of their heads: and, unluckily, there is nobody who can show a clear title to a voice influential in the matter.

But then there is the sum of 70,000*l*. or 80,000*l*. which was raised, before the Exhibition opened, by subscriptions, set on foot throughout the country in consequence of begging letters circulated by the commissioners. That money was subscribed for a definite purpose, for which it has not been needed or used. Not having been applied to the purpose for which the subscribers intended it, they have an undeniable right to insist that it shall not be spent in a way they disapprove of. It would be wrong on the part of individual subscribers to ask to have it refunded; but no one can deny their right to a vote in its appropriation.

To the subscribers, then, we make our appeal to defeat, as far as in them lies, the intended squandering away of their subscriptions upon a tasteless and useless job. The Crystal Palace is doomed; there is little use in asking them whether they would like to have their money appropriated to its sustenation. The institution for industrial education has been a mere proposition. But there are other ways in which it may honourably and usefully be disposed of.

The money was raised to aid an undertaking which it was believed would promote the taste and intelligence of the industrial classes. It ought to be regarded as a fund set apart for that purpose. It ought only to be spent in a way conducive to that end. Let the subscriptions collected in every locality from which contributions were received be devoted to institutions for public entertainment and refinement.

An earnest desire is felt throughout the country at the moment for the establishment of public libraries and museums in our large towns; some have already been founded, and legislative aid has been invoked to extend them and augment their number. Considerable experience in the working of mechanics' institutes and similar associations enables us to say with confidence that the best possible schools for the public are good and easily accessible libraries. We have no intention or desire to undervalue the importance of elementary instruction, or of the instruction which adults receive by lectures. But schoolmasters for the young, and lectures for those of riper years, can only teach their pupils how to make use of their intellectual faculties. They can only show them the process by which knowledge is to be acquired, and

initiate them in the practice of acquiring it. Ultimately every one must be his own teacher. But in acquiring knowledge, as in every human pursuit, nothing can be done without tools and materials to work upon. In self-instruction, books, maps, plans, drawings, are the tools and the materials to be used. Without them, men's best intentions to instruct themselves must be unavailing. But much as has been done to cheapen and popularise books, it is impossible that any private individual—especially anyone of limited means—can acquire in private property all the books he may require. Public libraries must come to his aid. It is in vain that we found schools for children—it is in vain that we support lectures for adults—unless we throw open to them large and varied collections of books.

Libraries are not only a necessary supplement to instruction; they are no mean substitute for efficient tuition. Any one who has barely been taught to read, if turned loose among a collection of good, interesting, instructive books, will unconsciously educate himself. He may read desultorily, merely for amusement of his idle hours; but some useful knowledge will be picked up, and will stick to him. The mere acquisition of a taste for reading is in itself a great step in advance. The persons who resort habitually to a public library contract acquaintance with each other; they talk about the books they have been reading; they interchange opinions about them; they teach each other to judge and argue; they stimulate each other to add to their knowledge. They become an unorganised class of mutual instruction. Their pursuits refine and elevate them. Their vague and desultorily acquired information intellectualises the society to which they belong, and creates an irresistible craving for education in the proper sense of the word.

What is true of libraries is equally true of museums, of botanical and zoological gardens, of collections of pictures and sculptures. Without these indeed books and teachers are inadequate instructors; they can do little more than impart words; men require to have before them the realities which words describe. In a museum men can realise much that they have read about—fossils, stuffed beasts, samples or representations of antiquities. In zoological and botanical gardens they can mark and watch the operations of living nature. In galleries of art they can develop and acquire the ennobling sense of the beautiful. Where such institutions exist the people necessarily and inevitably acquire knowledge and refinement. They come for amusement, and return and remain for edification.

Now, with the foundation of such institutions, as with every human enterprise, the beginning is the great difficulty. Every library or museum instituted in any one town stimulates others to rival exertions. Every imperfect collection begun animates men to complete it. Every contribution, however small for such purposes, induces men to unloose their purse strings to add to it. It is not wise to contemn the day of small things. Now that men are beginning in earnest to appreciate and aim at the establishment of local public libraries and museums every local fund for the purpose ought to be carefully husbanded. What the Industrial Exhibition was for a short time for the nation, local libraries and museums may be made

permanently for every town. The object for which contributions were made to a guarantee fund for the Exhibition is the object for which funds are now sought to establish local public libraries and museums. That guarantee fund not having been required or used reverts to be disposed of by the subscribers; and there can be no more legitimate application of it than to aid in the establishment of local public libraries and museums.

[...]

The duty of associated subscribers to the guarantee fund of the Exhibition, in various localities is, therefore, clear. Let those of every place that has contributed demand back their contributions to be applied to support and increase its public library or museum if it has one, or to found one if it has not. Their request cannot be decently refused by the commissioners, and will not be refused, if earnestly and perseveringly urged. They will thus go far to prevent the memory of the Exhibition being sullied by association with a gross job, and promote, to an extent of which they can at present have no conception, the great object of real, effectual national education. We call upon the metropolitan districts and parishes to be up and doing. We call upon Manchester, Bradford, Glasgow, Sheffield, Warrington, and all the places from which contributions to the Exhibition guarantee fund were sent. They have no time to lose.

The Great Exhibition Surplus Fund, *Daily News* (8 April 1852), p. 5

SIR,—The exertions of the *Daily News* in directing public opinion to what I believe to be the only equitable and judicious mode of appropriating the surplus fund from the Great Exhibition, and the notice you have been pleased to take of the memorial on the subject, adopted by the Warrington Local Committee, entitle you to the earliest communication of the answer which has been returned by her Majesty's commissioners, of which I accordingly enclose a copy.

The report referred to in the commissioners' letter is that of the former commission, dated November 6, 1851, containing the opinion that the surplus fund should not be applied to purposes of a limited, partial, or local character, on which opinion is now grounded their decision that they do not feel themselves to be in a position to comply with the application contained in the memorial. The prayer of the memorial was, that such recommendations might be made to her Majesty, as might have the effect of procuring the appropriation of the fund to the purpose suggested; and I do not clearly perceive how an opinion expressed in November, 1851, by a former commission, which had confessedly no powers to deal with the question, can either prevent the present commission from making such recommendation to her Majesty, or affect the representations on which the subscriptions were asked for in the spring of 1850; but the public will be happy to find that the

rumours which have been so rife, as to the probable appropriation of the fund are formally contradicted by her Majesty's commissioners, and that no appropriation 'of a limited, partial, or local character,' will meet with their approval. It remains to be seen what will be the plan recommended by the commissioners, and to apply to it the three tests which they have themselves proposed. If it should embrace a building of any description in London, it would be '*limited*;' for it would be confined to one locality, while the provincial museums and libraries, whose claims are supported by the *Daily News*, would extend their benefits over a hundred; that it would be '*local*,' is only to say the same thing in other words; and that such an appropriation of our subscriptions would be '*partial*' to London, and an act of positive injustice to the provinces, is the very ground of our complaint.

The sentiments expressed in the *Daily News* are evidently gaining ground; and I hope that the communication which I now enclose will induce other towns to join in urging their claims,—which, if duly pressed, will yet, I hope, effect a change in views of her Majesty's commissioners. I am, Sir, your most obedient servant,

THE SECRETARY TO THE WARRINGTON LOCAL COMMITTEE.

6th April, 1852.

————

Palace of Westminster, April 3, 1852

Sir,—I am directed by her Majesty's Commissioners for the Exhibition of 1851 to acknowledge the receipt of the memorial signed by yourself on behalf of the Warrington Local Committee, praying that the sums subscribed to the Exhibition fund by the various provincial towns may be appropriated to public objects connected with the progress of art, science, and education in the town from which such subscriptions have been raised, and in particular that the sum of 150*l*. remitted to the commissioners from the borough of Warrington, may be appropriated to the building of the Warrington Museum and Library.

The commissioners direct me, in reply, to transmit to you, for the information of the Warrington committee, the accompanying copy of a report addressed by them to her Majesty on the subject of the disposal of the surplus funds in their hands, and they would especially call the attention of the committee to the passages in that report in which they refer to the announcement originally put forward by them, that all subscriptions must be absolute, and definite, and in which they express their opinion that the surplus should not be applied to purposes of a limited, partial, or local character; and that they do not therefore feel themselves to be in a position to comply with the application contained in the memorial.

With request to the statement advanced by the committee that they understand that it is likely that the surplus fund will be appropriated to 'the erection of a building in or near London for the purpose of a museum or picture gallery,' I am directed to acquaint you that there has been no declaration on the part of the com-

missioners to justify such an opinion—that the enclosed report is the only document relating to the surplus that exists, and that no other report on the subject of its disposal has been made by the commissioners.

<div style="text-align:center">

I have the honour to be, sir,

Your obedient servant,

EDGAR A. BOWRING.

</div>

6.4 Albertopolis

The Kensington purchase created what Hermione Hobhouse has called 'a Quartier Latin' (2002) in West London; a complex of educational institutions that is the ultimate legacy of Prince Albert. 'Albertopolis', as it came to be known, was derived from several key purchases made in the 1850s on the south side of Kensington Road from the Villars family and the housing developer, Charles Freake.[13] The Kensington Gore Estate grew throughout the nineteenth century to house, amongst other things, the Albert Hall, the Natural History Museum and the Imperial Institute. In the 1860s the area of the grounds where 'The Brompton Boilers' – the building which housed the 1862 Exhibition – was located, were leased to the Horticultural Society. Each of the reports of the Commission to the government contained a map that showed the extent of the development of the site. It is impractical to include all of these here, but I have chosen the map from the *Seventh Report* of 1889 as I thought it particularly interesting for showing the position of the Albert Hall, the Imperial Institute and the Natural History Museum, but also the land earmarked for the as-yet-unbuilt Royal College of Music on the south side of New Road.

For Hobhouse, the area had a 'rather haphazard' (1995: p. 50) appearance due to the organic way in which it was created. But in 1992, lottery funding was granted to give the complex more coherence through the creation of a pedestrianised precinct, designed by Sir Norman Foster, with each of the main entrances of the major institutions redesigned to face inwards.

The major events in the development of the South Kensington complex are far too numerous for me to give anything other than a general flavour. The documents included here have been chosen because they mark key moments for Albert, prior to his untimely death in 1862 and posthumously, including correspondence on the organisation of the 1862 Exhibition, the Executive Committee's speech at the unveiling of the Albert Memorial (now located at the entrance to the Royal Albert Hall), and the Prince of Wales's address at the opening of the Royal Albert Hall on 29 March 1871.

One further important aspect of the afterlife of the 1851 Commission which needs documenting, is the establishment of scholarships, part of its educational remit, for students in Science, Industry and later, the Arts. The

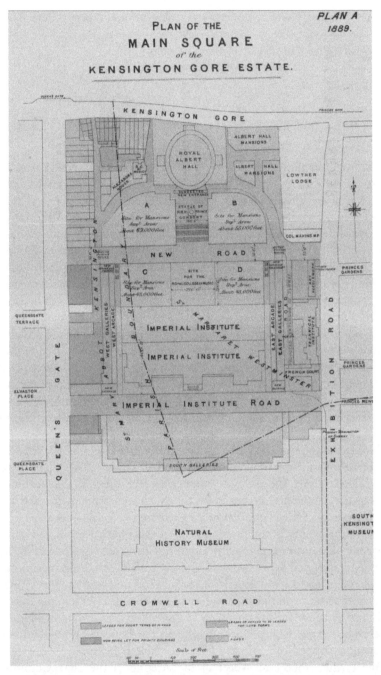

19 Plan of the South Kensington Estate, 1889, from Royal Commission, *Seventh Report* (1889)

Commission's patronage extended to the founding of the British School at Rome for scholars in Art, Sculpture and Architecture. The scholarships scheme prompted Nicholas Deakin to include the Commission as one of the most significant examples of Victorian philanthropy in the *Origins of the Welfare State* (1948). I have included the list of original regulations for Science Scholarships compiled in 1891.

Correspondence on the Subject of the International Exhibition of 1862 (*Fourth Report*, Appendix K), pp. 166–8

WHEREAS the Society for the Encouragement of Arts, Manufactures, and Commerce is of opinion that decennial Exhibitions of works of Industry and Art, showing the progress made during each period of ten years, would tend greatly to the encouragement of Arts, Manufactures, and Commerce; and it is intended that the first of such Exhibitions shall be held in London in the year 1862; that foreigners shall be invited to contribute; and that a guarantee fund shall be formed, in order to obtain adequate means for originating and holding the same:

In furtherance, therefore, of said intention, we, the undersigned, severally agree with the Trustees and Managers of the intended Exhibition in manner following:—

1st. The sum of 250,000*l.* sterling at least shall be and is hereby subscribed as the guarantee fund, in the sums set opposite to our respective signatures; and no liability shall be incurred by any person subscribing this agreement, unless the sum of 250,000*l.* be subscribed within six calendar months from this date, nor shall any subscriber be liable beyond the amount of his subscription. And every subscriber shall contribute in rateable proportion to his subscription to liquidate any loss, should such attend the undertaking.

2nd. The undertaking shall be under the management of five persons, hereinafter called the Trustees in whom all monies received on account of the undertaking shall be vested, and they shall have full and absolute powers to expend the same, and to enter into contracts, as well for works as for loans of money, and to do all things which may in their judgment be necessary for the undertaking.

3rd. The Earl Granville, K.G., the Marquis of Chandos, Thomas Baring, Esq., M.P., Charles Wentworth Dilke, Esq., and Thomas Fairbairn, Esq., shall be invited to become, and if they shall accept the office, shall be the first Trustees of the undertaking.

4th. On the death, resignation, incapacity, or refusal to act of any person invited to become a Trustee, or of any Trustee, another Trustee shall be appointed to supply the vacancy, by the majority in value of the subscribers present at a meeting specifically called for the purpose, and every Trustee shall sign a memorandum, on these presents, testifying his acceptance of the appointment; but, notwithstanding

any vacancy, the actual Trustees shall have full power to act in the management of the undertaking.

5th. The Trustees shall apply to Her Majesty's Commissioners for the Exhibition of 1851 to grant a portion of the ground purchased at South Kensington out of the surplus funds of that Exhibition as a site for the intended Exhibition; and should they not obtain such ground on terms satisfactory to themselves, they shall have power to acquire, by purchase or otherwise, any suitable site.

6th. The Trustees shall erect on the site they acquire all such buildings and conveniences, as well permanent as temporary, as shall in their judgment be necessary, and one-third part at least of the sum thus expended shall be employed in erections of a permanent character, suitable for such decennial or other periodical exhibitions, and, when not so used, suitable for other purposes tending to the encouragement of Arts, Manufactures, and Commerce.

7th. Subject to the provisions herein contained, arrangements shall be made for vesting the site and buildings of a permanent character in the Society for the Encouragement of Arts, Manufactures, and Commerce, for holding exhibitions of Art and Industry, and for other purposes tending to the encouragement of Arts, Manufactures, and Commerce, on such terms as may be arranged with the Council of the said Society.

8th. After the close of the Exhibition, or the previous termination of the undertaking, its affairs shall be wound up, and the temporary buildings sold. And should there be a deficit which the Society of Arts shall decline to liquidate, a sale shall be made of the interest of the Trustees in the permanent buildings. And if, after such sale, there shall remain a deficit, the ultimate loss shall be paid by the subscribers rateably. But in case there shall be a surplus, it shall be applied to the encouragement of Arts, Manufactures, and Commerce, in such manner as shall be determined by a majority in value of the subscribers present at a meeting specially called for that purpose.

9th. In case the undertaking be attended with loss, the Trustees shall assess such loss rateably upon the subscribers, and make a call or calls upon each of them for payment of his proportion of such loss; and if such calls shall not be paid on demand, the Trustees may recover the same from the defaulting subscriber as a common debt, in an action to be brought in the names of the Trustees. And a notice from the Trustees, requiring payment from any subscriber, sent by the post addressed to his usual or last known residence, shall be sufficient evidence of the calls having been made, and the production of this agreement shall be conclusive evidence of the liability of every subscriber to pay the money demanded.

10th. Every meeting of the subscribers shall be held at the rooms of the Society of Arts, or some other convenient place in London, and be called by the Trustees, or any two of them, or by not less than 10 subscribers, representing a total subscription of at least 50,000*l.* by notice sent to each subscriber through the

post addressed to his usual or last known residence, 14 days at least prior to the day fixed for such meeting. At each meeting a chairman shall be elected, and all resolutions shall be determined by a majority in value of the subscribers present. If subscribers, 10 at least in number, representing a total subscription of 50,000*l.* do not attend within 30 minutes of the time appointed for holding any meeting, no business shall be transacted.

Address of the Executive Committee for the Erection of a Memorial of the Great Exhibition of 1851 to His Royal Highness the Prince of Wales on the Occasion of the Inauguration of that Memorial on the 10th June 1863 (*Fifth Report*, Appendix I), pp. 100–2

MAY IT PLEASE YOUR ROYAL HIGHNESS,

IN the year 1853 a meeting convened by the Lord Mayor of London, Thomas Challis, Esq., M.P., and presided over by him, was held in the Mansion House, to consider the propriety of erecting some Memorial of the Great Exhibition of 1851, in connexion with a tribute of admiration to its great founder the Prince Consort, your Royal Highness's illustrious and lamented father. The propriety of the step was at once recognized; and it was resolved unanimously, as well by the country at large as by the meeting, that the Exhibition 'was an event of the greatest importance to the nations of the world, by enabling them to observe the relative influence of science, art, and national characteristics upon production, by furnishing the means of a valuable review of the past, and by marking a new starting point for the future progress of productive industry and giving it an increased stimulus.' The meeting saw, too, with the wise author of the undertaking, that its tendency had been to promote useful intercourse between all peoples, and to induce in them feelings of goodwill towards each other. Money was accordingly subscribed for the erection of a Memorial, and active steps were taken to obtain a place for the intended Monument on the site of the Exhibition in Hyde Park. Artists of all countries were invited to submit drawings and models in competition; and ultimately, out of nearly fifty, the design sent in by Mr. Joseph Durham was selected.

The endeavours to procure a site in the Park having failed, we, the Executive Committee, who had met with difficulties that might not have been anticipated, sought the aid of the Prince Consort. This was at once freely accorded on the condition, characteristic of His Royal Highness's noble self-denial, that the Memorial should be in no way personal, but one to which he could himself subscribe. The Royal Horticultural Society granted the fine site before which we now stand, on land belonging to the Royal Commissioners for the Great Exhibition, and therefore appropriate, the Commissioners themselves concurring in the grant; and from that time till the very last, His Royal Highness continued to give consideration and

personal assistance of inestimable value in completing and carrying out the project. Guided by his cultivated judgment, and aided by an increase of the funds, the design was enlarged and improved to its present form; and the last public act of the Prince in London was the approval of the statue of Her Most Gracious Majesty the Queen, then intended to surmount the Memorial.

A letter from your Royal Highness, after the painful event that had plunged the nation into grief, conveying the will of the Queen that instead of Her Majesty's statue that of her beloved husband should crown the Memorial, and offering your Royal Highness's own part to present the statue proposed to be thus placed—a letter which touched the heart of the country—enabled us to carry out the original desire of the subscribers, which was, emphatically, to offer a public and lasting tribute in connexion with the Great Exhibition of 1851 to the good Prince—'to whose far-seeing and comprehensive philanthropy' (as now recorded on the face of the Memorial) 'its first conception was due, and to whose clear judgment and untiring exertions in directing its execution the world is indebted for its unprecedented success.'

We take the liberty of expressing our great satisfaction with the admirable manner in which Mr. Durham has executed the commission confided in him. He has produced work that we believe to be honourable to himself and to the country; and we trust this feeling will be generally shared in, especially by those eminent persons who assisted in the Great Exhibition, and whose names he has consequently recorded on enduring granite.

In concluding this brief account of our proceedings, we tender most grateful thanks to the Queen for the interest Her Majesty has been pleased to show in the progress of this work, and the all-important assistance thus rendered us in our self-imposed labour. And we pray heartily and devoutly that Almighty God may, in His goodness, long preserve Her Majesty's life—a life most precious to her loyal and loving people.

It only remains for us to acknowledge most respectfully the anxious readiness with which you, Sir, accompanied by the Princess whom all the kingdom welcomes with open heart, and by your Royal Brothers and Sisters, have graciously taken part in the proceedings of today. We offer in the name of the subscribers our earnest thanks, and we solicit that your Royal Highness will now be pleased to command the uncovering of the Memorial.

Address Presented by his Royal Highness the Prince of Wales to Her Majesty the Queen at the Opening of The Royal Albert Hall of Arts and Sciences (*Sixth Report*, Appendix I), pp. 74–5

MAY it please Your Majesty,—As President of the Provisional Committee of the Royal Albert Hall of Arts and Sciences, it is my high privilege and gratification to report to Your Majesty the successful completion of this Hall, an important

feature of a long-cherished design of my beloved father, for the general culture of your people, in whose improvement he was always deeply interested. Encouraged by Your Majesty's sympathies, and liberally supported by your subjects, we have been enabled to carry out the work without any aid from funds derived from public taxation. I am warranted in expressing our confidence that this building will justify the conviction we expressed in the report submitted on the occasion of Your Majesty's laying its first stone, that by its erection we should be meeting a great public want. Your Majesty's Commissioners for the Exhibition of 1851, in further prosecution of my father's design for the encouragement of the arts and sciences, an object which he always had warmly at heart, are about to commence a series of Annual International Exhibitions, to the success of which this Hall will greatly contribute by the facilities which it will afford for the display of objects and for the meeting of bodies interested in the industries which will form the subjects of successive Exhibitions. The interests shown in the Hall by the most eminent musicians and composers of Europe strengthens our belief that it will largely conduce to the revival among all classes of the nation of a taste for the cultivation of music. Your Majesty will hear with satisfaction that results have justified the original estimate of the cost of the building, and that, aided by the liberal assistance of your Exhibition Commissioners, the Corporation will commence its management unfettered by pecuniary liabilities, and under conditions eminently calculated to insure success. It is my grateful duty to return to Your Majesty our humble thanks for the additional mark of Your Royal favour which is conferred upon us by your auspicious presence on the present occasion, when our labours as a Provisional Committee are drawing to a close. We venture to hope that when we shall have resigned our functions into the hands of the governing body, which will be elected under the provisions of the Royal Charter granted to us, Your Majesty will continue to the Corporation that measure of support which has been always graciously given to us.

Science Scholarships, including Regulations ([compiled 1891] *Eighth Report*, Appendix C), pp. 38–9

We stated in our last Report that we had resolved to allot an annual sum of not less than £5,000 a year towards the establishment of scholarships, for the purpose of aiding the development of scientific culture and technical training in the manufacturing districts of the country, as it appeared to us that scholarships intended to enable students in provincial colleges of science to extend their studies would be the best means of recognising the claims of the provinces to participate in the resources at our disposal.

A Committee of gentlemen, especially conversant with the working and needs of scientific education, was thereupon appointed, with the late Lord Playfair as Chairman, to prepare a scheme for the distribution and regulation of the scholarships, so that they might be supplementary to and not in competition with

scholarships provided by the Government or public bodies or by private endowment. This Committee pointed out at an early stage in its proceedings that very little would be gained by our action unless the scholarships awarded differed from those already existing, and that therefore they should be of a higher order, and awarded for research in the experimental sciences bearing upon the industries.

The recommendations of this Committee received our unanimous approval, and we resolved to adopt them as embodying principles on which the scholarships would be founded.

[...]

GENERAL REGULATIONS FOR SCIENCE RESEARCH SCHOLARSHIPS

1. The Scholarships are intended, not to facilitate attendance on ordinary collegiate studies, but to enable Students who have passed through a College curriculum and have given distinct evidence of capacity for original research, to continue the prosecution of Science with the view of aiding its advance, or its application to the industries of the country.

2. The Scholarships are of £150 a year, and are ordinarily tenable for two years, the continuation for the second year being dependent on the work done in the first year being satisfactory to the Scholarships Committee.

3. A limited number of the Scholarships are rewarded for a third year where it appears that the renewal is likely to result in work of scientific importance.

4. Candidates are recommended by the governing bodies of the Universities and Colleges to which Scholarships are allotted, and the recommendations are considered and decided upon by the Scholarships Committee.

5. The Candidate must be a British subject.

6. The Candidate must have been a *bona fide* student of Science in a University or College in which special attention is given to scientific study for a term of three years.

7. The Candidate shall be eligible for a Scholarship providing (1) that he has spent the last full academic year immediately prior to the time of nomination as a student in any faculty or scientific department of that Institution by which he is nominated, or (2) that he has been a student of such Institution for a full academic year ending within twelve months prior to the time of nomination, and since ceasing to be such student has been engaged solely in scientific study.

The word 'student' in the preceding regulation must be understood as comprehending one engaged in undergraduate or post graduate work.

8. The Candidate must indicate high promise of capacity for advancing Science or its applications by original research. Evidence of this capacity is strictly required, this being the main qualification of the Scholarship. The most suitable evidence is a satisfactory account of research already performed, and the Commissioners will decline to confirm the nomination of a Candidate unless such an account is furnished, or there is other equally distinct evidence that he possesses the required qualification.

9. A Candidate whose age exceeds 30 will only be accepted under very special circumstances.

10. A Scholarship may be held at any University in England or abroad, or in some other institution to be approved of by the Commissioners. Every Scholar is, in the absence of special circumstances, required to proceed to an institution other than that by which he is nominated.

11. The principal work of a Scholar must be a research in some branch of Science, the extension of which is important to the national institutes.

12. Scholars are required to devote themselves wholly to the objects of the Scholarships, and are forbidden to hold any position of emolument.

13. Scholars are required to furnish reports of their work at the end of each year of the tenure of their Scholarships. At the expiration of each Scholarship the reports of the Scholar are referred to an eminent authority on the subject treated of, who furnishes an opinion thereon to the Commissioners.

14. The Scholarship stipend is payable half-yearly in advance, but £25 is reserved from the fourth payment until the Scholar has made a satisfactory final report.

Notes

1 Ferdinand Sommer was a musician and inventor of the Sommerophone, a type of euphonium, which he had exhibited at the Exhibition.
2 For details of Sibthorp see 1.3.
3 The GLC was abolished in 1986 and control of the area given to the London Borough of Bromley.
4 This was reported in the *Financial Times* on 1 March 2015.
5 The window tax was repealed in 1851.

6 The national botanical gardens at Kew were founded in 1840. The Palm House, erected between 1844 and 1848, is the largest remaining Victorian glasshouse.

7 Charles Barry, an English architect, most famous for designing the rebuilt Palace of Westminster (1837–52).

8 Negretti and Zambra produced optical instruments and operated a photographic studio in London. They became official photographers to the Crystal Palace Company in 1854, and produced a series of stereoscopic illustrations.

9 John Sims Reeves was the foremost English tenor of the age; Clara Novello was a Welsh soprano, mother of Ivor Novello; Rudersdorf was a celebrated Russian soprano and music teacher with a notorious temper.

10 John Logie Baird set up the Baird Television Development Company in 1927 which made the first transatlantic television broadcast in 1928. Baird broadcast from Sydenham from 1933 until the facility's destruction by fire.

11 Buckland had named his daughter Crystal after the Palace he loved.

12 See 1.3.

13 Freake was a master builder and philanthropist.

Bibliography

Archives

Archive of the Royal Commission for the Exhibition of 1851, Imperial College, London
Bodleian Library, Firth Collection
National Library of Scotland, Crawford Collection
Wellington Papers, Special Collections, University of Southampton

Official publications

Hansard's Parliamentary Debates
Official Descriptive and Illustrated Catalogue, 3 vols (London: William Clowes & Sons, 1851)
Official Catalogue of the Great Exhibition of the Works of Industry of All Nations 1851 [Shilling Catalogue] (London: William Clowes & Sons, 1851)
Royal Commission, *Minutes of the Proceedings of Her Majesty's Commissioners for the Exhibition of 1851, 11 January 1850 to 24 April 1852* (London: William Clowes & Sons for HMSO, 1852)
Royal Commission, *Reports by the Juries on the Subjects of the Thirty Classes into which the Exhibition was Divided*, 4 vols (London: William Clowes & Sons, 1852)
—, *First Report* (London: William Clowes & Sons for HMSO, 1852)
—, *Second Report* (London: William Clowes & Sons for HMSO, 1852)
—, *Third Report* (London: George E. Eyer and William Spottiswoode for HMSO, 1856)
—, *Fourth Report* (London: George E. Eyer and William Spottiswoode for HMSO, 1861)
—, *Fifth Report* (London: George E. Eyer and William Spottiswoode for HMSO, 1867)
—, *Sixth Report* (London: George E. Eyre and William Spottiswoode for HMSO, 1878)
—, *Seventh Report* (London: George E. Eyre and William Spottiswoode for HMSO, 1889)
—, *Eighth Report* (London: Spottiswoode and Co. for HMSO, 1911)

Newspapers and periodicals

Anti-Slavery Reporter
Art-Journal
Athenaeum
Blackwood's
Builder
Bury and Norwich Post, and Suffolk Herald
Daily News
Financial Times
The Friend of the People
Globe
Household Words
Illustrated London News
John Bull
Journal des Débats
Lady's Newspaper
Leeds Mercury
London Gazette
Manchester Guardian
Morning Chronicle
New York Tribune
Northern Star
Patent Journal
Punch
The Times
Weekly North Carolina Standard
Westminster Review
World of Fashion

Primary sources, letters and diaries

Bassett, H. T. (1852). *A Poem on the Great Exhibition of the Industry of All Nations.* Dublin: Edward J. Milliken.

'Belshazzar' (1851). *Belshazzar's Feast in its Application to the Great Exhibition.* London: Houlston.

Berlyn, P. and Fowler Jr., C. (1851). *The Crystal Palace: Its Architectural History and Constructive Marvels.* London: James Gilbert.

Birch, H. (1851). *The Great Exhibition Spiritualized.* London: John Snow.

Chadwick, G. F. (1961). *The Works of Sir Joseph Paxton.* London: The Architectural Press.

Cole, H. (1884). *Fifty Years of Public Work*, 2 vols. London: George Bell & Sons.

Cowper, C. (1852). *The Building Erected in Hyde Park for the Great Exhibition.* London: John Weale.

'Denarius' [Henry Cole] (1851). *Shall We Keep the Crystal Palace, and Have Riding and Walking in All Weathers among Flowers, Fountains, and Sculptures?* London: John Murray.

Dickinson Brothers (1854). *Dickinsons' Comprehensive Pictures of the Great Exhibition of 1851*, 2 vols. London: Dickinson Brothers.

Doyle, R. (1859). *An Overland Journey to the Great Exhibition Showing a few extra articles and visitors*. London: Chapman & Hall.

Edwards, H. S. (1851). *An Authentic Account of the Chinese Commission, which was sent to report on the Great Exhibition; wherein the opinion of China is shown as not corresponding at all with our own*. London: Vizitelly.

Emerton, J. A. (1851). *A Moral and Religious Guide to the Great Exhibition*. London: Longman, Brown and Green.

Engels, F. (1892). *The Condition of the Working-Class in England in 1844*, trans. Florence Kelly Wischnewetsky. London: Swan Sonnenschein and Co.

The Exhibition Lay (1852). London: Groombridge & Sons.

Franklin, R. (1851). *Wanderings in the Crystal Palace*. London: Houlston and Stoneman.

Fuller, F. (n.d.). 'Diary of Francis Fuller', John Scott Russell Papers. Royal Society of Arts Archives.

Gascoyne, C. (1852). *Recollections and Tales of the Crystal Palace*. London: Shoberl.

Greeley, H. (1851). *The Crystal Palace and its Lessons*. New York: Dewitt and Davenport.

Higginson, F. (1851). *Koh-I-Noor; or The Great Exhibition and its Opening*. London: Pretyman & Rixon.

House, M., Storey, G. and Tillotson, K. (eds) (1965–2002). *Letters of Charles Dickens*, 12 vols. Oxford: Clarendon Press.

Hunt, R. (1851). *Hunt's Hand-Book to the Official Catalogues of the Great Exhibition*, 2 vols. London: W. Clowes & Sons.

Irving, J. (1872). *The Annals of Our Time: A Diurnal of Events, Social and Political, Home and Foreign From the Accession of Queen Victoria, June 20, 1837*. London and New York: MacMillan and Co.

Lardner, D. (1852). *The Great Exhibition, and London in 1851*. London: Longman, Brown and Green.

Leask, W. (1851). *The Great Exhibition: Analogies and Suggestions*. London: Benjamin L. Green.

Mayhew, H. and Cruikshank, G. (1851). *1851; or, the Adventures of Mr. and Mrs. Sandboys and Family who came to London to 'Enjoy Themselves' and to see the Great Exhibition*. London: David Bogue.

Newcombe, S. (1851). *Little Henry's Holiday at the Great Exhibition*. London: Houlston and Stoneman.

Onwhyn, T. (n.d.). *Mr. and Mrs. Brown's Visit to London to see the Great Exhibition of All Nations*. London: Ackerman.

Paxton, J. (1851). *What is to Become of the Crystal Palace?* London: Bradbury & Evans.

'Philoponos' (1850). *The Great Exhibition of 1851; or, the Wealth of the World in its Workshops*. London: Edward Churton.

The Philosopher's Mite to the Great Exhibition (1851). London: Houlston and Stoneman.

Ruskin, J. (1854). *The Opening of the Crystal Palace considered in some of its relations to the Prospects of Art*. London: Smith, Elder & Co.

Society for Promoting Christian Knowledge (1851). *An Address to Foreigners Visiting the Great Exhibition of Arts in London, 1851*. London: Gilbert & Rivington.

Stephenson, R. (1851). *The Great Exhibition; its Palace, and its Principal Contents*. London: George Routledge and Co.

Tallis, J. (1851–52). *Tallis's History and Description of the Crystal Palace, and the Exhibition of the World's Industry in 1851*, 3 vols. London: John Tallis.

Thompson, Z. *Journal of a Trip to London, Paris, and the Great Exhibition of 1851*. Burlington: Nichols & Warren.

Timbs, J. (1851). *The Year-Book of Facts in the Great Exhibition of 1851*. London: David Bogue.

Turner, J. (1851). *Echoes of the Great Exhibition*. London: William Pickering.

Ward, J. (1851). *The World in its Workshops: A Practical Examination of British and Foreign Processes of Manufacture*. London: William S. Orr and Co.

Warren, S. (1851). *The Lily and the Bee: An Apologue of the Crystal Palace*. Leipzig: Bernh. Tauchnitz Jun.

Whewell, W. (1852). *Lectures on the Results of the Great Exhibition of 1851, Delivered before the Society of Arts, Manufactures, and Commerce*. London: Bogue.

Whish, J. C. (1851). *The Great Exhibition Prize Essay*. London: Longman, Brown, Green.

Wornum, R. N. (1851). 'The Exhibition as a Lesson in Taste', *Art-Journal Illustrated Catalogue*.

Wortley, Lady E. S. (1851). *On the Approaching Close of the Great Exhibition and Other Poems*. London: W. N. Wright.

Secondary sources

Appadurai, A. (ed.) (1988). *The Social Life of Things: Commodities in Cultural Perspective*. Cambridge: Cambridge University Press.

Armstrong, I. (2008). *Victorian Glassworlds: Glass Culture and the Imagination 1830–1880*. Oxford and New York: Oxford University Press.

Auerbach, J. A. (1999). *The Great Exhibition of 1851: A Nation on Display*. New Haven and London: Yale University Press.

— and Hoffenberg, P. H. (eds) (2008). *Britain, the Empire, and the World at the Great Exhibition*. Aldershot: Ashgate.

Barton, A. and Bates, C. (2013). '"Beautiful Things": Nonsense and the Museum', in Shears and Harrison (eds), *Literary Bric-à-Brac and the Victorians*, pp. 49–66

Benjamin, W. (2008). *The Work of Art in the Age of Mechanical Reproduction*, trans. J. A. Underwood. London: Penguin.

Bennett, T. (1988). 'The Exhibitionary Complex', *New Formations*, 4, pp. 73–102

Brake, L. and Demoor, M. (eds) (2009). *Dictionary of Nineteenth-Century Journalism*. Gent: Academia Press.

Briggs, A. (1988). *Victorian Things*. London: Batsford.

Brown, B. (2003). *A Sense of Things: The Object Matter of American Literature*. Chicago: University of Chicago Press.

Buck-Morss, S. (1990). *The Dialectics of Seeing: Walter Benjamin and the Arcades Project*. Cambridge, MA: MIT Press.

Burris, J. P. (2001). *Exhibiting Religion: Colonialism and Spectacle at International Expositions 1851–1893*. Charlottesville and London: University Press of Virginia.

Buzard, J., Childers, J. W. and Gillooly, E. (eds) (2007). *Victorian Prism: Refractions of the Crystal Palace*. Charlottesville and London: University Press of Virginia.

Cannadine, D. (2008). *Making History Now and Then: Discoveries, Controversies and Explanations*. London: Palgrave Macmillan.

Cantor, G. (2011). *Religion and the Great Exhibition of 1851*. Oxford: Oxford University Press.

— (2015). 'Emotional Reactions to the Great Exhibition of 1851', *Journal of Victorian Culture*, 20, pp. 230–45

Childers, J. W. (2007). 'Peering Back: Colonials and Exhibitions', in Buzard *et al.* (eds), *Victorian Prism*, pp. 203–15

Clayton, J. (2007). 'Paxton's Legacy: Crystal Palace to the Millennium Dome', in Buzard *et al.* (eds), *Victorian Prism*, pp. 270–90

Clemm, S. (2009). *Dickens, Journalism and Nationhood: Mapping the World in Household Words*. New York and London: Routledge.

Cunningham, C. (1999). 'Gender and Design in the Victorian Period', in Perry (ed.), *Gender and Art*, pp. 175–92

Cunningham, C. and Perry, G. (eds) (1999). *Academies, Museums and Canons of Art*. Ithaca, NY: Yale University Press.

Daly, S. (2011). *The Empire Inside: Indian Commodities in Victorian Domestic Novels*. Ann Arbor: University of Michigan Press.

Darling, E. and Whitworth, L. (eds) (2007). *Women and the Making of Built Space in England, 1870–1950*. Aldershot: Ashgate.

Davis, J. R. (1999). *The Great Exhibition*. Stroud: Sutton, 1999.

— (2007). 'The Great Exhibition and Modernization', in Buzard *et al.* (eds), *Victorian Prism*, pp. 233–49

— (2008). 'The Great Exhibition and the German States', in Auerbach and Hoffenberg (eds), *Britain, the Empire, and the World at the Great Exhibition*, pp. 147–72

Deakin, N. (1948). *Origins of the Welfare State: Labour, Life and Poverty*. London: Victor Gallancz.

Dodson, E. J. (2002). *The Discovery of First Principles*. Lincoln, NE: iUniverse.

Fay, C. R. (1951). *Palace of Industry, 1851: A Study of the Great Exhibition and its Fruits*. Cambridge: Cambridge University Press.

Findling, J., 'The Great Exhibition and its legacy: the golden age of fairs'. *Encyclopaedia Britannica Online*. Available at: www.britannica.com/topic/worlds-fair (accessed 8 July 2016).

ffrench, Y. (1950). *The Great Exhibition: 1851*. London: Harvill Press.

Flanders, J. (2006). *Consuming Passions: Leisure and Pleasure in Victorian Britain*. London: Harper.

Forgan, S. and Gooday, G. (1996). 'Constructing South Kensington: The Buildings and Politics of T.H. Huxley's Working Environments', *British Journal for the History of Science*, 29 (4), pp. 435–68

Freedgood, E. (2006). *The Ideas in Things: Fugitive Meaning in the Victorian Novel*. Chicago: University of Chicago Press.

Fuller, P., Guerrini, A. and McAbee, K. (eds) (2010). *Ballads and Broadsides in Britain: 1500–1800*. Aldershot: Ashgate.

Gibbs-Smith, C. H. (1951). *The Great Exhibition of 1851*. London: HMSO.

Giedeon, S. (2008). *Space, Time and Architecture: The Growth of a New Tradition*, 5th edn. Cambridge, MA: Harvard University Press.

Gillooly, E. (2007). 'Rhetorical Remedies for Taxonomic Troubles: Reading the Great Exhibition', in Buzard *et al.* (eds), *Victorian Prism*, pp. 23–39

Greenhalgh, P. (1988). *Ephemeral Vistas: The Expositions Universelles, Great Exhibitions and World's Fairs, 1851–1939*. Manchester: Manchester University Press, 1988.

Hobhouse, C. (1937). *1851 and The Crystal Palace: Being an Account of the Great Exhibition and its Contents*. London: John Murray.

Hobhouse, H. (1995). 'The Legacy of the Great Exhibition', *Royal Society for the Encouragement of Arts, Manufactures and Commerce*, 143 (5,459), pp. 48–52

— (2002). *The Crystal Palace and the Great Exhibition*. London and New York: Continuum.

Howarth, P. (1951). *The Year is 1851*. London: Collins.

Huzzey, R. (2012). *Freedom Burning: Anti-Slavery and Empire in Victorian Britain*. Ithaca, NY: Cornell University Press.

Kember, J., Plunkett, J. and Sullivan, J. A. (2012). *Popular Exhibitions, Science and Showmanship, 1840–1910*. London: Pickering & Chatto.

Kriegel, L. (2007). *Grand Designs: Labor, Empire, and the Museum in Victorian Culture*. Durham, NC: Duke University Press.

Kumar, K. (2003). *The Making of English National Identity*. Cambridge: Cambridge University Press.

Leapman, M. (2011). *The World for a Shilling*. London: Faber & Faber.

Maré, E. (1972). *London 1851: The Year of the Great Exhibition*. London: Folio Society.

McClintock, A. (1995). *Imperial Leather: Race, Gender and Sexuality in the Colonial Context*. New York: Routledge.

Message, K. and Johnston, E. (2008). '"The World within the City": The Great Exhibition, Race, Class and Social Reform', in Auerbach and Hoffenberg (eds), *Britain, the Empire, and the World at the Great Exhibition*, pp. 27–46

Miller, A. H. (1995). *Novels Behind Glass: Commodity Culture and Victorian Narrative*. Cambridge: Cambridge University Press.

Mundhenk, R. J. and McCracken Fletcher, L. (eds) (1999). *Victorian Prose: An Anthology*. New York: Columbia University Press.

Nicoll, A. (1946). *A History of Late Nineteenth-Century Drama*, 2 vols. Cambridge: Cambridge University Press.

Nunokawa, J. (1994). *The Afterlife of Property: Domestic Security in the Victorian Novel*. Princeton, NJ: Princeton University Press.

Perry, G. (1999). 'Conclusion to Part 3', in Perry (ed.), *Gender and Art*, pp. 193–4

Perry, G. (ed.) (1999). *Gender and Art*. New Haven and London: Yale University Press.

Purbrick, L. (2001). *The Great Exhibition of 1851: New Interdisciplinary Essays*. Manchester: Manchester University Press.

— (2008). 'Defining Nation: Ireland at the Great Exhibition of 1851', in Auerbach and Hoffenberg (eds), *Britain, the Empire, and the World*, pp. 47–76

Pykett, L. (2004). 'The Material Turn in Victorian Studies', *Literature Compass*, 1, pp. 1–5

Raizman, D. (2003). *History of Modern Design: Graphics and Products Since the Industrial Revolution*. London: Laurence King, 2003.

Rappaport, E. D. (2001). *Shopping for Pleasure: Women in the Making of London's West End*. Princeton, NJ: Princeton University Press.

Rhodes James, R. (1983). *Albert, Prince Consort*. London: Hamish Hamilton.

Richards, T. (1990). *The Commodity Culture of Victorian England: Advertising and Spectacle, 1851–1914*. Palo Alto, CA: Stanford University Press.

Samuel, R. (1989). *Patriotism: The Making and Unmaking of British National Identity*, 3 vols. London: Routledge.

Shaw, C. (2015). *Britannia's Embrace: Modern Humanitarianism and the Imperial Origins of Refugee Relief*. Oxford: Oxford University Press.

Shears, J. and Harrison, J. (eds) (2013). *Literary Bric-à-Brac and the Victorians: From Commodities to Oddities*. Aldershot: Ashgate.

Shrimpton, N. (2013). 'Bric-à-Brac or *Architectonicè*? Fragment and Form in Victorian Literature', in Shears and Harrison (eds), *Literary Bric-à-Brac and the Victorians*, pp. 17–32

Smith, D. (2012). *Traces of Modernity*. Alresford: Zero Books.

Teukolsky, R. (2007). 'This Sublime Museum: Looking at Art at the Great Exhibition', in Buzard *et al.* (eds), *Victorian Prism*, pp. 84–100.

Wallerstein, I. (1974). *The Modern World System: Capitalist Agriculture and the Origins of the European World Economy in the Sixteenth Century*. New York: Academic Press.

Waters, C. (2008). *Commodity Culture in Dickens's* Household Words*: The Social Life of Goods*. Aldershot: Ashgate.

Weintraub, S. (1997). *Uncrowned King: The Life of Prince Albert*. New York: The Free Press.

Young, G. M. (1936). *Portrait of an Age*. Oxford: Oxford University Press.

Young, P. (2008). 'Mission Impossible: Globalization and the Great Exhibition', in Auerbach and Hoffenberg (eds), *Britain, the Empire, and the World at the Great Exhibition*, pp. 3–26

Index